THE TEACHINGS
OF
Mutton

LIZ HAMMOND-KAARREMAA

KERRIE CHARNLEY, xʷə́lməxʷ, q̓íćə́y̓/KATZIE

SNUMITHIA' VIOLET ELLIOTT, SNUNEYMUXW AND QUW'UTSUN (COWICHAN)

TUWUXWUL'T-HW TYRONE ELLIOTT, QUW'UTSUN (COWICHAN) AND SNUNEYMUXW

ANDREA FRITZ, LYACKSON FIRST NATION

CHEPXIMIYA SIYAM CHIEF DR. JANICE GEORGE,
Sḵwx̱wú7mesh ÚXWUMIXW (SQUAMISH NATION)

DANIELLE MORSETTE, SUQUAMISH AND SHXWHÁ:Y (STÓ:LŌ NATION)

MICHAEL PAVEL, SKOKOMISH/TWANA

saɫamit́ca SUSAN PAVEL, FILIPINA, KOREAN/CAUCASIAN SETTLER,
MARRIED INTO SKOKOMISH

XWELIQWIYA RENA POINT BOLTON, STÓ:LŌ

DEBRA QWASEN SPARROW, xʷməθkʷəy̓əm (MUSQUEAM)

JARED QWUSTENUXUN WILLIAMS, QUW'UTSUN (COWICHAN)

ELIOT WHITE-HILL KWULASULTUN, SNUNEYMUXW

SENAQWILA WYSS, Sḵwx̱wú7mesh ÚXWUMIXW (SQUAMISH NATION)

ALISON ARISS, IRISH/SCOTTISH SETTLER

THE TEACHINGS OF

OF

Mutton

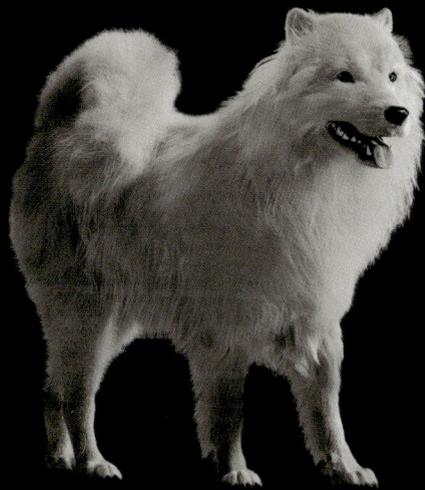

A COAST SALISH WOOLLY DOG

HARBOUR
PUBLISHING

Harbour Publishing Co. Ltd.
P.O. Box 219, Madeira Park, BC, V0N 2H0
www.harbourpublishing.com

Edited by Emma Skagen and Alicia Hibbert
Indexed by François Trahan
Cover design by John Montgomery
Text design by DSGN Dept / Naomi MacDougall
Printed and bound in South Korea

Canada Canada Council Conseil des Arts BRITISH COLUMBIA BRITISH
 for the Arts du Canada ARTS COUNCIL COLUMBIA
 Supported by the Province of British Columbia

Harbour Publishing acknowledges the support of the Canada Council for the Arts, the Government of
Canada, and the Province of British Columbia through the BC Arts Council.

Library and Archives Canada Cataloguing in Publication
Title: The teachings of Mutton : a Coast Salish Woolly Dog / Liz Hammond-Kaarremaa.
Names: Hammond-Kaarremaa, Liz, author.
Description: Includes bibliographical references and index.
Identifiers: Canadiana (print) 20240522419 | Canadiana (ebook) 20240530586 | ISBN 9781998526024
 (softcover) | ISBN 9781998526031 (EPUB)
Subjects: LCSH: Dogs—Social aspects—Northwest, Pacific. | LCSH: Human-animal relationships—
 Northwest, Pacific. | LCSH: Indigenous peoples—Northwest, Pacific—Social life and customs. |
 CSH: First Nations—Domestic animals—Northwest, Pacific.
Classification: LCC E98.D67 H36 2025 | DDC 636.7008%72—dc23

◇◇

This book is dedicated to all the Coast Salish ancestors whose knowledge nourished and sustained the Woolly Dogs, to the Knowledge Keepers who kept the memories alive, and to the Coast Salish peoples who supported this work so it could be shared.

CONTENTS

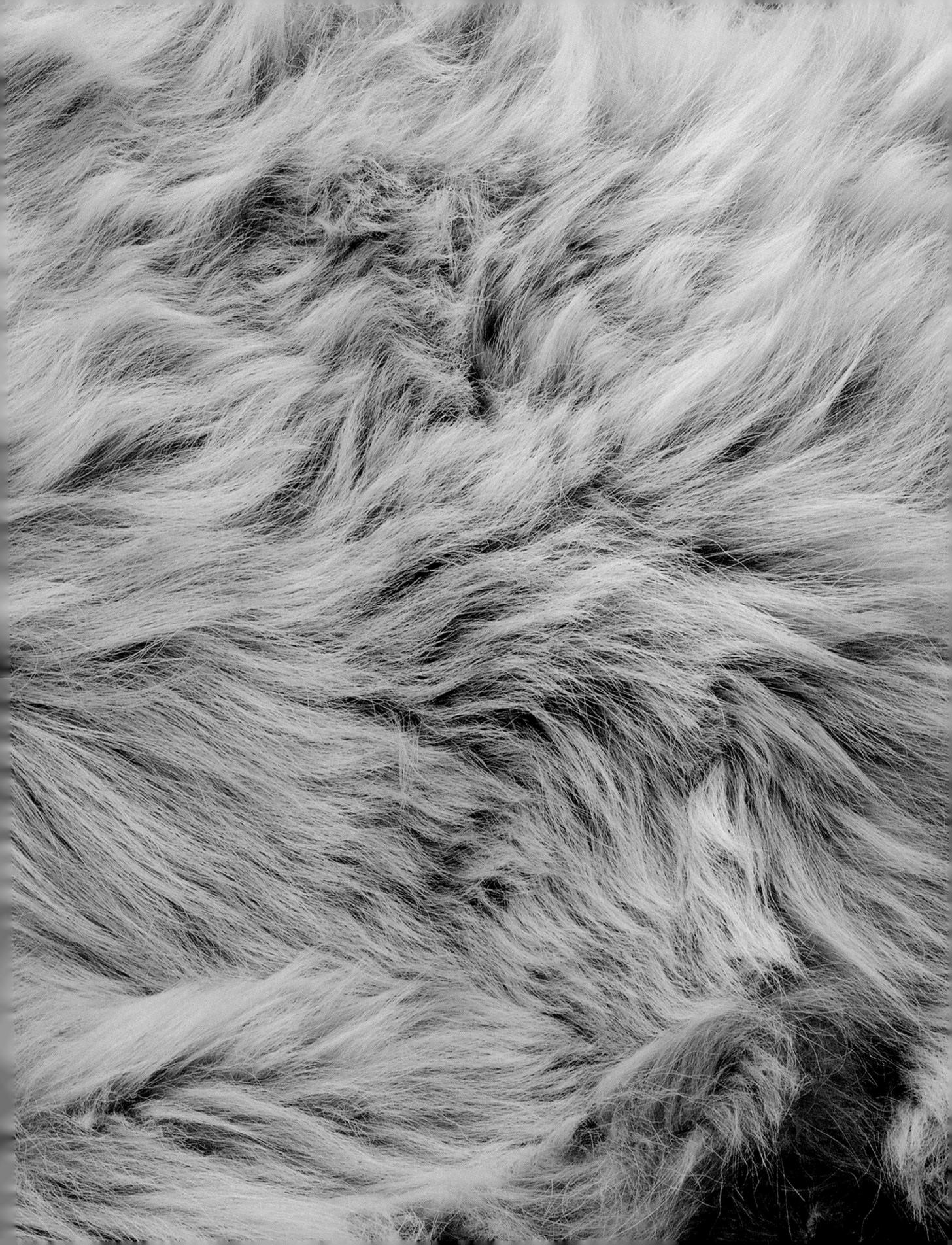

INTRODUCTION

LIZ HAMMOND-KAARREMAA

THIS BOOK EVOLVED out of a research project on a dog named Mutton, the only known Coast Salish Woolly Dog pelt in existence. The Coast Salish people I interviewed requested that I share, in an accessible way, what we learned about Woolly Dogs, the breed of dogs raised by the Coast Salish for its wool-like hair.

"Coast Salish" is an anthropological term referring to many First Nations who once shared a common ancestral language, but it is important to note that each Nation is unique, having their own origin stories, songs, dances, material culture, protocols, and language or dialect. Whereas many communities near each other have close relations and close cultural connections, it cannot be assumed that what was the practice in one community was necessarily the practice in another. For example, although one community might have shaved the dog fur off, another community might have been able to pluck it off, while a third would comb it out. These different practices could be the result of having slightly different lines of dogs. Perhaps one village had dogs that easily moulted, making plucking easy, whereas others had dogs that were more resistant to moulting hence were shaved. So this book is just a start, not the definitive end, in compiling knowledge about the Woolly Dog. Differences in culture and context are an important part of the knowledge.

Oral History on the use of dog wool has been passed down through generations and is well known in Coast Salish communities, but the knowledge

surrounding the dog is scattered. As Michael Pavel, a Skokomish/Twana man, says,

> Uncle [Subiyay Bruce Miller] would say that not everybody was taught the same thing, so pieces [of knowledge] would be scattered about. The basket might hold a bit of history, and the weaver would hold a bit of history orally, or another village would hold another piece of information and that none of us held all of it, and that would be why we would learn to rely upon each other because we would be trying to weave it all back together.

The English word *story* comes from the Latin word *historia*, meaning "history" or a "story of history." Likewise, the word *text* comes from the Latin word *textus*, which means creating a framework or structure or weaving a fabric—in other words, a textile.[1] It is a good metaphor for describing the framework of this book: weaving a story. Like a woven blanket, this book is interwoven with two types of threads or stories: the weft, consisting of Coast Salish voices written or recorded in a variety of formats, and the warp thread, written by me, a non-Indigenous person, gathering Mutton's history, his story and what his pelt is teaching us. The Coast Salish threads show how Woolly Dogs are an important part of Coast Salish cultures, embedded in oral histories, origin stories, place names and family history.

This interweaving of these threads combines the strengths of different ways of seeing and knowing, merging Indigenous Knowledge with Western, Eurocentric ways of knowing, thereby producing a stronger fabric or textile—a gift of multiple perspectives.

MY INVOLVEMENT IN Mutton's fascinating story stemmed from my love of spinning. Shortly before retiring as Director of Research Services at Vancouver Island University (VIU), I enrolled in a seven-year part-time spinning (e.g., yarn design) program and graduated as a Master Spinner. A requirement of the program was an in-depth applied research project. I live on Coast Salish Snuneymuxw Traditional Territory, and my project focused on Coast Salish spinning, as some of the tools, techniques and fibres are unique. In the course of my research, I learned that the only known Woolly Dog specimen—Mutton's pelt—was housed at the Smithsonian National Museum of Natural History in Washington, DC, and I went there to visit Mutton and to take a good look at his hair, or wool.

Around the time I was doing my Coast Salish spinning research project, I began my involvement with Tribal Journeys, a First Nations event where a coastal Indigenous community in either British Columbia or Washington State invites community canoes to journey by canoe to visit them. I first got involved when Vancouver Island University sponsored a canoe for Indigenous students and staff, and they were short of paddlers, so I volunteered. After that journey, I was invited by Snuneymuxw Elder Gary Manson to join his family canoe *Munu* (Hul'q'umi'num: blood child) and then to help his son, Adam Manson, skipper a youth canoe named *A'kwul'muxw* (Hul'q'umi'num: people coming together for a purpose). Canoes start in their home community and paddle each day until they reach their destination for the night, a community who hosts them, providing meals and opening their longhouse or community hall for the paddlers to share their songs and dances. Often, the journey would take one to two weeks (sometimes more), and paddlers would be hosted by many different communities. It is a way for youth and adults to reconnect with their culture and traditions. Some years the destination would be far south in Puget Sound; other years the journey would go north, and the farthest was Bella Bella. I am forever grateful to the people and communities who taught me so much on those journeys. Those journeys opened my eyes and changed how I look at life.

AFTER RETIRING, I continued with my research studying Coast Salish textiles, looking closely at the spinning characteristics (twists per inch, angle of twist, diameter, etc.), and became a research associate in the Anthropology department at VIU. In 2021, ten years after taking Mutton out of his drawer to examine him, I was contacted by two researchers at the National Museum of Natural History who asked if I would participate in a research project looking at Mutton's ancient DNA. I became a research associate at the Smithsonian.

My roles were to share knowledge of dog wool and the history of the Woolly Dog; to make sure this research direction would not go against any Stó:lō protocols (in the area where Mutton was acquired); to form an advisory committee of Coast Salish weavers, Knowledge Keepers and Elders to help guide the research; and then to interview Coast Salish people on stories and memories of the Woolly Dog to ensure Coast Salish voices were heard and guided the research. The advisory committee has been together for over three years now, and we are still sharing and learning. I am so grateful to the committee who helped guide, encourage, support and assist the project in so many ways.

I interviewed seven Coast Salish people from Washington State and British Columbia about the Woolly Dog—they shared what they have heard, stories passed down to them and their thoughts (and hopes) about the extinct breed.

I compiled quotes from all the interviews and grouped them by theme. I felt it was important that the voices of Indigenous people be "heard" without being paraphrased or overwritten by a non-Indigenous voice like my own.

THE RESEARCH PROCESS took what is called a Two-Eyed Seeing approach, known by the Mi'kmaq word *Etuaptmumk*. It means "learning to see from one eye with the strengths of Indigenous knowledges and ways of knowing, and from the other eye with the strengths of Western knowledges and ways of knowing… and learning to use both these eyes together, for the benefit of all."[2]

The research result was published by *Science*, one of the top academic journals in the world.[3] The journal accepted the quotes from the Coast Salish interviewees as data, giving the same credit to Oral History as they would for scientific data, and four Coast Salish people were listed as co-authors. In an editorial summary, editor Corinne Simonti said, "This study joins the growing number attempting to incorporate Indigenous groups in historical studies." This indicates not only that academic journals are now encouraging Indigenous Knowledge, co-authors and contributors to their articles, but also how scientists (and other disciplines) are looking for ways to do that.

One question I asked the advisory committee and other community members I interviewed was, apart from an academic paper about Mutton's DNA, how would you like the information learned to be shared? Overwhelmingly, people asked for something accessible to the general reader, using images and even audio and video.

This book is a result of that request, as is a documentary due to be released in the fall of 2025. In this book, I focused on the chapters dealing with Mutton in particular, his history and what his pelt has taught us. Coast Salish advisory committee members, weavers, artists, and others contributed chapters highlighting the importance of the dog—Woolly Dogs in particular—in Coast Salish culture through Traditional Stories, place names, family history, blankets and weaving.

MOST AUTHORS STATE, "Any errors in this book are mine." Yes, that is true, but it is more than getting a fact wrong; it is also about misinterpreting the

information, not understanding Indigenous concepts, making assumptions and parroting other settler or written accounts by people who interpreted what they saw without understanding the context.

I am sure Coast Salish and other Indigenous readers will pick up on these mistakes, and I humbly apologize for these errors. I will gratefully accept corrections in the hopes of revising the text for any future editions.

As a non-Indigenous interviewer, I make assumptions that I know and understand the context of a situation. I don't think about it; I don't question the context; I just assume I know. It is unconscious. I don't even realize I have made an assumption.

As I am aware that I often do not know the context or even the hidden assumptions I bring, I have tried to use the interviewees' own words as much as possible. I have lightly edited them for brevity and clarity, and I hope I have not overlaid their voices with my assumptions.

Interviewee Senaqwila Wyss, Sḵwx̱wú7mesh Úxwumixw (Squamish Nation), provides a good example of how one's cultural context and worldview can lead one to make wildly incorrect assumptions: "Louis Miranda, when interviewed in 1876, said when anything went wrong, a woman would grab her Woolly Dog before her child." Today, a Eurocentric world is commonly one of individual households, not a community household. As such, non-Indigenous people would read the above with surprise, shock, or even as if it were meant to be humorous—but as Senaqwila explains,

> We are such a close-knit community, there's a mother or a father, or older siblings, cousins or aunts and uncles or grandparents that are a very large part in childrearing. We trusted our entire family that our children would be safe, but we knew that our dogs were so precious that we would make them a priority because we knew our whole family would be there in a supportive role [to take care of the children], and so that [1876] quote just shook my whole world of looking at different narratives.
>
> So when I read texts written about [not by] Indigenous communities, I always take it with a grain of salt because I don't think they understand. They're trying to write it, but in English it just does not capture what we had in our mind.

To my Eurocentric worldview, Mutton's name is simply the name that George Gibbs, an American ethnologist and naturalist who travelled through

the Pacific Northwest in the 1840s and 1850s, gave his dog—a name with a reference to sheep. But it can be seen as derogatory on a few levels: *mutton* refers to sheep meat, intended to be eaten. And in the next section of this book, Kerrie Charnley, , xʷə́lməxʷ a professor of Coast Salish Indigenous literature and oral traditions from Katzie First Nation, explains that Mutton's name can be seen as especially disrespectful from a Coast Salish worldview. Her writing provides a good way to begin deeper conversations and to open doors to understanding more about the Coast Salish worldview.

On that note, the term Woolly Dog has been capitalized in this book. A simple reason is to distinguish the Coast Salish Woolly Dog as a breed from the description of any dog that was woolly, but more importantly, to acknowledge that this was a special breed of dog, unlike any in existence today. It's one that the Indigenous Coast Salish peoples carefully bred for thousands of years to develop its wool for use in making textiles.

While many dog breed associations prefer capitalization of all dog breed names (e.g., German Shepherd), most style guides prefer lowercase (e.g., golden retriever). Gregory Younging, in his book *Elements of Indigenous Style*, discusses capitalization of Indigenous terms and provides a useful guideline we have followed here: "Consider whether the term relates to Indigenous identity, institutions, or rights—in which case, capitalization is probably in order."

In the course of my research, I was inspired by the attention paid by my Indigenous collaborators to always acknowledging one's teacher—who told them the story, who owns the song, whose knowledge it is. Similarly, this is not my knowledge, it belongs elsewhere, and I have merely pulled it together as much as possible. In so doing, I may not have attributed the knowledge the correct way. If an informant was named by the person collecting the knowledge, I too could acknowledge them. However, many early chroniclers did not record from whom, or in which area, the knowledge was collected.

One of my friends, Snuneymuxw Elder Gary Manson, who has taught me what little I know of Coast Salish ways, once told me (and I paraphrase), "They took everything from us: our children, our language, our belongings. We had to hide ceremonies and, in many cases, keep our knowledge to ourselves so that it couldn't be taken." This is how some communities dealt with loss and the need to keep knowledge alive—they kept it private.

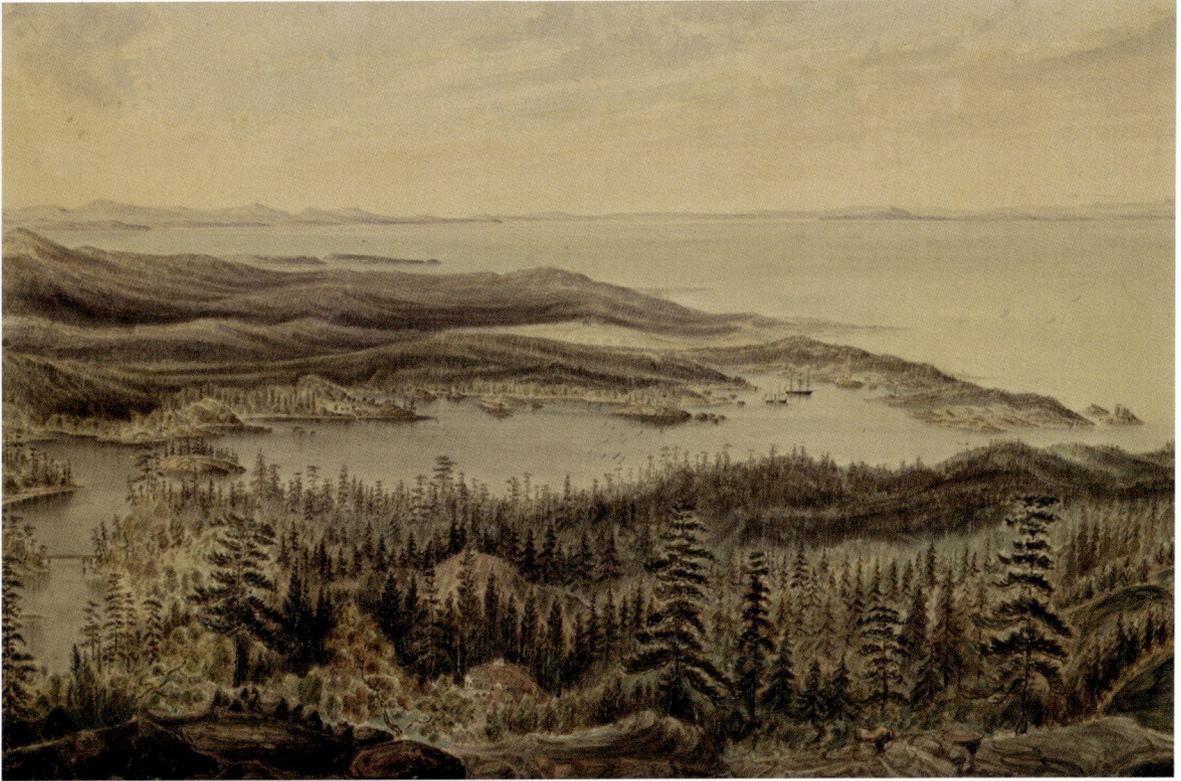

FIG 1

Some knowledge or teachings have always been private knowledge, owned by a person or family, and are not to be freely shared. Hence, some knowledge about Coast Salish Woolly Dogs—or the processing, spinning and weaving of the wool—might be lost given the devastation caused by contact, colonial policies and cultural disruption, or the teachings are considered private, so this book can never be fully complete.

There is a Coast Salish teaching *uy shqwalawun* (Hul'q'umi'num: be of good heart and mind) that I tried to follow during the research and in writing this book. The intention of this book is to collate and give back to Coast Salish people the bits and pieces of knowledge related to the Woolly Dogs that I found throughout my research, and to provide a way for non-Indigenous people to better understand the issues Coast Salish people have faced and to be more sensitive to the nuances of our woven stories. My larger goal is to offer a way of thanks to the Coast Salish people who opened my eyes. It is my hope that this book re awakens more memories, knowledge and teachings.

FIG 1 James Madison Alden was an artist hired to paint scenes as the US Boundary Commission surveyed the 49th boundary. This painting depicts Esquimalt Harbour, with Fort Victoria behind it, on Vancouver Island. The Boundary Commission was stationed here as it was being formed, and this is where George Gibbs (who became Mutton's owner) was hired in 1847. *US National Archives*

THE NAMING OF A COAST SALISH WOOLLY DOG

KERRIE CHARNLEY, xʷə́lməxʷ (PIERRE FAMILY, q̓íc̓əy̓/KATZIE)

NAMES ARE A BIG DEAL in the Coast Salish world. Honourable ancestral names are attributed to worthy contributors to the təməxʷ (this is our concept that encompasses not only the physical land, but, importantly, all living beings). Those considered worthy contributors include teachers, Elders, Knowledge Keepers, Land places and other beings and entities. The honourable names our Peoples bestow carry deep meanings and responsibilities, and they resonate throughout, and beyond, an individual's lifetime.

So here I would like to refer the reader to the name that was given to one of our precious and beloved Coast Salish Woolly Dogs: the name that appears in the title of this book. It is important to remember this particular Coast Salish Woolly Dog has not received a name from a Coast Salish family, community or ancestors (honour and ancestral names come from a collaboration by all of these relations). Rather, he is referred to in this book by the colonial name "Mutton." I would like to signal that this name is questionable and not appropriate within the Coast Salish Peoples' Knowledge system and protocols. As a q̓íc̓əy̓ Coast Salish person, I wonder who his original Coast Salish family and caretakers were; what name they would have honoured him with. In a Coast Salish context, and in a non–Coast Salish context, that colonial name could be heard as a derogatory term. Therefore, I would urge the reader to be aware that our Coast Salish teachings are not connected to that name. The name seems to have been given, probably by George Gibbs, as a moniker to the mischievous Woolly Dog he regarded as a specimen, or—at best—as a pet, and the name may indicate an affection he felt for our Coast Salish Woolly

8

Dog despite the dog's naughtiness. Further, I cannot help but wonder if this is the way colonial agents also thought of us Indigenous Peoples: naughty and getting in the way of colonial Land takeover (I use capital "L" Land to denote our Coast Salish təməxʷ concept). The name "Mutton" given him by colonial settler(s) might be framed as a tongue-in-cheek gesture, yet I cannot help but question it. I hear in this name nuances of yet another joke: the ridiculousness of his colonial name, at the expense of respect for Coast Salish Peoples; I hear in it the outlawing of our rights, values, protocols and teachings that came with the Potlatch Law (1885–1951). I worry that the continued application of this colonial name, in a subtle way, may diminish one of the main purposes of this book, from a Salish Peoples' perspective. That purpose is to decolonize colonial perceptions of us, to teach respect for our ways of knowing and being, and to right history. Fundamentally, the purpose of this book is to return our beloved Coast Salish Woolly Dog and the teachings that come with him, back to us. This book about our Woolly Dog, who is to us a sacred being, continues the return of the hearts of our Coast Salish Knowledge systems, which were torn violently away from us only a generation or two ago.

Our hope is that our sacred Woolly Being will be ceremonially honoured and protected with a worthy Coast Salish name in the not-too-distant future. For the many Coast Salish contributors, and for the broader Coast Salish communities, this would be an essential step in the return of our sacred Coast Salish Woolly Dog—physically, metaphysically and politically—to xʷəlməxʷ, to our world, to our təməxʷ.

HOW THE DOG CAME
TO LIVE WITH HUMANS

YÚY'YUX̱TXN JAMES CHEHOLTS OF SÍQ'ʷɬ
(TOUTLE RIVER BAND OF COWLITZ)

WOLF, COYOTE, AND DOG were brothers. They were hunters. They kept their campfire burning all the time. One day they were so busy eating the meat they had caught, they forgot to watch their fire. "Why don't you fix the fire?" Wolf asked.

"Oh, I have no time," one of the others said. By the time they had finished, their fire was out. Then one said, "Which one of us is going to go to the people and ask them for some fire?"

"Well, I can go. I'll ask them to give us some fire," Dog said.

"All right," his brother said, glad to let him go.

Dog went to the people to ask them for the fire. They had some food. "We'll give you something to eat. Stay with us," they said, and placed some food in his palm. He never went home. Today, one can see a cushion at the base of his palm, where they placed the food. He stayed there for good. His brothers are still angry with him because he never returned. When Wolf and Coyote meet Dog, they always fight him.[4]

1 FINDING MUTTON

IN FRONT OF ME, like a steel wall, is an imposing row of six-foot-high metal storage cabinets protecting the past from the present. Somewhere within this fortress an ancient breed of dog is held in one of the drawers. It is 2012, and I am in the basement of a storage facility at the Smithsonian Institution's National Museum of Natural History, in Washington, DC. The windowless room seems enormous, filled with rows and rows of metal cabinets, much like a library with its stacks of shelves.

Museum objects are parts of historical stories—sometimes concealed, sometimes revealed—often opening windows into a culture, a place or a time. Most museums only display a small percentage of the holdings they are entrusted with as stewards. Most objects are stored like this, not forgotten but available for research. I am here to unearth the story behind the object I am about to see.

I could never have found my way into this maze of cabinets and drawers by myself, but standing next to me is Suzanne Peurach, my underground guide and collections manager of mammals. We are about to open a drawer and look at one of the treasures—the pelt of a Coast Salish Woolly Dog.

Oral history of Coast Salish peoples from the Pacific Northwest coast of North America tells of a dog bred and raised for its soft, white, woolly fur that was spun into yarn for textiles and regalia. Access to wool in areas where mountain goats were not found (low-lying areas along the Salish Sea and on Vancouver Island) was a valuable resource.

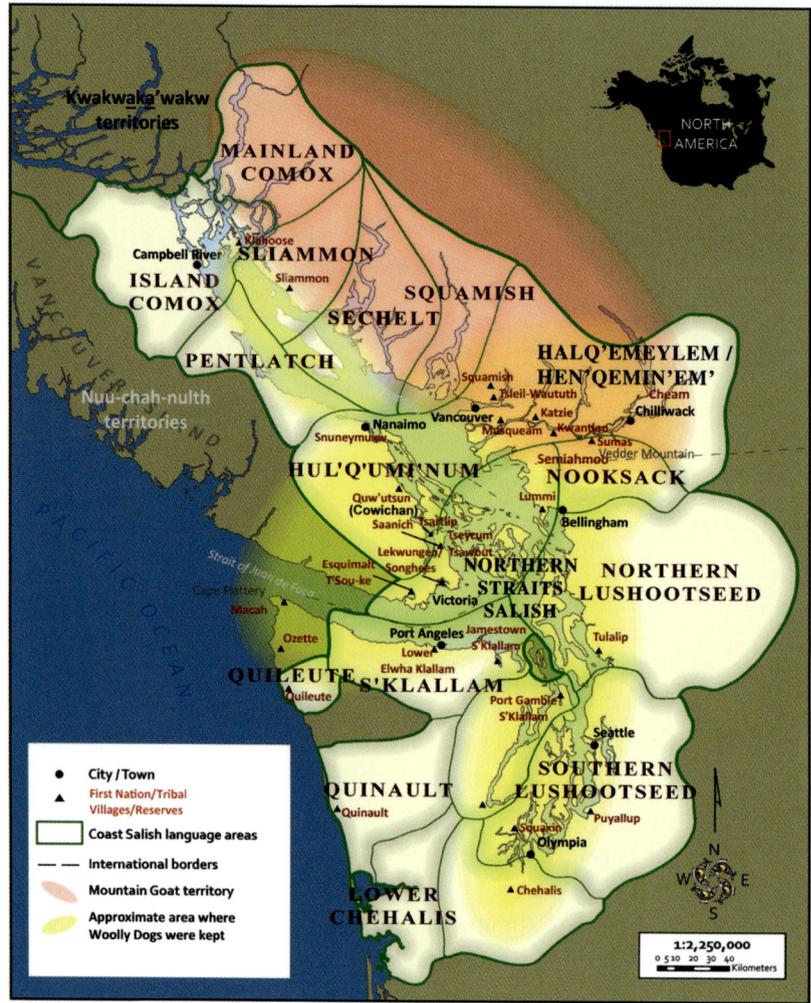

FIG 2 This map of Coast Salish territories on the West Coast of Canada and Washington shows where Woolly Dogs were kept (yellow areas) and where mountain goats were found (pinkish area) before the 1900s.

Map by Carlos Garcia Gonzalez, adapted by Jean Compton

FIG 2

For years, to non-Indigenous people, these Woolly Dogs were dogs of myth and mystery, subject to speculation. Despite Indigenous Oral History of the dogs and early explorer descriptions of them, some scholars questioned their existence, whereas others questioned the use of their wool in blankets. If they were bred for their wool, then where were the dog wool blankets? For those believing they existed, then what did the dogs look like? Others are astonished, even incredulous, to learn of dog wool being spun into yarn. Even researchers doubted their undercoat could be used to spin into yarn for use in weaving Coast Salish blankets. There were claims that the wool was too slippery, not strong enough, not good enough, too difficult given the tools of the time—all these questions plagued acceptance of the role of the dog in Coast Salish culture. I was there to take a good look at the dog's pelt and its woolly hair and to try answering some of those questions.

Candace and Cecelia

As Suzanne and I eagerly pull on latex gloves to protect ourselves against any toxic preservatives—a hundred years ago taxidermists might have used deadly arsenic to tan a hide—I silently thank Candace Wellman, the woman who rediscovered the forgotten dog lying in an old wooden drawer for 142 years. The drawer had rarely been opened other than to transfer the object into a more modern drawer. Without Candace, the dog would probably have languished in an unopened steel drawer for years to come.

At the time, in 2002, Candace, a petite woman with pixie-like short hair and an infectious smile, jokingly referred to herself as "just a housewife and archives volunteer." Yet she was the one—not archaeologists, ethnologists, museum staff or researchers—who pieced together the puzzle that led to finding the only known pelt of a Coast Salish Woolly Dog, one that came to the museum a century and a half ago, complete with a name. His European name is "Mutton."

In the early 2000s, Candace was volunteering one day a week as a research assistant at the Washington State Archives. "When the gals from the Genealogy Society came in and were copying early marriage certificates, they kept saying, 'Who are these women?'" Candace wondered, "Why is it that we know about the men, but we don't know anything about the women?"

When Candace found a list of "mixed marriages" in an old historical file, she resolved to find out about some of these unacknowledged women.[5] What started out, in her mind, as a quick project resulted in more than twenty years of research. At last count she has written three books, the first two on the lives of eight Indigenous women on her list who married some of the first settlers in northwest Washington State. She can no longer call herself "just a housewife and volunteer"—she is a respected historian and author.

Candace couldn't find much information on the women, so she researched their husbands to find out more about their wives. Like a dog with a bone, she tracked everything down that she could find.

One of the women she chose to research was Cecelia Chehaynuk, the daughter of the salmon trade lead middleman on the Fraser River with the Hudson's Bay Company (HBC), and wife of Dr. Caleb Burwell Rowan Kennerly. Cecelia was a woman from the village near Camp Semiahmoo, the headquarters of the US Northwest Boundary Survey (NWBS) Commission, where Kennerly was employed. Kennerly, twenty-eight years old when he started with the NWBS, was based at Semiahmoo, the present-day border crossing

town of Blaine in Washington State, for most of three years. During his time here he met Cecelia Chehaynuk; the two were married by local custom and soon had a son. Their descendants are prominent in the Lummi Nation reserve just north of Bellingham on the Lummi Peninsula.

Kennerly, who was from Virginia, had been a student under Spencer Baird at Dickinson College. Baird became the Smithsonian's first curator and, at the time of the NWBS, its assistant secretary. They were both passionate about birds and nature. In 1857, Baird arranged for Kennerly to go west and act as a medical doctor and naturalist on the American NWBS team, tasked with accurately surveying and marking the 49th parallel border. When he wasn't doctoring, Kennerly was sending natural history specimens back to Baird at the National Museum (as the Smithsonian was then known). It was an adventurer's dream job, being paid to do the things he loved: exploring, discovering new species and building a natural history museum.

Kennerly corresponded with Baird on his activities until Kennerly's untimely death in 1861.

If Candace wanted to learn anything about Cecelia, who had married Kennerly, she needed to read all of Kennerly's correspondence for mentions of his wife or their life together. So she headed to Washington and the Smithsonian archives, where she copied everything Kennerly wrote, and brought copies home to transcribe.[6] Unluckily for her, little of this had anything to do with Cecelia. Yet there was one passage that caught Candace's attention in passing.

In a letter dated August 19, 1859, a frustrated Kennerly wrote to Baird,

> We got another splendid [mountain] goat skin which was sent to Camp Skagit where Mr. Gibbs happened to be & he took charge of it; but most unfortunately his famous Indian dog "Mutton" got at it and ate the head off. He sent it to me yesterday & when I opened the bag & saw the injury I could almost have cried. Mutton was sheared a short time ago, & as soon as his hair grows out we will make a specimen of him.[7]

At the Smithsonian, a packing list dated September 1859 lists specimen #406 as "Mr. G's dog 'Mutton' Chiloweyuck Indians." Candace had a copy of the packing list too.

She was not surprised to read about a Woolly Dog. She was from the Northwest, she wrote on local Indigenous women and she was mentored by the late Coast Salish Lummi Traditional Chief Tsi'li'xw Bill James and his mother Fran, who were both weavers, so she knew the Oral Stories about the Woolly Dog,

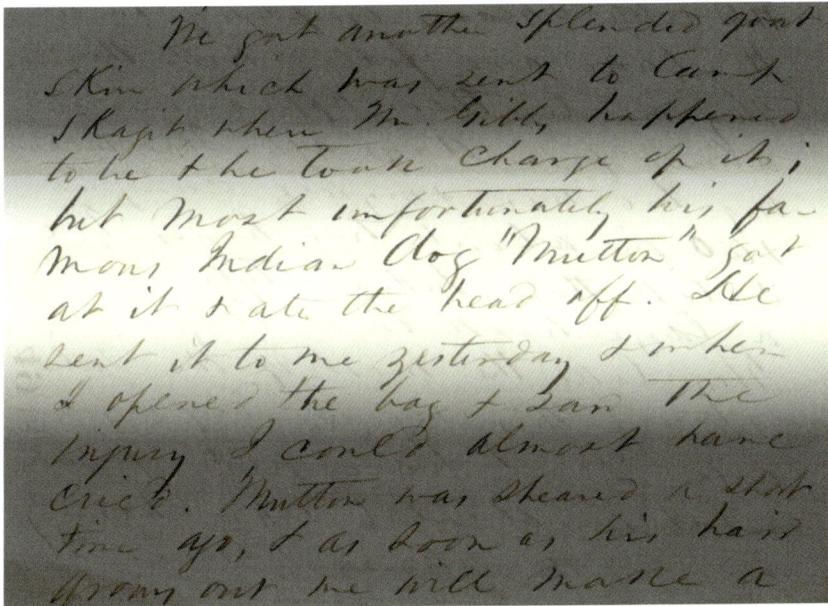

FIG 3

FIG 4

bred for its long wool-like hair to be used in weavings. She chuckled at the letter mentioning Mutton, but neither this letter nor Kennerly's other letters or documents provided her with any information about Cecelia and their son. Disappointed, Candace put the Kennerly letters aside and turned her attention to the other Indigenous women she was researching.

Mutton's Rediscovery

Months later, Candace came across a paper written by University of Victoria archaeologist Susan Crockford, who reviewed thousands of ancient dog bones. Crockford hypothesized, using bone sizes and formulas, that two breeds of dogs existed in the Georgia Strait/Puget Sound area—a larger village or hunting dog, and a smaller dog, bred for its long wool-like hair.

Without a known Woolly Dog specimen, it was Crockford's research that established a tool archaeologists could use to assist in identifying two dog types in the Salish Sea area. However, some archaeologists hesitate to place too much confidence in the theory that bone measurements alone could accurately identify Woolly Dog remains from other dogs. Having a confirmed Woolly Dog specimen would address this concern and open the door to much more research into Woolly Dogs, but in 1997 Crockford had noted that as far as was known, there were not any Woolly Dog specimens in any museum collections.[8]

At the time, Candace didn't pay too much attention, but that simple sentence written by Crockford obviously triggered something in her mind. Recalling the Kennerly letters—even though they did not provide the information she had hoped for about his wife, Cecelia—she bolted wide awake in the middle of the night, saying to herself, "But there *is* a Woolly Dog specimen! It said so in that letter I read."

She got up, Googled the museum staff directory and shot off an email to the collection manager, Robert (Bob) Fisher, telling him of the letter and the importance of the Woolly Dog, especially to the Coast Salish peoples. By breakfast, Candace had a reply along the lines of "Sorry, but I did not even know of Mutton's existence." Candace had a copy of the collection slip, and she sent Mutton's field number—#406—to Bob Fisher. She received an almost immediate reply. Bob would drive out to the Smithsonian Research Center warehouse, with the number in hand, to try to find Mutton.

Bob sent Candace a reply that same day. "He's still there and the tag with field number #406 is still attached to his leg." Candace sat back, quite stunned. "Gosh, it's like I made a scientific discovery, instead of all the experts. And I'm just a housewife writing a book!"

In 2002, after 142 years, Mutton was found in perfect condition in drawer #4.

This is where Suzanne Peurach and I now stood, ten years later.

Suzanne puts her hand on the drawer, pauses, looks at me and grins. After being so compelled to find out more about Woolly Dogs, I'm about to see and touch one—the only one.

Meeting Mutton

I feel so honoured and lucky to be able to touch Mutton, after first hearing about the Woolly Dogs many years ago, when I was in my early twenties and just starting to learn about spinning, dying and weaving. I had been blessed with the guidance of a marvellous and all-knowledgeable teacher, Judith McKenzie. Judith had grown up in Coast Salish traditional territory in Vancouver, near Musqueam, and had learned some Coast Salish spinning and weaving techniques in a time when not much was known and very few non-Indigenous people even cared to find out. But Judith cared. I learned how the Coast Salish spun wool for Cowichan sweaters, sometimes known as Salish sweaters, and I was hooked.[9]

I joined a weavers and spinners guild, and we often met at members' houses. I remember going to a meeting at Mary Barraclough's home in Cedar-by-the-Sea, south of Nanaimo, BC. I parked the car in her driveway, got out and stumbled over a full-sized cannon, so heavy that it was sinking into their front lawn. I could tell that Mary and her husband would be interesting people.

Ed Barraclough was a research scientist at the Department of Fisheries and Oceans in Nanaimo, and often travelled up and down the Pacific Northwest coast for his work. The story I heard was that he was hiking on a remote island near Southeast Alaska and came across this Russian cannon from the 1800s and somehow wrangled it home. He was retired when I met him, and judging by the depth the cannon had sunk into the front lawn, he had probably found it in the mid-1900s.

In 1955, Ed gave a talk on Woolly Dogs at the Nanaimo Historical Society and later wrote it up, eventually publishing it in a 1969 issue of *BC Historical News*.[10] Years later, that paper set me on a path to find out more about Woolly Dogs. When it came my way, I was so inspired I tried my hand spinning the wool from my niece's Samoyed dog, creating several scarves. So I knew that spinning dog wool—at least the wool of some types of dogs—was entirely possible, though no one said it was easy.

My career took over, and I put away my spinning wheel for twenty years, but I kept an eye open for any and all information about Woolly Dogs. When I was ready to spin again, I signed up for a multi-year part-time program to get my Master Spinner Certificate at Olds College in Alberta. The final year required a spinning research project and, since I lived on Snuneymuxw Coast Salish territory, I decided to look at Coast Salish spinning techniques, tools and fibres, which had many unique elements. I had not heard of any other cultures relying solely on dog wool for warm fibre. Yes, other cultures spun

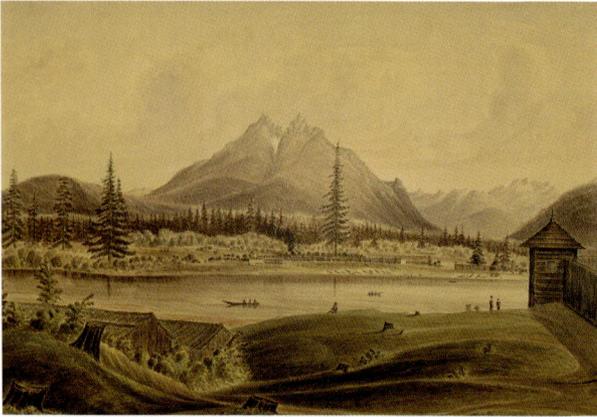

FIG 5

FIG 5 In 1858 HBC Fort Langley, on the Fraser River, was a major communication hub, and a stop for the Boundary Commission when they were working out of the Chilliwack Depot. This depiction of the fort was painted by James Madison Alden between 1857 and 1862.
US National Archives

dog hair—for example, the Chono of Chile bred the dogs as hunters of otters, but also used their hair in textiles—but they, unlike the Coast Salish, had other domesticated animals that provided spinnable fibre.[11]

My research never stopped. I started looking at the spinning characteristics of yarn in Coast Salish blankets in museum collections. My go-to was Paula Gustafson's 1980 book *Salish Weaving*, an incredible resource that many Salish weavers still look to today.

Gustafson did an extensive and thorough survey of most of the known Salish blankets in the world, including those whose provenance records state that they contain dog wool. She remained unconvinced they did contain dog wool and posed the question that has plagued everyone interested in Salish weaving ever since: "I examined almost all of the historical northwest coast textiles in museums in North America and Europe. I am still looking forward to examining a Salish dog hair blanket."[12]

Gustafson left the question dangling for years—where are the dog wool blankets?

Further, Gustafson cast doubt on the suitability of dog hair for spinning: "It is particularly difficult to work with using the suspension-spindle method of spinning employed by the Salish."[13]

If dog hair *was* used in blankets, then it makes sense that a special breed of dog existed. If no surviving blankets can be proven to contain dog fibre, doubt could be cast on the notion of a special Woolly Dog breed. If blankets *are* found to contain dog fibre, is the fibre similar to the fur of Mutton, thought to be the only surviving specimen of the breed, albeit as a pelt in a drawer? Or was Mutton just, well, a mutt that happened to have long hair and was collected by someone who did not really know any better?

As for whether one little old pelt in a museum drawer can represent an entire breed of dogs, or tell us all we hope to learn, at this point, in 2012, we simply don't know. But Mutton will, we hope, prove to be our best possible source of information.

For me, and for others sharing an interest in this hair-of-the-dog question, a detailed examination of Mutton's hair would be essential. Is Mutton's hair spinnable? I am eager to meet this "mythical" animal.

I grin back at Suzanne as she opens drawer #4.

THE ANCIENT STORY
OF SWUQ'US

JARED QWUSTENUXUN WILLIAMS, GRANDSON OF
QWUSTAANULWUT, QUW'UTSUN (COWICHAN)

BACK IN THE TIME before, in the time when the Elders say our first ancestors fell from the sky: Legends tell of how our first ancestor Stutsun landed atop the great two-peaked mountain in Quw'utsun. It was here where Stutsun first opened his eyes and looked out upon the valley descending down to the river below and eventually out to a great estuary where the river met the sea. They say that Stutsun fell to earth fully grown and with great strength and wisdom. But as Stutsun was the first to arrive, he found himself alone in this beautiful place. The first ancestors lived lives of extraordinary longevity and Stutsun spent years, if not decades, walking the valley and bathing in the many lakes, rivers and creeks that he found. Stutsun walked down the river to the sea and feasted upon the abundant shellfish and bathed in the clean ocean water. They say he walked all the mountain ridges and found all the sacred places before returning to the place where he had first arrived.

Still not knowing why he had arrived at this place, Stutsun cried out to his creator from atop the sacred mountain, where he'd first fallen from the sky. "Oh, great Creator, please send me a friend so that I may share this beautiful land that you have shared with me." Then, atop the mountain, Stutsun sang songs and danced for four days in honour of his Creator and to give strength to his prayer. On the morning of the fifth day, Stutsun began his way down the mountain looking for his new companion. As he walked Stutsun noticed a pile of boulders near his trail and noted that they were not there on his way up the mountain, so he turned to investigate. Soon, he encountered a cave where one had never been before. Summoning his bravery, Stutsun ventured into the dark cave hoping to find his new companion. Inside the cave was cold, damp and dark. Once he'd ventured deep enough that the sun's rays could not reach, he heard a sound like many footsteps

FIG 6

FIG 6 Lhumlhumuluts
Longhouse with Swuq'us
watching in the background.
Jared Qwustenuxun Williams

approaching him from within the cave. Stutsun stood, unafraid, awaiting whatever was making its way toward him. Then out of the dark depths of the cave came a creature Stutsun had never seen before, it had four legs, a tail, a long nose, pointy ears and was covered in fur. Stutsun's creator had seen fit to gift him with the most sacred human companion, a dog.

But this was not an ordinary dog, for this dog had a unique disability that bent its neck so the dog's nose was always pointed skyward. Elders would jokingly say that it looked snobby with its nose in the air. In Hul'q'umi'num this neck condition is called *swuq'aas,* and so Stutsun named his new companion Swuq'us. But despite his appearance Swuq'us was a healthy dog and lived a good long life with Stutsun. For many years Swuq'us was Stutsun's only companion. The pair would be inseparable and travel down the river and across to the many islands and lakes of old Quw'utsun. Then, as happens all too quickly with our four-legged companions, after a lifetime of friendship Swuq'us aged and couldn't keep up. Stutsun saw this change in his friend and took Swuq'us back to the mountain where he had first found him. Together Stutsun and Swuq'us sat atop the mountain and shared a meal together and then before long the two fell asleep under the starlit sky. But when Stutsun awoke, Swuq'us was already gone, having passed away in the night from old age. So in the morning, Stutsun carried Swuq'us from his resting place down the mountain to where the two great peaks joined. There Swuq'us was laid to rest, and the many stories of his adventures end.

But, to this day, the name Swuq'us still lives on in our language and in our place names. For that two-peaked mountain was henceforth called Swuq'us in honour of Stutsun's companion. For thousands of years, the Quw'utsun *Mustiimuhw* [Peoples] have called the mountain Swuq'us and kept the story of this powerful and highly respected being alive in history for countless generations. In this way, we still pay homage to the relationship between our ancestors and the many dogs they share this place with. In this way, we remember our place is in the weave of life and never above it.

2 MUTTON'S JOURNEY TO THE SMITHSONIAN

I PEER INTO THE DRAWER, and there, looking back at me, are the remains of what Kennerly, in his threatening letter, called the "famous Indian dog 'Mutton,'"[14] his pelt folded in three.

Suzanne, Mutton's caretaker, gently lifts Mutton out of the drawer and places him on a table, where we can have a good look at him and Mutton can, in Suzanne's words, "get some fresh air."

Mutton has been folded with his head and upper body on top, fur side up, his tail and lower body underneath and his back on the bottom. Why is he folded in three? This is unusual—most skins are stored flat. I wonder if this might have damaged Mutton's pelt.

Suzanne delicately unfolds him, starting with his upper body, opening it to expose the skin side. Surprisingly, after spending just over 150 years being folded, his pelt is still pliable, and not too stiff. Even so, Suzanne is careful, not wanting to cause any tears and not applying too much pressure in any one area. She unfolds the next layer, and his whole body is now lying fur side down. She lets him relax down onto the table and then cautiously turns him over to expose his fur.

Mutton seems suddenly transformed from a long-forgotten museum object into a real dog, a dog who had barked, a dog who had run around, a dog with an owner, a dog with a colourful, if puzzling, story of how he ended up here. I wanted to know that story, Mutton's story, and not see his pelt as just a curiosity, a random but interesting object in a museum. I had a feeling that Mutton could teach us a lot.

How Mutton came to be here, in this drawer, and what he represents turned out to be a fascinating story linking a couple of men—Caleb Kennerly and George Gibbs—working on the 1857–62 Northwest Boundary Survey with a much longer, ancient story shared by Indigenous Coast Salish men and women, whose territories are mostly located around the Salish Sea in the Pacific Northwest.

The Collection

The NWBS Commission's job was to place markers along the 49th parallel to mark the border that had been agreed upon by the British and the Americans back in 1846.[15]

When their survey duties allowed them time, both George Gibbs and Caleb Kennerly were collecting specimens to send on, as mentioned, to Spencer Baird, Kennerly's former professor and then curator at the National Museum (now known as the Smithsonian).

Gibbs was the interpreter, ethnologist and geologist on the team and often collected rock specimens for Baird, while Kennerly focused on natural history specimens. Because Gibbs was often in more remote areas, cutting trails and surveying ahead, he was able to collect many different fish, plant and mammal species, assisting Kennerly, who was stationed back at camp.

Each specimen was given a field number, noted in a field notebook, tagged with a specimen collection tag, and listed in a packing list that would go either in the box with other specimens to be shipped back to Baird at the museum or in a separate letter listing the contents on their way.

There are three tags attached to Mutton's pelt. The first is labelled "Boundary Survey, Archibald Campbell, Comm 'r'"—printed in bold at the top. Campbell was appointed the Commissioner overseeing the boundary survey for which Kennerly and Gibbs both worked. Campbell did not appear to have an interest in the specimen collection, but as the official in charge, his name had to appear on the documentation.

In the middle of this first tag, handwritten in pencil, is "Mr. G's dog 'Mutton' Chiloweyuck Depot," with "Dr. C.B. Kennerly" printed in bold at the bottom. This is probably one of the tags that Kennerly had with him in the field, preprinted to make it quicker to fill out. The casual "Mr. G's dog" and the brevity of the 'G' adds a tone of familiarity with the dog, and with Gibbs, on

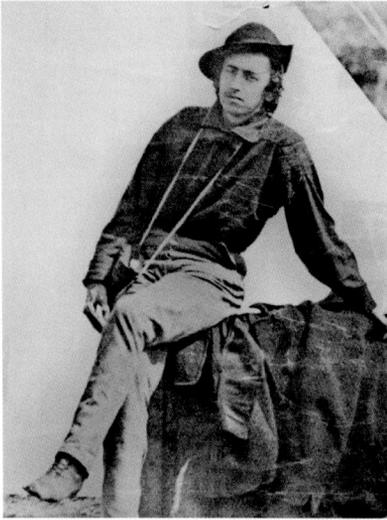

FIG 7

FIG 7 Caleb Kennerly in his expedition gear, 1860.[16]
Smithsonian Institution Archives

the part of whomever wrote it. Kennerly often affectionately referred to Spencer Baird's wife as "Mrs. B" in letters to Baird. This label is likely written by Kennerly.

A second tag with no preprinting, written in ink, reads, "A. Campbell 4762/4414 Canis Indian dog 'Mutton' Chiloweyuck Depot G. Gibbs." The numbers are current catalogue numbers designated by the National Museum of Natural History, assigned and written after Mutton arrived at the Smithsonian.

I compare these first two tags, starting with the one I assume to be written by Kennerly, with the brevity of "Mr. G's dog" showing a human connection. This second tag—with its factual declaration of catalogue numbers—may have been written by George Gibbs himself upon returning to the museum and cataloguing the collection, or by Spencer Baird. It was common that when collectors returned after their fieldwork, they would spend time at the museum cataloguing their collection. Gibbs arrived back in New York City in January of 1861, but Kennerly, due to be back in March of that year, died at sea while returning, so someone else had to catalogue the collection.

The third is a Smithsonian tag; it has the name "Smithsonian United States National Museum" printed on it, with space for a catalogue number. It looks as if it was attached last. In black ink is "4762, Canis familiaris (Indian dog) Chilowayuck Depot. A. Campbell." No mention of Kennerly or Gibbs.

There is also a note in the accession ledger where all the specimens' details (field number, collector, museum number, location where it was collected, etc.) are entered as they are catalogued. It says, "The dog whose hair is used by the Indians in manufacture of blankets. About 18 months old." So Mutton was still a young dog when he died. We don't know if Gibbs or Baird wrote the entry, but whoever did had to have a knowledge of the Woolly Dogs, and of Mutton, as they knew his age.

Kennerly was the man who wrote the letter threatening to make Mutton a specimen, and here, lying in front of us, thanks to the research of Candace Wellman, is Mutton, the only wool dog specimen known to exist. I want to know how Mutton died, and why so early in his life. I don't like the idea that his life ended prematurely, solely so that he could be "collected." Maybe Kennerly's threat was a wry attempt at humour—a joke between two old friends? There seems something wrong with the idea that Gibbs and Kennerly, who

seemed to love nature and the outdoors, and who appreciated wildlife, could carry through with the idea to make Mutton a specimen for the sake of science. Who would do that? What kind of men were they?

The Collector

A letter of introduction written by Spencer Baird to Joseph Leidy, a professor of natural history, confirms Baird's and Caleb Kennerly's close friendship and their shared passion for collecting, and provides some insight into Kennerly's character:

> The bearer of the present dispatch is C. B. R. Kennerly, Esq., of Virginia, one of the University of Pennsylvania students of medicine. His friends call him Caleb, for short, which, however he is not. He is the most notorious snake, salamander, bug, cave-bone, wolf, panther and tadpole catcher in the community, your humble servant perhaps excepted; having been his Lieutenant for years, and companion in his various misfortunes by lake, river and mountain. He caught most of those Julus [millipedes] and Passalus [beetles] I sent you, besides doing many other things too numerous to mention. Use him well for my sake as well as his own.[17]

At the time of this letter of introduction, Kennerly was twenty-two, seemingly a carefree young man with a love of the outdoors and nature. One can imagine him and Baird mucking about in swamps with mud up to their thighs, falling into rivers, lakes and streams, tramping through forests, climbing over mountains, exploring caves, chasing snakes and having the time of their lives doing what they loved most.

Six years later, with Baird's recommendation, Kennerly joined the survey team, carrying that same passion into the Pacific Northwest. Here was an opportunity of a lifetime, being paid to provide medical assistance to a group of men who required little medical attention, leaving him time to collect specimens not many non-Indigenous people had seen before and to do it in association with Baird, his friend and mentor.

Kennerly, despite having been trained as a medical doctor, was first and foremost a collector, but what about George Gibbs, Mutton's owner? Did he get Mutton as a pet or collect him as a specimen?

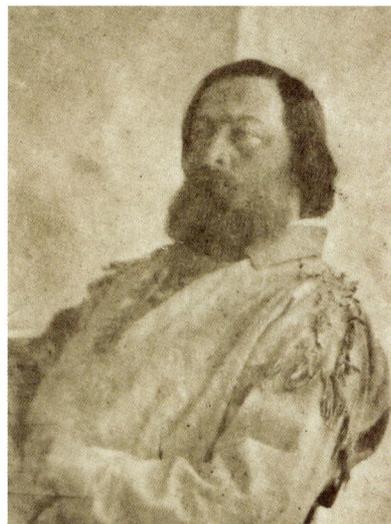

FIG 8

FIG 8 This photo (photographer unknown) of George Gibbs was likely taken between 1857 and 1860, while he was on the US NW Boundary Survey, as he is wearing his buckskins.
Smithsonian Institution Archives

Gibbs named his dog "Mutton." If you look up the word *mutton*, you will see a few definitions. One definition focuses on the age of a sheep: lamb (up to one year old), hogget (two years old), and then mutton (over two years, although some definitions just distinguish between lamb and mutton). Other definitions define it as a food term: the meat of an older sheep, which is usually tougher and more gamey than lamb.

However, Mutton's name could have derived from the French word for sheep, *mouton* (pronounced "moo-ton," with a silent *n*). There were many French-speaking Canadians in the area working for the Hudson's Bay Company at Fort Langley and other HBC forts.[18] Most people (settlers and Indigenous) living in the Colville Valley in the 1850s spoke French. One of the survey crew wrote that white men needed to speak Chinook Wawa (a trade language consisting of words from a variety of languages—Chinook, French, English, Nootka and even a few Hawaiian words).[19] The farther away from the coast, the more you needed to know the Indigenous language of the area you were in, or French, as many Indigenous people learned it through dealing with the Hudson's Bay Company.[20]

Gibbs wrote the first dictionary of the Chinook trade language, and in his dictionary, the word for sheep is *le moo'-ton*. So it is highly plausible that Mutton was named for resembling a sheep in any of these languages—*mutton* (the English word for an older sheep), or *mouton* (in French), or even *moo'-to* (Chinook)—and was anglicized to Mutton. Wherever the name Mutton came from, it is probably due to his sheep-like appearance and acknowledgement of his woolly hair being important. Or maybe Mutton had a habit of chasing sheep, chewing on specimens, and who knows what else—a sign of mischievousness to his owner. Perhaps it was this misbehaviour that got him into trouble one last time when Mutton chewed the mountain goat specimen, which may have led to the threat in Kennerly's letter.

Kennerly's use of the word "famous" in describing Mutton in his letter of August 1859 could refer to his fame as a Coast Salish Woolly Dog, or to his naughty nature, as evidenced by his chewing of the mountain goat skin. The term "famous" implies Mutton was a well-known dog, indicating he had been around awhile, well before Kennerly wrote the letter. Mutton was only about eighteen months old when he died, so it is entirely possible that he was acquired as a puppy.

Whichever it was, this "fame" —or perhaps infamy—may have led to his demise, to his preservation, and eventually to his rediscovery.

Mutton was not the only dog that gnawed at the bones of mammals Kennerly was collecting, and Kennerly must have been frustrated. A year before he complained about Mutton chewing the mountain goat, another dog from a nearby village gnawed the bones of river otters that Kennerly had collected. His frustration showed in another letter he wrote to Baird:

> I had two nice skeletons of the otters, & packed them in a box with weights on the top, & intended to clean them in the morning when to my horror & chagrin the abominable Indian Dogs during the night got out the bones & gnawed them to pieces. In pay for this, a beautiful skin of a large woolly Dog now hangs outside in a state of preparation for the Smithsonian Museum & as a warning to all others that may come around here without their owners with them.[21]

I am not sure if the so-called Woolly Dog mentioned in the letter is one of the dogs that chewed the otters or if it was a different dog that wandered around without its owner. In any case, Kennerly seemed to have it in for dogs, and his frustration may have been the cause of his deciding a year later to make a specimen out of Mutton.

The large dog mentioned in Kennerly's letter hanging outside his tent, being readied to ship to the Smithsonian, is at the museum now (USNM 3512), but to call it "woolly" is very much a stretch. Another researcher, Russel L. Barsh, spent time at the NMNH in 2002, and he looked closely at both Mutton and this other dog, matching up collection lists, tags and letters, and sorting out confusing accession records with field numbers.[22] Barsh suggests that perhaps at this point Kennerly, having only been on the coast barely a year, did not know how woolly a Woolly Dog could be. Perhaps he had not yet met Mutton? Or perhaps he used the term "woolly" loosely? The dog's labels and accession ledger list "Indian dog," with no mention of the Woolly Dog. This not-so-woolly village dog from Semiahmoo will prove to be an important drawer companion to Mutton.

Mutton and Mr. G

When Gibbs wrote of the clothing of the people of the Salish Sea and Puget Sound, he wrote of the considerable skill that went into making these items of dress. When talking about what he called a "petticoat" made from cedar or

FIG 9 George Gibbs was photographed here after returning to New York City from the Pacific Northwest, between 1861 and 1872.

Charles D. Fredricks & Co., Nevin King Collection, Beinecke Rare Book and Manuscript Library, Yale University

twisted grass, he called it "A garment of mystical sublimity,"[23] a phrase that stays in my memory. This line made him more human, a poet perhaps. I was curious to find out more about him.

In Gibbs's journals and notebooks, he never writes about acquiring Mutton. Only the tag on Mutton's pelt provides some information on where he was acquired, but this is not necessarily his birthplace. Kennerly's tag says "Chiloweyuck Depot." This depot had been built to house the supplies to support the survey team and was located near the outlet of the Harrison River, where the Chilliwack River meets the Fraser River, in present-day Chilliwack, BC.

Since Mutton travelled around with "Mr. G," as Kennerly called him, the tag would indicate where Mutton was acquired, but not where he met his end, nor where he may have been prepared for shipping. All museum specimens are and were marked with where they came from.

So, if the tag says "Chiloweyuck Depot" and the packing list also adds "'Mutton' Chiloweyuck Indians," then it seems clear that Mutton was "acquired" in Chilliwack. There were many Coast Salish villages in the Chilliwack area, so we cannot be certain which village Mutton came from, but likely from one of the Stó:lō Nations.[24] Gibbs wrote that Mutton was acquired from the "Chiloweyuck Indians," but it is possible they in turn acquired Mutton from elsewhere. Although why would they acquire a dog only to quickly turn around and give or sell him to Gibbs?

Perhaps some characteristic of Mutton's—hair not white, soft or long enough; or poor behaviour (too noisy, too rambunctious, too many specimen bones being chewed)—made Mutton ineligible to be bred, according to the rigorous standards set by those who made the breeding decisions. Maybe this is what provided Gibbs with the opportunity to acquire him.

We can't be sure exactly where, why or from whom Gibbs acquired Mutton; nor can we be sure of when. Looking at Gibbs's field notes, he spent time at Chilliwack and Camp Chilliwack on Chilliwack Lake in September and October of 1858. A few of Gibbs's sketches are dated June 1859, in the village of Palalthu, which is near Chilliwack Depot. Based on Gibbs's whereabouts, it seems he got Mutton as a puppy possibly in the fall of 1858 or as a one-year-old (approximately) in the late spring of 1859.

Had Gibbs acquired Mutton solely for the purpose of making him a specimen? Did he harbour grudges against dogs, or was he looking for a companion? Who was Gibbs as a person?

Isaac I. Stevens, the Governor of Washington Territory, met Gibbs in 1853.[25] "He is a thoroughly educated man," Stevens wrote of Gibbs, "and combines the habits of a student with the good qualities of a woodsman and mountaineer and has become very well acquainted with the Indian tribes through whose country the party has pass[ed]."[26]

Gibbs's co-workers on the survey record that he had a remarkable ability to learn new languages and converse with the Indigenous people he met. He wrote up well over two dozen vocabularies of various Nations, mostly along the Northwest coast. His language skills were so good that during a Chehalis Treaty Council meeting, he overheard two youths talking and realized they were talking in a language, Quileute, he had not heard before, but one that would locate their home south of the Makah and north of the Quinault in a remote area on the west side of the Olympic Peninsula, a tribe previously unknown to European newcomers.

Gibbs came from a wealthy family in New York City, whose interest in science was strong—his father was a mineralogist. When Gibbs was eight, his mother wrote to his grandfather that the child "would astonish some boys with his knowledge of natural history."[27] He had his own mineral cabinet and a bird collection that he had preserved. He was most at home in a laboratory, library or in the outdoors.

As a youth, Gibbs trained in the east as a lawyer, graduating in 1838 at the age of twenty-three. He worked as a librarian, eagerly became a California gold seeker at the age of thirty-four, signed on with the Oregon Mounted Riflemen, and was hired on as a treaty negotiator, then a customs collector in the Port of Astoria. He was an interpreter, a linguist, a surveyor, a geologist and a farm owner, but he was also much more. He was an artist, a mapmaker, an explorer, a collector, a scientist and an author. It was at the age of forty-two that he was hired to join the Northwest Boundary Survey as ethnologist, linguist, geologist and trail maker.

Joseph Harris, one of the astronomers (and, at twenty-one, one of the youngest on the survey team), grew to greatly respect the older Gibbs, who, at forty-three, was twice his age. Harris wrote many letters to family, and luckily those letters remain.[28] He wrote of life on the survey team, about what they ate, a little gossip, and about his fellow survey team members. Harris came from a Puritan background, and after drinking only a few glasses of champagne as they left San Fransisco bound for Puget Sound, he became seasick and decided not to drink at all on his assignment with the NWBS.[29]

This and his puritanism, which he did not seem to preach or lord over his colleagues, did seem to set him apart from them, though the ethics of puritanism, of working hard, self-reliance and frugality, made him compatible with them.

He brought up the problems of alcohol a few times in his letters home. Around Christmas 1857 he wrote, "If you don't drink at all you are considered a queer fellow; if you drink a little and won't drink as much as the company you give offence…"[30]

Gibbs, however, did not seem one inclined to drink. He was too interested in learning as much as he could.

In 1860, Harris wrote a remarkable and lengthy description of Gibbs, tinged with awe, in a letter to his brother, saying that Gibbs did a greater variety of work than anyone on the survey group. Harris writes that Gibbs always carried a gun to "entrap any unwary bird or beast for the Nat. Hist collection and always has in his pocket a little bottle nearly filled with alcohol which portends sudden death to any bug that may cross his path."[31] According to Harris, Gibbs also always carried a hammer and a bag to collect geological specimens, and a notebook to note the times of flowering trees and shrubs, or to record the local names of features, for a map he created as he travelled.

These notebooks of Gibbs's must have filled quickly, given Harris's description of the wide variety of subjects Gibbs was interested in:

> Any traveler that he may see, if he appears intelligent, is invited to contribute to his store of geographical knowledge; if he is a hunter—to the habits and ranges of animals; if an old resident, he is asked for numbers boundaries and characteristics of Indians, in regard to the length and severity of the winters, the amount of rain and snow, the time and height of higher water in the rivers, the thickness of the ice, the kind of timber, the distance to which salmon ascend the river, and the time the amount of furs collected from that district etc. etc. etc. etc….[32]

Harris goes on at length, saying how if anyone they met had knowledge of the area, they "have to give their quota of information in the way of vocabularies, dictionaries or grammars and Indian legends [Gibbs] is great on them… If his Indian [assistant] proves an expert with the gun, he has to shoulder it and travel off sometimes for days together to get some rare or perhaps mythical animals."

The letter continues for almost two pages, breathlessly listing the skills and virtues of Gibbs, culminating in "He has probably done more to gather new facts for science than any four men that have ever been in the territory."

Harris clearly indicates that Gibbs's greatest contribution is as a dedicated collector. So perhaps Gibbs had, with much foresight, "collected" Mutton with the ultimate intention of making him a specimen.

In one notebook, Gibbs seemed very interested in the Indigenous village of Palalthu near the Chiloweyuck Depot. This was an ancient village containing three large wooden houses and stretching nearly a hundred yards along the Chilliwack riverbank. Gibbs spent a few days there in the summer of 1858, measuring buildings, talking with the village Elders, writing down Traditional Stories, making notes about carvings and drawing several sketches. Perhaps it was here that he acquired Mutton.

In his travels throughout the Puget Sound and Salish Sea area, Gibbs knew by 1853 that blankets made of the hair or wool of Woolly Dogs were made on the Olympic Peninsula. He had even collected a few blankets that eventually ended up at the museum along with Mutton. In his journal for 1853, he wrote, "They also make a blanket or mat of dog's hair, twisted and woven in like manner and fringed. Their dogs have much finer hair than usual, sometimes curled and are sheared for this purpose from time to time."[33]

Gibbs, as a linguist, had recorded distinct names for the wool dog vs. the village or hunting dog in different languages or dialects. Along parts of the Fraser River and southern Vancouver Island, the wool dog was variations of *sqwemáy'* (Hul'q'umi'num), whereas in sections of Puget Sound it was *ske'-ha* (Lushootseed).

Gibbs had even identified the words used for "the dog sheared for fleece" for two language groups in Puget Sound: *ska'-ha* (Skagit) and *ské-ha* (Nisqually), distinguishing the Woolly Dog names from the common dog, which is *ko'-bai* and *sko'-bai* (Nisqually).[34]

Gibbs fits the bill of a renaissance man—someone who has wide interests and develops expertise in many areas. His lust for life, his thirst for knowledge and his intense interest in his surroundings made him very unusual, as was his dog, Mutton. Of all the people on the US border survey team, it makes sense that it was Gibbs, an unusual man, who acquired Mutton, an unusual dog with an unusual coat.

FIG 10

FIG 10 In this photograph of Joseph Harris, a note on the bottom says "NWBS," for the US Northwest Boundary Survey, so the photo may have been taken when he was still on the survey team.
Wisconsin Historical Society

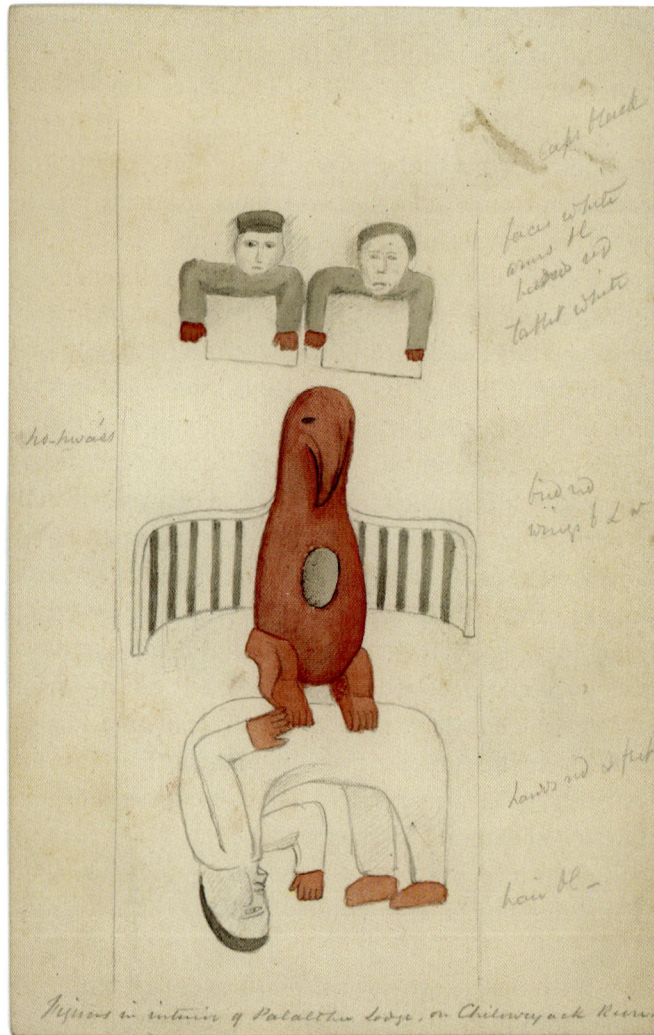

FIG 11 Figure in the interior of Palalthu Lodge, on Chiloweyuck River. Sketch by George Gibbs, possibly from June 1859.
Wisconsin Historical Society

Given his knowledge, Gibbs must have been acutely aware of the unusualness of Coast Salish Woolly Dogs, and given his passion for collecting, he would probably want to preserve Mutton as a representative of the breed for the future. It still leaves the question of whether Mutton died a natural death and became a specimen, or if he was killed before his time for the purpose of becoming a specimen. In either case, we now have his remains, from which we can learn a great deal.

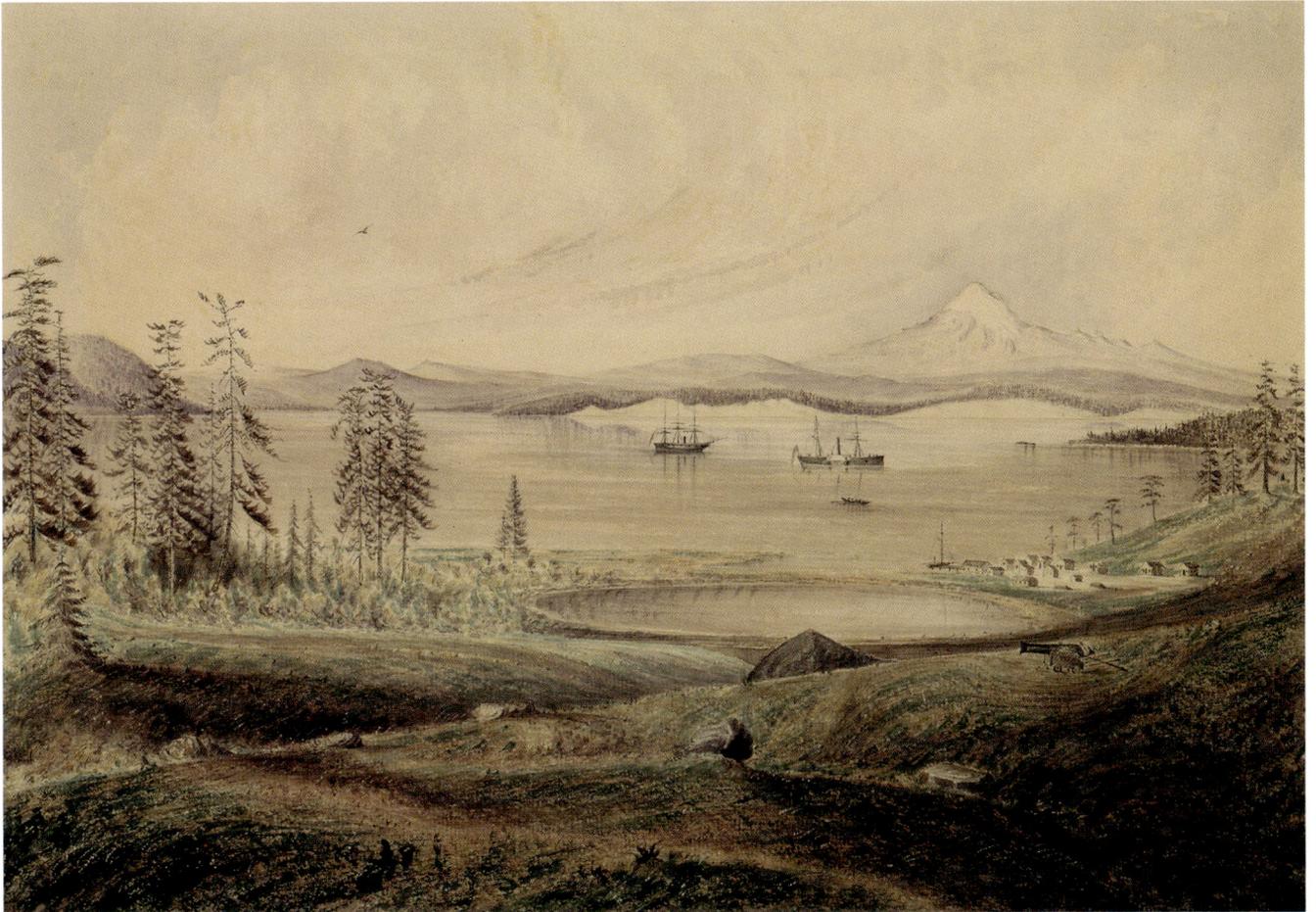

FIG 12

FIG 12 In this James Madison Alden painting, we see the view looking east toward Mt. Baker from a hill on San Juan Island, with the British ship HMS *Satellite* and the US Coastal Survey ship *Active* in the harbour. Both ships were charged with surveying the coastal waters, but neither country agreed on where the water boundary should be. This led to the San Juan Pig War of 1859 (and a resolution in 1872).
US National Archives

THE DOG CHILDREN AND THE ORIGINAL OCCUPATIONS

SENAQWILA WYSS, SḴWX̱WÚ7MESH ÚXWUMIXW (SQUAMISH NATION)

A LARGE DOG BELONGING TO the chief of a certain village sleeps with the chief's daughter, who becomes pregnant and attempts to discover who had slept with her.

She makes this paste and smears it on the palms of her hands so that the next time the person visits her, she is able to leave the marks on the shoulder and back. The girl and her father, the chief, are shocked to discover that the paint marks are on the dog.

When she gives birth, twelve puppies are born. The chief and his people are so ashamed that they abandon her and the village, leaving the girl alone with her puppies.

But one evening, when the puppies have grown somewhat and the woman is digging clams by a pitch wood light, she hears the sound of singing and dancing, and she returns quickly to her house, only to find that there's only her puppy children there.

But suspicions are aroused, and the woman returns to the beach, this time with a mat to obscure the torchlight from the house.

When the singing and dancing resumes she sneaks back to the house. This time she's unobserved and finds her puppies have taken off the dog skins, with the exception of one acting as a sentry at the corner. The dog children are dancing and singing, "Our mother thinks we are dogs, but we know better."

The woman rushes inside. She throws all the dog skin coverings into the fire, and now her children must remain human. They noticed that she was all alone and had no one to support her as a mother so each of the twelve took on a role that was part of our traditional roles. Now, people don't know each of the roles, but they are saying that the twelve roles are like the pillars of what it is to be Squamish

FIG 13

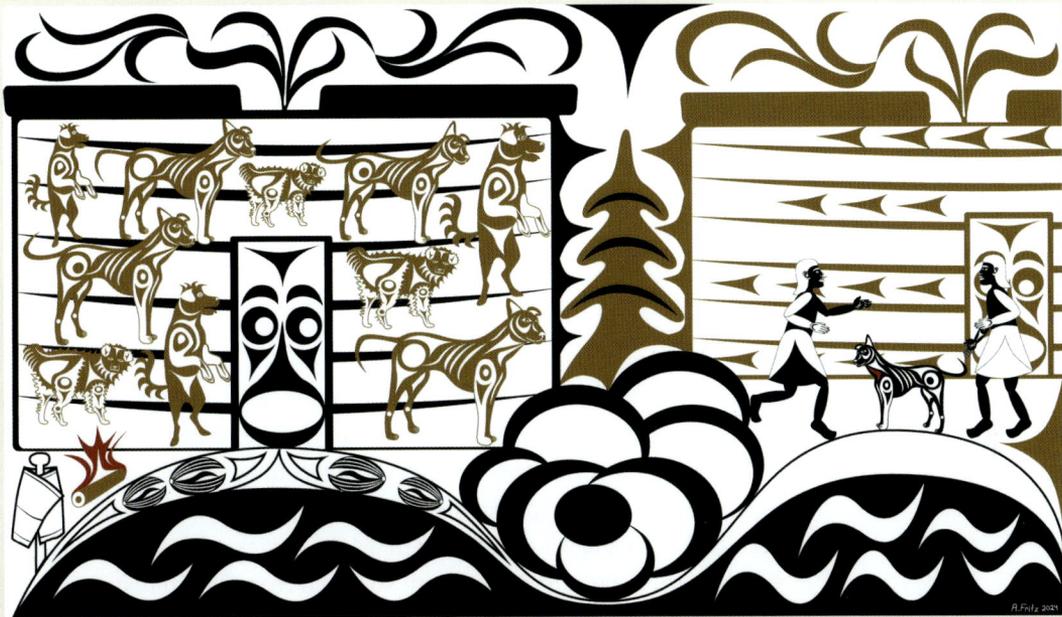

FIG 13 An illustration of *Nutsa Sqwulmey* by Andrea Fritz, Lyackson First Nation (*nutsa* means "we are all one," and *sqwulmey* means "wool dogs").

people: different roles such as fisherman, canoe maker, carver, basket maker, handyman, berry picker and weaver of blankets, collector of root foods, small-game hunter, deer hunter, house builder, prophet and song keeper, or healer.

These children then become the great providers. Eventually all people return to their abandoned village, and the woman and her children are then highly respected.

So part of what the Great Provider is sharing is about those different roles that they all carry, those different teachings.

3 THE WOOLLY DOG

AS SUZANNE AND I gaze at Mutton's thick pelt, I wonder how unique he was 150 years ago when Gibbs adopted him in 1858 or 1859.

Coast Salish Oral History tells of a treasured dog whose undercoat of long hair, warm and spinnable, was prized for its use in blankets, robes and regalia. This history is embedded in origin stories, family histories, basketry, possibly carvings and songs. With so much recorded in history, there must have been numerous dogs. Looking down at Mutton's pelt, I wanted to find out what was it about their hair that made them so special, just how numerous they were. And if they were so special that they were numerous, then why did they disappear? And why was Mutton the only existing remnant of Coast Salish Woolly Dogs?

At the time Gibbs acquired Mutton, other observers had noted that the Woolly Dogs were diminishing in numbers, making Mutton somewhat of an increasing rarity. But how common were they before settlers arrived? Gibbs may have acquired him because dogs like Mutton were fast becoming a rarity.

On the Pacific Coast, plant fibres such as cedar bark and nettle were commonly used by Indigenous Peoples for clothing. The only wildlife source of animal fibre for spinning into yarn was mountain goat hair; these animals were found on the mainland but not on Vancouver Island, in Puget Sound or on the Olympic Peninsula. The Coast Salish Woolly Dog was the only other source of animal fibre.

Many cultures in the world had dog breeds specific to their culture, but the Coast Salish had at least two archaeologically documented breeds—the

Woolly Dog, and the village or hunting dog. Keeping them separate to enhance the woolly coat of one of those breeds was unusual in the world, and certainly unique in North America. With a scarcity of animal fibre, having an animal domesticated and intentionally bred for its wool made it a very valuable resource.

Oral History telling of the existence of the Woolly Dog is reinforced by sightings described in the journals, logs and letters of early explorers, adventurers, naturalists and fur traders.

Written Accounts

One of the earliest written accounts of Woolly Dogs is by British naval Captain George Vancouver, or at least someone on board who wrote in the ship's log. On May 24, 1792, his ships were in Port Orchard, across from Seattle in Suquamish Coast Salish territory.[35] The ship's log provides a detailed account of the Woolly Dogs:

> The dogs belonging to this tribe of Indians were numerous, and much resembled those of Pomerania, though in general somewhat larger. They were all shorn as close to the skin as sheep are in England; and so compact were their fleeces, that large portions could be lifted up by a corner without causing any separation. They were composed of a mixture of a coarse kind of wool, with very fine long hair, capable of being spun into yarn. This gave me reason to believe that their woollen clothing might be, in part, composed of this material mixed with a fine kind of wool from some other animal, as their garments were all too fine to be manufactured from the coarse coating of the dog alone. The abundance of these garments amongst the few people we met with indicated the animal from which the raw material is produced to be very common in the neighbourhood. But, as they have no one domesticated except in the dog, their supply of wool for clothing can only be obtained by hunting the wild creature that produces it, of which we could not obtain the least information.[36]

Vancouver is suggesting the dog hair might be too coarse and needed to be mixed with some other animal to make such fine garments. This is the first recorded doubt about the spinnability of the dog wool alone to make a fine soft yarn. How closely did Vancouver or his assistants look at the dogs? Most of his crew would likely be familiar with spinning and weaving, coming

from working-class or rural backgrounds where most households spun and/ or wove. Did the observer examine their downy wool, the underwool below the outer guard hairs?

The ship's log does, however, say that the dog hair is capable of being spun albeit with the addition of some "wild" creature's wool. On the Pacific Northwest coast, the only "wild creature" that can supply wool for yarn is the mountain goat, whose undercoat is very white, fine and soft. So Vancouver's words are entirely credible, as Oral History often mentions blending mountain goat wool with dog wool. Yet Suquamish territory is on the Olympic Peninsula, where mountain goats are not traditionally found, and their wool must be traded for. This suggests that dog wool must have been more common than mountain goat wool.

A month later, Archibald Menzies, the naturalist sailing with Captain Vancouver, recorded his own observations. Writing on June 18, near what was likely northern Orcas Island, he observed many women weaving blankets with great "patience and ingenuity" with a yarn that was very fine and snowy white. Menzies conjectured that the yarn was made from dogs, yet all the dogs he saw were not white, and were muzzled. He was likely seeing the hunting dogs, kept separately, well away from the Woolly Dogs.[37] So we know there seemed to be two types of dogs in the area, one with long white hair and another type of dog, not white, and kept muzzled.

Menzies was clear that the yarn being made was very white and fine. Vancouver's log records a dog with thick fleece but suggests it had coarse hair. Did the white long-haired dogs provide all the wool, or was it too coarse and required mixing with the white soft down of the mountain goat? Perhaps a good look at Mutton's pelt can provide the answer to its fitness and spinnability. But what about how numerous the dogs were?

On June 2, 1792, Captain Vancouver was near Whidbey Island and recorded,

> Having reached the place where they [Naval Officer Whidbey and crew] intended to land, they were met by upwards of two hundred, some in their canoes with their families, and others walking along the shore, attended by about forty dogs in a drove, shorn close to the skin like sheep.[38]

This second account reinforces what seems to be an abundance of dogs, all having been shorn, which could account for the "abundance of these garments."

According to these two reports of 1792, the breed of Woolly Dogs appears to be healthy with a large population in just a small geographical area.

Sixteen years after Vancouver recorded his detailed account of the Woolly Dogs, Simon Fraser, who was exploring down the Fraser River in 1808,[39] made these entries in his journal in late June when he was approximately a mile south of the town of Yale (150 kilometres, or 93 miles, from where Captain Vancouver had noticed the dogs):

> Wednesday [Tuesday], June 28... Continued and crossed a small river [Siwash Creek?] on a wooden bridge... [Lady Franklin Rock]... This nation is different in language and manners from the other nations we had passed. They have rugs made from the wool of Aspai, or wild goat, and from Dog's hair, which are equally as good as those found in Canada.[40] We observed that the dogs were lately shorn.[41]

Simon Fraser had noted Woolly Dogs near the eastern extent of Coast Salish communities, and there was also an account of the dogs to the west of Coast Salish communities on the Olympic Peninsula in 1820s.[42] From the west coast to the eastern areas of Coast Salish territories is around 250 kilometres (150 miles), which means that around the year 1800, Woolly Dogs were spread across a wide area from east to west, and were numerous.

In Coast Salish territory, there were other sightings of dogs by early settlers, explorers and visitors, indicating the dogs' numbers, importance and worth. As we have seen, in 1792, Captain George Vancouver recorded seeing a drove consisting of forty dogs,[43] which seems impressive enough, but James McMillan, Chief Factor at the Hudson's Bay Company's Fort Langley, writes of seeing considerably more dogs in 1828, on three different dates:

> Tuesday 23rd. September. The weather as yesterday. 160 Canoes of the Cowitchs [Cowichan] traded few dried and fresh Salmon. Each (canoe) seldom contains more than one man with the family, and generally about half a dozen dogs more resembling Cheviot Lambs shorn of their wool.

> Wednesday 24th. Fine day. 60 more Canoes of Cowitchins passed...

> Wednesday [November] 19th. Still, a number of the Indians continue to descend the Stream with a vast deal of Stuff between Salmon dogs and Children piled up on huge Rafts supported by a Couple of Small Canoes...[44]

FIG 14 During Tribal Journey 2008, a dozen canoes come ashore at Stl'i lep, Departure Bay, Nanaimo, on their way to Quw'utzen (Cowichan).
Mark Kaarremaa

Over a two-day period, McMillan recorded over 220 canoes, each with about a half dozen dogs, and then two months later, he writes, "Still, a number of the Indians continue to descend…" Was there a continuous stream of people and dogs heading downstream and then over to Vancouver Island? Even if we only count the number of dogs in the two days mentioned in September, that adds up to over 1,300 dogs. McMillan mentions they were shorn, so it follows that he must be referring to Woolly Dogs.

I can easily envision what McMillan saw in my mind. In 2008, my first Tribal Journey, "Paddle to Quw'utsun (Cowichan)," we paddled from Fort Rupert near the north end of Vancouver Island to Cowichan Bay. By the time we entered Cowichan Bay, the flotilla consisted of over 110 canoes. Each canoe held at least six people, closer to ten (Figure 14). I could easily imagine a half dozen Woolly Dogs fitting in each. It would have been a powerful feeling crossing from the Fraser River to Cowichan Bay.

McMillan probably used the word "Cowitchs" to refer to the Cowichan of Vancouver Island, who had a traditional summer village on Lulu Island in the Fraser River and often travelled as far upriver as Yale, or the Snuney-muxw, Nanaimo, on Vancouver Island, whose summer village was close to Fort Langley. Both First Nations speak Island Hul'q'umi'num (though their languages differ slightly), very similar to the languages spoken along the southern section of the Fraser River, and both came from Vancouver Island to the mainland (the Fraser River) for the fall fish run. Oral History confirms that these two First Nations raised dogs for their wool. With the numbers mentioned, even if half the dogs were ordinary village or hunting dogs, it still adds up to a lot of Woolly Dogs. These dogs were not the oddball few. Just in one group (Island Hul'q'umi'num speakers), there were enough dogs to make them a substantial part of the culture, part of a textile industry. And if there

were so many, then that means there were probably specialized tools and techniques developed for dealing with the wool. Not only would the weaving and spinning and processing techniques be well developed, but these large numbers of dogs would have a great impact on the culture, how things are done, and how the dogs are carefully bred and maintained. There is so much more to learn.

Twenty years after McMillan noted the canoes coming down the Fraser River and forty years after Fraser passed through Yale, in 1846–47, Alexander Caulfield Anderson also passed through Yale. Anderson was a Hudson's Bay Company employee who led an exploration for a route to bring out furs from Fort Kamloops in the interior of BC to Fort Langley on the Fraser River. The 49th parallel border had just been agreed to, and the normal HBC route from Fort Kamloops goes through what would now be territory of the United States, hence the need for a route in British territory. Anderson described the Indigenous village of Teets or Tachinco (also spelled Sachino) that stood on the present site of Yale, as follows:

> From point to point as we descended the river the palisaded villages appear. Around gambol whole hosts of white [dogs], some shorn like sheep, others sweltering under a crop of growing fleece... The dogs in question are of a breed peculiar to the lower parts of Fraser's River, and the southern portion of Vancouver's Island and the Gulf of Georgia. White, with woolly long hair, and bushy tail, they differ materially in aspect from the common Indian cur; possessing however the same vulpine countenance. Shorn regularly as the crop of hair matures, these creatures are of real value to their owners; yielding them the material from whence blankets... are manufactured.[45]

It seems that in 1846 there were still a lot of Woolly Dogs around, yet within a dozen years after 1859 when Gibbs had Mutton, despite the value placed on Woolly Dogs, they were disappearing according to a couple of reports. One report is by Gibbs's counterparts on the British border survey team (they both had to agree on where exactly the border was). John Keast Lord, the naturalist who visited southern Vancouver Island and the 49th parallel areas between 1857 and 1860, wrote, "the dog from which the hair was procured is extinct or very nearly."[46]

So, if there were so many Woolly Dogs, what happened? Why did they disappear so quickly?

The Value of Woolly Dogs

In a culture that placed great value on blankets for clothing, bedding, room dividers, rain capes and spiritual protectiveness, having a renewable source of fibre would be valuable in many ways. Myron Eells, a missionary and scholar who lived in the Skokomish Reserve to the south and west of Puget Sound in 1874 until his death in 1907, also noted the dogs were disappearing during his time there.[47] Between 1800 and 1874, despite the Woolly Dogs being considered valuable, their numbers were declining.

Eells also wrote, "A woman's wealth was often estimated by the number of dogs she owned."[48]

But the meaning of *wealth* is much deeper than the European view of equating wealth with money. It is more complicated than that.

The Woolly Dog represented more than trade wealth; it represented different types of wealth. The Coast Salish view of wealth includes non-tangibles such as inheritance of family rights, songs and stories; respect and spiritual protection; as well as the narrower Eurocentric definition of wealth being the ability to purchase tangible things. As an example, the dog wool fibre spun into yarn and woven into blankets symbolized wealth of nobility, as Snuneymuxw Knowledge Keeper William White explains:

> The white nobility blankets, as currency and proof of high status were central to proof of status prior to a wedding ceremony. In this regard Swuqwuxw, as a wealth item, were also used by a potential husband as proof of his ability to take care of their daughter and represented visible proof of his Noble Ancestry.[49]

Xwelíqwiya Rena Point Bolton, a ninety-five-year-old Stó:lō Elder from the Chilliwack area, recalls that her great-grandmother Th'etsimiya kept dogs. Rena (Xwelíqwiya) said only the wealthy women of status had Woolly Dogs, and explained that dogs were a result of wealth, not the cause of wealth. Wealth came from the number of men in your household—they provided; therefore, they were your wealth.[50]

A woman with forty dogs would require many men in her household to hunt and fish and help provide for the dogs. So Eells's suggestion of equating the number of dogs with wealth was only part of the story.

Michael Pavel, a Skokomish/Twana Elder, told me about how much care and resources the dogs would need, and that only high-class or upper-class people had those kinds of resources, that kind of wealth.[51]

Just as *wealth* has many meanings, so too do the words for what was woven with the dog hair. *Blanket* and *robe* are often used interchangeably but can have different meanings. When used in life event ceremonies (births, weddings, etc.), the word *robe* is usually used to convey a ceremonial use. Some blankets are just that, blankets worn for warmth or sleeping. Others are used as room dividers, but robes are ceremonial in nature and these robes are usually created with that in mind. They are ritual, and often ancestors are thought to be guiding the hunter, spinner, weaver and dancer each step of the way. Each time the robe is worn, history builds upon the robe, giving it more value. Chief Janice George, a renowned Squamish weaver, explains, "They are protective garments that at times of great changes in a person's life—celebrating a birth, participating in a marriage, mourning a death—offer emotional strength."[52]

With this in mind, blankets and robes cannot be thought of in the same way as Hudson's Bay Company trade blankets. When HBC set up forts along the coast, they stocked them with trade goods and especially with mass-manufactured blankets, known as HBC blankets. There have been many suggestions that with so many HBC blankets, there was no need for dog blankets, and hence no longer a need for the dog. Some dog blankets were made for trade, and some were ceremonial. However, even the traded dog wool ones cannot be thought of in the same way that mass-produced blankets are. A dog-hair blanket carries much more meaning than an HBC blanket.

Dogs themselves were also valuable, not just in a monetary way. As Musqueam weaver Debra qwasen Sparrow said, "My grandfather [Ed Sparrow, born in 1898] told me that every village had them, that they were like gold because of course, they were mixed with the mountain goat and then rove and spun."[53]

The history of Woolly Dogs draws in fascinating people like James Teit,[54] who kept up a close correspondence with Charles Newcombe of the Provincial Museum of Natural History and Anthropology in Victoria at the BC Legislature.[55] In a 1908 letter to Newcombe, Teit included part of a conversation with a woman from Spuzzum about her memories of the Woolly Dog. She told him that at Spuzzum (100 kilometres up the Fraser River from Chilliwack), the dog wool was generally mixed with mountain goat wool, but people who did not have any dogs used only mountain goats. She said that the dog wool made a blanket softer and was already conveniently at hand, rather than hunting or scouting for shed mountain goat wool.[56] So it seems that in

some areas dog wool was valued for its softness but also for its convenience, as a resource easily collected.

So here are two important values of the dog wool—softness and ease of collecting with the convenience of having dogs at hand. With mountain goats, you either hunt them or walk their trails at the right time of the year when they shed their wool.

I was unable to confirm that Woolly Dog wool was preferred over mountain goat, though Ed Barraclough (the man whose lawn was defended by a cannon) wrote that Ed Brown, a Snuneymuxw (Nanaimo, Vancouver Island) Elder, was told by another Elder, Old Dick, around 1934 of an exchange of two fibres that Dick had witnessed:

> …at certain times canoes would arrive at Nanaimo of Sliammon Indians [Tla'amin Nation] from Squirrel Cove, Cortez Island. They brought bales of mountain goats' hair in trade for native dogs' hair. The Sliammon Indians had procured the hair from the mainland… as the mountain goat is not native to Vancouver Island. In the business of exchange, the bales of hair would be laid side by side, the hair patted down by hand, adding more of this kind or that of hair, until all were satisfied that the bales were even, then agreement was reached.[57]

This paragraph indicates that, in terms of trade, the fibres of the mountain goat and the Woolly Dog were equal. However, it is clear from Oral History that the mountain goat is valued for its spiritual protection as well as for its fibre. It doesn't appear that dog wool had a spiritual value other than the colour white, at least none that has been recorded, but it definitely held value for its availability, its softness and its spinnability.

Breeding

Maintaining separate breeds was essential to the Woolly Dog's survival as a breed. Long, thick hair and white hair are recessive genes, hence interbreeding the large, short-haired village dog with a smaller, long-haired, woolly, white dog would quickly produce dogs without the qualities needed to produce a warm, spinnable wool. The Coast Salish knew this. For the Woolly Dog to survive, they needed to be careful breed managers.

Xwelíqwiya Rena Point Bolton emphasizes that the woman who owned the dogs was the only one who could give permission to breed them. This

means the women who owned them had to know which traits and wool characteristics were important to develop through breeding. They would decide which dogs to breed.[58]

Michael Pavel, a Skokomish man, says,

There's so much that we know had to exist... and that was the science, and the skill, and the knowledge of caring for, breeding, grooming dogs. And the amount of knowledge that you would have is really quite surprising.[59]

The Woolly Dogs were kept protected and isolated from the village dogs, often on small islands or in pens, to intentionally breed for the wool. We do not know if all the Woolly Dogs were kept separated or only the dogs in heat.

An internet search on "where were Woolly Dogs kept" results in many pages suggesting the dogs were kept isolated on islands. A few web pages give the impression that the dogs were left on islands to fend for themselves, surviving on digging up caches of dried salmon while the village left to fish during the salmon runs. Perhaps this is true in some villages, but was it the Woolly Dogs or the village or hunting dogs that were left on islands? And was it for short periods, like a day or two, or longer? It could also be that only female Woolly Dogs in heat were isolated on islands or kept close to their owner inside lodges. I suspect if information makes it to one page on the web, it is easily accepted as fact and gets internet legs, often without context.

Judging by the care taken of the dogs and their importance, it is likely that they were carefully tended close by. The Cowichan took their dogs with them for the salmon season, as mentioned in the 1828 Fort Langley Journals.[60]

I did find two original reports on where the dogs were kept. The first, by Homer Barnett, suggests it was the hunting dogs that were left on islands.[61] The second report was by Wayne Suttles, a well-respected ethnologist, but it is unclear if the dogs left on islands are hunting dogs or Woolly Dogs.[62]

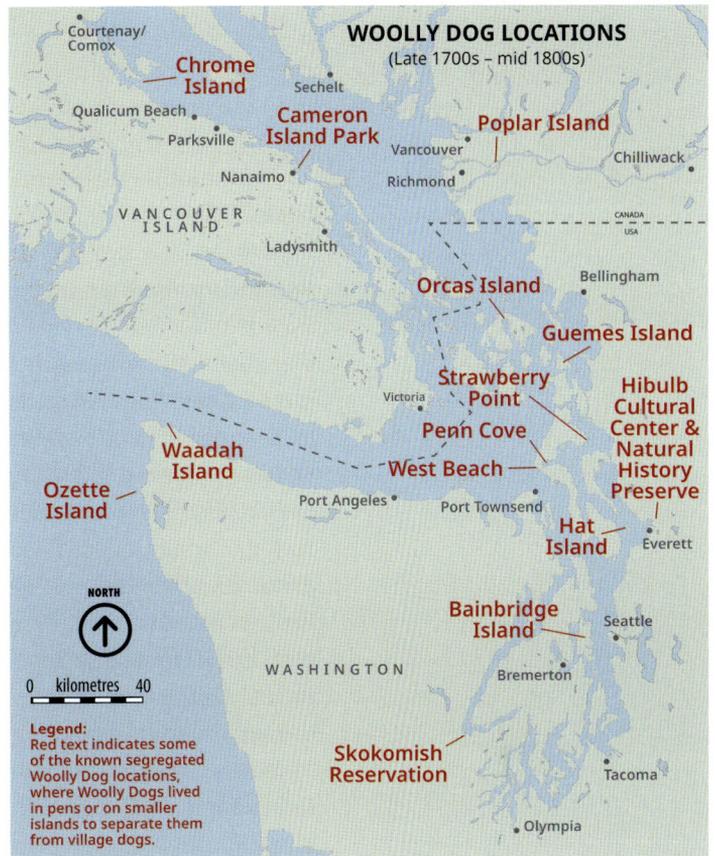

FIG 15

FIG 15 This map shows approximate locations where Woolly Dogs were known to have been kept prior and up to European contact, as noted in historical accounts. Just about every village kept Woolly Dogs; many additional locations, not pictured here, also likely existed.

Map by Roger Handling, Terra Firma Digital Arts, based on a map created by the Hibulb Cultural Center

In Nanaimo, the Snuneymuxw Elders say that Sqwiqwmi, (Little Dog Island), now known as Cameron Island, and the village along the shore, known as Little Dog Village, was where they kept their Woolly Dogs.[63] The Musqueam also kept dogs on an island, Poplar Island (called yeləɬkʷə and/or skʷtexʷqən), in the Fraser River.[64] The Samish kept their dogs on qweng7q-wengila7 ("place of many Woolly Dogs," now known as Guemes Island).[65] Just off Bainbridge Island (across from Seattle), the Suquamish also kept dogs on islands.[66] The Skokomish had pens to keep the puppies in,[67] as did other villages. After the Indian agent at Neah Bay threatened to kill the dogs who chased his horse, the Makah kept the dogs on an island close to the village and rowed out daily to feed them.[68] However, the Ozette people around the corner on the tip of the Olympic Peninsula kept their Woolly Dogs on Ozette Island. Written records mentioning some black, brown or spotted Woolly Dogs suggest that in some villages there either was some intentional or accidental interbreeding of the dogs to give those colours, or perhaps different breeds of dogs or varieties of Woolly Dogs.[69]

When Captain Vancouver (or his assistant) examined the clothing of the local people and wrote, "They were composed of a mixture of a coarse kind of wool" and that the "garments were all too fine to be manufactured from the coarse coating of the dog alone,"[70] perhaps Vancouver examined a Woolly Dog with coarser hair than the softer-haired Woolly Dogs in Spuzzum? Or perhaps he was comparing the wool with the hunting dog's hair and not a Woolly Dog?

Back at the Smithsonian, I instinctively look back in the drawer holding the village or hunting dog's pelt to see if I can see any similarities with Mutton's pelt, but no, the pelt lying next to Mutton was a village dog, larger, with shorter straight reddish hair. Vancouver could not have mistaken a village dog for a Woolly Dog unless it was a mixed breed.

It's time to take a closer look at the actual hair of Mutton.

THE TEACHINGS OF FIBRE

WHEN I WAS LEARNING *to weave cedar and Elder Sarah said to me, "Hey, Violet. I heard you're weaving." I nodded, yep. "And did you learn how to pull the cedar from the tree?"*

Yes, I did. She motioned for me to come sit with her. So I went and sat with her, and she said, "I want you to understand what you're asking from a cedar tree when you pull its bark."

I said, "Okay."

And she said, "It's like me asking you for your skin."

Okay, like that, this is a serious thing, I'm thinking.

She said, "So now when you go gather cedar, you put your hand on the tree and you just feel it. Does it feel okay? If it feels okay, you introduce yourself to the tree. You tell the tree who you are, that you're a weaver, and you're only ever going to take what you need." And I was only to take this much—between your thumb and your pinky finger—from a cedar tree. Yep. "And if it's 25 per cent of the tree, that tree's too small. Don't take it."

But you know, we're taught we are one with that cedar tree. And in our language, it's Xpe. And the cedar tree is one with us. And I've gone into this long story so you understand: Woolly Dog would be our relative in the same way. We're Woolly Dog's relative, and Woolly Dog is a relative to us. The gathering of the materials is as important as the weaving itself. The Woolly Dog would have been treated with the same respect as the cedar tree.

What you need to understand is anything that we did with any animal: we had this value. We're one with that, and they're one with us. We fed these dogs our best foods because we highly valued what they had to offer back to us.

SNUMITHIA' VIOLET ELLIOTT, SNUNEYMUXW (NANAIMO) AND
QUW'UTSUN (COWICHAN)

THERE'S CERTAIN ATTRIBUTES associated with the Woolly Dog. We would have a much more intimate relationship than with the mountain goat.

In many cases, one might say you would want to combine the attributes of the different fibres of mountain goat and dog wool. You would want to weave in all the strengths and not just separate it.

That's why we need to bring the Woolly Dog up, so we can continue to embrace that knowledge about how to care for one another. There are certain people that have that skill and ability to care for animals. That's what they're going to grow up and be. But, if there's no animals to care for, they've lost their purpose in life. They wander. They are, in many cases, confused about their identity.

We need to remember the teachings of the Coast Salish Woolly Dog and embrace those gifts to strengthen our communities, particularly about their teachings of unconditional love, loyalty, caring for one another, and having a zeal for life. Moreover, there are insights and teachings associated with the weaving process that can help us as people right now. A principal teaching of weaving is that it is meant to take two separate entities and weave them together to make them stronger or hold together everything in such a way that you become stronger, become more resilient. Would remembering the teachings of the Woolly Dog and understanding how these teachings are important to our community today be helpful? Would that make a positive difference in the quality of our lives? It would sure as hell make a difference versus not doing anything at all. So, the Woolly Dog is very important to us.

But the thing that's most important out of this is to realize that that wool dog created a gift to produce and to make something to create something to bring something alive. Let's do that. Let's bring that back to life.

We want to make sure to realize that the wool dog is still very much a part of our life. And it's generating a conversation and interaction and outcomes that is the embodiment of goodness.

Decades ago, we weren't wearing wool regalia. Now you go to a traditional ceremony and you see wool regalia. And then you say, "So what?" Well, you look at a picture from a hundred years ago. What were they wearing? They were wearing traditional regalia. Fifty years ago, maybe not so much. Today they are. We are alive, we are well. That's inspiring.

MICHAEL PAVEL, ELDER, SKOKOMISH/TWANA

◇◇◇

I TREAT ALL MY MATERIALS with respect, and try to use them to their best utilization. You don't want to waste anything, and so while one may be considered more prized, they're still going to be used.

DANIELLE MORSETTE, SUQUAMISH AND SHXWHÁ:Y (STÓ:LŌ NATION)

◇◇◇

WHEN I'M WEAVING, I think about the fibre. I just feel like it's sort of a live fibre, there is a sense of some kind of thread to the unknown to where our ancestors were or are, and that might be what makes any of us feel connected to it. At least that's how I feel.

DEBRA QWASEN SPARROW, WEAVER, MUSQUEAM

◇◇◇

FOR US SO MUCH was about balance. My late great-grandma would talk about how it was all about finding balance in in the land and in the materials, and you know where we lived. She said that we always had to live at a place where the freshwater and the saltwater met, where there was both the river and the end of the river came down near the shore, and that's where we build our villages, and that there was a significance to these different energies coming together, and I can kind of imagine that maybe that's how it was too, with the weaving, where you know the mountain goat wool comes from up in the mountains and the dog wool comes from the land.

Well for us . . . wool is just so significant. You know there's just so much that goes into it with the act of spinning it, and it becomes used in so many different ways, and the blankets are the big thing, and the blankets to us were really a form of currency in a way. And in giving away the blankets. That's how we amass wealth, by giving it away at Potlatch.

It was also used in a lot of different regalia, and it might not be the case, but I think that it would be what you had available that the people in your family had spun is what you used and all the different mixing of things and for different purposes.

I think that for it to be shared as readily available and accessible as it as it can be would be very important. I think that for the voices of Coast Salish people to be centred is imperative to the work itself not just in working against this history of colonization, but specifically to centre the narrative.

That's how the teachings are meant to be shared, and that this is the powerful way that our storytelling can continue to exist and for other people to learn is through the voices of our Elders and through our own voices.

Part of the whole narrative around the Woolly Dog that I find really interesting is that it starts to unravel, in a way, people's understanding of us as a hunter-gatherer society, and that our society was so much more complex than what people took, take it for in general. Hunter-gatherer is kind of this dominating narrative that just blankets everything and takes away the complexity and the nuances, and our relationship with the Woolly Dogs clearly shows that there is more complexity to this, and that our relationship with the camas patches and the clam beds and the way that we tended the land and tended the forests, these all show the systems that were in place that are far more complex than what people take for granted about Coast Salish culture.

And so that really it's so much about combating this simplistic aspect or the simplistic lens with which our culture is looked at and showing that actually things are much more complex than many may think.

In terms of specific special things that the wool was used for, I look at it in the same way that I look at our art, and how it wasn't just ornament, it was like a visual language and it was meant to imbue these objects with the love and the good energy and the good intentions and the history of our people, for the things that they were going to be used for, whether it was in daily life or in ritual life. We always tried to do things in a good way and in the best way that we could. When you're using the wool, there's significance to that when you're using different materials, there's significance to that.

Much of it was about opening ourselves, and speaking to and communicating with these materials because they had life too. In a way, everything was special in a sense, and everything had that energy and everything was meant to be spoken to and meant to be treated as a being. So that's one thing that stands out to me from my teachings, from my family and my great-grandma.

ELIOT WHITE-HILL KWULASULTUN, ARTIST, SNUNEYMUXW

THE SPECIAL QUALITIES are not physical, but more in the realm of feelings associated with love. There's a definite expression of love, unconditional love, that gets imbued into the Woolly Dog's fibres while being woven into regalia.

It is important to acknowledge that the entities, Mountain Goat and Woolly Dog and their fibres, were teachers. We also had plant teachers. So, the inclusion of fireweed and cattail, the animal wool, waterfowl down, all of those original teachers, plants and animals were spun together and provided a yarn that provided protection, love, transformation and cleansing. All of our first teachers' teachings got spun into the yarn to create the regalia that human people would then be adorned with, honoured with, cleansed with, and moved from one realm to the other realm. So we make sacred offerings to the plant and animal people and their teachings that are spun into the yarn, to the yarn then goes into the weaving, and then the weaving when it is brought to life (completed). So being spiritual is important to being a weaver and all along the way of collecting and processing what is involved in the weaving process. All of it.

I read a book in which the author talked about adding loft to the fibre, but it's not added for the reason that the author thought. It's like there's not quite enough duck down. There's not quite enough eagle down, waterfowl down to provide loft. No. Something else is going on there. For us, it's a spiritual decision to weave the spiritual essence of entities into our weavings. For example, it is a spiritual decision when we feel the importance of incorporating cattail fluff to spiritually cleanse a woven item to be received by our ancestors. Cattails grow in places where the water needs to be cleansed. The surface water must be cleansed, so cattails grow in a place of cleansing that area. So, there is a cleansing and a spiritual quality that moves through cattail to cleanse. So, the fibres of cattail represent cleansing and an alteration from one realm to another realm. Much like the Woolly Dog world that is imbued in the world of love and loyalty, cattail fluff imbues the quality of cleansing and a transformation that happens from this world realm to another world realm

saɫamit́ca SUSAN PAVEL, COAST SALISH WOOL WEAVING CENTER

4 THE WOOL

SUZANNE AND I BEGIN TO look at Mutton's hair. My first reaction is surprise at his colour. I was expecting the pure whiteness of a Samoyed dog. But it is not snow white. It is not dirty white. It is between a white and a light tan colour.

The Coast Salish Woolly Dog has always been associated with the colour white. Indigenous Oral Histories and early explorers have, with a few notable exceptions, claimed that the wool of this special dog was white, so perhaps Mutton is not "pure" and is the result of interbreeding with a village dog or a non-Indigenous dog. Mutton's colouring could be typical, or maybe different villages had slightly different looking white-haired Woolly Dogs with various shades of white.

The earliest written accounts of Woolly Dogs are from European explorers in the late 1770s, two decades before Captain Vancouver's observations were recorded, when Captain James Cook visited the west coast of Vancouver Island. His shipmate John Ledyard commented on the quality of the woven clothing "principally made with the hair of their dogs, which are mostly white, and of the domestic kind." [71]

The next written accounts mentioning the colour of the dogs are those of Vancouver in 1792, and Dr. John Scouler, surgeon and naturalist on board a Hudson's Bay Company ship, in 1825. They both entered Juan de Fuca Strait and into the Salish Sea, Coast Salish territory, and both described the dog hair as mostly white.

Paul Kane, a travelling artist and hence observant about colour, wrote on his visit to Fort Victoria in 1847 that "[t]hey have a peculiar breed of small

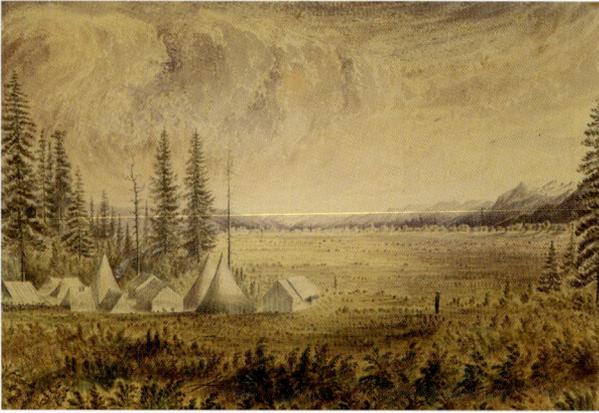

FIG 16 A view of the NWBS camp on the Sumas Prairie, looking north. The painting is by artist James Madison Alden, likely created in 1858 or 1859.
US National Archives

dogs with long hair of brownish black and a clear white. These dogs are bred for clothing purposes."[72] Another report says some Woolly Dogs had different spots of colour, but most speak of dogs being one colour—white. There are also a couple of accounts of yellowish-white Woolly Dogs at Cape Flattery in the mid-1800s. Interestingly, near present-day Chilliwack, where Mutton was acquired, the surviving accounts speak of the Woolly Dog as similar to a coyote, which is yellowish/tan, and say that the Coast Woolly Dogs were different from dogs from their area. Perhaps they are referring to the colour, with the Coast Woolly Dogs being whiter.[73]

Toward Mutton's rump there is a red tinge to his skin and his root ends. This is not part of his natural colouring but results from a toxic preservative applied to his pelt. It is a good thing that we are wearing gloves.

I poke his wool coat with the eraser part of a pencil. Only pencils, definitely no pens, are allowed in museums and archives lest pens leave ink on any of the objects in the collections. I am aware that very few people are allowed behind the scenes in the hidden collections area, but my email explaining my research into Coast Salish textiles has opened doors. Pencil in hand, I am on my best behaviour.

Spinnability

Although dog hair had long been believed to be an important fibre for the Coast Salish, in the early 1980s doubts arose again, prompted by Eurocentric views as to whether the dog fibre was ever spun into yarn, causing questions about the very existence of the special breed.

Paula Gustafson examined most of the blankets in the world's major museums and wrote the first major book on Salish weaving. Her first concern was over the spinnability of the dog hair: "Canine hair, no matter from what breed, is not a good spinning fibre, and it is particularly difficult to work with using the suspension-spindle method of spinning employed by the Salish. One main drawback is the slippery quality of the individual strands, even if the hair has a natural curl."[74] Gustafson suggested that dog hair could not be spun using the traditional Coast Salish spindle unless it was "mixed with longer and more tenacious fibres from some other animal or plant."[75]

Numerous Oral Histories mention mixing dog hair with other fibres, often mountain goat but also plant fluffs, like fireweed or cottonwood, and down. But aside from mountain goat, those other fibres would not assist with the spinnability of a slippery dog hair, as they are too short to help hold all the fibres together. If any spun yarn contained only dog wool and short plant fluff, then it would be the dog wool holding the short fibres together.

Stinging nettle (*Urtica doica*) and hemp dogbane (*Apocynum cannabinum*), also known as Indian hemp, provide long fibres that can be used to hold dog wool together, but those were more often used as warp, hidden by the weft in rugs and blankets, because they are not as soft as dog wool.

I want to look especially at the slipperiness, or not, of Mutton's wool. Can it be spun alone, or does it require a longer plant or animal fibre to help hold it together?

Mutton's hair is long—extremely long in some places. At first glance, his coat seems to be just one coat, but on closer inspection, he has a topcoat covering a fuzzy-looking shorter undercoat. The guard hairs of his topcoat are longer, straighter, thicker and definitely more slippery-looking than the undercoat.

Most mammals have evolved to grow two coats, a shorter-haired undercoat close to the skin, with finer hairs—the down for warmth—and a topcoat with its longer, thicker and stiffer hairs, known as *guard hairs*, spread throughout.

Like humans, dogs have different types of hairs, and each type has a purpose. Some hair is for warmth (the undercoat), some are sensory (think dog whiskers) and some are protective (eyelashes protect the eyes). The purpose of guard hairs is two fold: to protect the underlying softer fur/hairs from abrasion and to shed and repel water and/or snow. Hence the name "guard" hair.

A suggestion put forward by Elizabeth Miller, a Coast Salish textile researcher who has now passed away, is that the Woolly Dog originated in northern latitudes and had a mutation making the guard hairs thinner and therefore softer.[76] In a cold climate it would be important to shed moisture as much as possible to prevent the wool from freezing into ice, which would weigh the dog down and risk death. Thicker, strong guard hairs are needed to flick off moisture. In the Salish Sea area, where snow falls infrequently and stays for short periods of time, any mutation creating softer guard hairs would not be a problem. But that mutation is just a suggestion, still to be tested. A change in guard hair thickness could also be due to gradual migration south and years of natural evolution.

The length and softness or stiffness of guard hair is of interest to spinners as it will impact the softness of the yarn yet aid the spinning process. Spinning is the art and science of taking fibres and adding a twist to them to hold them together. Twist is what gives a yarn strength. The art lies in how well yarn is twisted, how consistent the twist is, and the even thickness of the yarn. The science is figuring out how to add enough twist to hold those fibres together without making the yarn kink or become brittle. At the same time, the spinner needs to consider how hard or soft a yarn should be and balance the amount of twist with the intended usage. If the fibres are short, like fireweed or cottonwood fluff, you need a lot of twist, producing a smaller diameter of yarn, which can reduce the softness. If the fibres are long, then you don't need as much twist, and you can make thicker yarn. You can, of course, combine short and long fibres. As any spinner knows, long hairs help tie the yarn together when spun with shorter hair and help retain the softness of shorter fibres. But if all the hairs are straight, without kinks, curls, waves or fuzziness, then a lot of twist is needed to hold the fibres together, and once again you lose the softness. We need to check Mutton's hair closely, both the longer guard hairs and the softer wool beneath.

It is Mutton's undercoat that looks most spinnable to me. The undercoat has a lot of crimp or fuzziness—what we would call "woolliness"—that would help the twist grab hold of the hairs, which would keep the fibres together. If fibres are too short or too slippery, then the twist can't get a grip and the fibres will eventually slip slide away and the yarn will come apart.

Mutton has both long, fine hair and shorter, fuzzy hair—a good spinnable combination that seems to not require the addition of longer fibres from another source, or at least it looks that way at first glance.

I want to pull a chunk of hair out and tease it apart to get a good look at it, but that is frowned upon in museums, which are there to protect and preserve objects, not to let visitors destroy them hair by hair. I also want to brush a lock of Mutton's hair back and forth to tickle the skin just above my upper lip, just below the nose. I have been told that spot is one of your most sensitive places to judge softness. But I dare not sink my face into Mutton's arsenic-preserved pelt. In my mind, I hear Xwelíqwiya Rena Point Bolton, Stó:lō Elder, telling me, "My mother said it was very beautiful soft wool." [77]

I get out an Ikea paper measuring tape and start measuring some of the hairs. It is frustrating. I should have brought a more scientific tape measure, or at least a proper ruler. But I am not too worried as Candace Wellman

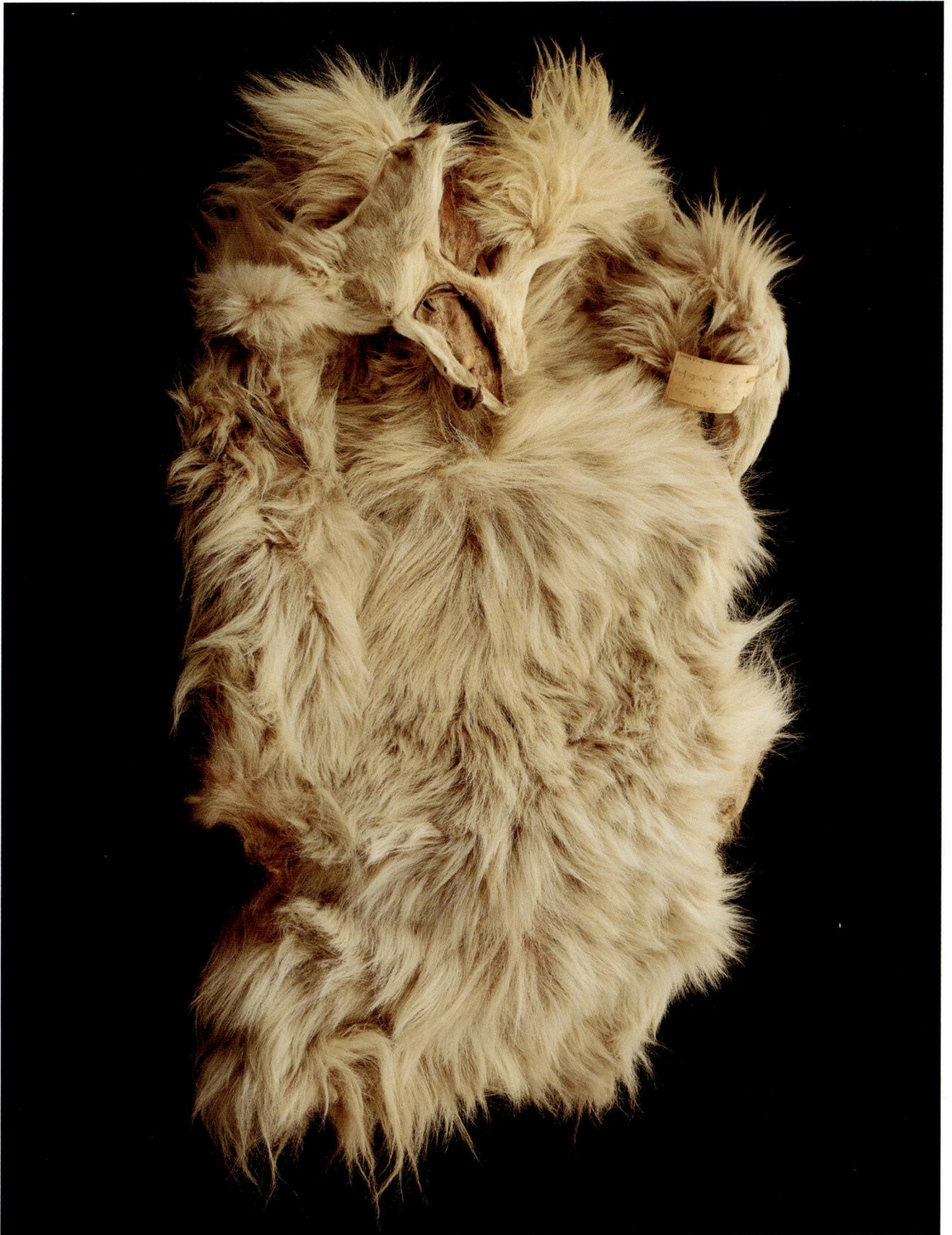

FIG 17

measured Mutton's hair when she was here visiting Mutton, under the careful guidance of Bob Fisher, the collections manager, and I have a copy of her notes.

Mutton's undercoat, although shorter than the guard hairs, is still quite long, averaging 6 to 8 centimetres (2¼ to 3¼ inches). Some hairs are much longer. Years later I am told by Melissa Hawkins, curator in charge of mammals, that Mutton's undercoat is unusually long for any mammal. Some hairs on his tail are 23 centimetres (9 inches) long. Tails probably don't shed like the rest of a dog's body, which might account for the extreme length, and they would be guard hairs, not the downy undercoat.

Fur Coats

Much confusion exists over the differences between fur, hair and wool. The collective English term is *pelage*—the hairy, woolly or furry coat of a mammal. They are all hair, though different types of hair. We tend to think of human hair as being hair, whereas sheep hair we call "wool," and mink hair we call "fur," but technically they are all hair formed by cells pushing out soft keratin that hardens into a hair fibre. The main difference between fur, wool and hair is that fur grows to a preset length and then stops. Hair, on the other hand, continues to grow, which is why we humans need haircuts. The Coast Salish Woolly Dogs needed to be sheared every year, so we know that their "pelage" was more hair-like than fur-like.

A coat of fur is most useful for warmth. Mammals living in cooler climates need one or more of the following: more hairs per square inch, more insulating-type hairs or longer hairs to overlap and make a thicker covering.

Clever ways have evolved to grow insulation for warmth. Polar bears (*Ursus maritimus*, genus *Thalarctos*, a.k.a. sea bear, ice bear or Nanuq) living in some of the coldest regions of the world are fascinating examples. It is hard to believe, but they have black skin to better absorb any solar radiation that hits them. They grow two types of hairs—a softer, shorter, thicker, warm undercoat that provides insulation, and guard hairs that are thicker and a little longer but lightweight, transparent and hollow. These hollow hairs trap warmth, and that layer of air provides insulating warmth and buoyancy.

Air is a wonderful insulator. The trick is to trap it. If you let the wind blow through your hair, it will take away your body heat. Trap that warm body air, and you trap your heat. Fuzziness also helps fibres create and preserve air pockets, and those air pockets are warmed by body heat and trap that heat.

Fur is hair, but the density of hairs in fur is far greater than on a human scalp. Sea otters live in the cold water of the Pacific Northwest in southeast Alaska and along the coast of British Columbia. Although other cold-water mammals have loads of thick blubber to insulate them, sea otters have very little. They rely on having incredibly thick fur to keep them warm. They have up to a million hairs per square inch and constantly groom themselves to keep air within their hairs while feeding themselves enough to keep their body producing heat. Humans have maybe only 1,000 hairs per square inch, which explains why we need hats. So, just the sheer mass of hair shafts in fur assists with trapping air, blocks the wind or the cold water, and conserves heat.

With dogs, the number of hairs per square inch depends on the size of the dog. Small dogs have 100 to 600 hairs per square inch, medium-sized dogs can have 15,000, and large dogs well over 80,000.[78] No one has counted Mutton's hairs, though from what I can see, it seems a lot. However, Mutton is a small to medium-sized dog, and his flattened pelt makes it hard to gauge the true thickness of his hair. As I look at Mutton's coat, I recall Captain Vancouver's words: "so compact were their fleeces, that large portions could be lifted up by a corner without causing any separation."[79] Yes, this pelt has thick hair, but from what I can see, it does not live up to Vancouver's comment about lifting whole portions of the coat.

Some dog breeds have fur-type hair—their hair grows to a preset length and then stops (e.g., Doberman pinschers and boxers). Other breeds have hair that keeps on growing (e.g., poodles). Many dogs shed, and their hair goes through a cycle: the growth stage, the resting stage and finally the fallout or shedding phase. Some dogs shed continuously (e.g., German shepherds), not all their hair at once, but every day some hair sheds while new hairs start growing. Some dogs are said to not shed (e.g., cairn terriers). Some dogs shed or "blow" their coat once a year, all at once, while other breeds do this twice a year (e.g., Bernese mountain dogs). In the spring as summer approaches, dogs "blow" their coat to prepare for a lighter, less warm summer coat. Then in fall they blow their coat a second time to make way for a warmer coat for the winter.

Other mammals "blow" their coat every year. Ancient short-tailed breeds of sheep—in other words, those with more ancestral DNA, like Soay, Shetland, Icelandic—and some of the Nordic breeds, moult (or roo, as it is also known) once a year, shedding most of their wool. The *Oxford English Dictionary* definition of the word *roo* is "To strip (a sheep) of wool by hand, instead of by

shearing; to pluck (wool) in this manner."[80] Cashmere goats have guard hairs all year and grow the fine, soft down as the days grow shorter and become cooler. As warmer days of spring approach, the down hairs start to moult but the guard hairs remain. Mountain goats take a different approach. They grow both down wool and guard hairs, and finer but longer hairs in between the two extremes, but come summer they moult everything.

Mutton is from a type of breed that "blows" its coat. The question is if his breed blew their coat once or twice a year. There are a couple of Oral History accounts indicating the Woolly Dogs were sheared twice a year. This makes sense, as a Woolly Dog would blow out their winter coat as the weather warms to make room for a lighter coat; then, as the weather cools, the lighter coat is shed to allow for the warm winter hairs.

According to Kennerly's letter of August 19, 1859, Mutton had been sheared a short time earlier, but we do not know when—perhaps June or July? A packing list indicates Mutton may have been shipped in September, or at least he was assigned a packing and field number in September. Perhaps the "packing list," if that is what it was, and the field number was merely a plan that never got carried out? This was something that needed more checking. Did packing lists accompany the boxes of specimens or were they sent by letter before the boxes shipped?

With Mutton's undercoat measuring an average of 2 to 3 inches and his guard hair 6 inches, his hair seems too long for such a short time period. If Kennerly considered "a short time ago" as being sometime mid- to late July and he was shipped in September (not quite two months), Mutton's hair must have grown at a rapid clip, say, an inch to two inches per month, which seems excessive. The average growth rate for dogs is ¼ to ½ inch per month depending on health, genetics, etc.[81] To be so prized for their long wool, Coast Salish Woolly Dogs probably had growth rates faster than most dogs. Nonetheless, the cut in July, shipped in September dates simply do not match with the length of Mutton's hair.

Four historical references comment on when the Woolly Dogs were seen "recently" sheared. Three (Captains Vancouver [82] and Galiano[83] and explorer Simon Fraser[84]) mentioned they saw recently sheared dogs around June (May 28, June 2, or June 28 in varying years). The fourth account is that of James McMillan at Fort Langley, who wrote of "dogs more resembling Cheviot Lambs shorn of their wool" in his journal on September 23.[85]

A shearing in, say, mid-June and a packing list date in mid-September

would account for a three-month growth of hair. Still, that would make for unusually fast-growing hair—the undercoat clocking in at 1 inch per month and guard hair at 2 inches per month. If June seems a reasonable time frame for when Mutton was sheared—given the historical records, and a month or two before Kennerly's letter—and if the breed blew their coats twice a year, then the next time Mutton would be sheared would be about six months later, around December. Given the length of his hair, he must have died close to the time when he blows his summer coat. But that does not add up to Mutton being shipped in September, creating a bit of a mystery. I was beginning to think that the September shipping date was incorrect. More research was needed to establish a more likely date.

Convinced now, by looking at Mutton's coat, that Gustafson's question about spinnability is answered and Mutton's hair is indeed spinnable, Suzanne and I carefully fold Mutton back into three layers and place him gently in the cabinet drawer. He is not alone there; he shares this drawer with another dog pelt, this one reddish in colour, like an Irish setter. Suzanne nods toward it: "And that is the village dog that Kennerly collected around the same time."

The village dog, collected from Semiahmoo, a village located next to the US survey camp near what is now Blaine, Washington, looks nothing like Mutton. Mutton has long hair; the village dog has short, fine, slippery, straight hair. With a start I remember Kennerly's letter to Baird complaining about a village dog gnawing on otter bones. This was that dog. Kennerly's letter (of March 5) claiming a large "woolly dog" was on its way was incorrect. It was not a "woolly dog," not like the real Woolly Dogs. By the time Kennerly listed it as field number 106 (dated February 1858), it was listed only as an Indian dog, not a Woolly Dog.[86] The anonymous village dog lying for years next to Mutton now too told a story and no longer looked like just another dog. I look at the tawny dog and, in my mind, I can see Kennerly, perhaps cursing and grabbing onto him, the dog looking guilty.

Fleetingly, I wonder what the village dog really looked like; he seems so diminished as just a pelt, in rough shape, his coat short and dull, lying next to the resplendent woolly Mutton, whose coat is still impressive after all these years.

Mostly, though, I wonder about Mutton and his fellow Woolly Dogs. We have learned so much from his pelt, but it would be so interesting to know what the breed truly looked like when these dogs were alive and kicking.

THE CULTURAL IMPORTANCE
OF BLANKETS

CEREMONIES FULFILL responsibilities, bringing honour to our Ancestors and our family. We conduct our ceremonies as it has always been done. "Don't change anything," we are told. The ceremony is planned to the very last detail. Everything that happens follows proper protocol. Every person has received rigorous training for their important role. We all go into ceremony wrapped in robes that have been woven for us.

The Coast Salish ceremonial robe is an object of extraordinary complexity. Said to exist in the supernatural realm, these robes are made manifest in the natural world through Ancestral guidance. Wearing a woven blanket during ritual is transformative, moving the individual from the domain of the mundane to a sacred space. They are protective garments that at times of great changes in a person's life—celebrating a birth, participating in a marriage, mourning a death—offer emotional strength. A well-made blanket conveys the owner's prestige in the community and demonstrates a weaver's technical expertise along with their finely honed artistic vision. The object, the maker, the wearer, and the community itself are bound and transformed through the creation and use of the Salish blanket.

You should think of blankets as merged objects. They are alive, because they exist in the spirit world. Their power is part of the weaver, part of the hunter, part of the wearer.

CHEPXIMIYA SIYAM CHIEF DR. JANICE GEORGE, ELDER,
SK̲WX̲WÚ7MESH ÚXWUMIXW (SQUAMISH NATION)

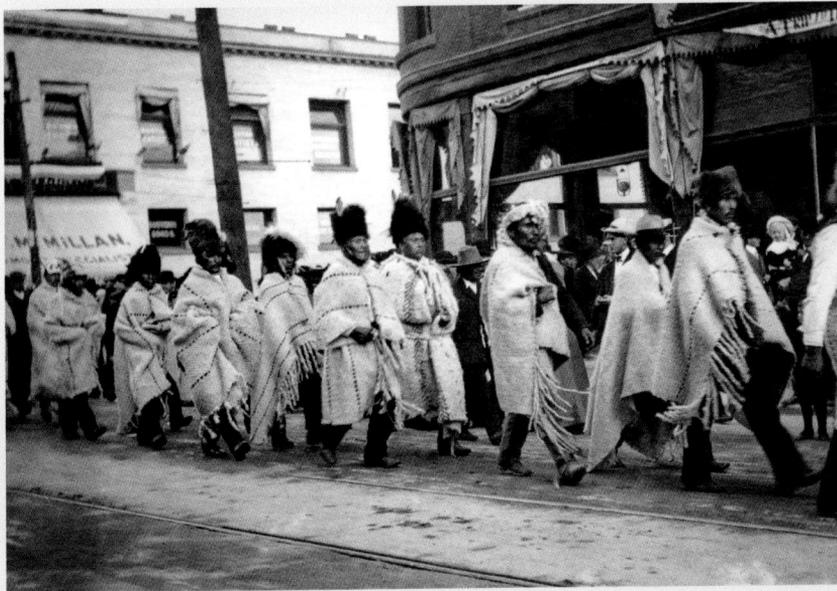

FIG 18

FIG 18 Indigenous men wear their twill blankets in a 1906 parade for the first visit of Governor General Albert Grey, the fourth Earl Grey. *Photo attributed to Ivor N. Austin, the City of Vancouver Archives*

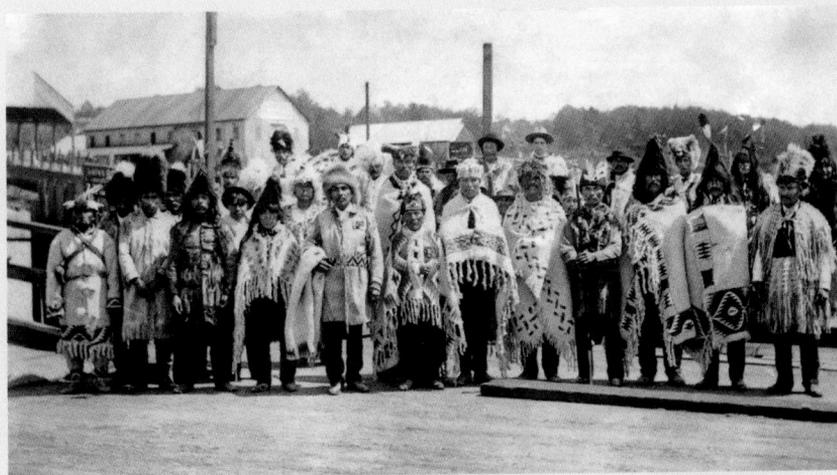

FIG 19

FIG 19 Skwxwu7mesh (Squamish) leaders pose on the North Vancouver wharf in 1906 to send Joe Capilano on his trip to England. Interpreter Simon Pierre, of Katzie First Nation, is sixth from the left.
Major James Skitt Matthews, Vancouver City Archives

I, KERRIE CHARNLEY, am the grand-niece of Simon Pierre. When he was seven-teen years old, the Chiefs of British Columbia appointed him as their secretary and translator due to his gift for learning languages and other skills. He accom-panied the three Salish Chiefs to London, England, in 1906 when they brought their petition regarding the Crown representatives in BC not upholding their end of the agreements to allow First Nations access to food sources. There was a fear of starvation in the upcoming winter. Simon and the three Chiefs met with the colonial officials and King Edward VII.

I am the great-granddaughter of patriarch Peter Pierre, who continues to be renowned across Coast Salish territories for his powerful medicine and leadership.[87]

He was and is still referred to as "Old Pierre" because he was an Elder and si?ɛm (siyam), a spiritually and powerfully gifted, honoured and respected healer/ medicine person and leader. Medicine includes food. When I met Musqueam Elder Edna Grant, the first thing she told me was that when my great-grand-father visited Musqueam he said a prayer at the water's edge. Immediately sockeye salmon appeared in such great numbers that one could walk across their backs to the other side. Old Pierre told the story of how his great-grandfather who lived on Guemes Island, or qweng7qwengila7 ("place where there are lots of Coast Salish Woolly Dogs"), was honoured with a stack of Woolly Dog and mountain goat blankets when he died and placed high on a grave scaffolding as was our custom.

Woolly Dogs and their wool held high spiritual value. The spiritual "value" is interconnected among all of the people involved in the weaving system: the dog caretaker, the dog, the woman who imagined the design for the spindle whorl, the man who carved the spindle whorl for her, the weaver of the blanket,

FIG 20

FIG 20 This is a photograph of Kerrie Charnley's great-grandfather Peter Pierre, taken around 1906.

Suttles and Jenness Publication

and the blanket itself and the wearer of the blanket. Energy is imbued into the blanket by each participant in the weavings' construction, not only on the physical side of life but also on the other spiritual and ancestral side helping us with the forming of the blanket on this side. The Woolly Dog and mountain goat wool blankets then were primarily and fundamentally power and protection blankets bestowed on Coast Salish persons doing important work for community and for family and beyond. This is why, in the early years of the twentieth century, the BC chiefs wore Woolly Dog and mountain goat blankets when they set out to England to petition King Edward VII regarding hunting rights and responsibilities and how representatives of the King in British Columbia were not adhering to the laws, responsibilities and agreements.

The spiritual practice of weaving blankets is a governance practice. When colonial agents drafted their laws, they sought to end the high status and regard women held in terms of power, influence, knowledge in Salish governance and education in our communities. Little of women's knowledges and practices is mentioned in the colonial historical archive. Although Jenness's The Faith of a Coast Salish Indian *mostly focuses on men, the passage below shows a rare reference to Katzie women and to our Coast Salish Woolly Dog:*

> *Every house had a low platform on both sides ... [They] slept on this platform, lying on rush mats or on dog-hair blankets ... When the weather grew cooler, they [men] added a sleeved deer-skin shirt that reached to the thighs and leggings of various skins, and over their shoulders they threw a goat's wool blanket, a fur robe, or a rain-cape of cedar-bark ... The women wore much the same costume as the men, but their shirt or dress had shorter sleeves and extended to the knees, while over a cedar-bark or* dog's hair *diaper they wore a short cedar-bark petticoat that laced down each hip to the knees and was held up with a belt.[88]*

Anthropologists, archaeologists and museum curators sometimes refer to Coast Salish material belongings as "artifacts." Musqueam leader Wendy Grant welcomed guests and made a speech at the opening of the "Fabric of Our Land:

FIG 21

FIG 21 In this Pierre family portrait, Kerrie Charnley's grandmother, Amanda, is on the far right in front. Beside Amanda is her mother, Katherine, with her blanket over her arm, and her father, Peter ("Old Pierre"), with her youngest sister, Matilda, between them. Her older sister, Margaret, stands at the back on the left, her brother Xavior on the right. The three oldest children—August, Frank and Simon—are not in the photograph.
Photographer unknown

Coast Salish Weaving" exhibit.[89] She said, "to us Coast Salish and Musqueam, they are not artifacts. To us they are our belongings. They are our relatives." Thus, it makes sense that my great-grandmother, Katherine Pierre, would include her honour and protection blanket, laden with knowledge, in the portrait taken of our family, both as a symbol of my great-grandmother's social position and because she would have included it as a relative.

Cedar bark can be processed so that it is soft. I was recently gifted mountain goat wool, and to me it is significantly softer than sheep's wool. The Woolly Dog wool must have had a super soft texture, making it most suitable for garments that would be worn close to the skin, such as Coast Salish lingerie. My desire to become smelah, that is, to become educated in the highest Coast Salish Katzie sense, and importantly for my keen interest in reviving and restoring my matrilineal legacy of wool weaving and for this current book on the Coast Salish Woolly Dog, women's leadership in weaving is pivotal. I look for the golden threads, reference to our matriarchs and their work wherever I can glimpse them in this book and I weave these illuminating threads of yarn together in an attempt at weaving the pieces of our ancestral feminine knowledge back together.

KERRIE CHARNLEY, Xʷə́LMƏXʷ, PIERRE FAMILY, Q̓ÍĆƏY̓/KATZIE

THERE IS A TERM stémxwuth *[which refers to] a special type of blanket weaving. So there's different names for a blanket or a chief's robe. There's a lot of different weaving terms, but this one is specifically talking about those three materials, the Woolly Dog, mountain goat, and fireweed.*

SENAQWILA WYSS, SK̲W̲X̲WÚ7MESH ÚXWUMIXW (SQUAMISH NATION)

I'D LIKE PEOPLE TO KNOW how valuable they [the dogs] really were. In essence, like how valuable the blankets and the clothing that were made from them were to tribal communities.

DANIELLE MORSETTE, SUQUAMISH AND SHXWHÁ:Y (STÓ:LŌ NATION)

A SALISH CHIEF BLANKET was all feathers and wool mixed and it was white. You know, there was no other colour, it was just white. I guess it would have to be somebody very special because can you imagine doing all that work? My good-ness. It would take probably two or three ladies just to make one blanket because my mom said you would have to weave the spun yarn on when it's still wet, and then you have to pound it down so it's buried [in the warp] because once it dries then the feathers will all fall off or start falling off. Yeah, but if it's still wet then it will stay, and then you're doing twill because you're going in and out of two warps at a time.

XWELÍQWIYA RENA POINT BOLTON, STÓ:LŌ

TWENTY YEARS AGO, there were not a lot of people wearing traditional wool regalia. When you wanted to wrap somebody, particularly a Speaker in a blanket, it was often a Pendleton blanket or even more recently an Eighth Generation blanket. They're very beautiful. I've got a bunch of them. But when I go on a ceremonial floor, the choice of the covering that exudes the most powerful prayer and protection for me is a traditional wool regalia item. I feel so much more love and protection. The Pendleton blanket and Eighth Generation blankets keep you warm. However, the prayers of the people aren't infused in the fibres as is done when weaving traditional Coast Salish wool regalia. I can't feel the power or warmth of those prayers in that commercial blanket.

MICHAEL PAVEL, ELDER, SKOKOMISH/TWANA

5 WHERE ARE ALL THE BLANKETS?

The Salish blanket, worn as a ceremonial robe, is an object of extraordinary complexity. Said to exist in the supernatural realm, these robes are made manifest in the natural world through Ancestral guidance.
LESLIE H. TEPPER ET AL.[90]

IT IS NOW 2017, five years after I first laid eyes on Mutton, and the air is charged with excitement in a large meeting room at the Burke Museum of Natural History and Culture at the University of Washington in Seattle. All the seats are filled, with people sitting on tables at the back. There are Suquamish people, Duwamish, Knowledge Keepers, Elders, academics, historians, Burke Museum staff and supporters, and a few journalists. We are on the traditional territory of the Coast Salish peoples, as the Burke Museum has just acknowledged, according to their customary and long-established protocol.

Before we go further, let's dig just a little deeper into the history of this particular territory, as it relates to Mutton's story. The land is governed by the Point Elliott Treaty (1855), which covers from the 49th parallel and includes the San Juan Islands and the eastern portion of Puget Sound down to the south end of King County.[91] The treaty was signed by Isaac Stevens, Governor of Washington State from 1853 to 1857, yet 175 years later it is still in dispute, as some of the signatories have never received the promised land and rights.[92] Judge James Wickersham (we will come to him again) would characterize this treaty in 1895, forty years after it was signed, as "unfair, unjust, ungenerous, and illegal."[93]

This treaty was signed three years before Mutton was born. The first of the many chiefs, or *si'abs*, to sign it was si'áb Si'ahl (Chief Seattle). The City of

Seattle was named for him. Si'ahl was si'áb of the dxʷdəwʔabš (Duwamish) and Suquamish. The treaty was also signed by George Gibbs, Mutton's owner.

Gibbs was hired by Isaac Stevens as surveyor and secretary to the Treaty team and, no doubt, for his knowledge of local languages and his legal background. Stevens wrote that Gibbs was a "gentleman of ability, exceedingly well versed in Indian affairs."[94] Gibbs persuaded Governor Stevens to establish many reserves on their traditional lands, rather than removal to one big distant reserve, as was common farther east, to recognize the differences in Indigenous language, culture and customary fishing areas. And because of that same George Gibbs and his dog Mutton, I am here at the Burke Museum, amid a small, expectant crowd of people, both Indigenous and non-Indigenous. At the front and to the right is a podium with a microphone and a projection screen; to the left is a table with a large blanket spread over it. This is a Salish blanket, over a hundred years old; humble, plain, tan-coloured with a dark brown stripe at each end (Figure 22).

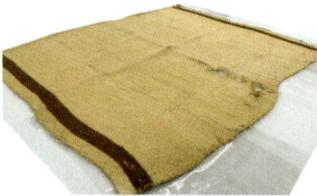

Worn and frayed, the blanket does not look exceptional, yet a group of six, both women and men, surround it in reverence. These are Suquamish (Puget Sound Salish) singers and weavers. They are singing an honour song to welcome the blanket back, out of its obscurity from the storeroom of the museum. The sight and the sound send chills up the spines of the people watching, a large gathering of some one hundred people. One weaver gently places her hands on the blanket. Her hands shake with emotion. Another woman gives a prayer of thanks to the blanket.

This blanket is one of the first to be "scientifically" confirmed as containing dog hair. Strange that it took so many years to find one. Very surprising, considering that throughout Coast Salish territories and those of neighbouring cultures, Oral Histories abound about Woolly Dogs raised and bred for their wool.

Types of Blankets

Very few Coast Salish blankets can be reliably dated back before 1900, but those that survive reveal an astonishing knowledge of local fibres, how to process them, how they should be spun, and a variety of weaving techniques.[95] These blankets are comprised of a wide range of fibres, making efficient use of plant, animal and bird materials—everything from fluff to fur to feathers.

FIG 22 A plain-weave blanket made of dog wool, from the Burke Museum of Natural History and Culture.
Liz Hammond-Kaarremaa

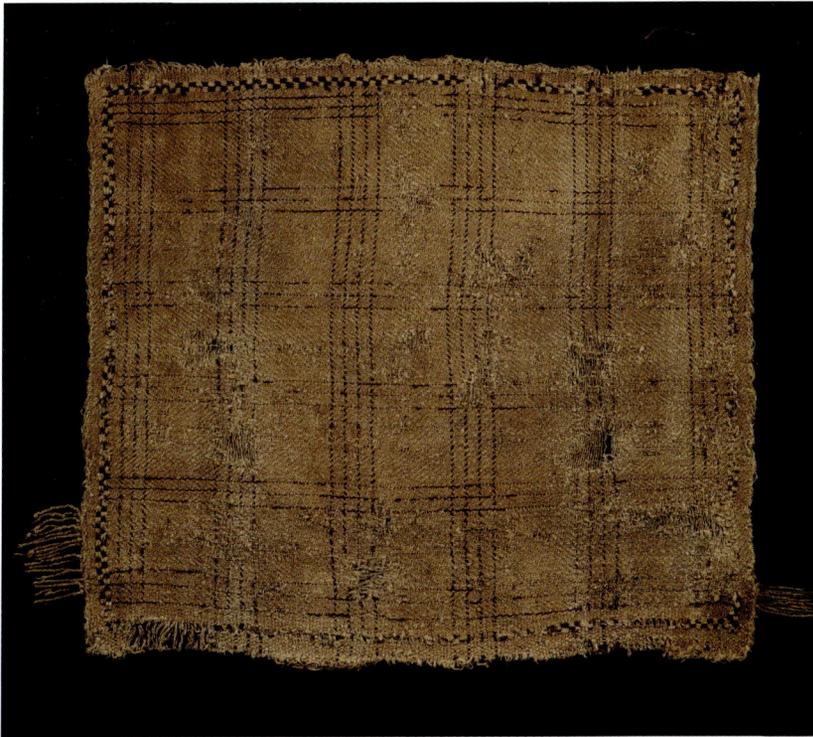

FIG 23

Coast Salish blankets, which early Europeans greatly admired and acquired in early trading, still survive in a few museums in North America and Europe.

The oldest blanket of the Pacific Northwest known to contain Woolly Dog wool is a Makah blanket known as the Ozette blanket. It was made by the people of Ozette, a village on the northwest tip of the Olympic Peninsula. Although this is not a Coast Salish blanket, the Ozette too kept Woolly Dogs, and their techniques for making blankets would be similar. The blanket was covered with mud due to a landslide, possibly an earthquake known to have occurred in 1700. It was this mud that kept oxygen from destroying the blanket, preserving it for hundreds of years. It has a plaid-like design to it, with some darker stripes woven down and across.[96]

Simon Fraser, descending the river named after him in 1808, wrote, "They make rugs, of Dog's hair, that have stripes of different colours crossing at right angles resembling at a distance Highland plaid."[97] Interestingly, Fraser's description of a plaid-like design is consistent with that of the Ozette blanket, which was created long before Fraser made this observation.

He also mentioned seeing a large copper kettle shaped like a jar and wrote of purchasing "a blanket of Dog's hair, a matted bag, a wooden comb of curious construction." He may have purchased more than one blanket.

FIG 23 This photograph shows a blanket of dog's hair, mountain goat wool, eider feathers, black-tailed deer hide and vegetable fibre. The design is similar to Simon Fraser's description of a plaid dog-hair blanket. The blanket was acquired, along with the items in the next two images, by Roderick Mackenzie, a colleague and friend of Simon Fraser, before 1819, and was later a gift of the American Antiquarian Society.

Peabody Museum of Archaeology and Ethnology, Harvard University

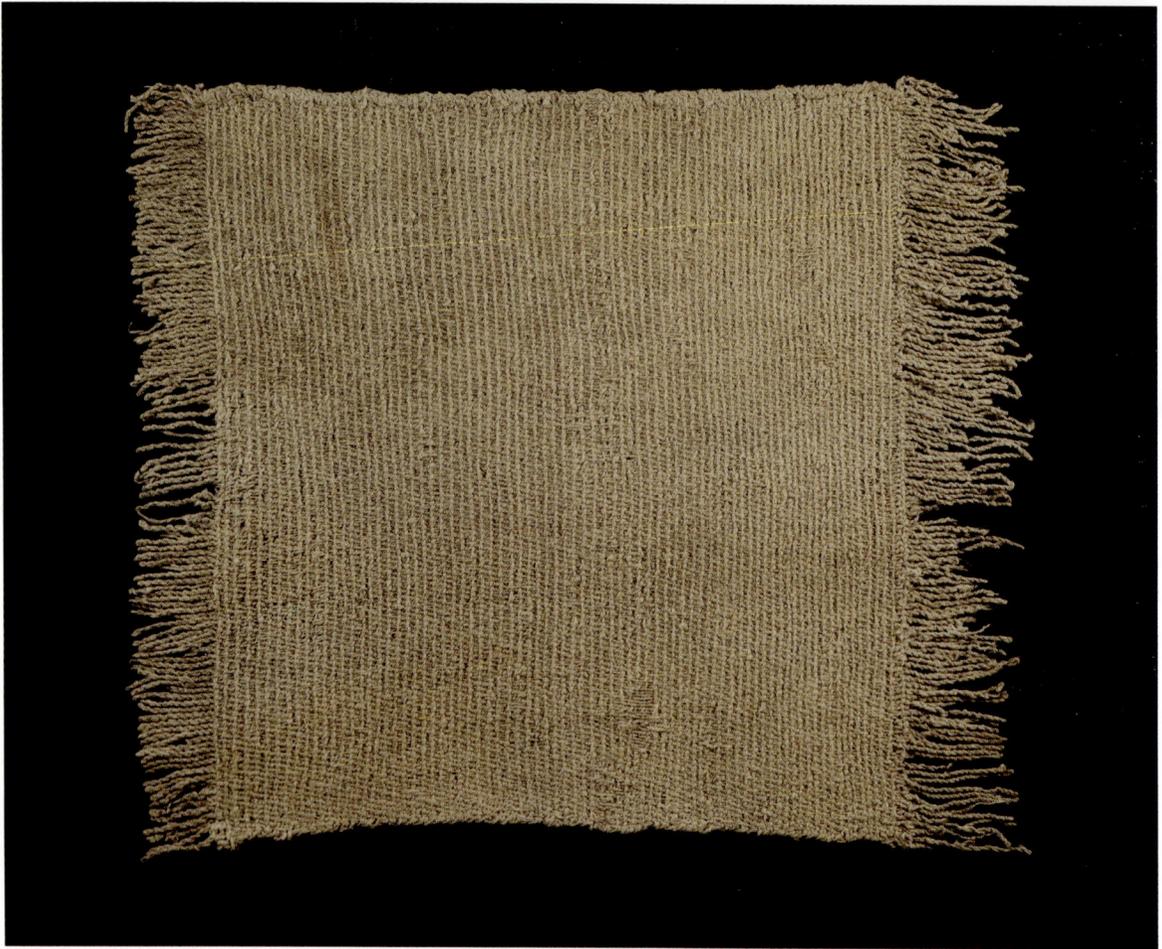

FIG 24

FIG 25

Susan Rowley, Director of the Museum of Anthropology at University of British Columbia, pointed out that all of the objects Simon Fraser mentioned could be the ones in the collection at Harvard's Peabody Museum originally donated by Roderick Mackenzie (who designed Simon Fraser's Montreal house) to the American Antiquarian Society, which in turn donated them in 1895 to the Peabody Museum.

Three of the objects are noted as being collected prior to 1819, well before many people were in the area (Fort Langley wasn't established until 1827): the plaid "Dog's hair" blanket, the white blanket and the comb. If these objects are indeed the ones collected by Fraser, it adds such a deeper story to them that they become not just isolated objects but they take on more historical, both Indigenous and first contact, importance, as well as being the next oldest known dog wool blankets from just upriver of Coast Salish territories.

BLANKETS CAN BE categorized by sizes and purposes, by time periods (based on designs)[98] or by weaving technique.

In the past, non-Indigenous researchers used design terms that, although perhaps unintentionally, subtly demeaned the weavings and the Coast Salish weavers. A good example is what has been termed "colonial-style," indicating that the patterns were taken from settlers' quilts rather than being designed by the Indigenous weavers. I think this may explain why a few blankets were said to have designs where "patterns are confused and disorganized" or that "the uncontrolled design might indicate either emotional distress or spiritual confusion." [99] If European quilts were the standard to which the Indigenous weavings were compared, then anything deviating from that would be seen as non-conforming.

A good example is a blanket at the Pitt Rivers Museum at Oxford University in England, which has a twin at the Alaska State Museum (which we come to later in this chapter), collected by Judge Wickersham. Chepximiya Siyam Chief Janice George, when looking at this blanket, went to an overhead walkway and looked down on the blanket and realized the weaver had created a "double-layered" blanket. In other words, it was as if a smaller blanket had been laid on top of the larger blanket, thereby providing more spirituality in the blanket. It was not "disorganized"; it was well thought out and cleverly designed, creating an illusion and providing more spiritual protection.[100]

This is a good example of two different points of view: the Eurocentric view, lacking the deep cultural context, which sees this style of blanket as

FIG 24 A plain white blanket with a looser twined-style weave of mountain goat with common eider feathers.
Peabody Museum of Archaeology and Ethnology, Harvard University

FIG 25 This comb, and similar ones, could have been used to comb out dog hair.
Peabody Museum of Archaeology and Ethnology, Harvard University

FIG 26 Close-up details of the blanket woven in twined style.
Liz Hammond-Kaarremaa

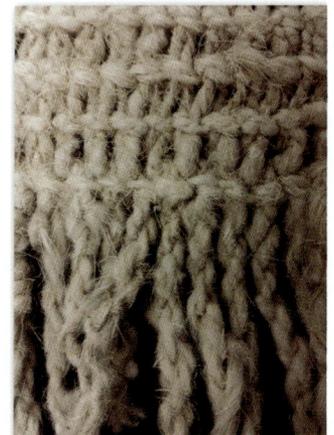

FIG 26

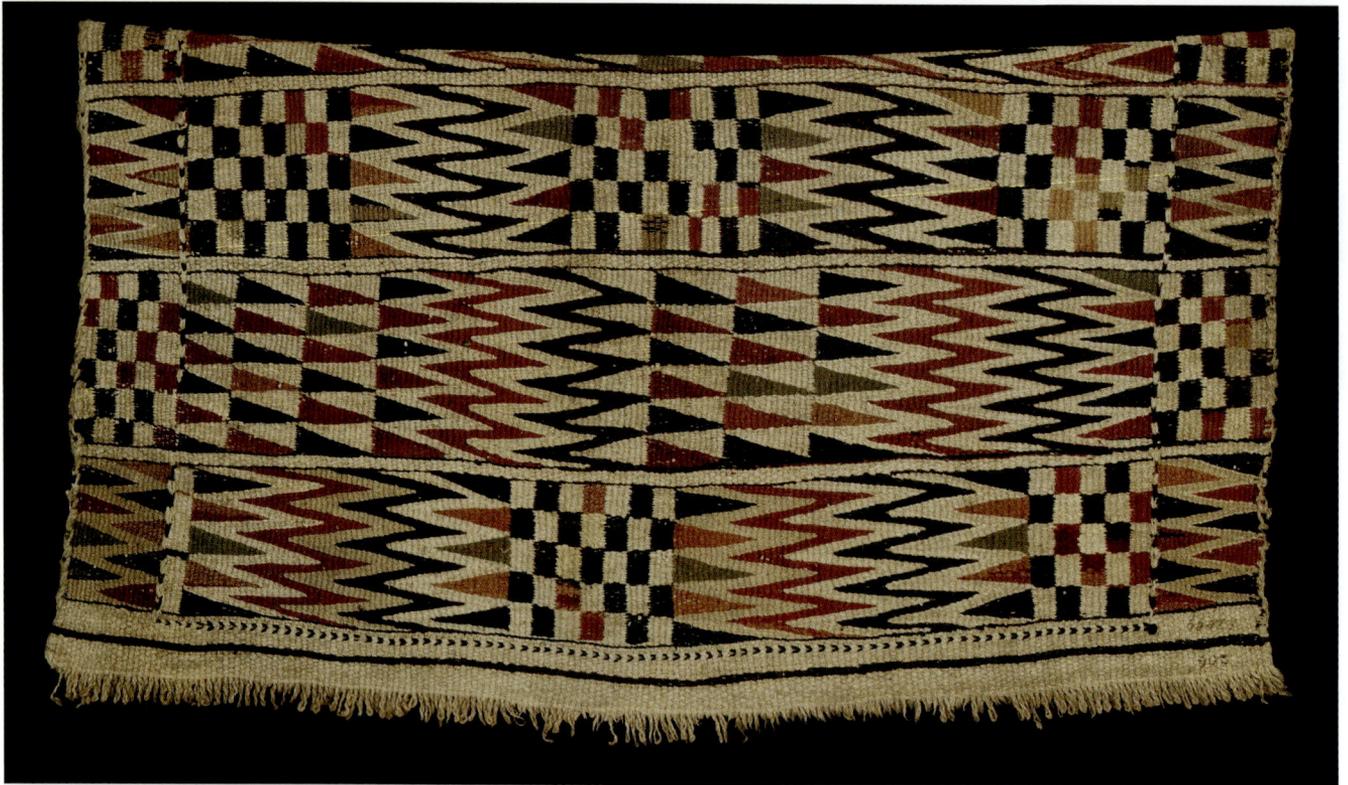

FIG 27 An example of a
"disorganized" design versus
a "well-thought-out" design,
showing the illusion of a
double-layered blanket.
*Pitt Rivers Museum, University
of Oxford*

a "disorganized design" based on European concepts of good quilt-making designs, and the Coast Salish view, informed by the culture of a cleverly designed blanket woven to give the illusion of a double blanket. Being aware of the biases people carry with them (e.g., a European measuring "good design" based on their background of quilt design) is a first step. Realizing that Oral Stories are Oral Histories, not mythmaking, and an openness to understanding more of the context, will bring more understanding of the blankets, their uses and their purposes.

The same may be said for the fibre contents of blankets. For example, mountain goat wool, a common fibre in most blankets, is considered very spiritual in many Coast Salish communities. Knowing the spiritual importance of mountain goat brings a different perspective to viewing blankets made from that fibre. Are there other fibres that hold spiritual or representative qualities? If so, what are those qualities they bring to a blanket? According to present-day Coast Salish weavers, some fibres have spiritual qualities, like cattails having a cleansing spiritual quality, yet we have no written accounts that mention those qualities, not even for dog wool. But does

74

an absence of the "written" word mean those qualities did not exist? We can see various fluff from plants in blankets as well as other plant materials. So they were added for a purpose. Knowing what exactly the plant was might help in understanding why it was added, for functional, practical, aesthetic or perhaps spiritual reasons. And how are they identified in blankets? Before analyzing the fibre content of yarns, a little background information on the weaving techniques used is helpful.

Weaving Techniques

Using standard weaving terms, there are three types of weaving techniques used for Coast Salish blankets: tabby (also known as plain), twill and twine.[101] The simplest style is known as tabby weave, for which the weaver takes the weft yarn over and under, over and under, over and under the warp yarns in one row. The next row starts with the opposite—under and over, under and over—and continues to the end of that row. Most baskets are woven with plain (tabby) over-and-under-style weaving, but surprisingly very few blankets are created this way. Weaving techniques from basketry often carry over to wool weaving, but not in this case. Some blankets, like the Ozette blanket from the northwest tip of the Olympic Peninsula, the oldest blanket on record, have a few rows of tabby weave. The Ozette blanket has tabby weave only where there are blue stripes, whereas the rest of the white areas are twill. The blanket we are celebrating today at the Burke Museum of Natural History and Culture is a tabby weave blanket.

The most common method of Coast Salish weaving is twill style, where the weft yarn goes over two warp yarns, then under two. Each row is offset by one warp so the over two, under two shifts over one, forming diagonal lines on a fabric much like that of blue jeans. The diagonal lines can also be reversed every now and then, to get what is known as diamond twill. Most twill blankets are white, and some have a stripe or two woven in; usually, these are strips of a commercial fabric that have been cut into long 1-inch-wide or narrower strips and added to give a strong contrasting colour.

Twill blankets make up the majority of Coast Salish blankets in collections and are made from white mountain goat wool in twill weave. Some have red (most common) or black fabric stripes woven in to add a few stripes of colour (see Figure 28).

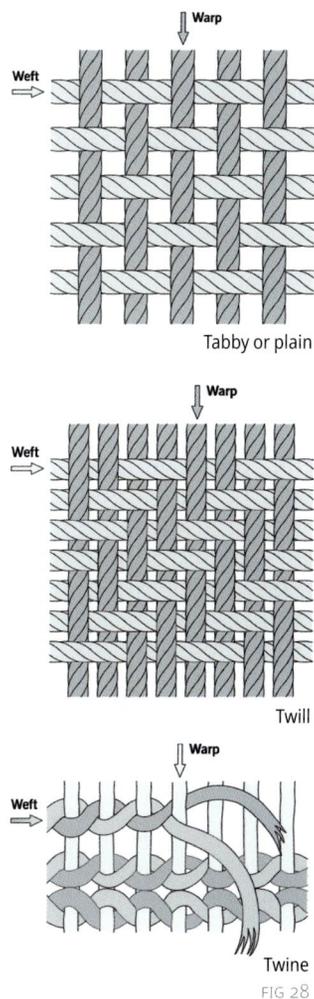

Tabby or plain

Twill

Twine

FIG 28

FIG 28 Three weaving techniques used for Coast Salish blankets.

Illustrator: Zdenka Hofman

FIG 29

FIG 29 Close-up of a Musqueam twill blanket, showing strips of fabric woven in. It is in the collection at the National Museum of the American Indian.

Liz Hammond-Kaarremaa

Older twill blankets have more twists per inch and wraps per inch (producing thinner, finer yarns) than newer twill blankets, indicating a change in the spinning processes over time.

The third style is twined weaving. This is a much tighter weave, and the very colourful robes are done this way. It looks like the weaver twisted each weft yarn around each warp yarn, but in actual fact, two wefts are used for each row, one behind and one in front, but between each warp yarn they switch places, tightening their joint grip on each warp yarn. Some of these robes or blankets are said to be twined so tight that the rain cannot get through. Twined weave is common in robes, with closely compacted, elaborate geometric twined robes made with many combinations of naturally dyed colours along with colourful commercial wool yarns.

Twined weaves like the Finland Blanket (see Figure 32) have finer yarns than the twill weaves. Many of the bright colours indicate commercial three- or four-ply or higher sheep wool.

There are other types of blankets where two techniques are combined, like weaving twill in the centre, making up the majority of the blanket, and a solid twined border along the edges, or a border of blocks of twined alternated with twill surrounding the twill, usually colourful, made from twining. This style is known as a hybrid style (see Figure 30).

Identification of Fibres

Many Coast Salish blankets when collected, especially in the 1800s, were noted as containing dog hair; this defining description is still listed in many museum catalogues. Yet for the last century, non-Indigenous people, even museum staff, have taken a Eurocentric view of blankets and have doubted the Oral History and the notes, journals, diaries and catalogues usually written prior to 1920. To be fair, it could be that, like Gustafson, they wanted to see scientific proof, not a collector's notes or someone's diary. Why the discrepancy? Why has such doubt arisen about the interconnected Oral History and early records—and why did it lead to later assertions indicating that no dog-hair blankets have survived?

There are a few reasons. First, as colonial policies strengthened, as if on a balance scale the credibility of Indigenous Oral History was lowered, disregarded or classified as "myth," while Euro–North American "science" was raised up as the gold standard, requiring material or physical evidence of the

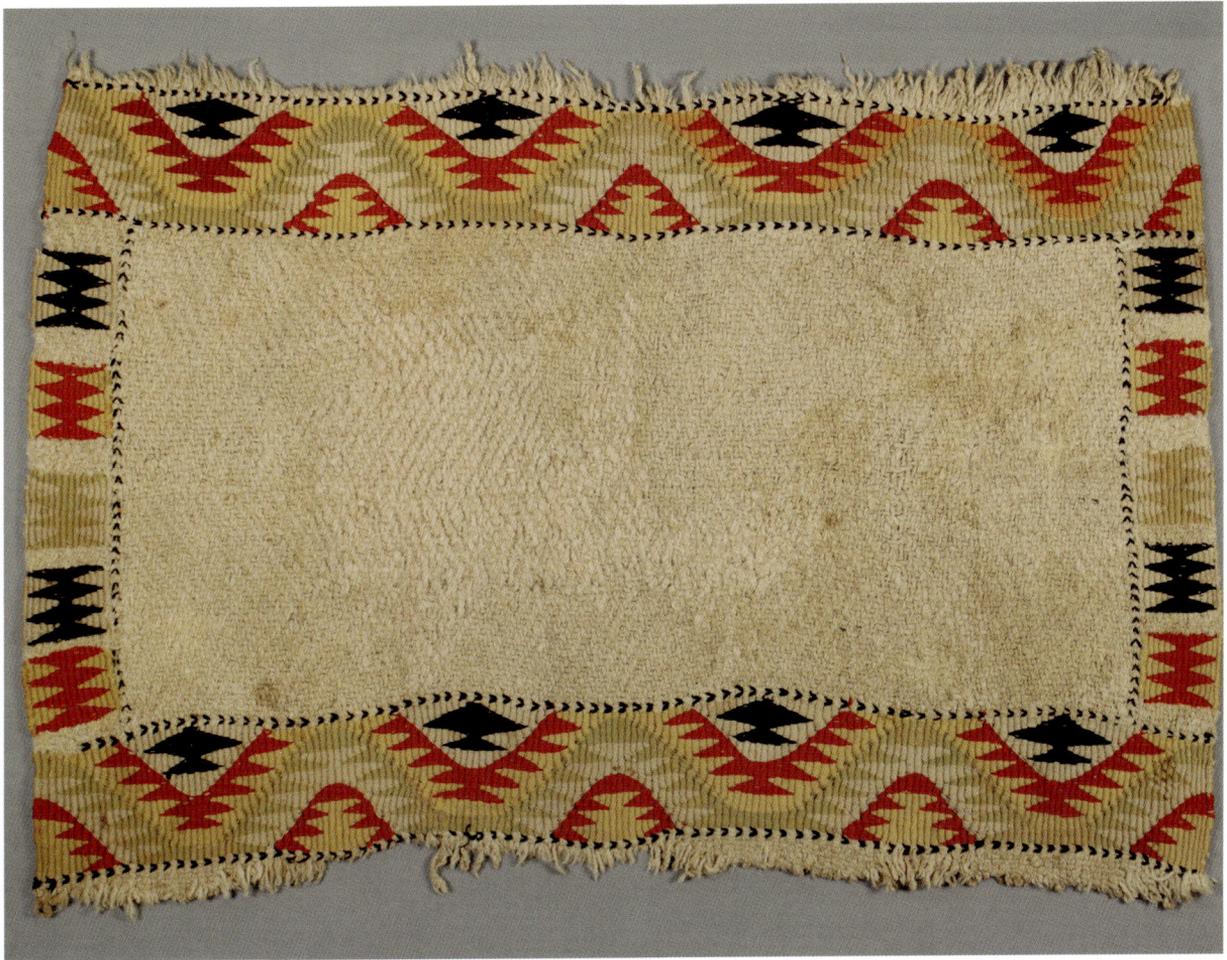

FIG 30

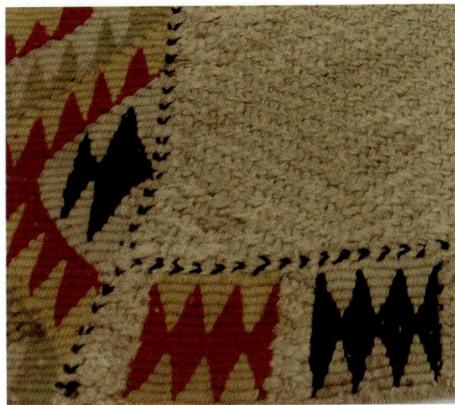

DETAIL

FIG 30 A hybrid *Swoqw'elh* (Chief's blanket) of twill (coloured yarns) and plain twill (white yarns). The blanket was made before 1906 by artist Sp!aq!elthinoth (Quw'utsun and Stó:lō). This blanket is thought to have been worn by Chief Calpaymalt in 1906, when he travelled as part of a delegation of Coast Salish chiefs to present a petition to King Edward VII in London, England, declaring that Aboriginal title had not been extinguished, that their land was being taken without permission and that treaties had not been negotiated.

Kyla Bailey, Museum of Anthropology, UBC

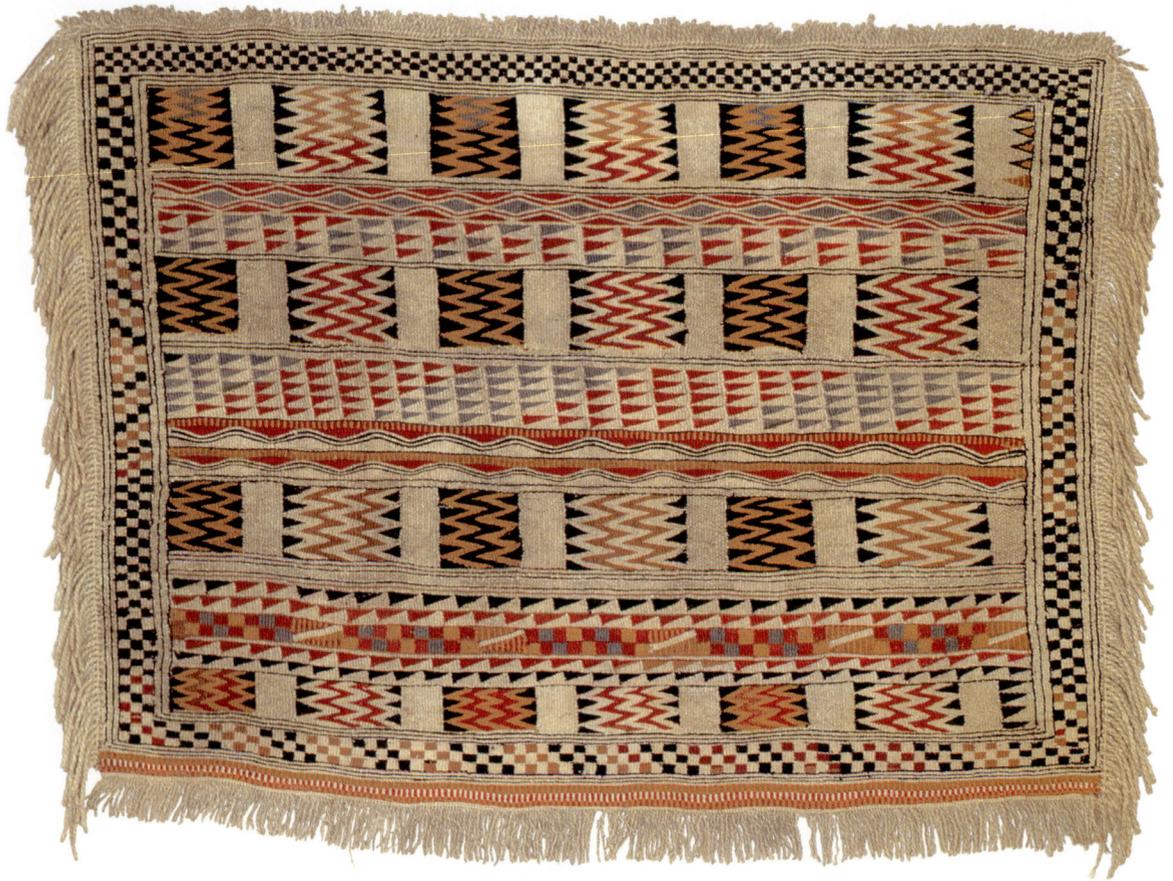

FIG 31

FIG 31 A twined Salish blanket, collected pre-1828, courtesy of the National Museum of Finland, Etholén Collection.

National Museum of Finland staff

FIG 32 Close-up of the twined Finland Salish blanket.

Liz Hammond-Kaarremaa

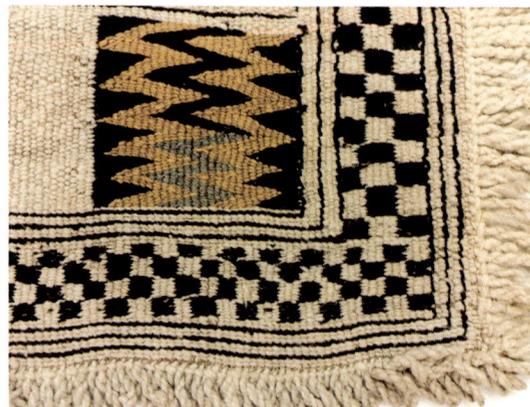

FIG 32

dog hair. And scientific proof of dog hair being in any blankets was difficult to establish.

Paula Gustafson raised a critical question in her well-researched book on Coast Salish weaving. Gustafson did a comprehensive and thorough survey of the majority of known Salish blankets in the world, including those whose provenance records state that they contain dog wool. She remained entirely unconvinced, and she posed the question that has plagued non-Indigenous people interested in Coast Salish weaving and exasperated the Coast Salish whose knowledge is more solid, ever since: "I examined almost all of the historical Northwest Coast textiles in museums in North America and Europe. I am still looking forward to examining a Salish dog-hair blanket."[102]

Because Gustafson questioned the extensive use of dog wool, she—perhaps unintentionally—reinforced the downplaying of Coast Salish Oral History. She suggested that dog wool needed to be spun in a blend with a stronger and longer fibre like mountain goat, and even small amounts of dog wool added to make a yarn would make a blanket into a novelty. In her mind, this would influence the cataloguing of a blanket, as it would be described as a dog wool blanket, however insignificant the amount of dog hair in it. Gustafson wrote, "In this light, the cataloguing of many Salish textiles as being made of dog hair is an understandable misconception."[103]

One of the earliest known Coast Salish blankets, thought to have been collected in 1803, is the "Lewis and Clark" blanket at the Smithsonian Institution's National Museum of Natural History (see Figure 33, done in the twined style). It provides a history of the difficulty in correctly identifying the fibres by eye alone. An early exhibit from the late 1800s or early 1900s describes the warp of this blanket being of plant fibre (*Apocynum cannabinum*, or "Indian hemp") and the weft being dog hair.[104] Yet, a few decades later, in the Smithsonian annual report of 1928,[105] the warp of this same blanket is recorded as an unknown fibre and the weft as mountain goat wool. Then, in the 1970s, having examined this same blanket, Gustafson described both warp and weft as plant fibre, likely Indian hemp.

Warp yarns are hard to see in tightly woven weavings as they are covered by the weft yarns, so one can be forgiven for not being able to tell what the warp yarns are made from, but the weft can be seen in all Coast Salish weaving styles. Over the years, the weft yarns in the "Lewis and Clark" blanket (Figure 33) have been listed as dog hair, later as mountain goat, and more recently as plant fibres. If you are lucky, a torn patch allows you to see the

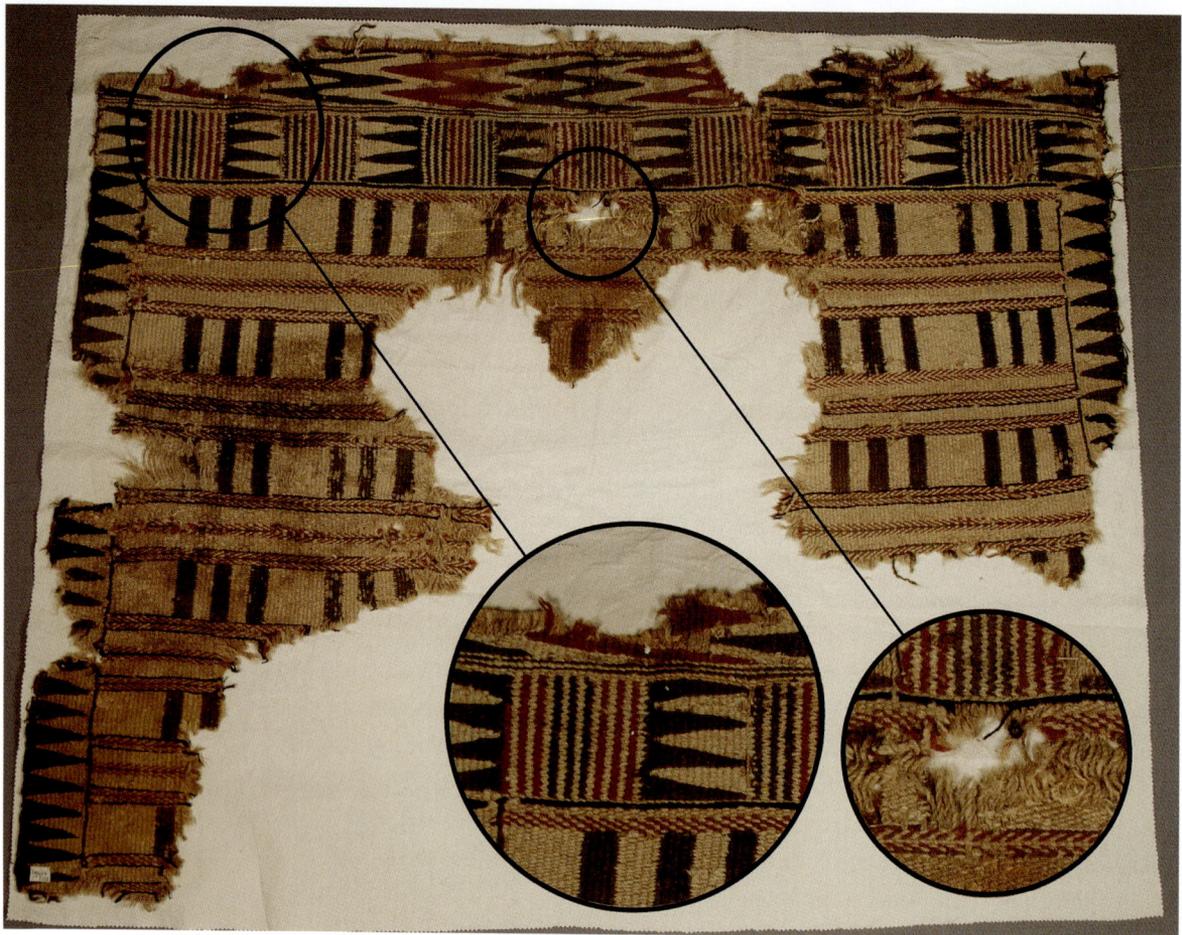

FIG 33

FIG 33 Twined blanket thought to have been collected by Lewis and Clark in 1804–06, showing close-up views.

Department of Anthropology, Smithsonian Institution. Photo adapted by Jean Compton

warp yarns. The blanket does have torn edges and holes in which the warp yarns can be seen, but still, over the years they have been identified as three different fibres.

Mountain goat fibre is easy to identify by eye due to the thick, coarse guard hairs embedded in the yarn with ends sticking out, though older blankets have less guard hair probably due to more time or to more efficient techniques to remove as many as possible. If the yarn has been dyed, the guard hairs, being resistant to dye, are easy to see against a coloured background. But it is difficult to say for sure whether the soft, shorter down fibres of the mountain goat are actually mountain goat and not dog wool. If the two fibres have been blended and then spun as one yarn, then it is almost impossible to know if dog wool has been added.

Another technique exists to try to distinguish mountain goat from dog wool: examining what they eat. In 1994, Rick Schulting, then a student at Simon Fraser University, had a twill (with a plain-woven edge) blanket from

Yale, British Columbia, analyzed for carbon isotopes.[106] This type of analysis can distinguish hair based on whether the animal ate a land (terrestrial) or a marine diet. Schulting's analysis of the blanket pointed to a marine diet. Only two mammals with hair were used for spinning at the time of the blanket's creation—mountain goats and Woolly Dogs. Mountain goats had a terrestrial diet, whereas Woolly Dogs were fed a large proportion of salmon, leading to the supposition that the blanket analyzed by Schulting was probably comprised of dog hair.[107]

Gustafson, writing well before Schulting's isotope analysis, felt that the only sure way to tell dog hair from mountain goat was by using a high-powered electron microscope. Without the "scientific proof," she held to her belief that dog hair was not a primary weaving yarn: "I believe the dogma has been too easily accepted without consideration of the practical aspects of the spinning and weaving process, and without consideration of the existing evidence."[108] Gustafson's argument was an attempt to discredit widespread Oral Histories.

Microscopes range from low-powered ones that magnify only 10×, with low resolution, to impressively high-powered and very technical ones. To distinguish a hair from one mammal species from another, a high-powered one is needed.

It wasn't until the 1980s, after Gustafson's book was published and desktop computers were invented, that very high-powered electron microscopes were connected to computers,[109] enabling better quality resolution, depth of field and the ability to finely control the microscopes. After that, specialty microscopes became more common at universities, and access to them became more widespread.

Advances in Technology

In 2005, just three years after Candace rediscovered Mutton at the NMNH (and a few years before I knew of Mutton's existence), Harry Alden was working at the Smithsonian Institution as a microscopist in art conservation, anthropology and archaeology. Now that they had a Woolly Dog pelt to compare to, he was asked if he could identify the fibres in a blanket (see Figure 34) at the National Museum of the American Indian (NMAI). The blanket's collection history is unclear, but it was purchased from a collector in 1925 and is believed to be from the Stó:lō territories along the Fraser River. The museum wanted

FIG 34

FIG 34 This plain twill blanket, with red fabric stripes woven in, is probably Stó:lō. It is housed at the National Museum of the American Indian.
NMAI Photo Services

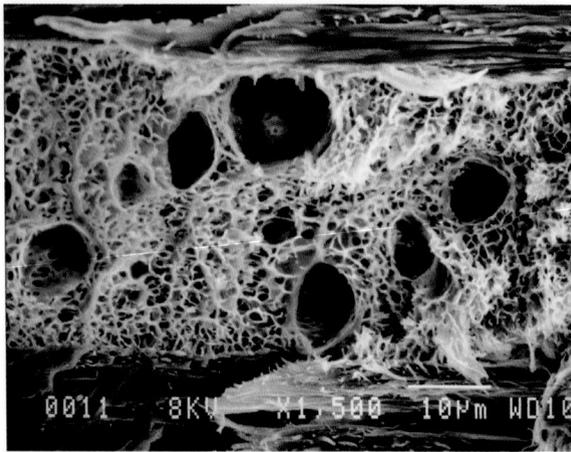

FIG 35

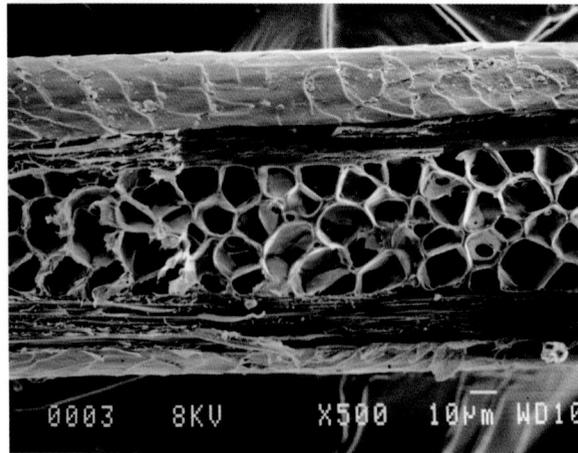

FIG 36

FIG 35 A guard hair from the Woolly Dog Mutton split lengthwise and seen under a high-powered scanning electron microscope (SEM). It shows a continuous medulla, with large, ovoid bodies.
Harry Alden

FIG 36 A mountain goat (*Oreamnos americana*) guard hair split lengthwise, showing honeycomb medullary architecture.
Harry Alden

to know if it was mountain goat or a blend with the addition of Woolly Dog wool.

Alden used a couple of different microscopes and techniques to look at mountain goat guard hairs, Mutton's guard hairs and then the hairs in the blanket to see if he could find a match. The first thing he noticed was the difference in the hair diameters. Mutton's hairs were much thinner than mountain goat hairs. Put simply, this means dog wool guard hairs are much softer and thinner than the stiffer and thicker mountain goat guard hairs.

Alden then split the hairs lengthwise to look at the inner core of the hairs. This inner core, called the medulla, can be used to distinguish one animal species from another. He found the inner medulla architecture of the two types of hair are quite different. Mountain goat medullas look like a honeycomb, whereas Mutton has a sponge-like medulla with randomly sized ovoid cavities. So, with a microscope and the ability to carefully split hairs, you can distinguish between Woolly Dog and mountain goat hairs. Alden found both in the blanket (Figures 35 and 36).[110]

This brings us to Dr. Elaine Humphrey, an enthusiastic microscope advocate with an unusual Welsh lilt merged with a Scottish accent, and an infectious zest for life. Humphrey has a wide-ranging knowledge of microscopes, thanks to her degrees in marine biology, zoology and oceanography. She has an endearing habit of saying something and then following it up with an offhand jest. "I needed a master's degree to be able to afford to send them [her two boys] to a school of my choosing. Motivation is a wonderful thing," and "My PhD gave me the opportunity to take up the most exciting job in the Advanced Microscopy Facility at the University of Victoria. Better than any drug."[111]

Humphrey thrives on discovery. As she went on to say, "Every new project that comes my way is an adventure into the unknown." So, when a stranger, Terrence Loychuk, approached her in 2004 with an unusual request to identify the possibility of Coast Salish Woolly Dog hairs in a blanket he bought at

an antique mall in Fort Langley, BC, she was intrigued with his discovery and volunteered her help.

Loychuk thought his blanket was a Coast Salish blanket, in his eyes similar to those seen in Gustafson's book, so he contacted her. Gustafson felt the only sure way of identifying dog wool was with an electron microscope and suggested he have it scientifically looked at, which led him to Humphrey.

Although mountain goat hairs are easy to identify in Coast Salish blankets by their tell tale stiff guard hairs, which tend to stick out, the Coast Salish Woolly Dog hairs are another story. Without a known sample of Woolly Dog hair available at that time (Candace's discovery of Mutton in 2002 was not widely known), and bearing in mind that Alden's 2005 research results weren't published until fifteen years later, what were Humphrey and Loychuk to do? Humphrey had nothing to which she could compare unknown fibres in a blanket. What identifying features should a researcher look for?

Humphrey and Loychuk contacted museums with blankets in their collections in an attempt to find a blanket with Woolly Dog hairs confirmed in it. Humphrey needed a sample. But at the time, only catalogue records indicated dog wool. The "scientific proof" of blankets containing dog wool had not yet been found.

Candace Wellman's 2002 rediscovery of Mutton, languishing in that drawer at the National Museum of Natural History, provided the much-needed dog hairs to compare with. Humphrey and Loychuk confirmed dog hair in Loychuk's "antique mall" blanket.

That discovery of Mutton and his hair samples and Loychuk's blanket led the two to team up and investigate blankets in many museums over the years. The two of them became known for putting fibres from various Coast Salish blankets under a microscope to identify the fibres in blankets.

Microscopes are only as good as the fibre they are used to examine. If the hair is in very poor condition—wear and tear—or you only have a couple of hairs or a newly forming hair yet having a mature medulla, then it is still difficult to positively distinguish between some fibres without the help of chemistry. In 2011, Caroline Solazzo, a post-doctoral fellow working at the Smithsonian, used protein mass spectrometry to identify different mammal fibres in Salish blankets dating between 1800 and 1927. She took a small 2-centimetre sample of yarn, vaporized it and analyzed the chemical signature in the gas it produced. Every mammal has different proteins, and each

type of protein produces a different signal, which is useful in identifying which mammal a hair came from. This method is particularly valuable when fibres have been too damaged to identify by microscope.

Solazzo analyzed eleven blankets in the Smithsonian collection, looking for proteins from mountain goat, dog and sheep. She included the blanket Alden had put under the microscope in 2005 (Figure 34). She found that seven of the eleven textiles contain dog wool: the fringe of one blanket, the warp of four blankets, and the weft of two blankets. Five have blends of dog wool and mountain goat. Only the fringe of one and the warp of another have pure dog wool. The older, pre-1850 blankets are the ones containing dog wool, which aligns with the decline of the Woolly Dog, as by 1859, as we have seen, people had been mentioning the near extinction of the Woolly Dogs.

Interestingly, Solazzo did not find dog wool in the blanket Alden had examined and found to contain dog wool (Figure 34). This only highlights the difficulty in identifying dog wool, even with advanced research techniques. If the blanket is a blend, then when you gather samples, it is a bit of a gamble whether your small sample actually contains all the types of fibres in a blanket. Solazzo carefully collected samples from the warp, the weft and the fringes, but she found no dog wool in the blanket.

Cataloguing Blankets

In 2016, I was given a fellowship to study Coast Salish yarns and textiles at the Burke Museum. The staff there had laid out all the Coast Salish belongings containing wool: regalia, rattles, dolls, blankets, etc.

At the time, I had not intended to look closely at the blanket we had all now gathered to celebrate at the Burke Museum in 2017. The photo I saw online ahead of my visit reminded me of an 1800s commercial blanket—a plain colour with a dark stripe at each end, not what I thought of as a typical traditional Coast Salish blanket in a museum collection. I thought it very typical of the blankets traded at the Hudson's Bay Company forts. When I arrived at the museum, though—there it was, laid out on a table inviting me to look at it, along with the catalogue report.

I was surprised at what I saw. The blanket was old, it was very unusual, and it was not a commercially made blanket. I immediately picked up the catalogue report to find out more and look for clues.

From the catalogue record:

ACCESSION DATA	ACCESSION ID 1974–33	ACCESSION DATE 08/09/1974	ACCESSION TYPE Accession: Gift
Dates	Date Range 1899	Late Date 1899	Type Date collected
Source Data	Collector:	Marianne Sheridan	Date, End 08/09/1974
	Collector:	Wickersham, Judge James	1899

When a new item is added to a museum's collection, it is registered as part of that collection. The registrar gives the donation an accession number. Whether someone donates one object or a group of objects to a museum, the incoming objects are given one accession number when an accession record is created. It could be a unique sequential number (24596) or a sequence limited to the year it arrived, such as 1889.23. The registration could be kept in an old ledger or, today, as a modern digital database record. It will list the accession number, the date it entered the collection, source (donor, fieldwork, purchase) and a brief description of what the accession is, such as "Salish blanket" or "trunk of regalia." It forms the legal history of the moment the item enters a museum's collection. It is usually startlingly brief.

In the early years a collector may have simply given their notes to the registrar to register. Today a committee will meet and hear about the item, consider the ethics (did the person have the legal or cultural rights to give it?) and consider if it meets the collecting mandate of the museum or should be rejected to refer to another institution. If it passes this discussion, then the paperwork goes to the registrar to be registered.

For instance, Mutton was field collected and simply registered. It is likely that once Mutton was in the collection, he went to the cataloguer. For a researcher, this is where the more interesting details are recorded. A different

collection number might be assigned, or, as in early museum days, the accession number be used. Each artifact or object in an accession is given a unique number by the collection manager. For example, a single blanket might be 1889.23.1; this hypothetical example was catalogued in 1889, as the 23rd donation of the year 1889, and in that accession group it is object number one.

This blanket I am looking at has the accession number 1974-33, having been donated to the museum in 1974 and being the 33rd object added in 1974.

It is through the accession information that the artifact's or belonging's story starts to emerge. A catalogue record is kept of everything known about the item: the date it was made, if known, or sometimes an estimated date; where it came from; who the maker/donor/previous owner was; a detailed description on the culture of origin; materials contained in it; measurements; information on the technique used to make it; and anything from field notes or the comments of the artist or a knowledgeable Elder. If it has a lot of information, it may also have a documentation file or a collector's field diaries. There could be more information in any conservation treatment reports, or a copy of, say, a DNA study.

But for nineteenth-century items, the information may be sparse, a single line of information. The details may be in archival correspondence. In this case, the Wickersham blanket at the Burke, we know Marianne Sheridan donated the blanket in 1974 and she had knowledge of it being from Judge Wickersham's estate.[112]

Every artifact/belonging has a story. Sometimes the story is a mystery. Sometimes the museum knows the background, and sometimes this is pieced together over the years. Sometimes two items with two different stories, like two chapters in the same book, meet and provide a more complete or conflicting story. All are important. Often the reason an item is collected is because of the value of the story it represents.

When we hear more about an item and related items, their stories intertwine, expanding into a bigger story, broadening our knowledge and understanding of the living culture from which they came. With different scraps of information about various items and how they relate to each other, new points of view may emerge, and we may see the objects differently, or better understand their story, or shift our insight.

Examples of this are Indigenous "artifacts" or belongings that were variously collected, bought, coerced or stolen and are now in museum collections. Each has a story, recorded by the museum or not, but to call them "artifacts"

somehow disavows this, disconnecting these items from their context, their culture, their vibrant stories.

A Coast Salish blanket might measure 1.5 metres by 1.2 metres (5 feet by 4 feet) and be made of mountain goat mixed with dog wool and woven in twill weave. Those are only data, like the physical measurements and materials, not the history and knowledge connected with the story.[113] But that blanket belonged to someone, and that is the story. Perhaps a few different generations inherited it. Someone might have been wrapped in that blanket during a naming ceremony. Perhaps they were given their grandfather's name to honour him and instill in the person receiving the name the characteristics or responsibilities held by the grandfather. That story is not about an "artifact" but about a belonging, the life of a belonging as a living part of culture.[114]

If Coast Salish weaver Debra qwasen Sparrow's grandfather's blanket was in a museum, it might contain this story:

> My grandfather [Ed Sparrow, born in 1898] watched my grandmother Spahqia and Thelekwutun's wife Selisya working on these blankets. He said "I didn't know what they were doing is getting me ready for my naming."
>
> …Then he tells me they took him to his great-grandfather's longhouse and they pass the name to him there and they prepared him and wrapped him in the blanket and started the work [of giving him his name] and he said it [making a blanket] was never done again after that.[115]

As more stories emerge, and more people are listening, museums are changing their terminology from *artifacts* to *belongings* to acknowledge the stories, the culture and the context in which the belonging lived.

The Burke Museum Blanket

What is the story behind this plain blanket? I read the catalogue sheet, which records all the information the museum has about it, and a story starts to emerge—but only about the collectors. The blanket came from a collection of Judge James Wickersham (yes, the same Wickersham who thought the treaties were unjust, those treaties governing the ground on which the Burke Museum of Natural History and Culture stands).

Wickersham was a lawyer in Olympia and Tacoma and was interested in local artifacts.

The historian in him collected many belongings from the Indigenous

FIG 37

FIG 37 A close-up of the Wickersham Burke Museum dog wool blanket, showing the weave and a tear exposing the warp yarns, which include deer or elk sinew.
Liz Hammond-Kaarremaa

Peoples of Washington State and Alaska. In 1899, he and his wife visited the Skokomish Reservation, returning with "a load of fine old Indian baskets" for the Tacoma Museum. He had also collected another blanket while in the Puget Sound area, known as "the Wickersham Alaska blanket" (see Figures 37 to 39). It has an intricate and gorgeous geometric design done in a tight twine. Hidden within the design is a very small triangle less than 3 inches wide and a few inches long. This is thought to be made of human hair spun into a yarn and then woven into the blanket. We do not know the story behind the use of hair in a blanket, nor the story behind that blanket, other than that Wickersham purchased it before 1900, when he moved to Alaska as a district court judge, taking both blankets with him.

Judging by the holes and thin spots in the colourful "Wickersham Alaska blanket," he probably used it frequently to sit on to keep warm.

Having seen other things Wickersham collected, I respected his eye for selecting unusual and quality items, so I looked more closely at the plainer HBC-style unassuming blanket in front of me, and I saw a few things that stood out.[116]

There was a tear in the plain blanket that exposed a few intact warp threads. It is the warp threads that hold the blanket together; they act like the backbones of a blanket and need to be strong. Some Coast Salish blankets have two warp yarns acting as one that the weft goes over and under; other Coast Salish blankets have warp yarns made of stronger material, like hemp dogbane, stinging nettle yarn or even animal sinew, which is super strong, sometimes compared to steel cable.

When I held a magnifying glass to the warp, I could see each warp yarn was actually made of three or four materials. It could be a little white cotton, maybe cedar. Or could it be sinew, or maybe all three? The weft was the plain tan fibres that did not seem to be mountain goat, as I couldn't see guard hairs sticking out. But it didn't seem to be sheep wool either, at least not wool from a common sheep, which typically has a bit of crimp.

What it reminded me of was Mutton's wool.

The weave was also unusual. It was a tabby weave in which the weft goes over one warp, then under the next. Coast Salish blankets are usually either tightly twined like the colourful "Wickersham Alaska" blanket or a twill weave where a diagonal ridge would form.

This was strikingly different from the Coast Salish blankets I had seen until then. What was that fibre?

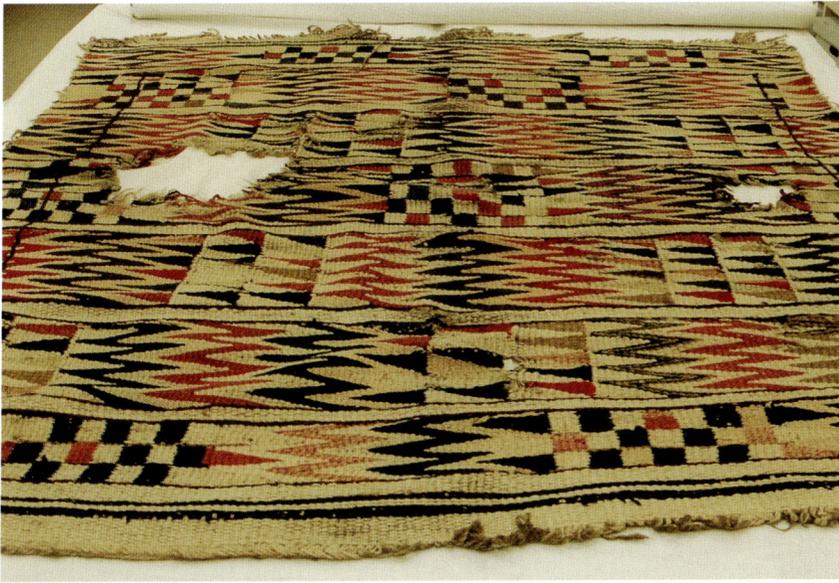

FIG 38

FIG 39

I suggested to the staff that the blanket be tested and connected them with Elaine Humphrey. She later confirmed it was dog hair.

At last, we had found a blanket comprised of at least 80 per cent dog hair, with some cedar, cotton and, yes, sinew in the warp yarns.

And now, a year after my first encounter with this plain, very old blanket—it is being ceremonially honoured at the museum, its story far more fully known than I could have guessed when I first saw it.

Listening to the Suquamish weavers and singers singing to the blanket, I realize that Coast Salish blankets have a life of their own, that they command respect and reverence—for these are animate objects, breathing history, knowledge, lessons and spirituality—they are alive with a heartbeat of their own. To view them with any degree of understanding, and to appreciate their importance, we need to acquire an informed perspective, one that places them in context, in their role, within their culture.

FIG 38 This is the "Wickersham Alaska blanket" laid out on a table, with the worn patches from where Wickersham had folded the blanket to sit on it.
Mark Kaarremaa

FIG 39 A close-up of the "Wickersham Alaska blanket," showing the blue wool and black hair triangle in the centre of the photo.
Mark Kaarremaa

MISUNDERSTANDING OUR RELATIONSHIPS WITH THE WOOLLY DOG

SENAQWILA WYSS, SḴWX̱WÚ7MESH (SQUAMISH)

Dogs were so important a long time ago that "when anything went wrong, a woman would grab her dog before her child."

SQUAMISH ELDER LOUIS MIRANDA, 1976[117]

The skwemáy̓akin [mixed dog and mountain goat hair blanket] is valued by the Skwxúmesh and Coast Salish people, due to the degree of knowledge and difficulty in obtaining the materials necessary to make this traditional garment.

THE LATE DEBORAH JACOBS, 2016[118]

THERE ARE ACADEMIC theories about why the Woolly Dogs died out. Most of them ignore the impact of colonial policies or don't understand the importance of the dogs to the people. They also misunderstand Indigenous concepts of wealth. Some of these misconceptions are unravelled by focusing on Squamish knowledge, history and experience.

Squamish Elder [Say̓xw Sxáaltxw-t Siy̓ám̓, the late chief] Louie Miranda may not have expected his words to begin a new conversation about Salish wool dogs almost fifty years after they were spoken. But to me, Elder Miranda's words could not be more powerful or important. I am also aware of how badly they have been misinterpreted as a lack of care in settler society, instead of as a specific set of responsibilities that would be held by a Squamish woman and weaver.

I want to reflect on Elder Miranda's words and connect them to the responsibilities of a family's longhouse. His words made me think that we trusted our entire family, and that of course our children would be safe! Weavers knew that

our dogs were so precious that we would make them a priority. We could do that because we knew our whole family would be supportive in that way. When I thought of Elder Miranda's words in that way, it quite honestly shook my whole world. I look at many of the settler narratives of who Indigenous people are and want to rethink them from a Squamish point of view. I think about the history of misunderstandings of Indigenous ways of being. The best way to overcome them is to begin at the beginning, with Squamish knowledge, history and relationships with dogs.

Dogs have been important to Coast Salish people for eons. Dogs are cherished beings as our other-than-human relatives, and the relationships we formed with dogs are special. Not only are they companions, but they are also family. Woolly Dogs had a special relationship with women and with weavers. Weavers were responsible to the dogs, to care for them, and that relationship of care developed over thousands of years. Those caring relationships come through in the stories we have kept and the language connected to Woolly Dogs that are similar across Coast Salish Nations. This is especially true with language, and the words for *dog* are similar across our languages. In the Squamish language, there is a specific name for a village dog, and for a fluffy hide dog (the Woolly Dog). And a dog with a man-made covering over its eyes, though I'm not sure of that species. And there is also "any dog," to refer to all dog species. The Squamish language is very specific, and I think there was a lot of misinterpretation with English. There's a whole "dog schema" in Salish languages, including root words and suffixes. For me, the knowledge of the language helps me understand how dogs were known, which of their attributes were important and why. In the history of settler colonialism, the loss of our languages equalled a loss of understanding our ways of being. That loss became a space where misunderstandings could grow into myths.

The Woolly Dogs and other dogs were part of the everyday lives of our people. I ask you to pause and think about the observations made and learning created by Indigenous women and men over thousands of years that allowed us to bring out the qualities of woolliness, whiteness, warmth and length in the little dog's coat.

My upbringing and knowledge include the ethnobotany taught to me by my mother, T'uy't'tanat-Cease Wyss. Indigenous knowledge and training include observing the behaviours of plants and animals. It's like a relationship, like a conversation, dialogue, or ways of communicating with these other-than-human beings that helps us best serve them so they will produce well in return. There is no word for sustainability in the Squamish language: our way of doing things was already sustainable and that was normal. We didn't need a special label for it like it is needed in English/settler society. It is this difference in understanding of the world that is important to remember and to rebuild.

Misunderstandings are not just in the past. For instance, in my high school, we were taught that the Potlatch was a chief's way of showing off his wealth and asserting his power over other community members. But that concept of a potlatch isn't how Squamish people understand it. A Potlatch is about thanking people for their generosity, for giving their time and energy and attention to the ceremony. It is a time and place to gift a part of our wealth. *Wealth* is another word that needs to be explained. "Wealth" is not understood as monetary wealth or an accumulation of things. Wealth is not about how much we had, and we didn't own property; we have a relationship to the landscape and the ecosystem as caretakers of land versus property ownership. Wealth is giving away and uplifting community. A wealthy Squamish/Coast Salish person is one who has built up strong social networks based on respect, one who has earned their knowledge, and who maintains their responsibility to uphold that knowledge. Often described as having rights to access certain things, be they plant and animals, land, fish, places of spiritual importance, songs, dances and ritual practices or ceremonies, those rights are also responsibilities to sustain and to redistribute those things to communities and families. The Potlatch is one way that families pass on and share knowledge. These kinds of ceremonies are important ways of transferring "wealth" that keeps a family and a community connected to its ancestors and its places.

The Woolly Dog is also not the only dog to be a part of Salish communities. We had extensive relationships with dogs for many purposes, working together in many relationships. The knowledge of dogs was deep, and there were several kinds of dogs that came into being through our relationships with dogs. I recall the story of the Coast Salish woman who gave birth to puppies. In the Squamish

culture, this story emphasizes the transformation and the relationship between the woman and Salish Woolly Dogs. The birth of twelve puppies in the story is like the twelve roles or pillars of Squamish society. These twelve pillars are like occupations and are still relevant to Squamish apprenticeship practices. It's interesting, historically, tattoos were used to mark an apprentice's learning process.

The story also provides guidance. It guided communities to practise the separation of a woman from her dogs when she was pregnant and is connected to the main theme of the story. Some of these things are specific to Squamish versions of the story, and other Nations emphasize different aspects of the story. Families may also have their own specific details or way of telling the story that's relevant to their family history, their knowledge, rights and responsibilities. All these things shape the ways the story is shared. The different versions or kinds of stories were viewed as irregular by Western scholars and historians, and they often thought the stories were fictional, instead of being re tellings of specific kinds of shared knowledge and history.

There were also tools and techniques of care that we used with certain kinds of dogs in our Squamish communities. For instance, to develop different breeds of dogs, we all had to have specific ways of keeping a dog in heat away from other dogs. I learned about a special tether that Squamish people used for hunting dogs, as hunting dogs did not live in the longhouse. The _kílxwten_ (tether) was a system of rope and vine maple pole connected to a tree or a stake that let a dog move but kept it from chewing through the rope.[119] It's important to think about the technologies we created for dogs because it gives us a better picture of the knowledge and skills that we held.

What I have learned about the history of dogs in my community shows me that we have some gaps that formed after contact. It is difficult to find first-hand knowledge, and I have turned to anthropological and ethnographic reports. But the reports did not share information from a Salish point of view, and interpretations have led to misunderstandings.

In terms of those gaps, I know there are spiritual connections with mountain goats, but I don't know what they are for the Woolly Dogs. There had to be a relationship of wealth with the knowledge needed to raise Woolly Dogs. But women were not seen by early ethnographers as having any important roles, and their

care for Woolly Dogs was not taken seriously. Were women specific to that role? I have not found any songs for dogs, but they do exist for other animals. I wonder if there are certain things that didn't get recorded because whoever was recording didn't know it was important.

It's not clear to me when we stopped keeping dogs in our community. It probably was during the creation of reserves and residential schools. It would be very difficult to care properly for dogs when colonial policies limited our access to fish, and when we lost access to our land. Fishing and hunting became illegal, and our dogs suffered from what assimilation did to us all. Forestry changed the landscape. And it was not just Salish people who suffered; there were instances of targeted removal of sled dogs in the north, and on the prairies, attempts to exterminate bison also disrupted Indigenous ways of life. So it was all over.

I understand that dogs were seen as a threat to salmon stock for canneries when commercial fisheries started in my grandma's time. My grandparents met at a cannery, that's when wage work for canneries was changing how people lived. They could not do that work and then just leave for a eulachan run. The canneries didn't run on nature's cycle. The choice to work in a cannery wasn't easy, and oppression played a role. The economy changed from reciprocation with the land, with community and with salmon. It was very damaging.

When I read anthropologists' interpretations of how it appeared that dogs were more important than children, I see a problem of misunderstanding. If you understand the way of being in a Squamish family, then you see how responsibility is shared with siblings, aunties and uncles, and grandparents, and they support one another. A woman could fulfill her responsibility to her dogs and keep them safe because she could count on her family to ensure that her children were also safe.

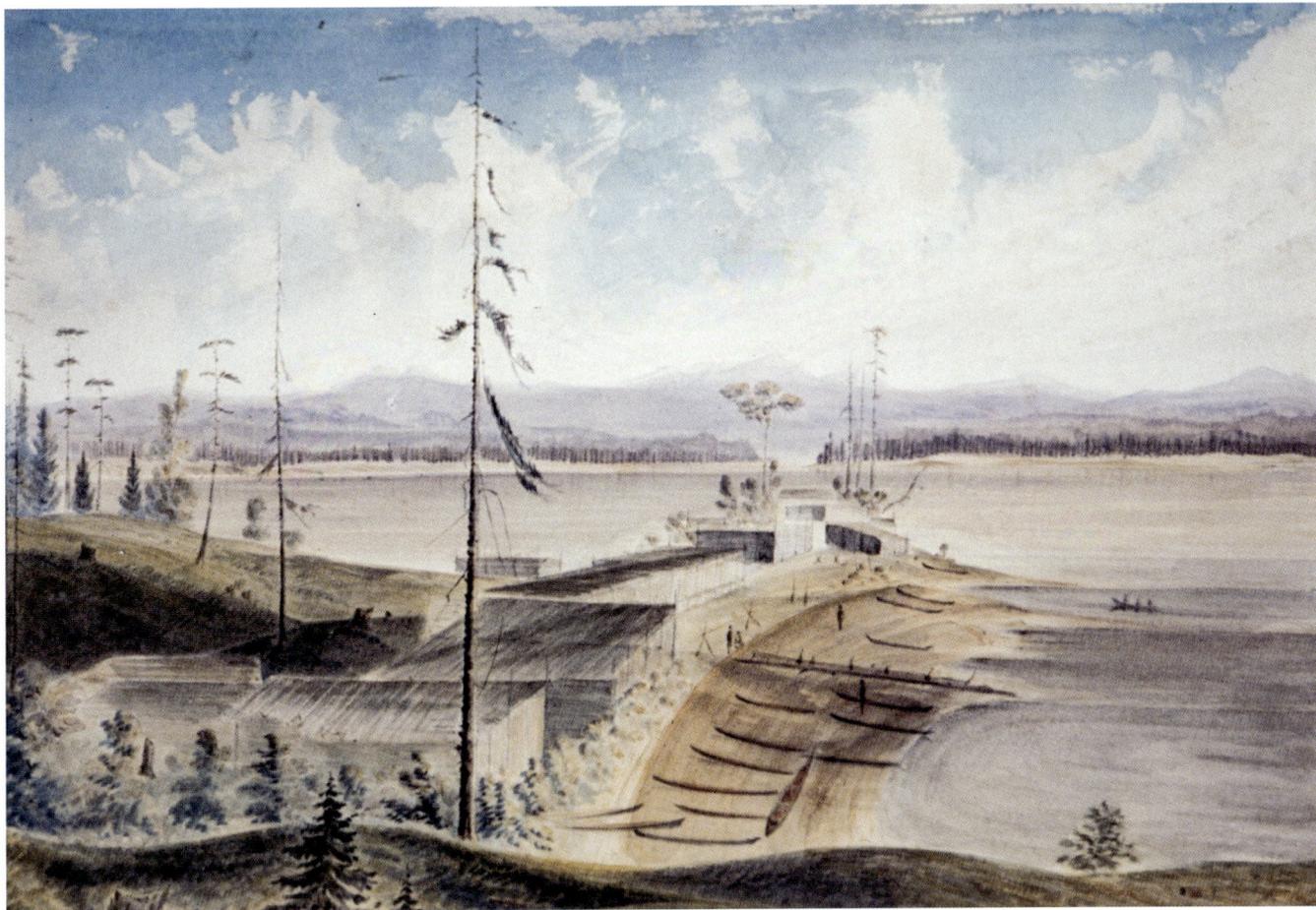

FIG 40

FIG 40 This James Madison
Alden painting dates from
1858 to 1862 and depicts
Nanaimo Snuneymuxw Village,
looking across to Protection
and Sayshutun islands, with
the mainland mountains in
the background.
RBC Archives

6 MUTTON'S ANCIENT ORIGINS

A FEW YEARS AGO, William Hiłamas Wasden Jr., a Kwakwa̱ka̱'wakw artist and singer, told me a story of two masks. The original, held in a museum, had been lent to the descendants and the community who originally owned it. This enabled a respected Elder and carver to study it, and to create a new one for the community for use in spiritual dances.

A ceremony took place in the Big House, with an audience gathered around the large fire in the centre of the floor. Smoke and sparks billowed up, as they waited to see the new mask danced in. The original mask and the new one lay side by side on a table behind a curtain, hidden from view. During the ceremony, the dancer left the floor for a quick change of regalia and to don the new mask. A helper placed the new mask in his hands, and the dancer rushed back to the curtained entranceway, waiting for his timed entry. The carver stood next to him and helped him place the mask on his face. It didn't fit! They hadn't tried it on before. With a minute to go, the carver whisked out his knife and deftly carved away the inside of the mask until it fit the dancer's face, and just in time, the dancer entered the floor of the Big House wearing the mask.

After the ceremony, they realized their mistake. In the dim light and the rush of the moment they had whittled out the wrong mask—the original one. They returned the newly altered original mask to the museum, with trepidation, along with a letter of apology. Before long, they received a reply from the curator, delighted with the expanded history of the mask.

I learned a lot from this story, and it is still teaching me. Why was I shocked when I heard the museum mask had been whittled? Why was I taken aback upon hearing of the curator's reaction? Who actually owns the mask? What does an object mean to a museum, compared to the meaning for the original culture? Over time, I returned to this story again and again, and like the smoke and sparks arising from the Big House ceremonial fire, more questions arose: How does a Eurocentric attitude toward museum objects differ from an Indigenous perspective? What is a museum? Whose museum is it? Who owns culturally important objects?

The Invitation

When I was first approached by Audrey Lin of the Smithsonian, tentatively asking if I might be interested in joining the research team, herself and Logan Kistler, her colleague, investigating Mutton, I didn't then realize how those questions forming in my mind would expand and continue to haunt me over the years. It seemed like such a straightforward idea, at least at first.

I recall Audrey's first, rather hesitant, Zoom call vividly.

"So, ummm—you see, I'm interested in trying to do some detailed molecular analysis to learn more about the ancestry of—well, of Mutton, you know—the Woolly Dog specimen in the National Museum of Natural History collections? Would you, uh, be interested in a possible collaboration on this project?"

Would I? I was so excited I could hardly speak, yet at the same time I was in a Zoom meeting with two people unknown to me, and first I needed to find out more about what they wanted to do—what was molecular analysis?—and how they wanted to go about it. Those sparks from the Big House ceremonial fire, loaded with questions about museum objects, were floating in front of me, and little did I realize how they would keep billowing up as the work continued.

Mutton had been owned by George Gibbs, a non-Indigenous man, not a Coast Salish person, and according to the tag attached to his leg, he was acquired from Indigenous people at Chilliwack in Canada. Mutton, or rather his pelt, would not be subject to the US Native American Graves Protection and Repatriation Act (NAGPRA),[120] which covers culturally important items such as funerary objects, sacred objects or objects of cultural patrimony

collected from within the United States. Technically he was collected outside of the USA, and a "white man's" dog, yet he represented Coast Salish Woolly Dogs and, by extension, the wider cultural context in which these dogs lived. We needed to keep this all in mind, and treat his remains with the greatest care, ensuring the entire project proceeded in a respectful manner.

This was early March 2021. Audrey Lin had first posed the question to me in an email a week before, asking if we could meet on Zoom, which had become a way of life during the COVID-19 pandemic. I quickly learned that molecular analysis really meant DNA analysis. I had been hoping for ten years that someone would successfully sequence Mutton's DNA. Given that he is the *only* known specimen of a Coast Salish Woolly Dog in the world, this proposal seemed thrilling to me. However, there had been two attempts to do this before, and neither had not been resolved completely, leaving questions.[121] Somehow this seemed different. Audrey was visibly excited, and her collaborator Logan Kistler was quieter, but with a calm smile on his face.

Analyzing Mutton's DNA meant more than identifying Mutton's ancestry. It could result in challenging the non-Indigenous theories, misrepresentations and misconceptions about the origins of the Woolly Dog, and it could resolve the doubt created in the use of dog wool in blankets.

I had heard Indigenous people speak out, questioning some of the prevailing non-Indigenous views that were becoming common and being taken for granted. Those views lacked depth and understanding of the cultural context, and from a Coast Salish point of view, they disregarded Indigenous Knowledge that had been passed down for hundreds of years. Indigenous viewpoints needed to be not just added to the project, but included right at the start to help guide the process and the questions that needed to be asked. Oral History and Western science combined could open doors for the non-Indigenous world to start to understand other points of view and ways of looking at and understanding the world. This was an important role that Mutton could perform. We could learn many things from what Mutton could teach us.

I noticed that Audrey's cautious approach and hesitant speech disappeared during our call. As I came to know her better, I realized that as her enthusiasm grew, her knowledge shone through in any conversation. When she knew exactly what she wanted to do or was on sure ground in her areas of expertise, she proved to be extraordinary to work with. Over the next two years I found she has many subject areas where she is extremely

knowledgeable, everything from anthropology to bioinformatics, from genomics, math and statistics to virus evolution.

A recent PhD graduate from Oxford University, Audrey had landed a prestigious fellowship at the Smithsonian Institution National Museum of Natural History. Her timing couldn't have been worse, coinciding with the onset of the global COVID-19 pandemic. She arrived in January 2020, barely a month before the World Health Organization declared a pandemic. Within months, the Smithsonian buildings were in lockdown, and Audrey had her project pulled out from beneath her feet. With buildings closed to the public and leaving staff with restricted access, her access to the many specimens in the storage areas was too restricted to allow her to continue her intended research project. Originally set to unravel the evolutionary tales of bird flu viruses and human immunity using pre-1918 bird specimens, she found herself at a standstill.

Audrey was steered toward a broad biology degree with microbiology as well as anthropology, a combination that would prove pivotal in her future endeavours.

With a master's degree in infection and immunity from University College, London, she then entered a PhD program in the zoology department at the University of Oxford, researching retroviruses—ancient virus markers—in the human genome—and their relationship with human cancers. But with changes in that lab, she found herself working on animal domestication in the lab of Greger Larson in the Department of Archaeology. Larson's laboratory looks at genomics, evolution and domestication of many animals, including pigs, chickens and dogs. Audrey focused on using bioinformatics to study genomic evolution, and she hung around people who studied ancient DNA of animals.

Finally at her dream job as a postdoctoral fellow in the Smithsonian Institution National Museum of Natural History (NMNH), Audrey was impatient to get going with her research, only to be completely thwarted and unable to enter the museum during the COVID lockdown. Her original project was to sample viral DNA from many waterbird specimens collected before the 1918 bird flu epidemic. This would require her to work with others in the lab over a period, and the COVID lockdown restrictions at the NMNH wouldn't allow that.

One day, looking for distraction, she was reading an article in *Hakai Magazine*, an online magazine from British Columbia focusing on science, society

and the environment—subjects important to coastal life. Her frustration with her stalled research started to dissipate as she read the article on Woolly Dogs.[122] Coming from a lab where people had studied ancient DNA of dogs, she was fascinated to learn of the Coast Salish Woolly Dogs bred specifically for their long, spinnable woolly hair, but what really caught her attention was the revelation that the only known pelt of a Woolly Dog, a dog by the name of "Mutton," was tucked away in a drawer downstairs in the very building where she worked. This gave her an idea.

Audrey showed the article to her colleague and adviser, Logan Kistler, and he too had never heard of the Coast Salish Woolly Dog, let alone known of Mutton. This was expected, considering he had never worked on dog genomes before. Intrigued, he agreed with Audrey's proposal to adapt and switch projects and look at Mutton's DNA, with a view to comparing it with the DNA of a Semiahmoo Bay village dog that Caleb Kennerly sent to the museum back in 1857. These two dogs, from roughly the same time period and from roughly the same geographic area, though by all accounts with different breeding histories, should provide informative comparisons.

The idea behind the project was a good one. Mutton's DNA would be able to tell us so much more about the breed of the dog. Audrey and Logan wanted to find out if Coast Salish Woolly Dogs were a separate breed, how long the breed had existed and in what ways they were different from village or hunting dogs. I was curious about if they related to any modern breeds or if the DNA could shed some light on where the dogs originated.

Before we could even start to answer those questions, we needed to open discussions with some Coast Salish people. Logan and Audrey were keen to proceed slowly and do this project paying close attention to protocol, respecting the key role of the First Nations people holding personal knowledge of and stories about the Woolly Dog. I realized from the get-go that they were on the same page as I was in this respect.

Between Audrey's enthusiasm and Logan's cool competence, I became sure that these two not only could do this project well but would do it with respect and with Coast Salish involvement.

Beginnings

With over ninety Coast Salish communities on both sides of the border, it was difficult to figure out the best way to proceed. To start with, we decided to speak with Steven and Gwen Point. Both Steven and Gwen are from the Chilliwack area where Mutton had been acquired. Steven had been Grand Chief of the Stó:lō Nation, a lawyer and a provincial court judge. He had also spent five years as lieutenant-governor of British Columbia. Gwen had been chancellor of the University of the Fraser Valley and was co-chair of the Assembly of First Nations Knowledge Keepers Council. At the time we approached them, Steven was chancellor of the University of British Columbia. They seemed the perfect couple to discuss the project with.

Once we had the okay to go ahead with the research, my role was to bring Coast Salish voices to the project through an advisory committee and through interviewing Coast Salish people who have knowledge of and interest in the dogs.

The advisory committee was formed as a community of interest from Coast Salish people both north and south of the border. These included weavers, Elders, Knowledge Keepers and people who had shown interest in the Woolly Dogs. Everyone was keen to learn as much as Mutton could teach us, starting with his DNA.

DNA is a genetic blueprint, the genetic information containing the ancestral history of each living thing. Think of your own self: all the genetic information (your genome) you inherited is stored in a six-foot-long DNA chain and copied into each of your cells. DNA is incredibly small; it has to be to be able to fit inside cells. So if you want to decipher it, it needs to be copied, and copied so the sample of your DNA is amplified enough to be read. In this project, we would be dealing with ancient DNA.

"Ancient" DNA (aDNA) is just old DNA, DNA found in old bones, or in old plants collected long ago, or in old pelts of a dog like Mutton. The older the DNA, the more likely that it may have been degraded, fragmented or contaminated, making it hard to isolate and amplify. Parts of the aDNA will be missing, but other parts can be extracted out of the teeth, bones, plant or pelt. The quality and quantity of aDNA depend on various factors, such as the age, preservation and treatment of the sample, the type and source of the DNA, and the methods and protocols used for extraction and analysis.

Logan's title is Curator of Archaeobotany and Archaeogenomics. When I asked what this mouthful meant, he explained that he uses archaeology,

aDNA and genomics to study the domestication of plants and relationships with humans and the environment. Switch out "plants" for "dogs," and the process and skills needed are similar. Although Logan had not worked on dog DNA before, he has done many extracts of aDNA from old specimens, many of which are much smaller than a dog pelt (think a kernel of corn). He knows the careful planning, rigorous standards and special techniques required to be successful at getting as much intact aDNA as possible out of a sample.

In this study, the aDNA of only two specimens came under scrutiny: Mutton and the Semiahmoo Bay village dog, who shared Mutton's drawer. Logan could work on his own in the lab to do the careful extraction. "Yeah, we can do it," he had told Audrey, but he had to do it in a super clean room—a bio-bubble. It would only take a couple of days at most. It was doable, but no one could guarantee that Mutton and the village dog had aDNA that could be extracted or amplified. That was the first step, to try to obtain as much good-quality aDNA as possible.

While Logan spent a few days in the lab by himself, extracting what he hoped would be good-quality DNA, Audrey started contacting other experts who could add to Mutton's story.

Angela Perri was one of those experts. Her work in genetic analysis of ancient dog remains and ancient people often correlated with known migrations of people, and this could help place Mutton and his ancestry far back in time. Perri and her colleagues have been able to show that dog domestication probably arose from the grey wolf in Siberia about 23,000 years ago, and that dogs probably accompanied their human companions into the Americas as the glaciers started to disappear, dispersing together throughout the continent about 15,000 years ago.[123] That doesn't mean that Mutton's "breed" crossed over from Siberia, but way back in time, dogs did, perhaps even Mutton's very distant ancestors.

Place of Origin

The question that has come up again and again is where did these Woolly Dogs come from in the first place? Oral History maintains that the Woolly Dogs have always been here, yet early explorers and historians and a few researchers sought other explanations. Writing in 1918 about Coast Salish blankets, Frederic William Howay, a judge with an interest in history in the early 1900s in British Columbia, suggests the dogs originated in the north:

"Kamchatka where a dog with similar 'melancholy whine' exists. Or from Japan, brought by a wayward junk?" He bases this on a report that the Woolly Dogs had a whine rather than a bark.[124]

Howay is not alone in suggesting a Japanese connection. He may have picked this idea up from John Keast Lord, who shared the same notion in his 1866 book describing his time on the coast.[125] Working for the British North American Boundary Commission surveying the 49th parallel, he was the team's equivalent to George Gibbs, and like Gibbs he was a naturalist, collecting specimens, though in his case for the British Museum rather than for the Smithsonian.

Lord was also a veterinarian in charge of the pack horses and mules for the British survey team. In 1860, they needed more pack mules, and he travelled to California, where he purchased mules, then drove them 1,000 miles overland following the Columbia River. As a veterinarian, he paid close attention to the mammals he saw, recording the information. He had joined the British team in 1858, where he encountered Woolly Dogs in Nanaimo and other places. Striving for an explanation of their origin, he suggests, "Long before the arrival of European explorers, they could have come from the north, or the more probable supposition is they came from Japan, as there is little doubt Japanese ships and junks did visit this coast, and the art of weaving could have been learned from those who brought the dogs."[126]

It is surprising that Lord would think of weaving as a skill that needed to be brought to the Pacific Northwest, yet Europeans often thought Indigenous people were somehow inferior, and that view informed their theorizing that any technologies would have been introduced rather than developed from within. There were a few Europeans who remarked on the exquisite craftsmanship of the blankets: "very neatly wrought,"[127] "more durable,"[128] "equally as good,"[129] "cloak of fine wool"[130] and "curiously wove by their fingers with great patience & ingenuity into various figures thick Cloth that would baffle the powers of more civilized Artist."[131] It seems Lord could not comprehend that a very high level of skill could develop within the coastal communities. People along the Pacific Northwest coast were expert weavers in basketry. If you can weave three-dimensional objects like baskets, you can easily weave two-dimensional objects like blankets; you do not need to import those skills.

Lord also suggests, "The first possessors of these white dogs were, as far as it is possible to trace, Chinook Indians, a tribe once very numerous and

living near the entrance of the Columbia River. Thence the dog will reach Puget Sound and eventually must have been carried to Nanaimo, across the Gulf of Georgia."[132] Lord gives no indication of where he heard this or why he gives it credence.

That was some of the thinking 165 years ago, but even in the last twenty-five years, the question of origin has again been raised. An early DNA analysis, never broadly published, suggested that the Coast Salish Woolly Dog was closer to a Siberian dog than a European dog, but it led some people to think the Woolly Dog was related to a Tibetan breed, or a Japanese breed like a Shiba Inu or an Akita.[133] This in turn could be interpreted as the dog having originated in the Eastern Pacific and having arrived in the Pacific Northwest more recently. That early DNA research was never fully published, perhaps because they were not able to amplify a long-enough DNA sequence; this was in the early 2000s, the early days for DNA technology. Twenty-five years later, the technology for looking at aDNA is much more fine-tuned.

Once Logan had extracted the aDNA from Mutton's pelt, and Hsiao-Lei Liu, the lab manager, prepared the extraction into a format that can be sequenced on computers, it was sent to a specialist lab in New Jersey and then back to Audrey for analysis. Audrey compared already publicly available data from ancient and modern dogs and, working with European collaborators, was able to also add a handful of new unpublished data from ancient dogs and wolves. This can and did take Audrey and Logan months, but the results were worth it.[134]

Up until now, the only way to distinguish between Woolly Dogs and village dogs was by looking at bones. In the 1990s, Susan Crockford had reviewed over a thousand dog skeletal remains from twenty archaeological sites spanning 5,000 years in the Pacific Northwest.[135] From the variations in size, Crockford was able to classify the bones into two types of dogs, a smaller dog (the Woolly Dog) and a larger one (the village or hunting dog). There would always be outliers, for example, a largish small dog or a smallish large dog, but generally, one could assume certain bone sizes relate to one or the other dog type. Mutton's bones have not been kept—with the exception of his lower leg bone—so they cannot be compared to Crockford's dog types. However, the lower leg bone on its own is one of these outliers. It is bigger than one would expect. But aDNA adds a whole new depth of information. With aDNA, we could now confirm, or not, that categorizing the bones into two types does

hold true (a future project Audrey has in mind), and then look at relationships to find out how much the breed varied over time or over geographic areas and determine whether the aDNA is close enough that we can assume a trade in the dogs, and perhaps more importantly, with aDNA we could look back in time to see how far back the breed went.

Mutton's aDNA showed an ancient lineage that emerged in North America in precolonial dogs, after dogs originally arrived from Eurasia. This lineage has now died out and has been replaced with European dogs. There may be remnants (bits of that DNA) of precolonial dogs, but within just a few hundred years, those lineages gave way to European lineages. Very few dog breeds have any precolonial aDNA. An exception is the Chihuahua, which has 2 to 3 per cent precolonial DNA. Some of us humans have more Neanderthal DNA than that.

Mutton himself has 16 per cent European ancestry. This means he had one great-grandparent that was a European dog. This could be the cause of having larger leg bones than expected for a Woolly Dog. Given the onslaught of European dogs in the area and how quickly these dogs became the dominant lineage, it is impressive that Mutton had only one "European" great-grandparent. The rest, or 84 per cent of his aDNA, points to precolonial ancestors from thousands of years ago.

So who are Mutton's closest relatives? Genetically, he is closest to 5,000-year-old bones found in the North American Arctic. His genes are precontact and not like European dog genetics. Although he does "look" like a Samoyed, he does not have Samoyed genetics.

Mutton's aDNA analysis indicates much more than precolonial dog genetics. His aDNA also records impressive husbandry, and careful breeding over thousands of years. Even more striking is that his aDNA shows that his kind goes back a minimum of 2,000 years, and more likely closer to 5,000 years, as a separate breed. A dog breed is intentionally bred to bring out a particular set of characteristics, uses and purposes and is distinguished by things like appearance, colour, hair type and behaviour. The breeding ensures they are not bred with another breed of dog, like a hunting dog that would be bred for behaviour like the ability to smell, chase or flush out prey. In the case of Mutton and his forefathers and foremothers, they were not an accident—Coast Salish Woolly Dogs had been intentionally bred to produce their woolly coats.

Gene Selection

Logan also wanted to look at selective breeding, trying to find the characteristics (genes) the dogs were selected for. "I expected to see nothing," he said, "but it was like Christmas. There was so much that indicated that the wool and hair were selected and bred to be used in spinning and weaving."

To understand the magnitude of this requires a little background on the genes that code for the special characteristics of Woolly Dog hair: long hair, shedding ability, woolliness and the colour white.

Hair length and the colour white are controlled by what are known as recessive genes. To produce white puppies, both parents need to pass on the recessive gene coding for white. If one of them passes on the gene for black, then black dominates and the white gene recedes, producing a non-white puppy. Other genes and factors also influence the colour, but generally the recessive nature of the gene will give way to black.

The same is true for hair length in dogs. The genes encoding for long hair actually differ in other dog breeds, but Mutton has a mutation in the most well-known gene coding for long hair (*FGF5*), plus the common ancestor going back thousands of years also had it, meaning the breeding was intentional through all those years to keeping hair long. It can be more convoluted, but what we know so far is that long hair is a recessive gene and requires both parents to contribute the long hair gene. This means if you are breeding for long, white woolly hair, it would be critical to keep the Woolly Dog breed separated from the shorter-haired, darker-coloured village or hunting dogs.

So, in summary, Mutton and the Coast Salish Woolly Dog breed did not migrate from Siberia, though their ancient ancestors did. The Woolly Dog breed was "created" here, intentionally bred for the special characteristics that produced the desired long woolly hair.

When you think about Mutton, who lived and died in the late 1850s at a time of burgeoning colonial expansion, and how he only had one European ancestor, this speaks volumes about how much care had been taken to keep the breed "pure." Even when the Coast Salish world was undergoing huge changes and Indigenous people were being decimated by diseases, care was still being exerted to keep the lineage of the Woolly Dog breed.

As Logan said to me, "Through those hair, skin and wool genes we could see that this resulted in a long tradition of careful selection over thousands of years—a testament to the knowledge and care provided by the Coast Salish people."

Logan and Audrey identified as many genes as possible related to the hair and skin of Mutton and searched for mutations that might explain his special woolly hair. They identified a few genetic mutations, including ones named *KRT77* and *KANK2*, which are linked to a rare condition causing woolly hair in humans—not just curly hair but chaotic "woolliness." The woolliness would entrap air pockets, keeping warmth in. Curiously, these gene variants are also found in woolly mammoths. These variants could be a cold weather adaptation, but more research needs to be done to know for sure.

The question arises often as to whether the Woolly Dog breed could be cloned back into existence. According to Logan, it is almost impossible to do that: "The fact is *all* ancient DNA is too degraded for cloning, which requires the cells to be in very good condition." Although Mutton's aDNA provides a lot of information, it is not a complete genetic blueprint. Many gaps are missing, not just in the DNA but in our knowledge. Even the media talk about recreating the woolly mammoth is really not about cloning one but taking information from ancient genomes to edit genes into a closely related modern species—in other words, to take an elephant and make it hairy. It may look like a woolly mammoth, but it's just a hairy elephant.

Similarly, one could decide on the woolly characteristics of the Coast Salish Woolly Dog and find dog breeds that might carry the genes for some of those characteristics, then try to breed them to produce something similar to the Woolly Dog. However, with current technologies one would never be able to recreate the Coast Salish Woolly Dog breed. This dog came into being over thousands of years of careful breeding, and many of the genetic details have long since disappeared. By tinkering with genes long enough, you could end up with a dog with very spinnable hair, but many breeds with spinnable hair already exist: Samoyeds, Alaska malamutes, huskies, Akitas, Bernese mountain dogs, Great Pyrenees, etc. In the current scientific landscape, Mutton and the Coast Salish Woolly Dogs will remain unique.

We do not have all the answers. It always seems that the more you learn, the more there is to learn. New techniques, new technologies and newly revealed Indigenous knowledge will add more to the story as the years go on. The knowledge gained from Indigenous history and Mutton's aDNA is like that fire in the centre of the Big House floor; smoke is still obscuring things, but the sparks are also lighting up new learnings.

CONNECTING TO OUR ANCESTORS

SNUMITHIA' VIOLET ELLIOTT, SNUNEYMUXW AND QUW'UTSUN (COWICHAN),
AND TUWUXWUL'T-HW TYRONE ELLIOTT, QUW'UTSUN (COWICHAN)
AND SNUNEYMUXW

COAST SALISH PEOPLES relish any connection to our Ancestors that we can find, and Mutton the dog is such an example.

To understand just one such story of the Salish Woolly Dog, the species Mutton belonged to, we must journey to Snuneymuxw' territory to an island called Swiqwmi. It is the island that was reserved specifically for Woolly Dogs. The dogs were highly cherished for many reasons. They had been selectively bred over countless generations for their soft and woolly fur. They were fed a specific diet consisting mostly of salmon, which was known to enhance the growth of a soft and shiny coat. The wool the dogs produced was used in our traditional weaving.

Weaving was the responsibility and the honour of high-standing people in our community. They were often the partner of the hereditary chief or otherwise high-standing members of our society. It was also a great honour and responsibility to care for the dogs; they were considered sacred.

Our Hul'qu'minum' word for Woolly Dog hair is *Squmeyulqun*. The word for dog is *Squmey'*.

In the territories of our neighbouring, mainland relatives, they held mountain goats similarly sacred. We would often trade Woolly Dog hair for the mountain goat hair, which we would spin and ply together, sometimes with down from birds to soften it. These fibres would be used to create blankets, which would be gifted to those of high status, someone we would call Siem.

I had the opportunity to see such a blanket at the Museum of Anthropology at UBC. It had a red stripe and a green stripe; I was curious about the purpose of the stripes. The curator of the exhibit told me they were portions that had been ripped from Hudson's Bay Company blankets. I thought, "Of course they are. That's the creative minds of our Ancestors at work."

There have been attempts to say that the reason for the extinction of the Salish Woolly Dog is that we merely allowed them to breed out, die off or otherwise

disappear along those lines. In my educated opinion, that would not have been allowed to happen. These dogs were sacred beings; they were not a mere resource, but an integral part of our being and community. They were just as much family as our human kin.

In Snuneymuxw territory, what you may know as Nanaimo, where the Civic Arena used to be, there was an archaeological dig. That site, prior to contact, was a small island called Squmeyulqun. You may notice the root word, *Squmey*.

At that site, they unearthed hundreds of dog bones, piled up. Evidence points toward those dogs being slaughtered. Throughout the colonization of what we currently call "Canada," we see a common thread: settler colonizers killed off that which Indigenous Peoples held dear and important to survive, whether that be physically, culturally, emotionally or spiritually. We see it in the plains with the buffalo, in the interior and north of what we currently call "British Columbia" with the beaver, in Inuit territories with their sled dogs, and in policies such as the Indian Act, the Pass System, the Potlatch ban, amongst thousands of other examples. Coast Salish peoples would not have allowed the disappearance of Squmey' of their own free will.

Snuneymuxw' people have ancestry relating to 1850s Hereditary Chief Joe Wyse. He is my great-great-grandfather, my great-grandma Agnes's father. It was his grandfather or great-grandfather who still practised the tradition of having multiple wives. His wives and daughters were weavers. The Hereditary Chief would carve blanket pins for the blankets they would weave. These pins were called *cugnustun*. There came a time when there were too many blankets being made; the Chief could not keep up and had to hire people to carve them for him. In typical Coast Salish fashion, the Snuneymuxw' people teased him and gave him the name cugnustun, poking fun at his inability to carve them fast enough. The name stuck, and there were generations of cugnustun afterwards. It was my grandfather, Norman Johnnie, who told me this history. His grandparents were Joe and Jenny Wyse.

The uses of these mountain goat/Woolly Dog blankets were many. High-standing Hereditary Chiefs wore regalia, part of which being woven blankets or shawls. When hosting a memorial, naming or a wedding, these woven blankets can be seen piled high on the rafters of a longhouse, as the host gets ready to give away

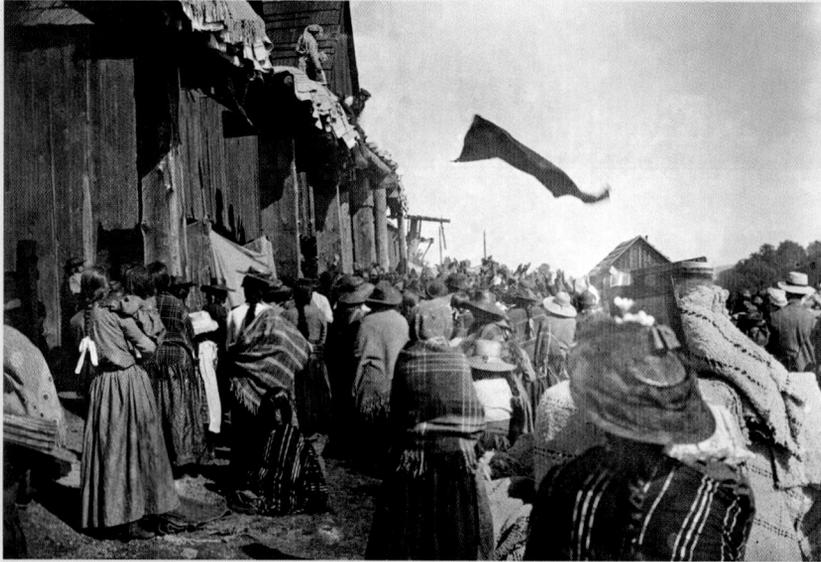

FIG 41

FIG 41 In this 1913 photograph, blankets are being tossed from a platform to the crowd below during a Potlatch at Quamichan, on Vancouver Island. *Royal BC Museum and Archives, Rev. Tate*

the blankets to people who have attended this gathering. Some of these blankets were thrown down to the guests after the naming or memorial or wedding.

This image is an example of men running at a mountain goat/Woolly Dog blanket. These blankets in particular were woven in such a way that they would come apart in four to six pieces. So, when guests would tug at the blanket to try and claim it for themselves, the blanket would come apart and they would each get a piece. These blankets were given away to honour the guests for attending the ceremony, and they were treasured not just for their warmth, but also because they had value as a trade item.

The next bit of history comes from my mother's side. Her mother is the late Emily Manson. She was interviewed by Marjorie Mitchell from the University of Victoria. I have transcripts from the interview. Others in my family have cassettes of the recordings of the interview.

My grandmother Emily was born at Departure Bay. Her family's longhouse was built near to where the Pacific Biological Station now stands. Emily speaks about her family coming down the hill of Departure Bay. They were coming back from Tluqtinus, currently known as Lulu Island, as it was fishing season on the river currently known as the Fraser River.

While traversing the hill, they happened upon a young man climbing the hill. He asked if any of them owned the trunks he had just seen. Once he left, the group sent a young person to see if the trunks he had mentioned were theirs. The young person returned and said that yes, they were their trunks, but the contents had been removed. Those trunks had held some of the family's most prized possessions, their blankets. They had been stolen.

My grandma Emily also spoke of a gigantic loom that went across the entirety of the length of their longhouse, and how her own grandmother had woven on such a loom roughly half of its length prior to passing away. Emily's oldest sister finished weaving this blanket. As an oral people, we do not have much history written from our own perspective. It's exciting to have a slice of history preserved in this way, especially from my own relation, Emily Manson (Fraser).

Just as the Woolly Dogs are sacred, so too is the process of weaving. You have to spiritually and emotionally prepare oneself when collecting the wool, processing it, and when using the material. You ask for spiritual guidance, and you must be of good heart and mind when working.

When weaving for a specific person, you ask for guidance and direction. You pray that person may be protected, and that they too may find guidance and direction. We wholly believe that we leave a part of ourselves in our work, and not just us, but the materials we work with, too, carry a small part of each being they have been intertwined with. The Woolly Dog we received the wool from has just as much a part to play in the actual weaving as the weaver, and shapes the final product just as much as the weaver does, too.

Although we have been physically disconnected from Squmey', the teachings that our Ancestors learned from being in connection to them have lived on. My son and I are both weavers. I am a wool weaver and a cedar weaver, and my son is primarily a cedar weaver. We carry the same teachings that our Ancestors would have learned and passed on about Squmey' into our weaving with other materials. Everything is done with purpose and intent, nothing is wasted, consent is asked for, and all beings involved are treated with dignity and respect.

Mutton's existence allows us to have a tangible connection to our Ancestors, Squmey', our culture, and our territories. And that is just one story from one community. There are many other communities who exist alongside these beautiful animals, our kin.

◇◇◇

FIG 42

FIG 42 This 1847 painting by Paul Kane is called *Crossing the Strait of Juan de Fuca*. It shows Kane and his party returning by canoe to Fort Victoria, BC, in a storm. Kane completed this sketch from memory and wrote in his journal: "Chea-clack, considering that our canoe was too small, succeeded in changing it for a larger one, and at 3 o'clock a.m. we embarked and proceeded to make a traverse of thirty-two miles in an open sea. When we had been out for about a couple of hours the wind increased to a perfect gale, and blowing against an ebb tide caused a heavy swell. We were obliged to keep one man constantly baling to prevent our being swamped...It was altogether a scene of the most wild and intense excitement: the mountainous waves roaming round our little canoe as if to engulf us every moment, the wind howling over our heads, and the yelling Indians, made it actually terrific."

Stark Museum of Art

7 OTHER DOGS

You can see that there's different uses, different breeds, different types of
jobs and roles that the dogs were in the community.

SENAQWILA WYSS [136]

THE FOG LAY THICK on the water as we paddled into Koeye Bay, a remote area
on the Inside Passage, a protected waterway extending along the central Brit-
ish Columbia coast to southeast Alaska. We were in the *Munu* (Hul'q'umi'num:
blood-related child) Snuneymuxw family ocean-going canoe on a Tribal Jour-
ney, with some hundred or so other canoes, hailing from various First Nation
communities up and down the coast, some from as far away as Nisqually at
the southern end of Puget Sound. Each canoe held six to a dozen mostly Indig-
enous paddlers, all on a journey of cultural renewal to help youth connect
with their culture.

As we came close to shore, the fog thinned and we could see the longhouse
just up from the beach. Canoes were already offloading people and ferrying
camping gear from support boats to shore. We had had a long day, paddling
20 nautical miles, having started twelve days and 250 nautical miles ago in
Nanaimo.

We offloaded people, then paddled out to where our support boat was
anchored to load the canoe with camping gear. As Gary, our skipper, passed
me another bag of gear, he asked, "Liz, do you have bear spray?" I nodded.
"Good. Keep it handy."

We paddled back to the beach, where a man and two very large dogs were
greeting people. "Welcome to Koeye. You can sleep in the longhouse or set up
tents, but keep them as close as you can to the longhouse. This is grizzly coun-
try. Never go into the forest without at least three other people. Do not walk

down the beach to the river—that's where the bears hang out." He pointed to the two imposing, but friendly, dogs lying on the sand. "See these dogs? These are working dogs. They are guard dogs. They stay outside. Their job is to warn us of bears. If you hear them barking, get into the longhouse. Let them do their job and listen to them." We looked at the dogs with more respect.

These were European Pyrenees dogs, bred to protect their owner's family and farmstock. They have a ferocious bark that we hoped not to hear. They were the right breed of dog to have in this wilderness area.

Working Dogs

All over the world dogs have been bred for different jobs: hunting, protection, herding flocks of sheep or cattle, companionship, lap dogs, etc. The Coast Salish had at least two types of dogs, kept and bred for specific purposes. They had hunting dogs, trained to chase down deer or other animals, as well as the Woolly Dog, bred for its long woolly hair.

Many cultures around the world have used dog hair, spinning it into yarn,[137] but they have also had other animals providing wool, and did not rely solely on dog hair. In some cases, a dog was bred for another primary purpose, and the hair was a side benefit. Take these Pyrenees dogs, whose job was to guard us from bears—their thick wool-like hair would probably make a snug sweater for this foggy day. I was certainly tempted to sit by them and comb their coats, gathering fibre to spin.

In northern BC, the Tahltan people had a dog they bred and trained for hunting game, often bears. It provides a good example of how a dog breed could be specialized not only for hunting but hunting for specific types of game. According to Oral History, this dog had been around since time beyond memory, bred to protect the people.

James Teit was a hunting guide and an ethnographer living near Spences Bridge along the Fraser River in the late nineteenth century. He wrote of the Woolly Dogs of the Coast Salish, and when he spent time in the Telegraph Creek area of northern BC in 1905, he also wrote of the Indigenous dog in that area. This dog "had been used extensively in the hunting of black bear, especially in the spring when a small dog could move quickly on the crust and hold a bear in deep snow until it was killed with bow and arrow or muzzleloader."[138] Known as the Tahltan bear dog, this animal was, according to Teit, "as indispensable to the Tahltan as snowshoes." When interviewed by

researcher Leslie Kopas, Tahltan Elder John Carlick bluntly stated, "If you had a bear dog you could find game. If you didn't have a bear dog, you starved."[139]

The Tahltan bear dog is now extinct for several reasons, including a distemper outbreak in the 1940s and an outbreak of the flu and measles in 1942 that killed many Elders who cared for these dogs. According to Crow Clan Elder Liz Edzerza, with too many untended dogs on the loose, a cull was deemed necessary, and the dogs quickly died out.[140]

The bear dog was small, agile and fearless; its bark varied according to the type of prey it was chasing, providing the hunters with information. It had a distinct ruff of fur around its neck and a short, stumpy, bushy tail resembling a shaving brush. The ears were pointed and upright, the fur dense, typically black and white.[141]

The Tahltan were not the only Indigenous people to have bear dogs in British Columbia. According to William Halliday, an Indian agent at the north end of Vancouver Island and on the nearby mainland, the Kwakwa̱ka'wakw people of Kingcome Inlet, not too far from where I encountered the Pyrenees bear guards, also kept valuable bear dogs.[142] Halliday also recalled seeing Woolly Dogs in his early days on the coast, having arrived in 1873 as a child.[143]

Dr. George Suckley, who was assigned to write up the reports on the mammals and salmon collected by Gibbs and others on the Northwest Boundary Survey, wrote a brief, broad overview of the types of dogs he observed in what is now Washington, Oregon and southern British Columbia. He observed two main breeds of dogs. He writes of "one resembling the coyote, or Prairie wolf, and very probably crossed with that animal, which is the kind used for hunting; The other, a long bodied, short legged, turnspit looking cur, which is the peculiar property and pet of the women." Suckley then goes on to describe a third type of dog "the dog used by the Skagit, Clallam, and others of the lower part of the sound and Gulf of Georgia, which is shorn for its fleece. Vancouver mentions these as resembling the Pomeranian dog. They are a pretty good size, and generally white, with much longer and softer hair than either of the others but having the same sharp muzzle and curling tail as the hunting dog."[144]

The Coast Salish hunting dogs were much valued for their companionship and/or skills—some were given names, and special ones were given ancestral names. According to Coast Salish ethnographer Homer Barnett, who observed

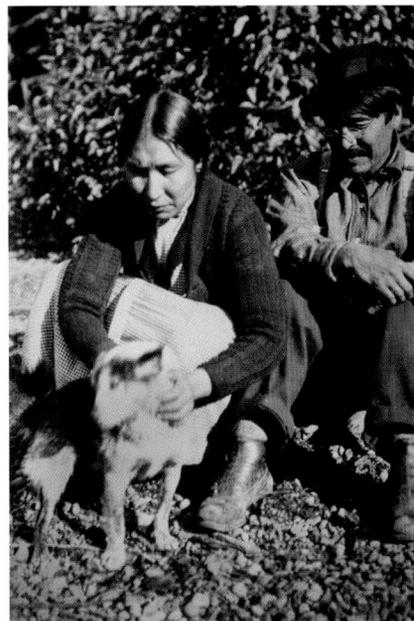

FIG 43

FIG 43 Mary Jackson and Charley Quash, with a Tahltan dog in Tahltan, Telegraph Creek, BC, in 1915.
Canadian Museum of History, James Alexander Teit

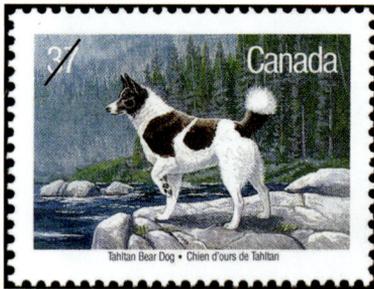

FIG 44

FIG 44 Tahltan bear dog stamps like these were available from Canada Post in 1988. The stamp was based on a painting by Mia Lane and designed by David Nethercott. Note the dog's short, bushy tail.

Canada Post and Library and Archives Canada

in the late 1930s, "Dogs [hunting] were given names ('Deer Heart,' etc.), and some people took the trouble to bury them. One Cowichan man in recent years made a coffin for his dead dog, wrapped it in wool, put a watch in with it, and buried it."[145] These dogs also underwent rigorous training involving, in his non-Indigenous view (which seems to discredit Indigenous Knowledge), "magical applications along with a more realistic regimen."[146] Training most often was designed to drive deer or elk into deep water, but in some areas, dogs were trained to rouse mountain goats.[147]

Although we generally simplify the types of dogs to either Woolly Dogs or village dogs, the roles played by dogs in Coast Salish territory are many: guard dogs, Woolly Dogs, village dogs (being scavenger dogs or not having an assigned role) or hunting dogs. Oral History also refers to dogs being used as guide dogs. The Hul'q'umi'num language even has a word for the role of a guide dog—*shlemuxutun*. This could have been either a hunting (or village) dog or a Woolly Dog.[148]

Sixteen years after Captain Vancouver entered Juan de Fuca Strait from the west and mentioned Woolly Dogs in Coast Salish territory in 1792, Simon Fraser wrote about the Woolly Dogs, as he came from the east and travelled down the Fraser River.

In between these two locations lies mostly Coast Salish territory, roughly 150 miles from east to west and 150 miles from north to south.

Wool Dogs Outside of Coast Salish Territories

An earlier mention of dogs being used for their wool in the Pacific Northwest dates from 1778 when Captain Cook entered Nootka Sound, in nuučaańuł (Nuu-chah-nulth) territory, on the west coast of Vancouver Island, north of Coast Salish territory. Although Cook mentioned wool garments, which were rare, he did not mention dog wool, but John Ledyard, who sailed with him as a marine, did mention it, describing garments as being "principally made with the hair of their dogs, which are almost white and of the domestic kind."[149] This appears to be the earliest non-Indigenous observation of a mostly white dog along the coast, though it occurred north and west of Coast Salish territory.

The Makah of Ozette, Cape Flattery and Neah Bay on the Olympic Peninsula had many Woolly Dogs. Their Oral History makes this clear, as do the journals of early explorers. Sailors aboard ships rounding Cape Flattery

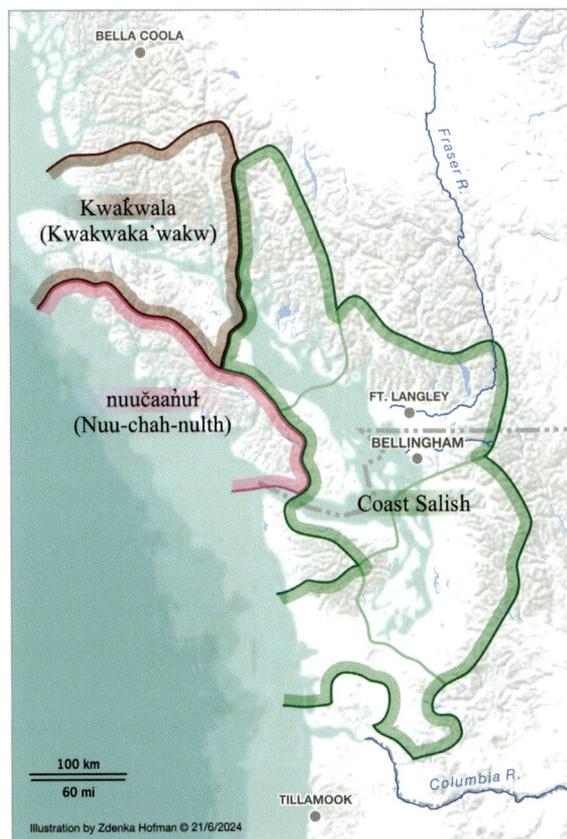

into the Straits of Juan de Fuca and on into the Salish Sea left a few noteworthy accounts of seeing these dogs, and John Scouler's journal of early 1824 is one example: "The natives of Tatooch [Island] show much ingenuity in manufacturing blankets from the hair of their dogs. On a little island a few miles from the coast they have a great number of white dogs which they feed regularly every day."[150] Descriptions from men like Scouler tell of dogs outside of Coast Salish territories. These descriptions strongly resemble other descriptions at that time of Woolly Dogs in Coast Salish areas. The Makah on the Olympic Peninsula are not Coast Salish, speaking Qʷi·qʷidiččaq "Makah Language," a language from the Wakashan language family, and having different cultural customs. They are related to the nuučaańuɫ (Nuu-chah-nulth) on the west coast of Vancouver Island, and their ocean-going canoes would travel up and down the coast trading and visiting. Pre-contact, there may have been Woolly Dogs of one sort or other at many locations along this section of the coast. The Makah may have traded their dogs, or were these different breeds of dog?

Makah Cultural and Research Center, in Neah Bay on the Olympic Peninsula, has the oldest blanket found on the Pacific NW Coast, from the Ozette Archaeological Site, a Makah village partly buried by a mudslide 300 to 500 years ago and unearthed in 1970. The blanket had been preserved by mud and is in poor condition, but Terry Loychuck and Elaine Humphrey put some of the fibres under the microscope and found dog hair, so we know that dogs have been used for wool by coastal First Nations since at least 1700.

A few other reports exist of Woolly Dogs outside Coast Salish territory. Farther north and in the late 1800s and early 1900s, Franz Boas studied the Kwakwaka'wakw people at the northern tip of Vancouver Island with the help of George Hunt, a Kwagu'ł man from Tsaxis (Fort Rupert). Hunt described a Woolly Dog named Qalakwa, a word that means "mixing oil with water," which produces a whitish colour. According to Boas and Hunt, it was common to give names to dogs. Qalakwa, owned by an important chief, had short legs with long, straight hair-like wool, though not curly, and apparently

FIG 45 This map outlines the three major language territories: Coast Salish, nuučaańuɫ (Nuu-chah-nulth) and Kwakwaka̱'wakw.
Map by Zdenka Hofman

this dog's hair covered his eyes and hung down to the ground. We know the dog was kept for its wool, as Hunt described how the wool was cleaned and spun.[151]

It is feasible that different First Nation villages may have had slightly different lines or breeds of Woolly Dogs, though descriptions from the southeast Vancouver Island/Puget Sound/Lower Fraser River dogs seem to be consistent. As long as a dog provided usable fibre, it would be considered valuable. This is a line of inquiry that Audrey would like to pursue, to see how similar to Mutton's aDNA other dogs said to be Woolly Dogs are. In other words, how closely related was Mutton to the Woolly Dogs of the Makah at Neah Bay, or to Woolly Dogs in the southern section of Puget Sound?

There are other reports of Woolly Dogs from the northern tip of Vancouver Island. In 1892, a Mr. Victor B. Harrison of Nanaimo, who was seven at the time, recalled seeing three Kwakwa̱ka̱'wakw men from Hope Island arrive in a canoe with three small dogs. Harrison described these as being similar to the dogs observed by Hunt and Boas: short legged, with thick, barrel-shaped bodies and long hair of a light colour. Twenty years later, Mr. Harrison reported another sighting of wool dogs on Hope Island by foresters, and an unsuccessful attempt to get a specimen for the provincial museum.[152] A newspaper report from the 1920s also suggests Woolly Dogs were seen on Hope Island.[153]

The Nootka Sound Woolly Dog

Another researcher involved in the Mutton aDNA project at the Smithsonian was Dr. Iain McKechnie, a Pacific Northwest coastal archaeologist with a specialty in zooarchaeology and marine historical ecology. Working with Indigenous Peoples along the west coast of Vancouver Island in Barkley Sound, nuučaańuł (Nuu-chah-nulth) territory south of Nootka Sound, Iain and his crew had discovered bones in the late 2010s belonging to what Iain believed to be a Woolly Dog. He based this belief on Susan Crockford's bone measurement work.[154] His work in the Tseshaht First Nation village site of Ts'ishaa in the Broken Group Islands upholds the nuučaańuł Elders, history of Woolly Dogs in their territory, which lies outside Coast Salish territory.

Iain and his co-workers had taken to referring to the remains they discovered as those of a "Nootka Wool Dog." I found another reference to a "Nootka wool dog" by Lt.-Col. Charles Smith, a naturalist and author, in his 1839 book

on Mammalia.[155] He describes a large dog with pointed ears, highly valued for its woolly coat of black, brown and white. Smith suggests an Asian origin of the Woolly Dogs and proposes the odd notion that the breed could be introduced to the peasantry of Norway and Scotland for economic benefit from the wool. Just how these two countries, with their plentiful number of sheep, could possibly benefit from Woolly Dogs is open to question, though perhaps domesticated Woolly Dogs may have been easier to manage, and far better companions, than sheep!

Another reference appears on a website that seems to take considerable care to separate fact from what is described the "murkier waters" of information (or misinformation) about the "Nootka Sound Dog."[156] Here the dog is given the scientific name of *Canis laniger nolis*. According to this source, apparently the Zoological Society of London in 1842 or 1843 had at least one specimen of the "Nootka Sheepdog" that resembled a large Samoyed dog. One brief mention of the "Nootka wool dog" does appear in the online archives of the Zoological Society of London, but even the archivist of the society was unable to track down any further information.

If there had been a Nootka Sound Woolly Dog, was it related to Mutton?

Determined to learn more, I contacted Susi Szeremy, the author of the web page. She apologized for being unable to quote the source of this information with any confidence, saying, "I think it was in Desmond Morris's 2002 book *Dogs: The Ultimate Dictionary of over 1,000 Breeds*."

Desmond Morris is perhaps best known for his 1967 book *The Naked Ape*, which has sold over 20 million copies. Twenty years after that book came out, his book *Dogs: The Ultimate Guide to Over 1,000 Dog Breeds* was published, in 2002. After so much time, I doubted if I could possibly discover where Morris found the information about the Zoological Society's interest in the "Nootka Sound Dog," or if the Nootka Sound Dog was in fact the same as the Coast Salish Woolly Dog. In Morris's book on dog breeds, he does, however, mention the "Clallam Indian Dog," a Coast Salish Woolly Dog from across the Strait of Juan de Fuca from Victoria, BC.[157] But Clallam territory is a couple of hundred miles south of Nootka Sound. Where did Morris get his information more than fifty years ago? When I expressed my concerns that I was chasing an unsolvable mystery to Susi Szeremy, she said, "You know Desmond Morris is still alive—maybe you could ask him directly. " So, having eventually unearthed his contact information, I reached out.

Desmond Morris was ninety-seven at the time of this book's publication, and when we exchanged emails in 2023, he was living with his son in Ireland. He apologized; after almost a quarter of a century, he couldn't remember what his source was, but he believed it must have been London Zoo.

Some of the pieces of his interesting life started to come together. As curator of mammals at the London Zoo, his extensive knowledge of mammals fuelled his authorship of *The Naked Ape*, a classic on humankind's evolution and our most basic needs, and later led to his book covering 1,000 breeds of dogs. He mentioned almost in passing his extensive television work for the BBC, and I learned of his remarkable success in his dual career as a surrealist painter, even exhibiting with Joan Miró.

Morris was disappointed that his book had missed the Coast Salish Woolly Dog. I assured him that the "Clallam Woolly Dog," which he has included in his book, was likely the same breed as the Coast Salish Woolly Dog. Corresponding with Desmond Morris proved to be a real delight:

> When I was Curator of Mammals there in the 1960s I once had a pair of New Guinea Singing Dogs that had been presented to a famous orchestra conductor—who begged us to look after them. They were an ancient breed related to the dingo. Instead of barking, they made a sort of yodelling sound. A friend of mine, the comedian Spike Milligan, asked to see them because he wanted to hear their song. He listened attentively and then summed it up by saying that their Bach was worse than their Bitehoven.

The question still in my mind was: is the Nootka Sound Wool Dog the same as the Clallam/Coast Salish? The Smith report states that the Nootka Sound Wool Dog was large and of a different breed.[158] Iain thinks it was larger too. The problem is that we have no known specimen. So I asked Morris, "If the London Zoological Society had one or more of the Nootka dogs, what would they have done once they died? Would they donate the pelts or skeleton to a museum? It would be wonderful to find a specimen that we could compare with the Coast Salish Woolly Dog."

To which he replied:

> If the pelts were saved by the London Zoo in the 1840s, they would have gone either to the Natural History Museum in London, or their museum in Tring. The Tring Museum has some wonderful early dog specimens—bulldogs with long legs, etc.

The Natural History Museum's catalogue had no mention of the Nootka dog, but the Tring Museum? I had never heard of it. Morris explained that the Natural History Museum at Tring was originally the private museum of Lionel Walter Rothschild, 2nd Baron Rothschild; today it is under the control of the Natural History Museum, London. It houses one of the finest collections of stuffed mammals, birds, reptiles and insects in the United Kingdom.

I sent a quick email to Audrey, the aDNA researcher, as she had mentioned she was going to England in a couple of weeks to attend her official graduation for her doctorate. Maybe she could stop in at the Tring Museum and check their records.

By coincidence, a fellow student she corresponded with was doing research into the impact of the Victorian-era rules for dog breeds and was visiting the Tring Museum the next day and would do a search for us.

Audrey happily reported back that her colleague did indeed find a Nootka dog specimen—a skull, miscatalogued as an "Esquimoux" dog. He would run some DNA tests from a small bone sample. We are still waiting for the results.

Iain was delighted with the new find of the Nootka Sound Woolly Dog at the Tring Museum. The Tring dog has provenance, which means a record exists of it being brought to London from Nootka Sound because it was a Woolly Dog. This Nootka skull is, aside from the Makah Woolly Dogs from Ozette, which resembled the Coast Salish ones, the only known specimen from the West Coast labelled as a Woolly Dog. We would soon be in a position to compare Mutton's DNA with that of the Tring dog to see how closely related they are and if they are the same breed or totally different. As results become available, in the future McKechnie and other researchers will be able to use these results to establish a comparison with what he and his team suspect might be bones from other West Coast Woolly Dogs.

We know Mutton was a Coast Salish Woolly Dog and that this breed was widespread in Coast Salish territories. We also know Nations from other nearby regions kept them, like the Makah, and with the discovery of the Tring dog we know there were Woolly Dogs at Nootka. They may have been even more widespread. Taking into account the Hope Island dogs, the Nootka dog, the Makah dogs, and the dog from the village site of Ts'ishaa in the Broken Group Islands, it seems the Woolly Dogs lived all over the Pacific Northwest Coast. We commonly use the term "Coast Salish Woolly Dog," but perhaps, more accurately, when discussing the whole Pacific Northwest Coast, we should say the Woolly Dogs of the Pacific Northwest or Northwest Woolly Dogs.

THE CARE AND FEEDING
OF DOGS

NOT LONG AGO, my great-grandfather, on my grandma's side of the family, told the story of how his great-grandfather was a keeper of Woolly Dogs on qweng7q-wengila7 ["place of many Woolly Dogs"] what is now called Guemes Island [also known as Dog Island] (Samish/Puget Sound) in the Salish Sea, just southwest of here (Katzie/Musqueam) (Vancouver). There are at least four versions of the story, each with its own specific cultural teachings for specific audiences. This is a version of the story, told to me by my daughter Keisha Amanda Charnley (a version she had heard and thought maybe it was in the Jenness book), as I remember it, followed by a longer one.

He said: "One day this man fell dead. However, my uncle, a shaman, was called for and he prayed over the man. Four days later the man came back from of the dead and announced that he was told his work was not yet done here in the land of the living, and he continued on looking after the 'flock' of Woolly Dogs under his care for a long time."

On my great-grandfather's side of the family the names passed down are mainly Samish. My great-grandfather, Peter Pierre's mother's father, c'alqe'nəm, was from Guemes Island, which is also called "Dog Island" for the Coast Salish Woolly Dogs that we had there. The story passed down through my maternal line took place in the very early 1800s, a time when there were not the mental or physical borders crossing our Coast Salish territories and relations like there are today. There were Coast Salish land and ancestral-based cultural spiritual governance practices, values, relationships, ways of relating and understanding, and a science that recognized that all life forms had a right to live at its centre, woven into our Oral Tradition and into our honour blankets. My great-grandfather explains:

My mother's grandfather was a powerful chief who came from Guemes Island, in the State of Washington. When he died the people wrapped his body in many goat's wool blankets and laid it on a high platform… His widow… [o]n the third morning… heard a sound over her head, and… saw the blankets move… Terrified, she fled to the village and told her relatives, who accompanied her to the grave again. Seeing the blankets still moving, one of them climbed the platform and handed the corpse down. As they unwrapped it carefully, blanket by blanket, the dead man suddenly sat up and said: "Go back to my house and clean it thoroughly."

Some of the villagers remained near him, while others went back and purified his house… [T]hey carried him down, still wrapped in the blankets in which they had carried him to his grave. He walked from the door to his usual seat and announced: "I shall now tell you what I have seen, so you may tell other people later…"

The people then gave my grandfather a new name, čawa'yəs. Meaning "he who came back to life."[159]

There is a Coast Salish concept that corresponds with an idea of "upper class." This idea of Coast Salish royalty corresponds with being educated, being "smelah." One is not necessarily born into this status but one earns it through one's Elders educating them. This is why when I was growing up it was so important to my grandparents and elder relatives to ensure they taught me my genealogy and where I came from, knowing one's history and genealogy and other things. Knowing these things not only helped one's own well-being but it contributed to the well-being of the community. In this vein, there was a spiritual or special or prestigious position that the person or people who care-took and protected the Woolly Dogs had.

KERRIE CHARNLEY, xʷə́LMəxʷ, PIERRE FAMILY, q̓íc̓ə́y̓/KATZIE

◇◇

IT WAS EXPLAINED TO *me by my Uncle Sonny (George Miller, Skokomish) who, when reacting to a glossed over description of the Woolly Dog, said, "Too often our culture or important aspects of our culture are conveyed in a simplistic manner and neglect our sophisticated outlook about certain aspects of our existence. Take the Woolly Dog, for example, where an author simply says there were packs of twenty or so dogs being kept on an island to prevent crossbreeding with non-Woolly Dogs." Then for the entire afternoon, my uncle then went on to explain to me the basics of the Coast Salish Woolly Dog Society.*

Families that had the means to do so—were generally upper class with the means and resources—cared for a large family of Woolly Dogs. It took a considerable amount of time and resources necessary to feed, groom, breed and to take care of their health and vitality. It's not an easy endeavour to look after a family of Woolly Dogs, and this could be anywhere from five to six or ten to fifteen or up to twenty or thirty in a village of Woolly Dogs. If it was just myself, I could take care of five to eight to maybe ten. But if I had fifteen or twenty Woolly Dogs, that would require at least three, if not four or five people to care for them, especially when you start to think about the quantity of food that's necessary to keep them healthy… It's quite an investment of time and energy.

Ask yourself, who cared for the health and vitality of these dogs? Well, a vet did. We had to have vets. Because if you have husbandry, you're caring for a group of animals, you have to have someone who knows how to care for the sickness and the health and vitality of them. You have to. Who does that today? Vets do. Who did it 1,000 years ago? A vet. They graduated from life experience and knowledge that was handed down from others who cared for and understood what was necessary to care for the Woolly Dog.

I was told they were never left alone. And I would say that it's to each one's preference about how they cared for them. As I've heard some stories, they left them on islands for months at a time. And I was told they were cared for and diligently protected because they were wealth. If you left them anywhere, if someone came upon them, they would take them. We didn't leave them in places where people could have easy access to them and steal them, because they would. But they were kept in places where they could be cared for ... We didn't particularly have an island. We had areas that we dedicated to care for, and we would have in this case pens or places that were protected to keep them separate so they didn't run away or we could keep them protected.

We were told there was a very popular stew that was given to Woolly Dogs that would give them the kinds of nutrients that would be necessary for them to be healthy and for their coats to be vibrant. I would say that at least three plants were incorporated in this mixture. There would be the Indian potato, Indian carrots, and a type of fern.

MICHAEL PAVEL, ELDER, SKOKOMISH/TWANA

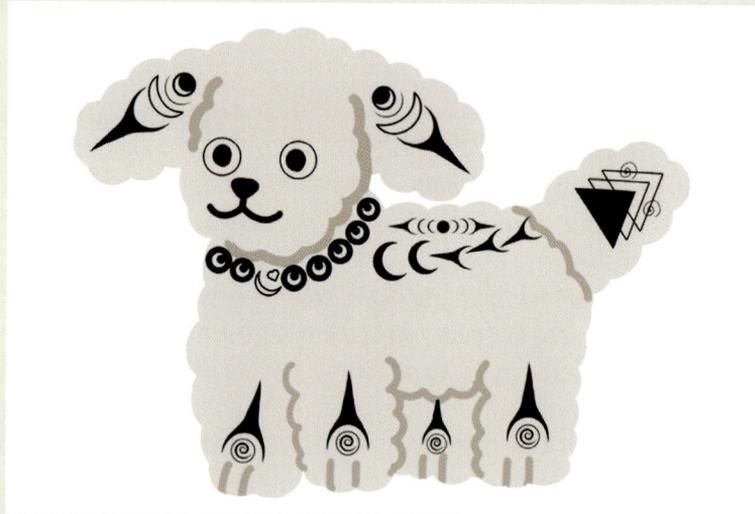

FIG 46

FIG 46 Artwork depicting a Woolly Dog by contemporary Coast Salish artist Senaqwila Wyss.

ONLY THE WEALTHY WOMEN *of status had wool dogs and you weren't allowed to breed them unless you got her permission.*

Now the men and women were considered very wealthy if they had many men in their family. They owned the men. They owned the wealth because men were hunters and fishermen and builders. If there was war from another tribe, the men fought with them. So if you had many men in your family, you were a very rich woman. My mother told me that. She said we didn't have money. We had men. They were our wealth.

Whatever they [people] ate, all the dogs would eat too. A lot of fish and deer meat.

XWELÍQWIYA RENA POINT BOLTON, ELDER, STÓ:LŌ

WHEN A DOG IS IN HEAT, every other dog around them for miles knows they're in heat, so we understand that going to an island was to separate from other dogs. Or in the interior they didn't have islands so they had their own landscape-specific ways of keeping a dog in heat separate from other dogs.

The hunting dog was not in the longhouse, which does differentiate the Woolly Dog to other species.

SENAQWILA WYSS, SK̲WX̱WÚ7MESH ÚXWUMIXW (SQUAMISH NATION)

THEY WERE KEPT on Bainbridge Island, and they were isolated so they didn't breed with other types of dogs.

My teacher, Virginia Adams. She had mentioned that they, you know they were only fed salmon and such a good diet to keep their coats nice and fluffy.

DANIELLE MORSETTE, SUQUAMISH AND SHXWHÁ:Y

MY GRANDFATHER [Ed Sparrow, born in 1898] told me that they were kept separate, always. They had their own pens. They were kept like sheep in pens [on an island]. At the foot of 6th [Avenue] in New Westminster, called Poplar Island, is where they isolated.

DEBRA QWASEN SPARROW, WEAVER, MUSQUEAM

THE WOOL DOG WAS a distinct breed and was not used for hunting. Wool dogs lived in the house with their owners and were given special care and a different diet from the hunting breed. Owners tried to prevent their interbreeding with hunting dogs.[160]

FRANK ALLEN, INFORMANT FOR ELMENDORF (1860–1945), SKOKOMISH FATHER AND A DUNGENESS KLALLAM MOTHER

MY FATHER PENÁĆ DAVE ELLIOTT told me a story about how in the old days when people lived in the low shed-roof-style houses where there was a hole in the roof to allow smoke to escape, that one day a cougar jumped on the roof and came down the hole, grabbed a Woolly Dog and leaped back up the hole onto the roof and was gone with the dog.

JSINTEN JOHN ELLIOTT, ELDER, W̱SÁNEĆ[161]

I DID JUST HEAR Uncle say that it wasn't just salmon, it was deer, elk, other protein, not just fish.

saɫamitćа SUSAN PAVEL

WHEN I THINK ABOUT, it's Snuneymuxw and our connection to the wool dogs and Cameron Island [known as Sqwiqwmi'] is where I go first. There are a number of stories connecting to them from there. Sqwiqwmi'. That means little dogs, and so what that says to me exactly is that Cameron Island was one of the dog sanctuary islands, and it lines up exactly with the rest of the history of Snuneymuxw because downtown Nanaimo is built on top of what used to be xwsa'luxw'ul, which was the home of the Saalequun people.

The Saalequun were the highest-ranking and the wealthiest group in Snuneymuxw, of the different groups that came together to become Snuneymuxw under the Indian Act. That group had the rights to the largest fishing weir right at the mouth of the river, and they were the only ones who didn't spend their winter in Departure Bay because they had their own site, Cameron Island, which is right adjacent to downtown where their village was from being a dog island.

And then I've also heard stories. Willie Good shared this with me, about how the name also comes from a rock that used to be somewhere near by Cameron Island and it was a giant stone wool dog.

So this area is significant. You know the waterfront where the Nanaimo harbour is, but also especially the Newcastle Channel, these are all really significant places in our history where Xals [Creator being or transformer] was known to walk and where Xals had turned a large number of different animals into stone along the shore. So there being a stone wool dog down toward Cameron Island makes perfect sense as well, and I guess it's gone now but it was somewhere near where the Port Place mall is.

ELIOT WHITE-HILL KWULASULTUN, ARTIST, SNUNEYMUXW

8 THE DIET OF WOOLLY DOGS

A DEAD SALMON LIES on the table in front of me. Dr. Tim Goater is dissecting it, with impressive enthusiasm. We are looking for parasites, a familiar quest for Goater. As a parasitologist and university professor, he gets very excited about parasites, having studied them, their ecology and evolution for many years. His over-the-top enthusiasm is catchy, and his university students love him.

We are in a classroom lab at the Bamfield Marine Sciences Centre with microscopes, tweezers and fish, trying to spot nematodes (worms, to non-parasitologists) curled up just under the salmon's skin, or lurking in cysts, or in the heart, all signs of parasite infection. A student yells out, "Tim, come look at this one. It's coming out of the heart artery." Tim scrunches his eyes and wanders over, looking puzzled. Nematodes are not usually found in fish hearts.

Tim pokes the heart artery, which is unusually stiff, and loudly exclaims, "Holy cow, Batman." He carefully starts to grasp a particularly tough worm, pulling on it gently to dislodge it from the heart. Enthralled, the whole class surrounds him, watching his slow, careful movements. Every now and then, Tim emits another exclamation: "W-e-e-ell, I'll be dipped in dog shit." His sayings are legendary. The worm starts to come out. Students are grimacing. Tim jumps back as the stiff translucent worm emerges. Eyebrows furrowed, he peers closely at it, noticing a greenish leaf-like stem at one end. There is silence while we all wait for his identification. "Holy liplock on a boot,

Batman! It's a beansprout!" The class is in an uproar, laughing so hard. "You fail." Tim jokingly pokes an accusatory finger at the student who pulled the clever prank, having inserted a beansprout from his lunch into the heart of the salmon.

Parasites commonly live in fish of all types, Tim Goater explains, apparently delighted by this fact, and many seem to thrive in salmon. A salmon dinner has never been quite the same for me.

Beansprouts aside, it is very apparent that Indigenous dogs were carefully tended in their diet. Although bacteria and parasites were not fully understood in the 1800s by Western science, Indigenous Peoples up and down the coast developed knowledge over thousands of years that helped avoid deadly parasites and ensured the survival of dogs.

A young Indigenous woman once told me, "Salmon is life." On the coast of BC, this is a simple fact of life, nowhere more so than in the salmon-bearing areas of Coast Salish villages. With five different salmon species and different runs of salmon happening at different times throughout the year, fresh salmon is the lifeblood of Coast Salish territory. Without salmon, the people would have starved. Today, salmon is still central to the culture and diet of the Coast Salish (and other First Nations). In some communities, households leave large insulated plastic coolers or totes out in front, alongside the road, as a matter of course. When the community fishermen bring back salmon, they distribute the fish throughout the community, leaving them in these household totes.

Traditionally, salmon were also essential in the raising of dogs. Oral History repeatedly reveals that Coast Salish dogs were fed mostly salmon, the main source of food on the coast.

A huge amount of salmon was needed to keep the people and their animals fed. One dog requires an estimated one kilogram of salmon per day.[162] The salmon would have to be cooked or cured, a very labour-intensive process, to provide food for people and dogs in the winter when fresh salmon was out of season, but during the salmon runs in the spring, summer and fall, the dogs could have eaten the salmon raw. This puzzled parasitologist Tim Goater; from his considerable expertise in studying parasites, he had learned that raw salmon may contain a parasite that kills dogs. How can dogs survive on a diet of salmon if the parasite found in the salmon can kill the dog?

Salmon Sickness

Some accounts indicate that dogs did indeed die from eating raw salmon, as I discovered in a couple of references to dogs dying of what was likely parasitic disease. The first is dated 1814 and comes from northwestern Oregon when fur trader Alexander Henry noted in his journal the death of dogs after consumption of raw salmon.[163] Another account appears in the 1854 report *A Survey of Mammals* written by George Gibbs and George Suckley:

> The native dogs of Oregon subsist well upon fish, which they even do not hesitate to eat raw. Salmon, which is their common food, will make any blooded dog from the States very ill; scarcely one dog out of ten recovers. This "salmon sickness," as it is called, attacks the dog but once.[164]

So, although the "blooded" dogs, a.k.a. settlers' dogs, fared poorly on salmon, either the Indigenous dogs had evolved to subsist very well on salmon or very careful husbandry of the dogs was practised—or perhaps both.

This "salmon sickness" or "salmon poisoning" is caused by a pathogenic bacterium living inside a flatworm (fluke) species. The parasite goes by the scientific name of *Nanophyetus salmincola*. This flatworm species has an extraordinary and complex life cycle (Figure 47).

It starts life as a small egg in the feces of an infected dog, and in a freshwater environment becomes a little swimming larva that penetrates a specific river-inhabiting snail. This vestigial parasite then multiplies and exits the snail as another type of larva. These larvae enter a fish, most commonly salmon and trout, and become tiny cysts in the flesh. If the salmon is eaten raw by dogs, the flatworm cysts pass through the stomach and attach to the wall of the dog's intestine, where they become egg-producing adult flatworms. The bacteria can now escape into the dog and can cause sickness and death within a week. So, it is the bacteria in the flatworm, not the flatworm itself, that cause the sickness and death.

The life cycle is so complicated that you wonder how on earth the bacteria and parasitic fluke evolved in such a complex fashion! And then you start to wonder how humans figured out what caused their dog's death. And how did bacteria invade the fluke that came from a salmon that got infected with larva that lived in a snail that came from another larva that emerged in the feces of a dog? Who studies that kind of thing? Tim Goater, for one, and his brother Cam, also a parasitologist and co-author of their authoritative study of parasites.[165] Fascination with parasites seems to run in the family.

Coyotes, wolves and bears are also affected by this bacterium that can kill them, along with dogs, whereas adult wolves eat mainly the head portion of salmon and seem to survive, though it is not certain if they eat only the head to avoid parasites or to ingest higher-nutrient food.[166] Infected fish are found from California to Alaska but more commonly between northern California and the Salish Sea and down Puget Sound. According to the Goaters, "Dogs that eat an infected fresh salmon die within 7–10 days if untreated. The symptoms include a high fever, vomiting and diarrhea." In dogs that recover, there is a strong life-long immunity to further infections.[167]

A short report by reader C.J.S. in the 1880 edition of *Field and Stream* suggests a method that may have been used to cure salmon sickness:

> I have been told by an intelligent settler, an employee of the Hudson's Bay Company, in the early days, that they used to give the blood [of the salmon] to their dogs on the arrival of the fish [fall run], for the purpose of making them sick. Then after curing them they would feed them on salmon for the rest of the season. He also says he has seen many dead wolves on the banks of streams frequented by fall salmon, and supposed they were poisoned by their blood.[168]

The so-called cure was "a mild physic [medicine], repeated as often as may be found necessary. Gunpowder, sulphur and salmon oil have been commonly and successfully used by the early settlers."[169]

William Elmendorf, an ethnologist who worked with both the Skokomish at the southern end of Puget Sound in the late 1930s and the Yurok of northern California, recorded that

> [w]hile American dogs often die from eating dead salmon, or dying spawned out ones, the Yurok guarded against this by feeding the pups dried (and broken-up) salmon, with a little fresh salmon mixed in. The proportion of fresh was increased until by the time the dogs were grown, they could gorge on salmon of their own finding with impunity.[170]

There could be two explanations for this protection. First, the mothers' milk might provide antibodies, providing the pups with a little initial

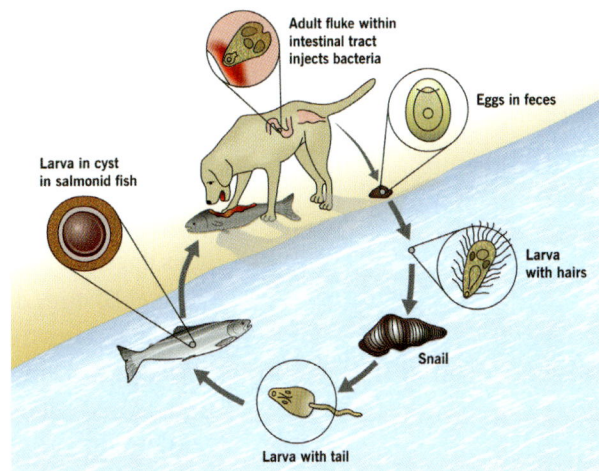

FIG 47

FIG 47 Diagram of the life cycle of the bacterium that causes salmon sickness.
Adapted by Zdenka Hofman

immunity, enough to survive the first small feedings of raw salmon. Then increased raw salmon meals gradually provoked the puppies to develop more immunity. There may also be a genetic protection that has evolved in Indigenous dogs and in wolves, coyotes and bears.

Oral History and traditions may also have been useful in preventing salmon sickness. On the west coast of Vancouver Island, restrictions were placed on dogs preventing them from eating salmon during the early run.[171] Restrictions related to timing may also help, such as the nuučaan̓uł (Nuu-chah-nulth) warning that "[t]o let dogs and cats eat fresh salmon until the butterball [bufflehead] ducks had appeared would also cause the [salmon] run to fail."[172]

Today, the cure is antibiotics, and usually, once infected, the dog's immunity prevents a second attack.

Other food would also be fed to dogs when it was plentiful and available.

Elmendorf also recorded that the Skokomish "[w]ool dogs lived in the house with their owners and were given special care and a different diet from the hunting breed."[173] Whatever they were fed, it was likely with a view to retain the softness of the Woolly Dog's coat.

Hair Analysis

Sometimes diet shows up in the animal's hair. Is it falling out, is it mangy, does it feel brittle, does it easily break or have split ends? What else can Mutton's coat of hair tell us?

Mutton's coat looks healthy. If he could talk to us, he would likely tell us he had been well fed. He can't speak, but we have his pelt and his hair and his feet. In the time-honoured tradition of animal teacher, familiar in so many Indigenous cultures, Mutton has a wealth of information to share. Every hair on his body tells his story and teaches us.

Often, an animal who experiences some sort of stress, say, an illness or short-term starvation, will record that stress in a weakness in each hair. A thinning spot will appear along the shafts of hair at the root end when the stress hits and then grow out as the hair grows. When buying a sheep fleece, it is common to test for these weaknesses by taking hold of a lock of fleece and jerking it apart. You want the longest fleece to spin a strong yarn. If there is a weak spot, the lock will split into two, coming apart where the stress caused

the hairs to thin. The weak section points to a time when the animal was under stress—closer to the root means it was a recent stress; closer to the tip of the hair indicates it occurred a while ago. Mutton does not appear to have any thin weaknesses in his hair.

Not only will the hair show visible signs of disease, stress or poor nutrition, but also written into hair and bones is a record of diet. Analysis of hair and bones reveals a terrestrial diet (e.g., meat or grains) or a marine diet (e.g., fish), and even whether more corn than oats was eaten. For archaeologists, bones and hair are like a book you can open to reveal ancient diets.

Close examination of only a few hairs can determine what kind of a diet Mutton ate. He won't be the only subject of such analysis. Sharing Mutton's Smithsonian storage drawer is the pelt of that village dog collected in 1858 from Semiahmoo. Hairs from each dog will be analyzed, and their diets compared. Did they eat the same type of foods? Did the dogs live mostly on salmon? Or were their diets different since Mutton lived with George Gibbs, a European whose own diet would be different from Indigenous people? Mutton's research team leader Audrey Lin invited archaeologist Chris Stantis to carry out a series of high-tech tests, to tell us more about Mutton and the Semiahmoo village dog.

Chris specializes in archaeological chemistry. She likes to tackle questions about ancient diets, how diets can reflect social lives and tell more of their stories and answer related questions. Her research involves using stable isotope analysis, a technique that looks at minute pieces of hair and bone.[174]

To understand this process, it helps to have a little information on how bones and hair are created. They are made from proteins; collagen protein makes bones, whereas keratin proteins make hair and nails. These proteins are made from amino acids, which are large molecules that contain mainly carbon, nitrogen, oxygen and hydrogen atoms. All this comes from the food you eat, which is made up of those same atoms.

Practically speaking, atoms are the smallest unit making up any matter. Two of these atoms are of special interest in analyzing Mutton's hair: carbon and nitrogen. It turns out not all carbon atoms are exactly the same. If you were to count all the bits that make up a carbon atom, some atoms would have twelve bits and others have thirteen bits. We call these atoms carbon-12 and carbon-13, or sometimes ^{12}C and ^{13}C if we like superscripts, but they are still carbon atoms, just different types. These different types are called

isotopes. If you could weigh the tiny isotopes, carbon-13 atoms weigh a tiny bit more than carbon-12 atoms. This makes sense as carbon-13 atoms have that extra bit. The same with nitrogen, though nitrogen has fourteen or fifteen bits. And it is these different isotopes with different weights, stored in our bones and hair, that can tell us about our diet—or Mutton's. The isotopes are like a signature of our diets, securely stored in hair and bones.

Isotopes such as carbon-13 are termed *stable* because they don't change over time. In contrast, radioactive isotopes change (decay) into different atoms. Radioactivity is a useful phenomenon for radiocarbon dating, but stable isotopes are reflective of what Mutton and other animals were eating when they were alive.

Plants evolved different ways of storing energy from sunlight, so having more (or less) of one type of atom reflects how a plant evolved to better survive in different climates. Plants growing in warmer, dryer climates have evolved to retain more carbon-13, and plants growing in cooler, wetter climates retain more carbon-12. People, or dogs, who eat plants from warmer climates, such as corn or sugarcane, are eating and storing more carbon-13 in their bones and hair. People in wetter, cooler climates like the Pacific Northwest tend to eat plants like wheat or potatoes, which retain more carbon-12.[175] Marine foods are somewhere in the middle.

Knowing how much carbon is in hair or bones, and the type of carbon, tells us about the plants that were eaten. Someone from Mexico would eat more corn than someone in the Pacific Northwest, and this would show up in their hair and bones. So carbon can tell us where the food plants were grown. Chris can analyze the dogs' bones and hair, and coax Mutton and the Semiahmoo village dog to teach us about their diets. Did they eat the same diet, or were their diets different, given that Mutton lived with an American man while the Semiahmoo village dog would probably have eaten traditional food?

Nitrogen levels can also tell us about the food chain and where in the food chain the food came from. Start with the tiny phytoplankton in the ocean, at the bottom of the food chain. It is eaten by something larger, like krill or shellfish. The food level is now one level higher. At each level more nitrogen is found, so the krill has more nitrogen in its body than does the tiny plankton. Then something eats the krill, say, a small fish. This is now a higher food level, and the small fish has more nitrogen than the krill. Then a larger fish eats

the smaller one, and then a seal eats the larger fish, then an orca eats the seal. Each time the food chain is getting built up, level by level, and the nitrogen levels are getting higher and higher.

On land the food chains are more compressed; for example, a deer eats plants and wolves eat deer, but there aren't many animals that eat a wolf. Perhaps a bear. So, terrestrial food chains are shorter and have less nitrogen-15 than the longer food chain of marine mammals. At the top level of a marine food chain, mammals have much more nitrogen. Thus, nitrogen is useful to distinguish not only the food chain but also between marine food sources and terrestrial ones. High levels of nitrogen point to marine-based food, and low levels indicate terrestrial plants.

Chris looks separately at bone collagen from the dogs' feet and at hair from their pelts. She starts with the bone samples. To measure the amount of carbon and nitrogen atoms, Chris takes a few very small samples of bone collagen and puts them in a machine that weighs the different isotopes and the ratios between the isotopes of carbon and nitrogen. Depending on the ratios, she can tell what Mutton and the Semiahmoo village dog ate.

Other ancient dog bones from the Pacific Northwest have had their bone isotopes analyzed, and Mutton and the village dog can be compared to them. Chris plots the results to see if they match or differ and also includes a deer in her testing, to represent an animal that eats only terrestrial vegetation (in essence, a terrestrial herbivore). Mutton would have eaten a mixture of marine and terrestrial foods, in other words, fish like salmon and meat like deer.

The Semiahmoo village dog is very similar to other ancient dogs from British Columbia, and he too shows high nitrogen-15, which indicates a food higher in the food chain, high enough to be marine and higher, with medium carbon-13 values, which would be typical of being fed fish. Freshwater fish would not show a marine diet component, so the fish was probably salmon, as salmon is the only marine food found away from the coast, along the Fraser River, for example, at Keatley Creek or Cathlapotle up the Columbia River, both places where other ancient dogs have been found and analyzed.[176]

Researcher Alejandra Diaz, who studies diets, diet changes over time and resource usage of pre-contact people along the Fraser River, completed a PhD thesis focused on isotopes from dogs found in archaeological sites along the Fraser River in British Columbia. She included isotopes from sulphur, as well as carbon and nitrogen. Sulphur isotopes can distinguish between freshwater

fish like trout and marine fish like salmon. She found dogs from even far up the Fraser River had a high marine diet from salmon.[177] So Woolly Dogs (and village or hunting dogs), even those far from the coast, ate mostly salmon for most of their lives. For dogs, not natural fishing animals, to have so much of their diet from salmon means throughout their lives they were consistently supplied with food by humans.

But not Mutton. He proves to be an exception.

The takeaway is that the Semiahmoo village dog sharing Mutton's storage drawer ate a diet very similar to other Indigenous dogs, yet Mutton's diet was different, reflecting that Gibbs probably fed him whatever he himself was eating—a mixture of fish and game—whereas village and hunting dogs ate almost exclusively salmon.

This technique of looking at marine vs. terrestrial diets was also used by Rick Schulting, a researcher at Simon Fraser University, in 1994, when he was analyzing a blanket found along the Fraser River near Yale, where Simon Fraser recorded his sighting of Woolly Dogs in 1808. Schulting looked at the carbon-13 in the hairs of that blanket and compared them to some of the ancient dog isotope analysis done earlier; they too matched with what seems to be a typical dog diet of mostly salmon. Schulting showed that the fibre in the blanket was almost 100 per cent from the same species of animal, that the fibre was not a mixture, and that it came from a species with a marine diet.[178]

In the Pacific Northwest, only two animal fibres were plentiful and could be spun: mountain goat and Woolly Dogs. Although Schulting's analysis does not prove directly that the fibre in the blanket he studied comes from dogs, it does tell us two important facts. First, it is almost impossible that mountain goats fed on salmon or another marine source of carbon in this area, given that they are herbivores and live at higher altitudes. Mountain goat hair would produce isotopes very similar to deer, since they eat local plants lower in carbon-13 with no meat to enrich their nitrogen values. With mountain goats ruled out, Woolly Dogs are left as the likely source of fibre.

Domesticated dogs typically eat what their human owners eat. In the Pacific Northwest, salmon was a staple of human diet, and dogs would either be fed food that their humans ate or would scavenge it, so the village dog shows a diet from marine sources, whereas Mutton shows a terrestrial diet.

Bones grow very slowly compared to hair, reflecting years' worth of diet, averaged and accumulated over those years. Bones are replaced, but

slowly—think of a broken bone and how slowly it heals—so the bone sample tells us about the diet throughout much of the dogs' lives. Hair is much shorter lived. It grows a little longer every month, just as Mutton's hair did. The hair samples are useful when looking at the short time span when the hair grew.

The nitrogen samples in the hair reflect those of the nitrogen in their bones, meaning the diet of these two dogs was stable throughout their lives, not just during the shorter time it took for the hair to grow. Taking that longer overview, the village dog ate mostly a marine diet and Mutton a terrestrial diet. So, the nitrogen analysis tells us the village dog and Mutton ate different diets and that this was pretty much the same throughout their lives.

It is the hair sample analysis of carbon that proves to be the most interesting, and the most mysterious. Chris cut the hair into six segments for Mutton and five segments for the village dog, as his hair was shorter. Mutton's hair grew much faster than the village dog; after all, he was bred to have fast-growing hair. Remember that the village dog was not sheared, so his hair likely represents a year's growth, whereas Mutton's hair reflects growth from his last shearing—maybe up to six months of growth.

Keeping track of which is the root end (the newest part of a hair), which is the tip end (the oldest) and where the other pieces are located along the hair is essential in this analysis. In doing so, Chris should find if Mutton's diet changed over the lifetime of a hair. And she does!

Humans will cut their hair every now and then as it grows, as well as shedding some hairs throughout the year. In the dog world, some dogs shed all at once, some dogs shed throughout the year and some dogs don't seem to shed. The Semiahmoo dog probably shed throughout the year, but Woolly Dogs, which were bred for long hair, had a faster hair growth rate. Certain breeds shed in the spring and in the fall, especially those with long, warm, woolly hair, as they would need to shed the winter coat to grow a lighter summer coat. We do not know for sure how often Woolly Dogs shed, but shearing took place at least once a year. Oral History from some villages suggests twice a year.

On August 19, 1859, when Caleb Kennerly was upset that Mutton had chewed the skeleton of a mountain goat specimen destined for the Smithsonian, he wrote, "Mutton was sheared a short time ago, & as soon as his hair grows out we will make a specimen of him."[179]

We can assume Mutton was sheared sometime between June, as reports from explorers and travellers suggest, and August 19, likely before the end of July 1859. Gibbs could perhaps have sheared Mutton himself, but what would he do with all that dog hair while he was working and having to travel light? He would have had no use for it himself. The shearing was most likely to have occurred when Gibbs was near a Coast Salish village, where the women would know how to shear him.

In June and early July, Gibbs was working between Chilliwack (where he acquired Mutton), along the Chilliwack River, and Lake Chilliwack. At the time there were many villages along his route, so it is likely Mutton was sheared in June or early July.

In the back of my mind, I am still wondering about Mutton and that supposed packing date of September, meaning he must have died in August or September. Perhaps his hair can provide a hint of when he died. His hair is, on average, five inches long. We do not know how quickly Mutton's or any Woolly Dog's hair grew, but given the length of his hair, and given what we know of when he was sheared, we can assume Mutton's hair represents a minimum of four and a maximum of six months' growth. This means Chris's hair segments, divided into six pieces from one hair, probably each represent three to four weeks of hair growth. We cannot make the same assumption with the village dog, as he wasn't bred for his hair. He has short hair and it probably shed naturally, throughout the year, and we don't know how quickly it regrew. However, these samples show a timeline of both dogs' diets.

For the village dog, over the unknown lifetime of his hair, his diet remained the same. But for Mutton, if each sample shows approximately a month of growth, we could guess that back in June/July his carbon-13 levels were much higher and then fell over the months to November/December.

This creates a mystery. Mutton's hair seems to indicate a diet rich in foods from a warm, dry climate, food like corn or molasses, with the oldest segment, the tip, having the most concentration. Over the four to six months, less and less of that warm-climate food emerges in the analysis until by the root of the hair Mutton's diet reveals more of what his bones record—that for most of his lifetime he was a terrestrial omnivore, feeding on meats such as deer, with marine sources of food such as salmon. So where did this warm-climate food come from?

Mutton's Diet

Chris emails me with a question. "What was Mutton eating?"

To answer this, I need to know where Mutton was. Since Mutton was with Gibbs, I need to know where Gibbs was and where he procured his food.

Did Mutton eat corn? If Gibbs ate corn in some form or other—like Johnny cakes—then likely he also fed Mutton corn, but where would Gibbs get the corn? It would have had to be imported from the south. At the time, perhaps June and July 1859, when Mutton's carbon-13 levels were highest—meaning Mutton was eating a lot of corn—the nearest stores were the HBC trading forts Fort Langley and Fort Hope, along the Fraser River.

According to Dr. Lorne Hammond, curator of history at the Royal BC Museum, who studied the fur trade, HBC forts would stock dried salmon, potatoes, beans, venison, pork, beef, ducks, geese—but not corn. However, US Army forts would stock corn and molasses, as they were standard issue ration. The US Army provided supplies to the NWBS team, and these supplies were kept at various depots to support the team. There was a depot located at Chilliwack, where Gibbs and Mutton were that summer.

A US Army fort was being built at Fort Colville, east of the Columbia River, and that is exactly where Gibbs, and perhaps Mutton, ended up in December 1859, right when the newest hair sample (the root) shows no corn or molasses (or other warm-climate plant source).[180] This is the opposite of what we expected. They should have had corn and molasses there, but Mutton's hair does not show he ate any while there.

This was getting complicated, so I plotted out where Gibbs (and probably Mutton) were from April 1859 to December 1859, and came up with a map outlining their journey. From January to May, they were back and forth between Camp Semiahmoo (base camp), Sumas and Chiloweyuk. June was spent mostly in the Chiloweyuk Depot area (see Figure 48).[181]

A US Army camp was stationed on the coast at Camp Semiahmoo in 1857 to provide protection and supplies for the NWBS team. This camp would have supplied the survey crew by ship or mules.

In 1858, a rough trail led from Camp Semiahmoo through to Fort Langley on the Fraser River, 14 miles away, but supplies could be easily shipped from Camp Semiahmoo, around Point Roberts and up the Fraser River to the Chilliwack Depot. Water was much easier to navigate than rough trails. So, if the US Army had corn and shipped it to the Chilliwack Depot, this might explain the high levels of corn showing up in the tips of Mutton's hair.

A possible answer is offered to us by a fellow member of the survey team, one Joseph S. Harris. Hired as an astronomer for the NWBS, this is the same young man who so admired George Gibbs, describing his multitude of skills in a letter to his brother. Harris wrote many letters to his family back in Pennsylvania about his life out west. Two letters to his family seem to address the mystery of the corn.

On July 2, 1859, at Camp Chuch-che-hum (southeast of Chilliwack Lake), Harris reports they picked up supplies on their way to Camp Skagit. They ate well:

Fried mush [cornmeal boiled until dry, then sliced and fried] & molasses, buttered toast, biscuit and coffee formed the breakfast staples. Ham and bean soup is an inevitable dinner dish, but preserved corn and tomatoes, potatoes, grouse and groundhog help out the bill of fare; Apple pie Duff or Indian pudding [cornmeal, molasses and spices] ends the repast.[182]

This could solve the mystery of where the corn came from. Gibbs and company, and evidently Mutton, judging by his hair, seemed to eat corn and molasses for breakfast, probably lunch, and for dinner. Mutton snacked on Johnny cakes, mush and pudding—all made with corn!

A second letter from Harris, dated December 19, 1859, after he arrived at Fort Colville, sheds light on the lack of corn in Mutton's later meals: "There are quite a number of cattle here, which keeps us always supplied with fresh beef... I have been intending all summer to have, when we arrived here, the mush breakfast cakes that I used to be so fond of at home. But unfortunately, the cornmeal has given out and it can't be done."[183]

So it seems that Fort Colville was out of corn, and it was winter. Supplies were limited to what was on hand—beef. The lack of provisions is noted by Harris, who later wrote that some of the men suffered from scurvy.[184]

If we assume Mutton was not, in fact, dispatched in September, as the packing list suggests, and that by December he was still alive, then knowing where Gibbs and Mutton were, and having first-hand information of their diet, helps explain the isotopes for high levels of warm-climate plants in Mutton's hair tips and low levels at his hair roots. Clearly, Mutton feasted on corn several months before he died.

Matching up Gibbs's known locations with Mutton's diet of corn (or lack thereof), according to his hair isotopes, shows that in December Mutton likely

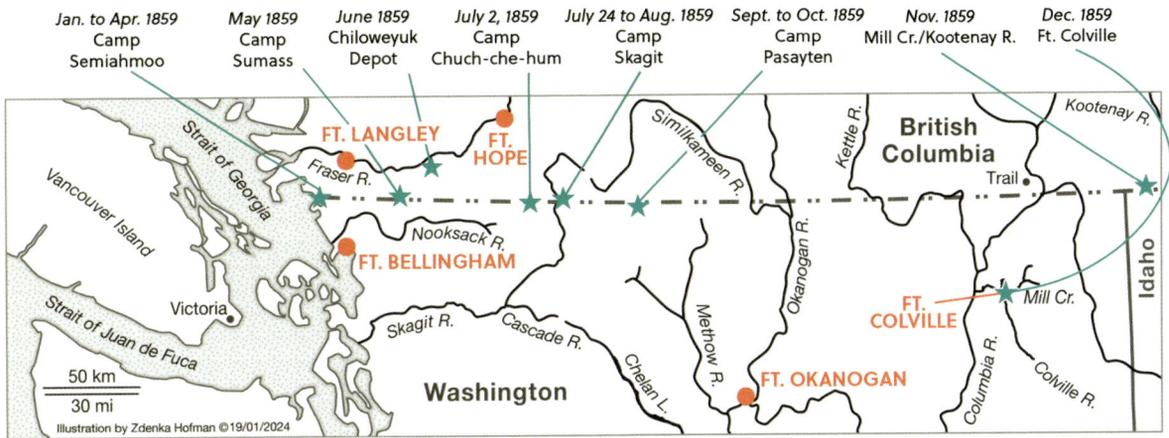

Jan. to Apr. 1859 Camp Semiahmoo · May 1859 Camp Sumass · June 1859 Chiloweyuk Depot · July 2, 1859 Camp Chuch-che-hum · July 24 to Aug. 1859 Camp Skagit · Sept. to Oct. 1859 Camp Pasayten · Nov. 1859 Mill Cr./Kootenay R. · Dec. 1859 Ft. Colville

FIG 48

FIG 48 This map outlines the various locations where Mutton and George Gibbs spent January to December 1859.[185]

Map by Zdenka Hofman and Harry McKeown

reached Fort Colville, where we know Gibbs also was, and that the fort had run out of corn by then, which is reflected in the root section of Mutton's hair. The tip of his hair, on the other hand, shows a diet high in corn or molasses, which is consistent with where we know the men were at that time—and with them eating corn two or three times a day.

We know from Harris's love of corn that Mutton had access to corn in June and July and into August, and corn started to run out in late September and had run out by December when everyone was at Fort Colville. The hair isotope analysis of Mutton's diet matches Gibbs's location and the timeline. It's likely that Mutton was in Fort Colville, where they had run out of corn, and according to Gibbs's journal, that was in December. Mutton's hair near the root (newest growth) showed no corn. The tip of his hair, on the other hand, showed high levels of corn, which according to Harris and his love of cornmeal, placed them at Camp Chuch-che-hum in July. Could it be that Mutton died sometime in December and the so-called packing list was created well before he was "packed," and well before he died?

The isotopes in both the hair and the bones tell us that Mutton had a different diet from his drawer companion, the village dog, and all other ancient dogs (Woolly Dogs included) found on the coast or way upriver where salmon runs supplied food with marine isotopes.

With the help of sophisticated scientific analysis—of carbon and nitrogen isotopes, and with microscopic analysis to hand—Mutton's importance as animal teacher only increases. He is leading us toward deeper understanding of his breed and more sympathetic understanding of his own background representing Woolly Dogs, who were quickly disappearing during his lifetime.

THE IMPACT OF COLONIALISM

MY GRANDFATHER [Ed Sparrow, born in 1898] *watched my grandmother Spahqia [and] Thelekwutun's wife Selisya [see Figure 65] all working on these blankets. He said, "I didn't know what they were doing is getting me ready for my naming. They were working on big piece you know, not like yours. You guys have small pieces. Big pieces," he said. "And big balls of wool they'd already worked on."*

I said, "Oh, what was the wool made out of?"

He said, "Mountain goat, and those dogs that they kept in pens." Then he tells me they took him to his great-grandfather's longhouse and they pass the name to him there and they prepared him and wrapped in the blanket and started the work [of giving him his name] and he said it [weaving blankets] was never done again after that.

Some of those Elders were in residential school and didn't get the chance to carry any more customary knowledge. And they feel bad about it because they don't have what my grandmother taught to me because they missed it when they were forced into school. You have to remember, residential schools created huge gaps in our histories and memories, and the families and the children suffered. Of course there are exceptions where people kept the knowledge going.

DEBRA QWASEN SPARROW, WEAVER, MUSQUEAM

EVERYBODY DIED FROM *smallpox, except my great-grandmother, Mrs. Vedder. But her two sisters died. And so, my great-grandmother Mrs. Vedder raised those two boys with her own children.*

The people that wanted Canada were the true colonizers. That's the way. What they do to every country they colonize. They make it patriarchal. They break down the local jurisdiction, the government, the local governments, everything, and change it.

In the old days when a man married, he had to move to his wife's village. That was the way. It didn't change until the church came in and said no, when a woman marries, she has to move where her husband comes from. The husband is the head of the household.

 Each village, each family, have their own little differences, and the women are the ones that have the children, and they teach their children.

 But if we take these women out of the village and move them somewhere else, they're out of their element and they're living with other people who don't think the way they do. And so this is what they did to colonize us. They just mixed us all up and no one knew who they were, what their bloodlines were. And so no one knew anything anymore, the history and their stories and names and status. Everything was all mixed up.

 And then the men start marrying non-Indians and bringing them into the villages and then, everything gradually changed to European because the white women are very strong. They want their way and things done properly according to them, and the native women just keep quiet because if they are too pushy and demand too much, they're going to get fined or they're going to get put in jail.

 So here we are and that's why we lost everything.

The worst thing that they did, the smartest thing they did, was bring in alcohol. Because once a man got hooked on alcohol, the women couldn't do anything anymore. They were helpless and they were being abused.

Yeah, people won't talk about it. No. They were not allowed to keep the wool dogs because that showed signs of authority and high breeding. The women that had dogs were highborn women, and as long as the dogs were there, this reminded the people of who were highborn. They were just either told to get rid of them or they took them. I don't know.

After they took the dogs, and what could they do? They only had the mutts that were left around. The ones that they kept for the wool were no longer allowed. And they were the ones that had the long under-wool.

They were told they couldn't do their cultural things. There was the police, the Indian agent and the priests. The dogs were not allowed. She had to get rid of the dogs. And so the family never ever saw them.

Our people were not allowed to spin like on the shxwqáqelets. What do you call it? Yeah, the spindle whorl. They could spin on a European one but not on the shxwqáqelets.

They couldn't use their looms, and they would take them out and burn them or they would give them to museums or collectors or whatever.

If they caught you making baskets or digging roots or preparing anything like that, then you would get fined. And if you couldn't pay the fine you went to jail.

So everything came to a halt. Everything. The singing, the dancing, the drumming. We were not allowed to have any of those things.

The blankets were not allowed and the feather garments that were made for dancing. They were not allowed; they would collect them all and burn them, or they would sell them.

The generation that was there when the Europeans came and colonized us, that's where it ended, and there was just a few people who sort of went underground. And my grandmother and my mother were two of them.

We had a smokehouse on the north side of Sumas Mountain. And right on the shores of the Fraser, there's no roads going there, only their railway. And that's where I learned. That's where I learned to spin and make blankets and do basketry. And you just turn the shxwqáqelets like this [on your thigh]. I had my own shxwqáqelets. My grandmother had to make one for me. We use it when we're at the smokehouse down by Devil's Run [Liyómxetel] because we'd be in jail if we're caught with it. I learned everything I had to that they could possibly teach me.

Because I was a carrier. The hereditary carrier of the knowledge, the history and the culture, the protocol, everything. I had to carry to the next generation, and so I had to be taught.

XWELÍQWIYA RENA POINT BOLTON, ELDER, STÓ:LŌ

◇◇

I'VE HEARD THAT THEY [wool dogs] were deliberately taken from the area and killed off to make way for I believe Hudson's Bay blankets. That was just one way for the natives to rely on something else versus, you know, creating their own. I heard this from my late teacher.

DANIELLE MORSETTE, SUQUAMISH AND SHXWHÁ:Y (STÓ:LŌ NATION)

THE COAST SALISH WOOLLY DOG reminds us that his presence is not a benign historical fact. There was brutality of colonialism that led to extinction of our Woolly Dog. Gibbs and his contemporaries were players implicated in this fact. What if colonialism was not so brutal? Would Woolly Dogs still be here? Laws associated with the Indian Act meant Indigenous Nations could not vote federally until 1960 and our cultural, spiritual and land-based laws and governance practices were outlawed with punishments ranging from fines to imprisonment to public hangings. The law drafters targeted our ways of governance woven into land and place(s). Reservations and residential "school" institutions cut us off from sources of culture and livelihood, from our "vitality" and our sharing and enacting of the depth of our knowledges, tearing our families apart physically, mentally, emotionally. Our spirits and our spirituality persisted, however, maintaining our inner structures upon which the rest were attached. This is why we are continually and currently able to restructure, recover, return (to our lands and waters), restore and re-story our teachings and practices in the ways we are today in governance, in art, which are intertwined.

KERRIE CHARNLEY, Xʷə́LMəXʷ, PIERRE FAMILY, q̓íc̓əy̓/KATZIE

THE PEOPLE WHO WERE *caring for the Woolly Dogs also confronted the racism and discrimination of the non-Natives, particularly Indian agents, and they killed the dogs. They didn't want the dog producing wool or the people maintaining traditional practices that would prevent their "civilization." Myron Eells [missionary, 1843–1907] writes down that one way to cheaply civilize the Indian was by dressing them in non-Native clothing. Yeah, to be a civilized Indian, you'd wear European or American clothing. However, if you wanted to be a real Indian, it would be important to put on traditional wool woven regalia, particularly if an individual was high class. The Indian agents during the early stages of colonization didn't want me to maintain my identity. He didn't want me to speak my language, didn't want me to wear my clothes. He wanted me to wear his clothes, wanted me to have his identity, wanted me to be civilized in his eye.*

MICHAEL PAVEL, ELDER, SKOKOMISH/TWANA

HUNTING BECAME ILLEGAL. *Fishing became illegal, so it was definitely systematic, but during those times it was kind of almost, a by-product, the result, that because we couldn't feed the dogs our diet, of things that we've hunted for ourselves or fished.*

There are different ways. They didn't directly say in all communities, "no dogs allowed," but as a result of no fishing allowed, you're not allowed to hunt. So I see colonization being this indirect impact on how dogs were maintained.

It wasn't like "no one can have more than one dog," like there's no dog rules necessarily, but it was impossible to do any of that with everything else that is going on.

SENAQWILA WYSS, SḴWX̱WÚ7MESH ÚXWUMIXW (SQUAMISH NATION)

I DON'T REMEMBER specifically anything about how the Salish wool dog went extinct in Snuneymuxw [Nanaimo], and it's always kind of been really interesting to me too, because I know how significant they were to us and I understand their place within our socio-economic practices.

A lot of what I see from looking online says like, "Oh well, it became more convenient to use sheep's wool," so these dogs just went extinct. Well, that's one way of looking at it, but I don't think that really would have been the case, because these are really cherished dogs to us, and that it would have been more convenient or whatever, that doesn't really align with my understanding of our practices and our culture.

I think about when if we're preparing cedar boughs for ceremony, it's really critical that you harvest them before sunrise. You could harvest them anytime around the day, but to us, it's imperative that you do this work in a really specific way, and the protocol is followed. So even if it's less convenient, that's where the energy to it comes from for us.

And so with using the dog wool or the mountain goat wool, as opposed to sheep's wool that could have been purchased in bulk or whatever, I just think that it doesn't really make sense to me, and I think that there's probably more to what was going on, whether it was all of the impacts of colonization, and I also think that in this case specifically, with the wool dogs, the impacts of the smallpox epidemic probably can't be understated. Where in many communities only one in ten people survived, and I can only imagine that it's difficult enough to keep your loved ones alive, never mind that the animals that you keep and maintain. That probably had a devastating impact on the wool dog population as well. And then the ongoing erasure and suppression of our culture.

ELIOT WHITE-HILL KWULASULTUN, ARTIST, SNUNEYMUXW

9 PROCESSING WOOL

DOG HAIR FLEW all about me, causing me to sneeze. Thousands, or so it seemed, of soft hairs were in the air. The slight breeze lifted them out of my hand as I grabbed a handful to look at it. I knew now why the husband of the dog owner had laughed in disbelief when I had asked for some of his Samoyed dog hair to spin. "Tell her to fill her boots," he chortled, shaking his head.

I wondered if perhaps Paula Gustafson, the author of the book *Salish Weaving,* was right—"Canine hair, no matter from what breed, is not a good spinning fibre."[186] Yet despite my inability to control all the hairs flying about, that statement just didn't make sense. I was beginning to suspect Gustafson didn't know dogs as well as she knew weaving. A short-hair terrier has totally different hair from a Samoyed or an Alaskan malamute or a Coast Salish Woolly Dog. Perhaps she had tried to spin the hair of a short-haired silky-haired dog? A challenging handful of Samoyed hair? And to be fair, at the time Gustafson was doing her research, she had never heard of Mutton, let alone seen his woolly hair.

Thousands of years of careful breeding for the wool also meant thousands of years carefully accumulating the knowledge of how to use that wool. I just needed to learn the correct way to process the hair.

Plucking, Shearing and Combing

"Mutton was sheared a short time ago, & as soon as his hair grows out we will make a specimen of him," wrote Caleb Kennerly on August 19, 1859.[187] Although we don't know exactly when, we do know that Mutton's wool was harvested.

The first step is collecting the wool from the dog. There are a couple of Oral History accounts indicating that the dogs' wool was collected twice a year.[188] One Quinault man recalled the hair would grow to around 3 inches and "they were sheared each time the hair attained its full length, usually twice a year."[189] For double-coated breeds like Mutton, they often naturally shed or "blow" their coats twice a year, in the spring around May through June to shed their thick winter coat and then again in late fall to shed the thin summer coat and allow the thick winter coat to grow in. If this was the case with Mutton and the other Woolly Dogs, and the hair did a twice-yearly natural shedding, then the hair at the root would stop growing and would thin to a natural breakage point before being pushed out of the follicle by the new hair. This would mean it wouldn't require much to "help" the shedding process. The dogs' natural inclination to shed would make it easy to harvest the wool at those times.

If Mutton had been sheared around June, and if indeed he shed twice a year, then he would be due to be sheared again around November, just in time for the winter coat to grow and thicken. Traditional history also describes some dogs being either sheared, plucked or combed.

Plucking was commonly done to the hides of mountain goat.[190] The pelt was removed from the goat, moistened with water and rolled up while damp. After a few days, the skin would loosen, allowing the down wool and hairs to be pulled or plucked from the skin.

With dogs with a down undercoat and therefore a natural shedding time twice a year, the wool would easily come away from the skin, so plucking could easily be done. Paul Fetzer, a PhD candidate at University of Washington, interviewed Agnes James of Nooksak in 1950 and wrote, "Dogs were plucked twice a year. Hair not cut off, the little dog would be squeaking."[191]

In 1964, Oliver Wells, a local farmer and amateur ethnologist near Chilliwack, interviewed Mrs. Amy Cooper, of Soowahlie, who recounted to him the plucking process as she had heard from others: "Yeah, in the spring, you know, when they begin to molt, take off their winter wool? Well, they just knew what

time. And she says that every time … you pulled one, poor little doggy there would 'week, week, week'; and then she says that she'd sing along with the dog there."[192]

Wells also interviewed Harry Edwards, in October 1964, who recalled the Cheam people (east of Chilliwack) would keep dogs and shear them. Shearing could mean using a sharp-edged tool (e.g., mussel shell) and your thumb to grab locks of hair and twist, pulling the hairs out by the root if the hair was starting to shed. If, however, the wool was harvested outside of the shedding time, then cutting or shearing the wool would be necessary, using a sharp edge to cut it as described by one of anthropologist Ronald L. Olson's Quinault informants in the 1920s: "The shearing was done by holding a tuft of hair at a time and cutting it close to the skin with a carefully sharpened mussel shell knife."[193]

According to Erna Gunther, an anthropologist at the University of Washington, the Snohomish also raised dogs (*sqe'xa*) exclusively for their wool, as did the Klallam. "For shearing, the dogs' forelegs were tied together, and the wool was cut with a stone knife."[194]

Diatomaceous Earth

Many communities spoke of using white clay for cleaning the wool, as did early visitors. Paul Kane, the artist visiting the Coast Salish areas of Puget Sound and Fort Victoria in 1847, wrote, "The hair is cut off with a knife and mixed with goose down and a little white earth, with a view of curing the feathers."[195]

Similarly, the American Indian agent James G. Swan, writing in the 1860s about the "Cape Flattery Indians" (Makah) of northwest Washington State, observed that after the wool had "been sheared off, [it] is packed away with dry pulverized pipe clay, for the purpose of extracting the oil or grease. When a sufficient quantity has been obtained, and has remained long enough in the pipe clay, it is carefully picked over by hand, and beaten with a stick to knock out the dirt."[196]

Whereas Kane suggests the white clay was used to cure the feathers and Swan suggests it was used to extract the oil from wool, they agree that it was used in preparing the fibres for the spinning process.

In 1890, twenty years after Swan, anthropologist Franz Boas, in writing of

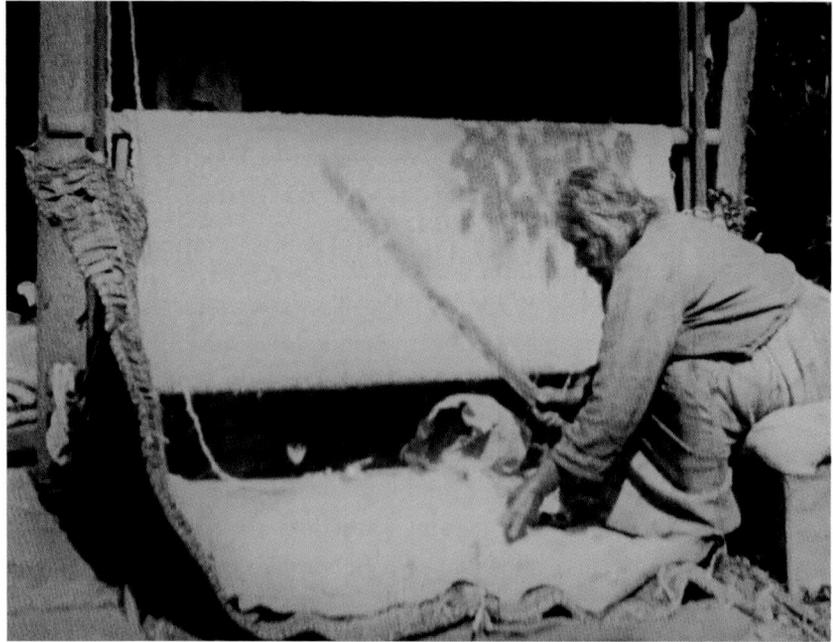

FIG 49

FIG 49 A still image from a 1928 film by Harlan I. Smith shows Skwetsiya, a Squamish woman also known as Mrs. Harriette Johnnie Haksten, pounding diatomaceous clay into the fibres before spinning them and weaving them into the blanket.
Canadian Museum of History

the Songhees (Lekwungen) Coast Salish group on southern Vancouver Island, described in detail the preparation of wool, but he made no mention of feathers, just wool:

> The hair which is to be spun is first prepared with pipe-clay (*st'a'uok'*). A ball, about the size of a fist, of this clay is burnt in a fire made of willow wood; thus it becomes a fine, white powder, which is mixed with the wool or hair. The mixture is spread over a mat, sprinkled with water, and for several hours thoroughly beaten with a sabre-like instrument until it is white and dry; thus the grease is removed from the hair.[197]

Ts'umsitun, a Puneluxutth' (Penelakut) man who lived in the village of Hwts'usi, south of Chemainus on Vancouver Island, described a certain black clay used in the preparation of the fibres:

> Now, first, to make these blankets, the Indians used to take the hair of the skin of mountain goats. Then they got a black mud. There is a place I know of… where in the old days the Indians used to dig this mud. I only know of this one place, and the Indians would come from all parts to get it. It is very, very black and sort of greasy when you rub it in your hands. Well, they made this mud into balls, then they made a little hole and in it they

put a fire of alder. When the fire was red and very hot, no flames, they put sticks across the top of the hole, and between the sticks they put the mud balls, and kept turning them round and round to bake. As they baked, they got white until, when they were quite baked, they were as white as snow.[198]

Boas also mentions another use of this white "pipe clay": "Burnt pipe-clay is used for cleaning blankets. The clay is spread over the blanket, sprinkled with water, and then thoroughly beaten."[199] This suggests the white clay was used for finished textiles and not only in the preparation of wool for spinning.

James Teit, an anthropologist who worked with Franz Boas, quoted Boas's description of Songhees wool preparation and noted that the Lillooet people also used this white clay, or "pipe clay," in the preparation of fibre. All these reports indicate a fairly wide geographic spread of Coast Salish First Nations who used white clay, from the east as far upriver on the Fraser River at Lillooet to the west coast of the Olympic Peninsula at Quileute and many places in between, including Vancouver Island and the Puget Sound area.[200]

The "white clay" or "white earth" or "pipe clay" is known as *diatomaceous earth*—a layer of earth that is made of a deposit of diatoms. A diatom (hence the word *diatom-aceous*—"of, or pertaining to diatoms") is a tiny creature, so small you need a microscope to properly see it, and is typically found in plankton. These tiny creatures have an external skeleton made of glass (silica). Aside from humans, these are the only organism in the world that live in glass houses! Some of these houses have ornate patterns, such as circles or stars or segmented rectangles, each species having its unique architecture. They live in water. Different species of diatoms prefer different water conditions. Some varieties like saltwater, others need fresh water, some like clear running water, others happily live in muddy swamps, and some prefer warm water just as others survive only in cold water. I mention this because diatoms can tell you what the environment was like thousands of years ago just by the shape of their glass architectural skeletons.

When the diatom dies, the dead plankton drops to the bottom of the lake or sea, where the inside body dissolves, leaving the outside glass skeleton. Over hundreds of years, layers accumulate, forming a white to off-white rock that is easily crumbled when dry and resembles clay when wet.

During the last ice age, glaciers covered parts of British Columbia and Washington State. This roughly covers the area of Coast Salish territories. When the ice started to melt, glacier lakes formed under them, providing

some species of diatoms to flourish—those that like cold, mostly still, fresh water. It took thousands of years for these glaciers and then glacial lakes to disappear, but the diatom skeletons remain in the depressed areas left behind by the glacier lakes. These layers can often be seen not too far below the soil covering them or along stream beds where the banks have eroded, exposing the black, grey or white remains of the layers, depending on how much organic material was mixed within the diatoms.

It is the organic material that needs to be burned out of the diatomaceous mass, changing the colour to white when the organics are burnt off and only the diatoms remain.

Unlike clay, diatomaceous earth doesn't absorb water and swell; it stays the same size, though the water might be absorbed within the hollow skeleton. Once the organics are burned out, the diatomaceous earth can be easily pounded into powder that feels like talcum powder, soft and slippery. Once burnt or dried, a ball of clay will be heavy, but a ball of diatomaceous earth will be noticeably lightweight.

The diatoms are not only lightweight but hollow, allowing water, oil or grease to fill the bodies, thereby absorbing any oil and grease and making mountain goat or dog wool cleaner and whiter.

Mountain goat wool is sticky with grease, making it hard to spin, dog wool doesn't have as much oil, but adding diatomaceous earth to either of them makes them easier to spin by not only cleaning and removing the stickiness, but also adding a smoothness by coating tangled wool. Much in the way hair conditioner added to our hair makes combing easy, diatomaceous earth makes the spinning easier and more uniform with not as many clumps of fibre accumulating in the yarn.

Cleaning, whitening, removal of oils and grease, and making wool easier to spin are not the only uses of diatomaceous earth. Remember Boas's comment about sprinkling it on finished blankets? Yes, it would clean those blankets, as would washing them in warm water, but it turns out there is another reason.

In *Working with Wool: A Coast Salish Legacy and the Cowichan Sweater*, Sylvia Olsen, who married into the Saanich Tsartlip Nation, asserts that diatomaceous earth was added to fibres as a natural insecticide.[201]

Those microscopic glass diatoms are harmless for humans to ingest; diatomaceous earth is, after all, used as an ingredient of makeup and even toothpaste. It is, however, fatal for small insects. There are two suggestions

about why this is: either the hollow skeletons absorb all the fluid from insects, dehydrating them, or the microscopic diatom skeletons are sharp, piercing the exoskeletons of creatures such as fleas and thereby killing them.[202] Available at gardening shops, diatomaceous earth in its dry form can be used to prevent infestations of insects and slugs, but it does take time to be effective.

When Kane wrote, "The hair [of the dog] is cut off with a knife and mixed with goose down and a little white earth with a view of curing the feathers,"[203] and, similarly, in Swan's description, "[When the dog wool] has remained long enough in the pipe clay, it is carefully picked over by hand, and beaten with a stick to knock out the dirt,"[204] they are both probably referring to the amount of time diatomaceous earth takes to act as an insecticide and kill bird mites, fleas and other small insects found in feathers or dog wool.

So this extraordinary "white clay" (diatomaceous earth) performs a very useful list of functions in processing mountain goat and dog wool, and for feathers. But the story doesn't end there.

Xwelíqwiya Rena Point Bolton, a Xwélmexw (Stó:lō) weaver and matriarch who was taught the traditional craft skills by her mother and grandmother during the Depression, and whose great-grandmother Th'etsimiya kept Woolly Dogs, noted that "the clay" cut down on the oily lanolin of the goat wool. Further, she describes, with a weaver's knowledge of details, the mixing of a white clay with wool fibres for an additional purpose:

> The Steqó:ye Wolf side of my family specializes in types of weaving in wool: the Tii:t side of the family from upriver made fine, fine weavings of mountain goat wool mixed with dog hair … The Wolf women of the family in Semá:th [Sumas] have specialized in a kind of twill weave called swox'wath. Swox'wath is not just the twill weave; it is also the way the fibre is prepared. Small feathers and feather down are mixed with mountain goat wool and dog hair. This is all then mixed with fine white clay and a bit of water. Then it is spun out on a spindle whorl while it is still wet. The wool strands were sometimes strung out across the Big House, or up to the smokehouse and back down. It took two women to do this. Then when the strands have dried, you would shake out the clay and have a beautiful feathery yarn. This was the work of the Semá:th Steqó:ye people.[205]

This "fine white clay" (diatomaceous earth) provided the cleaning aspect and made the fibres easier to spin, but it also seems to be useful for keeping

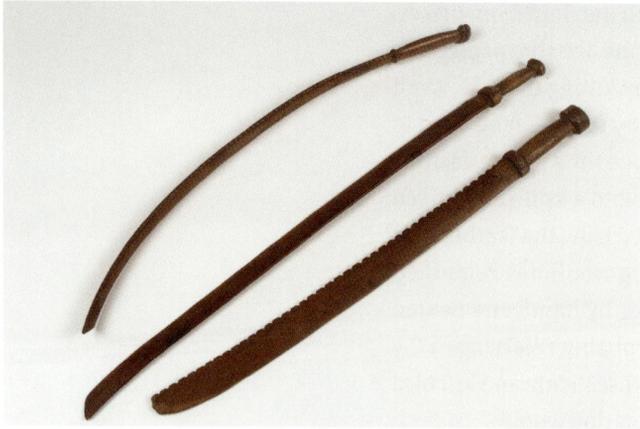

FIG 50

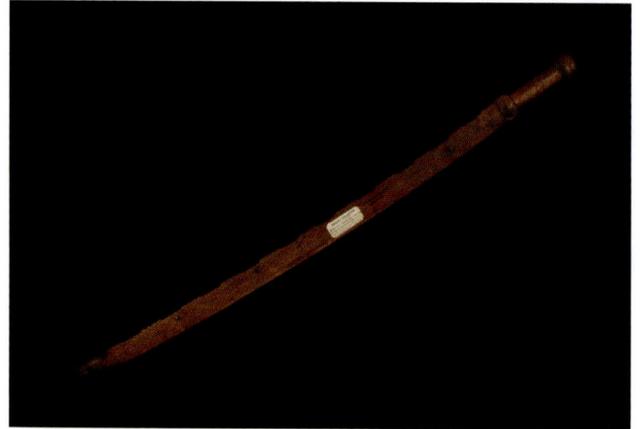

FIG 51

FIG 52

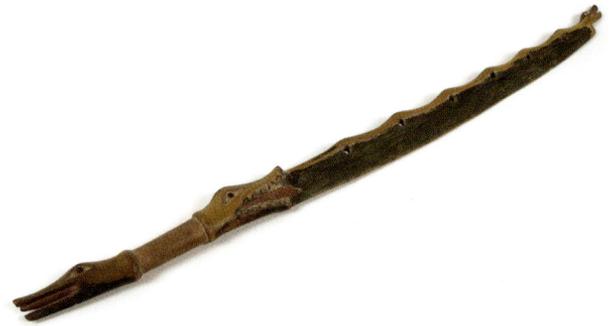

FIG 53

FIG 50 Wooden swords used in preparing mountain goat wool (and likely dog wool). Note that one of the swords has a ridged edge. Collected from the Cowichan (Vancouver Island) area by Lieutenant George T. Emmons (1883–1907) and preserved at the National Museum of the American Indian.

NMAI Photo Services

FIG 51 A weaving sword of yew wood, which was used for beating diatomaceous earth into the wool before spinning, and was also used to tighten the rows of weaving. Notice the teeth.

Pitt Rivers Museum, University of Oxford, Henrietta Clare

FIG 52 Close-up detail of a weaving sword with teeth.

Pitt Rivers Museum, University of Oxford, Mark Kaarremaa

FIG 53 A wooden sword used for beating grease out of wool, carved to represent duck heads with red, yellow and green. Also collected from the Cowichan (Vancouver Island) area by Lieutenant George T. Emmons and housed at the National Museum of the American Indian.

NMAI Photo Services

everything together until the spinning twist has been added, stabilizing the yarn.[206] Keeping all the feathers and down in the forming yarn can be difficult when your hands are busy spinning. The twist locks them in, first while spinning a single and then again when two singles are joined by opposing twist in a ply.

Before we get to the actual spinning, there are many accounts of beating the diatomaceous earth into the raw fibres with a stick or wooden sword. The sword is long, roughly 3 to 4 feet, with a handle at one end attached to a long blade, similar to a knife blade, though blunt and gently curved. It is often referred to as a *weaving sword* and seems to have several uses. First, it can beat the diatomaceous earth into a pile of laid-out fibre, breaking up any chunks of diatomaceous earth into the fibres as well as fluffing up and mixing the fibres. The sword would also be used to mix or blend different fibres together, such as mountain goat and dog wool.

The swords can also be used to tighten the rows of weft while weaving, pressing them down to the finished rows below. Although many weaving swords in museum collections are plain edged, there are a few like the one at the Pitt Rivers Museum at the University of Oxford, which has an interesting pattern along the thin edge, a series of four teeth with a few inches between each set of teeth (see Figures 51 and 52). Another one at the NMAI has teeth as well (see Figure 53). One wonders what the purpose of the teeth are. Decoration, perhaps? Or maybe these are spaces to ensure the lines of the twill line up as the weaving progresses.

One account from a Quinault man[207] states, "Before being clipped the dogs were washed, a white clay or diatomaceous earth being used to remove grease and dirt from the wool."[208] It seems the dog might have been powdered with the dry pounded diatomaceous earth, left on for an unknown amount of time, before being sheared.

In keeping with the report of the Quinault man, a couple of accounts indicate the pelt of a hunted mountain goat was coated with diatomaceous earth and pounded with a weaving sword before removing the wool. The first account comes from a museum catalogue whose original record has gone missing.[209] The second statement is from Joanne Vanderburg, in her 1954 MA thesis, and unfortunately does not give a source.[210] According to her account, the fine white powder was sprinkled over either the fibres or the whole mountain goat pelt, the latter being beaten with a wooden sword for a few hours before the fibres were removed.

One other interesting piece of information diatoms might help provide is a hint of where any given blanket came from. It may be possible to survey the common sites where diatomaceous earth was procured and identify the typical species of the diatoms found in each location. If the species list is unique for each location, the list could be compared with a list of species found remaining in any blanket. This would not prove a blanket was made nearby, as the diatomaceous earth could have been traded in from elsewhere, but it may be another tool that would help point to the origin of a blanket.[211]

I wondered if Mutton had been sprinkled with diatomaceous earth before his shearing, but I suspect that since he was still a puppy, he would have been too rambunctious and would have shaken it out. When I looked at his pelt, it showed no sign of diatomaceous earth having been sprinkled through it, though preservatives had been added. Mutton's wool would have likely been sheared first and then mixed with diatomaceous earth and perhaps blended with mountain goat.

The Mixing of Fibres

Often dog wool is mixed with plant fluff and seeds, though anthropologist Homer Barnett suggests this was done more in the lower part of Vancouver Island, and not in the north. The reasons given are varied. Sometimes this would be done to extend the wool, if scarcity was a concern. Or this could be done to achieve soft, luxurious blankets, in which case dog wool would be mixed with small feathers or the downy section of a feather stripped off the quill or just down feathers. Other suggestions to extend the wool are adding fireweed, cottonwood fluff or cattail seeds. Short seed fluff like fireweed fluff or cattail is difficult to spin by itself and is easier to spin if longer fibre, such as dog wool, is added to help bind things together.

Another possible reason for using fluff was to increase loft, even though any experienced spinner knows how to spin to increase loft (make the yarn fluffier with lots of air pockets) without adding extra fibre. Adding these plant fibres is often mentioned by non-Indigenous people and couched in pejorative terms like "adulterants," "fillers," or a "less-valued fibre." But there may be other reasons that are not known (at least to me) that might involve special qualities like the cleansing quality of cattail fluff mentioned earlier.

Woolly Dog wool is often said to have been blended with mountain goat

hair. Some Nations consider the mountain goat to be very spiritual and by blending the two wools you were adding that spiritual component. The book *Salish Blankets: Robes of Protection and Transformation, Symbols of Wealth* goes into more detail about the spiritual qualities of mountain goat wool. A quote from Snuneymuxw Elder Dr. Ellen White[212] in that book explains, "The mountain goat is the most pure of all the animals because it lives in remote areas, near the sky. Nothing can reach it there."[213]

Most Nations see the mountain goat as adding spiritual properties, but around 1908, James Teit, an ethnographer living up the Fraser River in Interior Salish territory, interviewed a Nlaka'pamux woman from Spuzzum. She recalled Woolly Dogs and suggested a more practical reason for using mostly dog wool: "People who did not have any of these dogs used only goat's wool. The using of dog's hair it is said made the blankets of a softer texture & furthermore they supplied a source of wool right at hand, whereas the goats had to be hunted and their wool thus cost considerable labor."[214]

Reasons for mixing fibres range from adding spiritual qualities to practical ones of softness and access to a particular fibre.

If mountain goat is to be used, the stiff guard hairs need to be removed as much as possible. Woolly Dog guard hairs are much thinner than mountain goat and can be left in without making the yarn scratchy. The more mountain guard hairs in a blanket, the pricklier it would be, and the guard hairs also resist dyes. The longer guard hairs can easily be pulled directly off the hide, or if the mountain goat wool was collected from bushes, they would be pulled out, but this all takes time. In researching yarns in Coast Salish textiles, I found the older the blanket, the fewer guard hairs were in it, implying that a long time ago, more time was spent picking the hairs out, or possibly they were left in to extend the amount of fibre (taking the longer stiffer ones out and leaving shorter or thinner ones in), or a change in technique was made.[215]

Two accounts survive suggesting efficient techniques for removing guard hairs. One method is to lay the mountain goat wool (and dog wool) on a woven twined cedar mat then fluff and beat it with a sword, and the mat will trap the stiff guard hairs.[216]

A similar method, apparently much more efficient, was recalled by Annie Zixtkwu York, a distinguished Nlaka'pamux woman and Elder from Spuzzum.[217] After the wool was laid out and the easily accessible stiff hairs were pulled out,

…the cleaned wool was then washed and put, still damp, in a large round coiled basket, a type made especially for this process. The powdered diatomaceous earth was added to the basket, and the wool was stirred with a flat stick with a continuous circular motion. This lined up the long stiff kemp fibres in one direction and mixed in the fulling compound. The roving was then pulled out continuously, rolled on the leg and deposited in other baskets or rolled into balls. This was then spun singly or double, depending on the purpose for which it was intended.[218]

The coil weave of the basket would grab any stiff hairs. Pulling out the roving was probably done in a regular width, say, an inch, so the top inch would be pulled out from the top rim of the basket, then the next inch in a continuous and consistent roving. Having the fibres lined up (they would be parallel to the rim) and in a continuous roving helps to create a smooth yarn.

Once the fibres have been mixed with the diatomaceous earth and perhaps mixed with other fibres, spinning can begin. Some have suggested the spinning process itself adds a spiritual connection, as the wool becomes transformed into yarn.[219]

Spinning Fibres into Yarn

A variety of methods and tools can be used to transform fibres into a yarn, from a simple thigh-spun yarn to using a stick with a hook at the end, or an even more efficient spindle with a whorl.

First, a quick review of some terminology as it relates to spinning. To start a yarn, the fibres are bunched together into what is known as a *roving*. The roving is formed by adding more overlapping bundles of fibre to lengthen the amount and adding a little twist to create a rough yarn. The fibres will separate unless more twist is added. Spinning is all about twist. It is the twist that keeps the fibres into a yarn, gives it strength and helps prevent abrasion of the yarn. A yarn needs just the right amount of twist: too little twist and the yarn falls apart, too much twist and the yarn will kink, be hard to handle, become too brittle and break.

If your survival depends on making yarn (for textiles) or cordage (for tying things together, e.g., rope, string, twine), then you learn the most efficient ways to make them, and efficiency comes hand in hand with the type of

fibre and the type of tool. Around the world, making cordage was originally done by twisting fibres using your fingers. This is a slow method but requires no tools other than hands.

To make a yarn, one must first make a rough roving by rolling it down one's thigh, giving it some initial twist and adding more fibres as needed to lengthen the roving, then store the slightly twisted roving in a box or basket. At this stage it is bulky and loose and doesn't have enough twist to be strong enough to hold it together for long. The roving can be spun a second time to add more twist and to strengthen it.

A more efficient way is to make the rough roving then add more twist using a spindle. A spindle can be as simple as a stick with the roving attached where the stick (spindle) is twirled or spun around using your fingers. The simplest spindle is just a stick with a tapered point, or a hook on the end. An even faster and more efficient method is rolling the spindle down the thigh. It is easier to roll a rounded stick than a loose bunch of fibres in a roving.

The spindle needs to be long enough to roll on the thigh and, at the same time, to store the already twisted yarn. You don't want the already twisted spun yarn to interfere with rolling the stick, so a wheel known as a *whorl* is added to the spindle holding the yarn, preventing the yarn from slipping down and interfering with the twisting process.

A stick with a whorl is usually called a *spindle*, though technically, the stick part by itself is the spindle.

At this stage the twist can escape out the ends of the yarn. Twist is energy, and it can move along the length of the yarn, especially when the yarn is freshly spun. Even with a tighter twist, the yarn isn't stable yet. To fix the twist, holding it in place to prevent it moving, two single yarns are plied together, making a two-ply yarn. To do this, two single yarns are joined and twisted together but in the opposite direction. The singles were spun by rolling down the thigh, so to make a two-ply, they are joined by rolling them together, this time up the thigh. It is like two yarns holding each other to prevent untwisting. Most Coast Salish yarns are two-ply—it adds strength and warmth and helps prevent abrasion.[220]

A couple of accounts reveal that the singles were made using the hand to roll fibres down the thigh and then underwent a second twisting on a spindle. The first spin, creating the roving on the thigh, puts some twist into the yarn, but it might not be enough. Barnett suggests that in the north of Georgia Strait,

the wool is spun on the thigh, then rolled into a ball to store it until twisted more using a spindle.[221] In the south, Barnett suggests that the spindle might only be used for plying.

Ronald L. Olson, the anthropologist working with the Quinault in the mid-1920s, had three informants for his book section on weaving. This covers the Woolly Dog and its shearing, as well as spinning and weaving the wool.[222] He prefaces this section with a warning: "My informants, however, gave inadequate and conflicting accounts of the method of weaving, but I give the divergent opinions for what they are worth."[223]

Note Olson's use of the term *weaving*. Yet it is not weaving (weaving is the making of the textile); rather, it is the spinning (the making of the yarn) being discussed. This is an example of a male view of women's work and not having a full understanding or appreciation of the subject being studied,[224] yet the Indigenous informers knew much more of the context. The "divergent opinions" are indeed worth including, and the conflict he points out may not be conflict; rather, it may be different ways of achieving the same thing—yarn—or different ways of achieving different styles of yarn:

> Twisting of this hair into yarn was done simply with the fingers or by means of a spindle which was rolled down the thigh. The spindle whorl was eight inches or so in diameter. A third informant stated that a spindle (without whorl) which had a hook at its tip was used to pick up the tufts of hair out of the split stick, the spindle being merely twisted by the fingers of the right hand. The yarn was then rolled into balls.[225]

This "third informant" had earlier talked about shearing the dog, tuft by tuft, with a sharp mussel shell, then placing the tuft in a cleft stick to keep the hairs aligned, the cleft acting much like a clothes peg. Using a stick with a hook to grab those tufts of fibres and twist them is an efficient method of pulling out fibres from the cleft stick continuously—the twist in the fibres will grab more fibres, and the spinner just needs to pull the already spun yarn away from the cleft stick in a consistent manner. It also helps to keep the fibres aligned, making a smoother and thinner yarn.

All three methods—finger twisting, hand twisting a spindle, and rolling a spindle down the thigh—are entirely doable. Finger twisting is slow, hand twisting a spindle is not much faster, and rolling a spindle or a stick down your thigh is faster. In addition to these methods, another very common

one was simply to skip the spindle and roll the fibres down your thigh, as described above. If you were very efficient at it, you could do two single yarns at the same time by rolling them separately down your thigh, careful that they don't get entangled with each other. Then when they reach your knee (or lower), let them join and now roll them, as one yarn, up your thigh in the opposite direction to twist the two into one two-ply yarn, then repeat the next thigh-length sections.

With the stick or spindle methods, the yarn made can be stored by winding it onto the stick or spindle, which becomes a large ball of yarn with a stick in the middle. This ball can be formed in such a way as to create a centre-pull ball, which allows you to take the end in the centre and the end on the outside and ply them together. Rolling the fibres into a yarn on your thigh produces lengths of yarn that eventually needs to be rolled into a ball of yarn. Once two balls of singles are made, they are joined together into one combined yarn.

Any of these methods work. What does matter, in terms of which tools and methods are used, is what type of textile is being woven. The type of yarn being made needs to match the type of blanket or robe being made; different tools and techniques are used for the different types of yarn.

This is not a hard and fast rule—for example, a Salish spindle with a large 8-inch whorl is typically used to make thick yarn suitable for a twill blanket, and a small whorl used for thinner yarn, but you can also use the large spindle with a different method to make thinner, tighter wool and the small whorl to make thicker yarn. It comes down to efficiency: what tool or technique is faster and easier to use to make yarn for a certain type of robe or blanket?

There are various sizes of spindles and whorls, and they are matched with the fibre being spun. Stinging nettle would be spun on a small spindle, and the whorl might only be an inch or two in diameter (see Figure 54) and made of stone, with a stick perhaps eight inches long.

This small type of spindle is found all over the world and tends to be used with long fibres of flax or nettle, or with sheep wool that has a lot of crimped fibres that can grab onto each other. The spindle is light enough and hangs from the roving and is twisted in the air. Like you would a spinning top, you twist the stick and let it spin in midair while your hands are pulling fibres out of the source and helping guide them into the forming yarn. The pull of gravity adds tension, helping to pull the fibres straight, while your fingers can pull out the right amount of fibres, thinning the roving to the desired width while the twist is being added by the turning spindle to hold it all together. This is

FIG 54

FIG 54 A Coast Salish stone whorl found at Shingle Bay, Montague Harbour, on Galiano Island. It is about 4 centimetres (1.6 inches) in diameter and weighs 17.2 grams (0.6 ounces).
Liz Hammond-Kaarremaa

FIG 55

FIG 55 Top, from left: European-style with top whorl (wood); Icelandic with top whorl (wood); Shetland Islands bottom whorl (slate/stone); East India bottom whorl (metal); Thai middle whorl (wood). Bottom: Coast Salish stone, probably used for nettle.

Liz Hammond-Kaarremaa

FIG 56 Three whorls. Note the raised centres where the spindle stick goes. Collected from the Cowichan (Vancouver Island) area by Lieutenant George T. Emmons, 1883–1907.

NMAI Photo Services

FIG 57 Three spindle sticks also collected from the Cowichan area by Lieutenant George T. Emmons.

NMAI Photo Services

FIG 56

FIG 57

a typical European method and is also the most common method in South America.

The whorl can be either at the top or the bottom of the spindle. In Europe it tends to be at the top, whereas in South America it is at the bottom. The whorl not only holds the yarn so it doesn't slip off or get caught in the loose fibres just being formed into yarn, but acts as momentum, determining how long the spindle will turn. The diameter and the weight alter both the speed and the length of time the spindle will spin. A heavy whorl will spin quicker, adding more twist than a lightweight one. If most of the weight is closest to the centre, where the stick is, it spins fast. If the weight is out at the edges of the whorl, it will spin slower, adding less twist.

If you have slippery fibres, you can't use the spindle as a drop spindle (one that hangs in the air); the roving isn't strong enough to hold the weight of the fibres and the spindle. The fibres will slip apart and the spindle will drop to the floor. In this case, the spindle is supported by something: the hand, a clamshell, a tabletop—something to stop the pull of gravity from pulling the roving apart before enough twist can enter the yarn and stabilize it.

The two predominant types of Coast Salish weaving, twill and twining, require two different types of yarn: twining uses a tightly spun yarn with a thinner diameter and more twists per inch; twill requires a looser weave, using a thicker, bulky yarn with fewer twists and more air trapped within. The hybrid style requires both a thicker yarn for the twill sections and a thinner yarn for the twinning. Tabby weaving can use either.

Here is where the Coast Salish created a unique tool and technique for spinning to match the wool used for the type of robe or blanket.

For spinning a tight yarn for robes made of mountain goat or dog wool, a larger whorl, maybe 6 inches wide, would be used on a stick around 30 inches (76 centimetres) long. If you are spinning a light, bulky yarn suitable for the twill blanket, your spindle needs a large whorl, perhaps 8 or 10 inches in diameter, and a long spindle stick to hold the bulky yarn as it gets spun.

The traditional Salish spindle is around 90 centimetres (36 inches) long, with a whorl around 8 inches in diameter. The large whorl is made from a

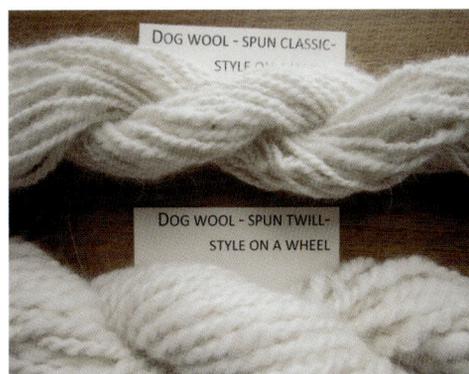

DOG WOOL - SPUN CLASSIC-STYLE ON A...

DOG WOOL - SPUN TWILL-STYLE ON A WHEEL

FIG 58 Close-up of a twill woven blanket. Maker unknown.
Burke Museum of Natural History and Culture

FIG 59 Dog wool, spun thin for classic twining (top), and thicker for twill (bottom).
Liz Hammond-Kaarremaa

FIG 60

FIG 61

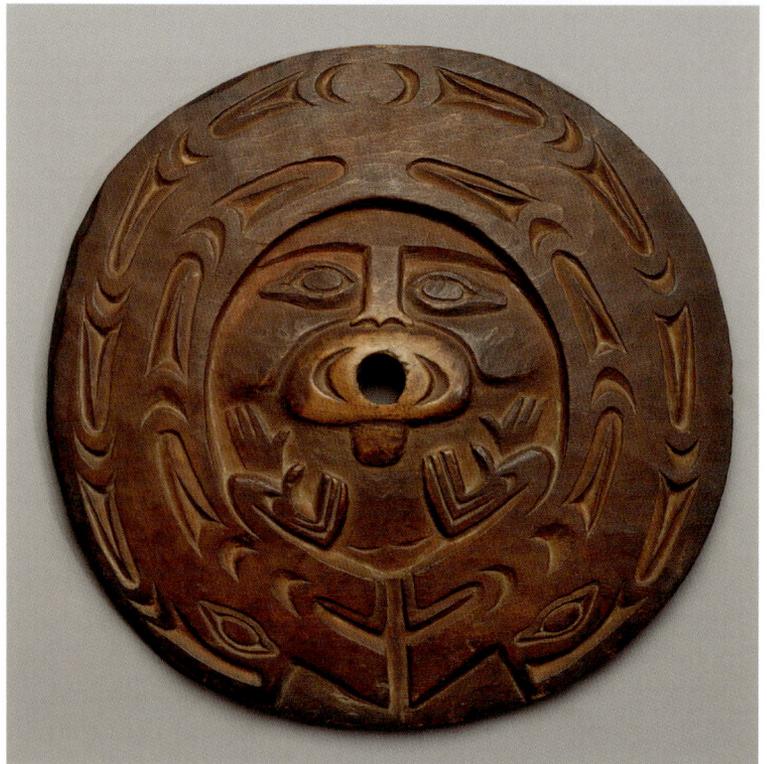

FIG 62

local wood, often maple. The large size and weight of the whorl mean it will turn slowly but steadily, giving a low twist to a thick yarn.

One side of the whorl tends to be flat, or has a slight inner bowl-type curve, and the spun yarn is rolled around the stick just above the whorl. The bottom side of the whorl faces the spinner and has a slight bottom-of-a-shallow-bowl curve to it. Often the side facing the spinner is carved. The whorl is placed about a third of the way down the tapered spindle, and the spinner's hands hold the spindle. The large size of the spindle stick and the whorl make the spindle heavy, and it needs to be supported somehow without putting too much stress on the barely spun roving of fibres while the twist goes in.

The weight of the whorl adds momentum to the spin, making the stick spin longer but slower. The whorl also holds the yarn away from the thigh. In a Paul Kane sketch (see Figure 66), the whorl seems very close to the tip, which might make it too top heavy and hard to balance—a little farther down might be more accurate. Where it is placed depends on how the spinner is going to use it. In the Kane sketch, the spinner uses her upright right hand to support the growing ball of yarn being wound onto the spindle and to turn the spindle. (See also Figure 65, which also shows a woman spinning yarn.)

TEXTILES SUFFER FROM a type of invisibility in anthropology and archaeology, mostly because of their tendency to disintegrate over time unless in oxygen-deprived environments: the thin air of the high Andes, low-oxygen bogs, frozen in ice, or like the oldest surviving blanket and fragments from the Ozette site near the tip of the Olympic Peninsula in northwest Washington, mentioned previously. Wood and metal stand a better chance of remaining intact. In the Pacific Northwest, monumental carvings overpower the senses and overshadow textiles.

On top of that, most of the ethnographers and observers of the spinning and weaving of blankets and robes in the 1800s and early 1900s were men. As such, not as much attention (very little) was paid to the weaving arts, or as they referred to it, the "domestic arts" or "women's work." Because of the low importance given to textile production, processes were deemed unimportant, often ignored, recorded incorrectly or with the wrong terminology.

Olson, as we saw, wasn't familiar with spinning, and even Paul Kane, whose visual works of art are some of the best records of that time, wrote "yarns are plied on a distaff,"[226] but a distaff is a tool for holding wool while your hands are busy spinning it. This probably is a mistake made by a man who didn't know the details of women's work at the time. But Simon Fraser, the young Scotsman from the Hebrides—home of some of the finest wool spinning—observed in 1808 that both a distaff and a spindle were used, showing he knew the difference. Fraser was a rare exception when he noted in his journal on July 1, 1808, "Dog's hair, which is spun with a distaff and spindle is formed into rugs."[227] A distaff is a tool that acts like a third hand or arm. It holds the wool while you use a spindle and your two hands to spin the fibres into a yarn. Very few observers seem to know the difference, and in many cases the terms are interchanged, but you cannot spin yarn with a distaff; it merely holds the fibres, much like the cleft stick that one of Olson's observers mentioned. But Fraser knew his spinning terms.

A rare exception of a woman observer in the early 1900s was Mary Lois Kissell, an expert with the American Museum of Natural History and later an associate professor in the Home Economics department at Berkeley. She studied Coast Salish textiles, and, in the fall of 1915, made arrangements with

FIG 64

FIG 63 A spindle whorl with salmon and raven design collected by George T. Emmons in the Cowichan area, 1883–1907.
NMAI Photo Services

FIG 64 It has been suggested that this Quw'utzen (Cowichan) wooden spindle whorl carving is reminiscent of older styles, circa 1800.
Smithsonian Institution

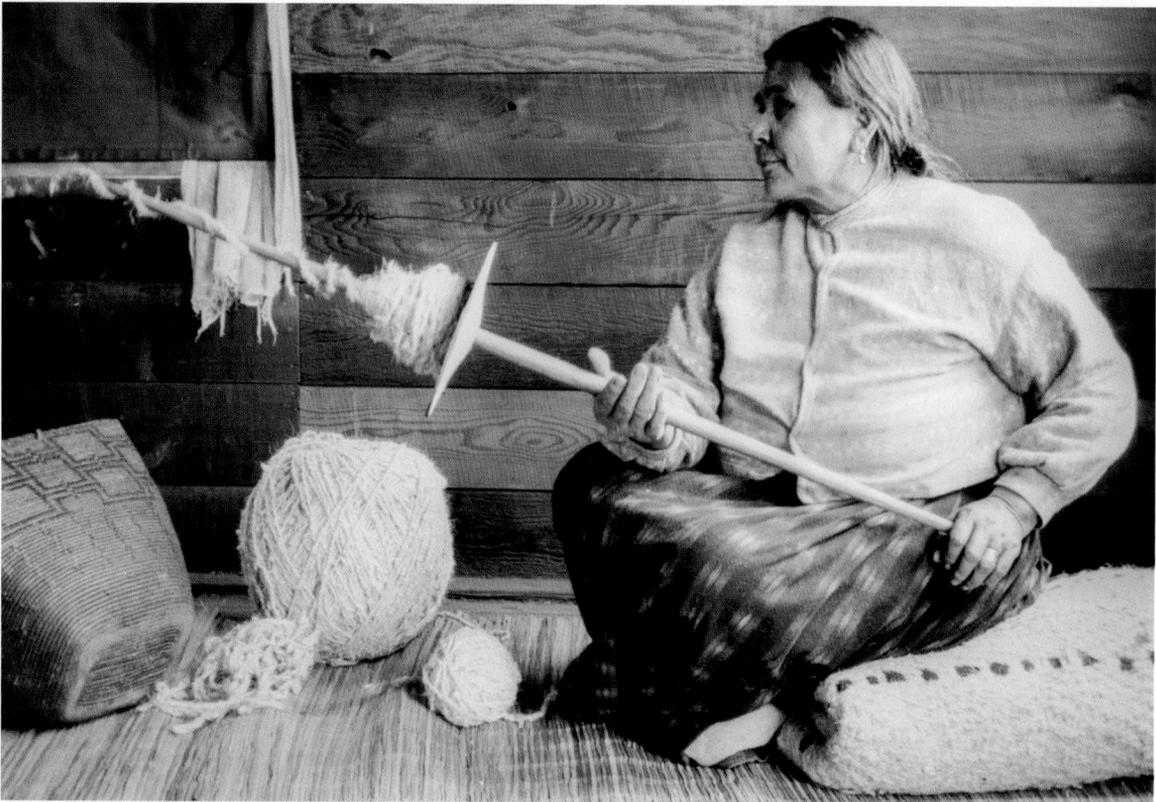

FIG 65

FIG 65 Mrs. Selisya Charlie was a Cowichan woman who married into the Musqueam Nation. The photograph was taken by Dr. Charles Newcombe on November 5, 1915.

Royal BC Museum

Charles Newcombe of the Royal BC Museum, to visit in November to discuss co-authoring a booklet on Coast Salish blankets. Dr. Newcombe arranged a visit to a few villages, where he took this photo of Selisya Charlie spinning with a large spindle (Figure 65). Kissell carefully recorded the use of the spindle and described the method in an article in 1916.[228]

Kissell described the process thus:

First a roving is made by hand spinning the fibre against the thigh, this roving is then put through a tension ring in the rafters or the upper frame of a loom and then down to the spindle.

After proceeding through the tension ring or over the loom frame, the end of the roving is tightly twisted for a short distance between the palms and then attached to the upper arm of the spindle shaft near the whorl. Everything having been made ready, the spinner squats upon a mat on the floor and with outstretched arms raises the huge spindle to an oblique position by grasping its lower end in the palm of her left hand and clasping its shaft a little below the whorl in her right. The twirling might be

termed a tossing motion which is performed by the up-turned palm of the right hand. When the roving has received the required amount of twist the upper end of the spindle is swung upward and backward, thus bringing the next draft of roving through the tension ring and permitting, after the spindle end is again dropped to position, that the loosely sagging and already twisted yarn be wound upon the spindle. This is accomplished by lacing the yarn back and forth in large oval coilings on the upper arm of the shaft as the spindle is lifted and lowered from the oblique to the vertical and from the vertical to the oblique while it is still revolving. After the stretch of completed yarn is wound on the shaft the spinner returns to the twirling motion that the freshly drawn roving may be twisted, when it is wound on the shaft as before described.[229]

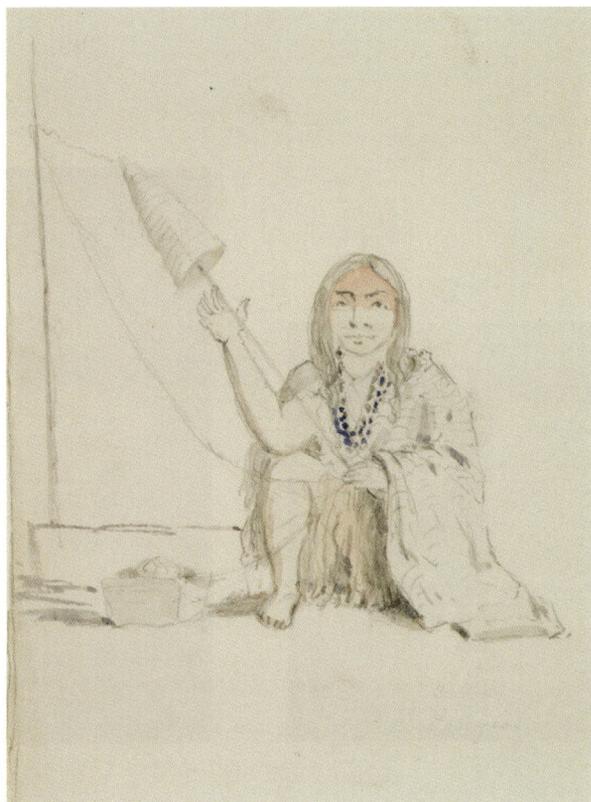

FIG 66

FIG 66 This watercolour and graphite Paul Kane painting is titled *A Songhees Girl Spinning*, and was completed between April and June 1847, near Songhees, on Vancouver Island (Central Coast Salish territories). *Royal Ontario Museum*

H.G. Barnett, who might have observed this process in the 1930s, explained how the ring was used:

In operation this spindle was held in the two hands. The butt end rested in the palm of the right hand; while, with the left, the shaft was given a tossing, twirling motion. The rove [the barely twisted length of fibres] was attached to the shaft near the whorl. It passed upward through a ring suspended from a post, and then downward to the ball to be spun on the floor. This arrangement made for tension on the thread while it was being twisted. As each length was finished, it was wound about the spindle shaft, and another section was pulled through the ring.[230]

A tension ring does not have to be used, though it helps to hold the yarn in one spot and it keeps the yarn higher than the spindle. You could also have the yarn held up by a roof beam or, in modern days, a curtain rod. Mrs. Helen Jimmy, a Cowichan woman, was photographed in 1949 spinning the spindle on her thigh while her left hand was acting as the tension ring, holding the roving about 12 inches above the tip of the spindle.[231] The tension ring

FIG 67

FIG 68

FIG 67 A spinning tension ring with wooden carving in the shape of a bird, at the Field Museum of Chicago.
John Weinstein

FIG 68 There are only a few examples of this Coast Salish tension ring in museums, and they seem to be associated with birds. This item is from the lower Fraser River (Stó:lō) area.
Royal BC Museum

performs two tasks: providing something to pull the yarn against to allow the twist to flow evenly along the length of the twisting yarn, but also taking the weight of the roving and holding the yarn up until that twist can enter it.

The spinner sits sufficiently far from the tension ring to allow enough distance between it and the tip of the spindle. For plying, the distance can be quite far. For spinning a single, the yarn is likely to come apart and need fixing at some point, so the spinner sits closer and the tension device would be lower, say up over an upright loom, a curtain rod or a hook on a door.

Remember that twist is energy. It is alive when freshly twisted and will traverse back and forth along the yarn until something stops it: a knot, a kink, or something like a tension ring providing an angle that stops the twist from continuing. This is where the matching of the large spindle being lifted up toward the tension ring comes in handy. While the spindle is being twisted, the twist builds up but can't travel past the tension ring. As more twist is added, the yarn may kink or the twist builds up in one spot and not in others. However, when the spindle is pulled back, like a fishing rod, the yarn line straightens between the tip of the spindle and the tension ring. When that happens, the uneven twist runs up and down the yarn, evening the twist out along that length. Now that it is even, it can be wound onto the spindle and the spindle

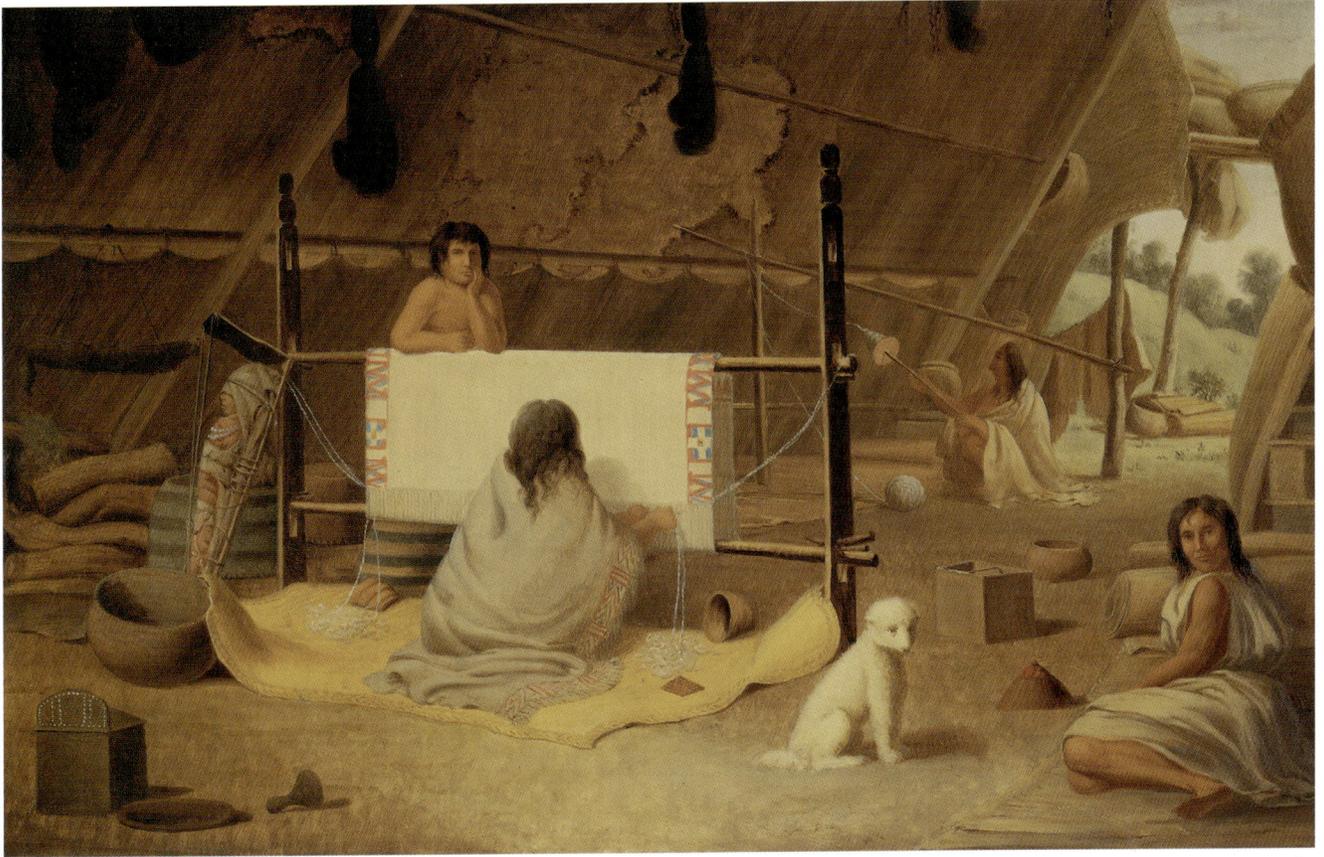

can tug more yarn to twist through the tension ring and start again. The longer the distance from the tension ring, the more even the yarn will be, though that is also a result of consistent spinning, for example, turning the spindle the same number of turns for each length spun.

As Barnett suggests, some traditional methods might spin the singles on the thigh twice, then use the large spindle to ply them together. Alternatively, the large spindle could be used both for spinning the single yarn and for plying. Another possibility is that your method could change according to the tightness of the yarn you are creating; you would simply do whatever seems most efficient. A very bulky, lofty yarn is probably best made using the large whorl spindle for both the singles and for plying.

IN THE PAINTING by Paul Kane, which was based on his 1847 visit to Fort Victoria in British Columbia (Figure 69), you can see a woman weaving a traditional blanket with a colourful geometric twined border around the plain white twill. You can also see in the background a woman spinning using the

FIG 69 This oil-on-canvas painting, *A Woman Weaving a Blanket*, depicts a Songhees/ Saanich (Central Coast Salish) woman. It was completed from 1849 to 1856, a few years after the artist, Paul Kane, was in Fort Victoria in 1847, and is comprised of three different sketches (Figures 66, 72 and 73). Note that in the background there is a spinner using a large spindle, with the yarn held over a roof beam.
Royal Ontario Museum

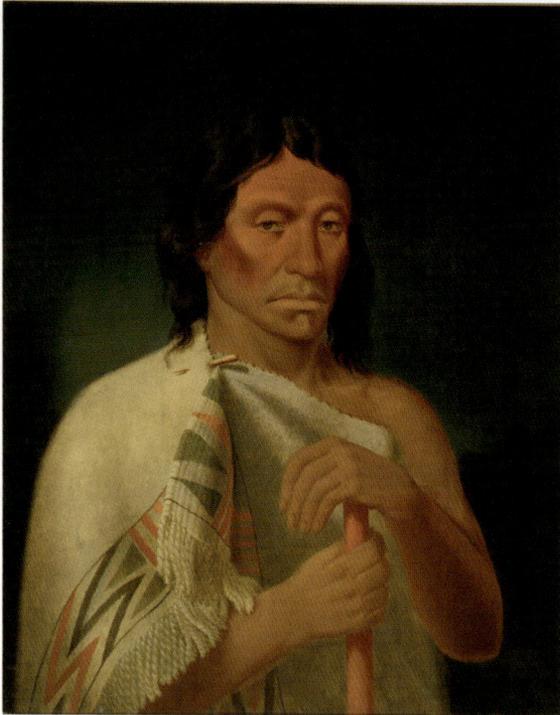

FIG 70

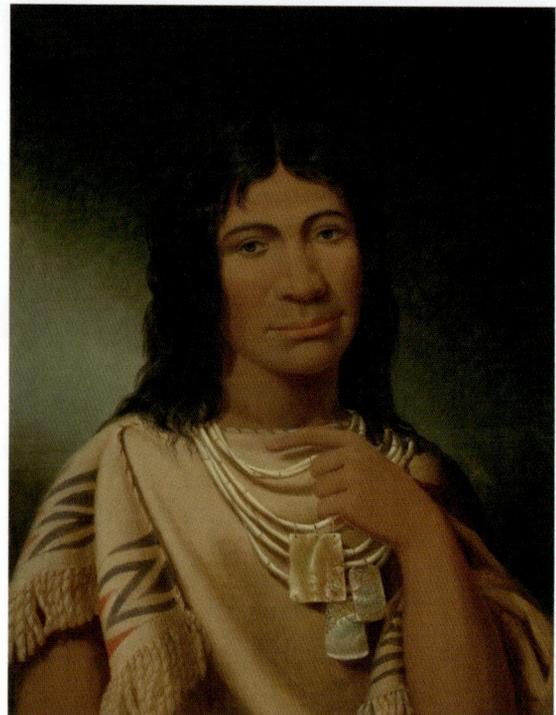

FIG 71

FIG 70 This oil-on-canvas Paul Kane painting, *Chee-ah-clah, Songhees (Central Coast Salish)*, shows Chee-ah-clah wearing the same robe as the one the Clallum woman is wearing in Figure 71. The border design of the robe is similar to the one in the painting being woven in Figure 69.
Royal Ontario Museum

FIG 71 A second Paul Kane oil-on-canvas painting, *A Clallum Girl, Clallam (Central Coast Salish)* features a remarkably similar robe and pattern to the one Chee-ah-clah is wearing in Figure 70.
Royal Ontario Museum

Coast Salish spindle, with her yarn going up and over a roof beam. Kane wrote, "The hair … is then beaten together with sticks, and twisted into threads by rubbing it down the thigh with the palm of the hand, in the same way that a shoemaker forms his waxend, after which it undergoes a second twisting on a distaff [spindle] to increase its firmness." [232] Kane captured all these scenes in sketches and combined them in this painting to show the whole process of creating a blanket or robe. And sitting upfront, in a place of importance, is a recently shorn Woolly Dog.

One of George Gibbs's notebooks seems to be his reference book in which he kept track of things he might want to refer back to: books in his collection, lists of birds, lists of latitude and longitude and observations of various locations, monthly rainfall amounts in Oregon City in 1854, and other miscellaneous things. Of special note is his list, or inventory, of Indigenous items he collected, and in many cases, he also noted where the item was purchased. In this list he included the following:

Dogs hair blanket—Puget Sound
Feather blanket—Straits of Fuca
Dogs hair for blankets—Puget Sound

FIG 72

FIG 73

Many of the items in this two-page list are now housed at the National Museum of Natural History in Washington, DC, but these particular items are a bit of a mystery. The feather blanket could be Figure 76, a blanket of dogs' hair and feathers; the donor is not certain. The dog-hair blanket could also be Figure 76.

Unfortunately, there is no record of dog hair by itself in the collection. We have no idea when the list was written, though some of his lists were dated 1857, a year before Gibbs acquired Mutton.

FIG 74

FIG 75

FIG 74 Close-up of the robe in Figure 76 showing pure Woolly Dog wool in the fringe. Department of Anthropology, Smithsonian Institution.
Liz Hammond-Kaarremaa

FIG 75 Close-up of the robe in Figure 76 showing down feathers. Department of Anthropology, Smithsonian Institution.
Liz Hammond-Kaarremaa

FIG 76 A robe made of swan down and warp of dog. Department of Anthropology, Smithsonian Institution.
Liz Hammond-Kaarremaa

FIG 76

What we do know, without any shadow of doubt, is that George Gibbs recognized the beauty of the robes and blankets with dog wool. His memorable description of them as "Garments of mystical sublimity" is a fitting accolade given what we now know of the breed of dog they came from and the attention that went into breeding and caring for these animals over thousands of years. [233] We may never understand the fate that befell Gibbs's dog Mutton, or why his pelt ended up in a drawer in the Smithsonian, but we do know he has become central in our understanding of these dogs, and we now know that thousands of years went into careful breeding to produce a dog with woolly hair woven into "Garments of mystical sublimity."

ART AND CANINES

I THINK THE STORIES are the big one, to understand more about its significance and its role within our communities.

But for me as an artist, it's not just understanding the symbolism of things, but understanding from a broader and deeper sense how our worldview was situated and how things existed within our worldview and the ways that our ancestors lived in the world and with each other and with all of these beings.

One of the biggest things for me, and my whole art practice, really, has emerged from the work that I did to learn and research after my late great-grandma Ellen White passed away. Just realizing how much knowledge went with her and how spoiled I'd been being able to just go and sit with her whenever I wanted.

I really realized that to be able to continue her work and to be able to eventually become the kind of Elder that she was, there was just so much more that I have to do.

So I started reading, researching and looking and speaking to people in the community and just trying to learn everything I could about Coast Salish culture.

What I really realized too is just how many, how many gates are up in the way for us as Coast Salish people trying to learn about ourselves and who we are and how difficult that is to do. Fortunately, I have the privilege of coming from a family that carries a lot of this knowledge and has done a lot of this work, so I was able to ask questions and say, where should I be looking or who should I be reading?

Also, with my undergraduate background, I have a lot of research skills. But for people who didn't come from that, like it would be so difficult. It would be almost impossible at times to navigate some of the way that this knowledge is kept. I realized is that if people really want to learn about who we are, they have to go to our own forms of self-expression, you know our art and our stories, so

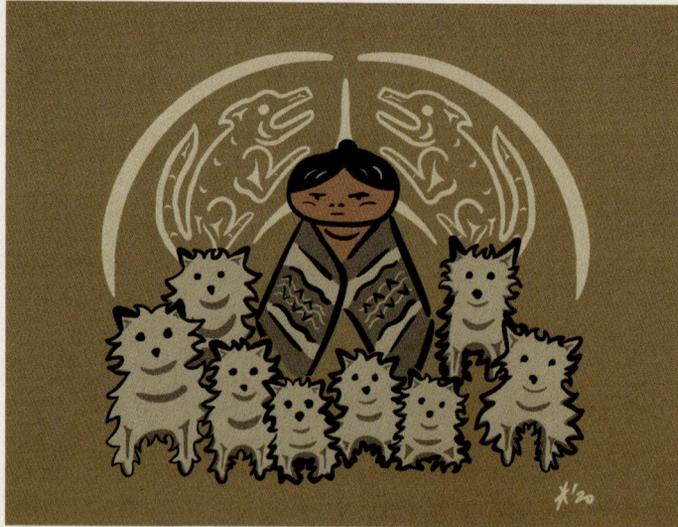

FIG 77

FIG 77 This giclée print, *Si:em Slhelhni' i tu Sqwiqwmi's*, which translates to "High-Ranking Young Woman and Her Wool Dogs," was created by Eliot White-Hill Kwulasultun in 2020.

when it comes to sort of the archive and the ways of talking about Indigenous knowledge or traditional knowledge, I find that it's really, really important to start shifting that narrative and talking about, you know, the sources and the communities and actual voices.

In doing this work we help make sure that it's there for future generations and it's being passed down, and it's being passed like the river is kind of flowing different patterns now, but it's still being passed down, and that's important.

With my understanding of our art and the representation of beings in our art, it seems to be a distinct difference between the use of the wool dog or a dog and the wolf, you know, and they carry different meanings within their imagery and the symbolism of it. The wolf would be a helper to people, and so when it's used in their art, that's generally what it means to represent, is to honour that connection that they have with the wolf, which is a different representation, I think, than when people represent the wool dog. I think that the wool dog kind of is more of a representation of wealth for our community to show that we come from high-ranking people. That's kind of an interesting distinction to me.

ELIOT WHITE-HILL KWULASULTUN, ARTIST, SNUNEYMUXW

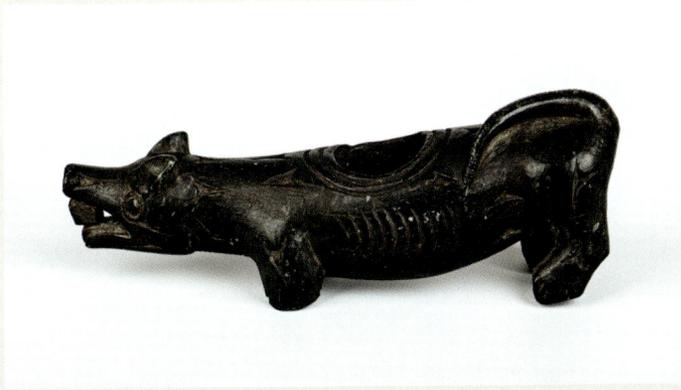

FIG 78

FIG 78 A rare black stone carving (possibly made of steatite) of what could be a dog, measuring 11.5 centimetres (4.5 inches) long and 4.1 centimetres (1.6 inches) high. It was collected by Colin Robertson at Fort Langley on the Fraser River before November 1833. Kept at the Perth Art Gallery and Museum, this is the only known pipe of this type. It shows the ability of Salish artists to create three-dimensional carvings using the same elements and principles as on shallow relief carvings.
John Watt

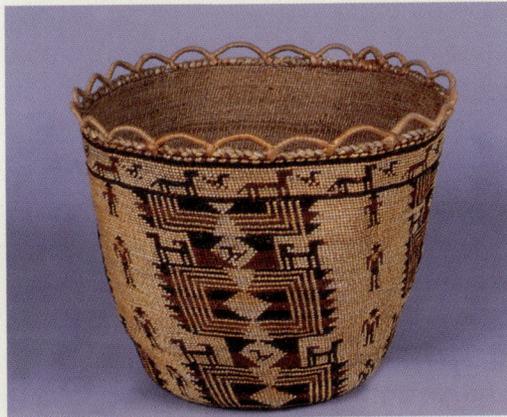

FIG 79

FIG 79 Skokomish baskets often have wool dogs (shown with curled tails) and wolves (their tails droop down) woven into the basket design.
Burke Museum of Natural History and Culture

THE SKOKOMISH OFTEN *included imagery of wolves and wool dogs in their basketry. In 2000, Elder subiyay Bruce Miller described the basket in Figure 79:*

> *The rim design: Wolves and Helldivers—The wolves gave the Twana man the life model that Puget Salish Society was based upon. They taught man loyalty to his people, the necessity of an orderly hierarchy, the importance of honour and family and that only the strong survive.*
>
> *The Helldivers, commonly known as the Western Grebe symbolize swiftness and watchfulness. Their power to escape the enemy was the result of paying attention and watching for signs of danger.*
>
> *The Box in a Box: A series of rectangles within each other symbolizes accumulated wealth as well as knowledge.*
>
> *The Wool Dog: Standing on top of the box design is the wool dog a symbol of material wealth. This dog is the main emblem of the Skokomish Tribe.*
>
> *Crows Dishes: Triangular shapes bordering the ends of the box design represent limpet shells split so that one half is on each side of the box design. During pre-human times when animals were people these were crows feast dishes.*
>
> *Puppy Pens: The diamonds in the centre of the box designs represent puppy pens where the wool dogs were raised. The puppy in the design is like the Hell Diver except the puppies face to the left and the Hell Diver faces to the right.*
>
> *The Man Design: The man is surrounded by symbols that represent his culture. He is secure in the knowledge of his true identity; it gives him strength and a foundation for personal security. This has been his identity from the beginning of time.*[234]

SUBIYAY BRUCE MILLER, SKOKOMISH/TWANA, 1944–2005

FOR ME IT'S MY HEALING, yes, you know, weaving really has been a part of my healing. I think it heals. And I think it's my medicine, and I have absolutely no desire to have any nonsense around my work. I'm too spiritually connected to it. Maybe I'm a romantic and I think of the values of the originals, like the dogs and what people have access to, and I like to share that with everybody. All of us in the world of spinners and weavers, and we have just put it aside, as if it's not worth anything or it's some romantic artsy thing on the side, but I really feel like it's the core of life.

DEBRA QWASEN SPARROW, WEAVER, MUSQUEAM

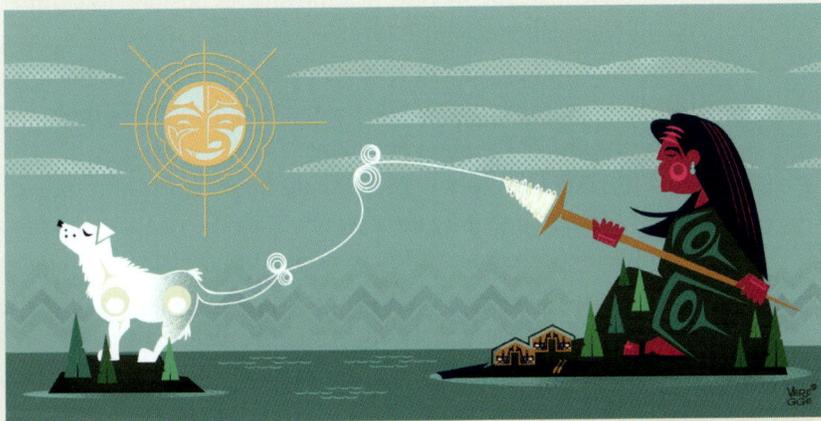

FIG 80

FIG 80 The late artist Jeffrey Veregge (from the Port Gamble S'Klallam Tribe, with Suquamish and Duwamish tribal ancestry) designed this artwork for a February 23, 2021, article that appeared in *Hakai Magazine*: "The Dogs That Grew Wool and the People Who Love Them," by Virginia Morell. Veregge's design depicts a Coast Salish woman spinning Woolly Dog wool. *Artwork courtesy of Christina Veregge*

10 WHAT DID WOOLLY DOGS LOOK LIKE?

I LOOKED AT the photo of a Wanapum woman with two young girls and a dog (Figure 81). It was from an obscure report on archaeology written in 1927 by Herbert Krieger, at the time just starting his position as curator of ethnology at the National Museum.[235] He took this photo the year before, while doing some archaeology survey work along the middle Columbia River. His caption reads, "The dog is of the type formerly kept by these Indians for the use of their shaggy coat in blanket making."[236]

Could this be a photo of a Woolly Dog? This "Columbia River" dog had short hair, though if it was a Woolly Dog, the photo could have been taken shortly after shearing. The dog was small, with a sharp pointed snout, but had large (for its size) ears that were floppy. Mutton's ears are small (for his size), and being small were probably not big enough to flop over. Candace Wellman had measured Mutton's ears back in 2002 when she found him lying forgotten in the drawer. His ears were perfect triangles—6 by 6 by 6 centimetres (2¼ by 2¼ by 2¼ inches).

In Krieger's report, he mentions dogs and dog wool being found along with mountain goat in an archaeological dig in Wahluke on the Columbia River in central Washington State. Dog and mountain goat wool, if that was what he saw, could have been traded in from elsewhere. When he made a list of animals with notes, he did not distinguish the different types of dogs. In his report, he listed "Dog: An extinct variety kept for the use of their shaggy coat of hair in blanket making; kept as watch dogs and used on the hunt but

not eaten." [237] His word "extinct" was at odds with his photo caption, the photo having been taken the same year as he wrote "extinct."

There are no other written reports of the Woolly Dogs being bred in that area; not even Lewis and Clark mentioned seeing any Woolly Dogs during their six months along the Columbia in 1805. [238] John Keast Lord, George Gibbs's opposite on the British border survey team, did speculate, with no sources, where the Woolly Dogs came from and suggested, "More than this, the first possessors of these white dogs were, as far as it is possible to trace, Chinook Indians, a tribe once very numerous and living near the entrance of the Columbia River. Thence the dog will reach Puget Sound and eventually must have been carried to Nanaimo, across the Gulf of Georgia." [239] But Wahluke was the middle Columbia River, hundreds of miles from the mouth. It could also be feasible that by 1926 any Woolly Dog of the area had died out and the dog in the photo was a mongrel pet dog. Krieger's photo and text just didn't ring true enough for this dog to be a Woolly Dog.

There are other photographs claiming to be of Woolly Dogs, ranging from small floppy-eared dishevelled lapdogs to large white dogs with pointed ears and shaggy medium-sized dogs, and everything in between. It is hard to sort them out. Some of the photos were taken in the 1940s and others into the 1970s, a good hundred years after they were reported fast disappearing by a couple of observers in the 1850s and '60s. [240]

Two photos in circulation suggesting they are images of Woolly Dogs show a wide disparity in their sizes (Figures 82 and 84). It is difficult to say with any confidence what the Woolly Dog looked like without digging deeper into the origin of the photos or knowing more about who took the photo or where. All those details can help to sort out the Woolly Dog from other dogs.

Figures 84 and 85 were found in the collection of papers by a former curator of the Royal BC Museum (RBCM), Dr. Ian McTaggart-Cowan. The back of both photos states they were taken by Diamond Jenness, an ethnographer who came out to the coast to study Coast Salish culture for a few months in 1935/36. [242]

William (Billy) Newcombe was hired as assistant curator of biology at the RBCM in 1928 but was laid off in a budget cut in 1933. However, he had been

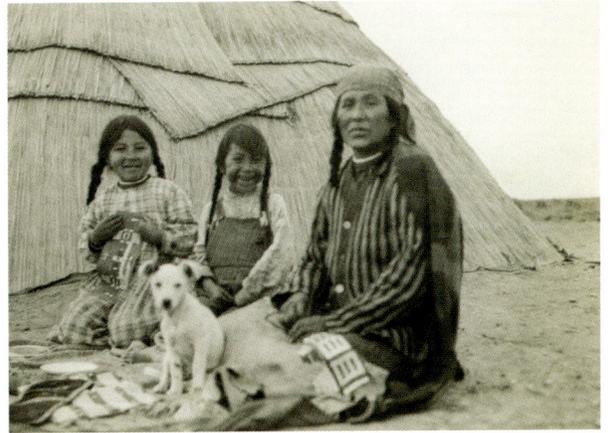

FIG 81

FIG 81 A Wanapum mother, two children and a dog are in front of their tule mat–covered tipi by the Wanapum, or Columbia, River. From the Department of Anthropology, Smithsonian Institution.
Herbert Krieger

born and bred as a researcher of not only biology but also ethnography. He had for years accompanied his father, Charles F. Newcombe, on expeditions along the coast to gather natural history specimens. Both father and son acted as agents for major museums around the world, becoming well known and respected for their research and knowledge. Billy Newcombe continued his passion for ethnography and self-financed his work.

In October/November of 1935, Billy Newcombe spent many days with Jenness touring him around southern Vancouver Island. Jenness later recorded in his notebook, "In 1936 [1935] I noticed an old, creamy-white dog on Saanich [Tsawout] reserve that seemed to carry some of the old strain. The owner had sheared it every autumn and sold the hair to a relative on the mainland, who knitted it into mittens."[243] A month later, in a letter to Newcombe, Jenness wrote he received a letter from someone named Allen, who stated, "The photographs do not show whether or not the ears are erect, a rather characteristic trait of the Indian [sic] dogs so far as I have seen them."[244] So here is someone who is suggesting that the ears of Indigenous dogs are upright, a key fact to keep in mind, as it comes up again and again.

This brings us to Allen, probably Dr. Glover Morrill Allen, who taught zoology at Harvard and wrote the 1920 book *Dogs of the American Aborigines*, making him the North American dog expert of that era.[245] It seems that Jenness sent copies of the photos to Allen to ask him his opinion. Perhaps it was different photos—at this point we don't know—but Allen's statement about erect ears would suggest that the photo from East Saanich is probably, as the caption states, a "mongrel," a dog with "possible" Woolly Dog ancestry, with floppy ears being an indication of introduced European dog genes. Prior to Allen, Dr. Benjamin Smith Barton wrote an article on "Indian Dogs" in 1803, summarizing, "His ears do not hang like those of our dogs, but stand erect, and are large and sharp-pointed. He has a long, small snout, and very sharp nose."[246] This was a very general description based on reports of dogs mostly on the East Coast but suggests that dogs of the US and Canada had upright ears and Europeans ones had ears that hung.

Allen's book quotes two others who positively state that the ears are upright—George Gibbs and George Suckley, both of whom had seen the dogs by the 1850s. It is important to know that he is quoting people who know Woolly Dogs, have seen them and have talked with the Indigenous people about the dog's wool being used to make yarn. Krieger, who took the picture

of the woman, her two children and a small dog with floppy ears (see Figure 81), on the other hand, was writing seventy years later, in 1927, and, as far as we know, had only heard of the Woolly Dog. Another ethnologist also writing in 1927 was Ronald Olson, who spent a few months on the west coast of the Olympic Peninsula. He wrote that his three Indigenous informants told him the dogs had upright ears. His informants also described the process of collecting and spinning the hair. Olson names all three of his informants and mentions that all were over the age of sixty and one over ninety, thereby giving weight to their descriptions.[247]

Figure 82 is a photo of Mrs. Mary Adams, possibly a Duwamish woman from the Port Madison Reservation, with her dog Jumbo. It appears in the book *Types of Canoes on Puget Sound* by T.T. Waterman and Geraldine Coffin.[248] It is a well-known photo, having appeared in museum exhibits as an example of a Woolly Dog. Digging a bit deeper, I followed the trail of the photographer, who turns out to be Douglas Leechman, an anthropologist who was with the National Museum of Canada.[249] Leechman published an article in a now obscure magazine, *Nature Magazine*, on "Fleece-Bearing Dogs," in which the photo appears with a different title and caption: "She knew of the dogs that gave fleece. Jumbo beside her, is like them [Woolly Dogs], but is a white man's dog."[250] Leechman quoted a conversation with Mrs. Adams:

> "Do you remember," I asked her, "the dogs whose wool the Indians here used for making blankets?"
>
> "Yes, I remember hearing about them, though I never saw them. My mother knew them, and her mother, and they both made such blankets long ago."
>
> "Were they dogs like Jumbo?" I asked curiously.
>
> "Yes, like Jumbo," she replied, "they were white dogs, with long hair, but Jumbo is not one of them. He is a white man's dog, not an Indian dog."

So, we know that Jumbo is not a Woolly Dog. However, by saying "Jumbo looks like them," Mrs. Adams gives us clues of what a Woolly Dog looks like, assuming all Woolly Dogs were similar. Jumbo's ears are upright, and they look a bit small for his size.

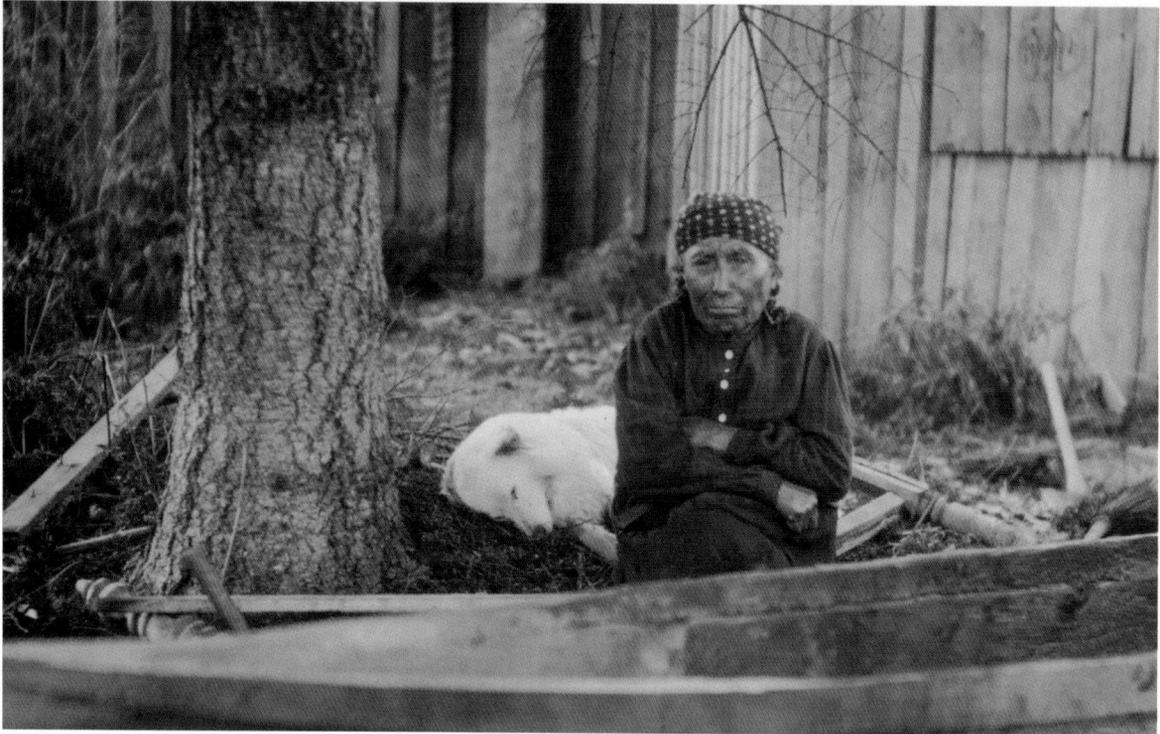

FIG 82

FIG 82 Mrs. Mary Adams and
her dog, Jumbo, in March 1920.
The small fishing canoe was made
by Jack Adams of Port Madison
Reservation.
Douglas Leechman

FIG 83 This 1896 photo has
been used as evidence when
referring to Woolly Dogs. The
Chilliwack Museum and Archives
describes it as "Two First Nations
Girls Holding a Salish Woolly Dog."
J.O. Booen

FIG 83

FIG 84

FIG 85

THE PHOTO OF TWO women and a dog (Figure 83) has also been thought to depict a Woolly Dog. In 2001, Elizabeth Flower Anderson Miller, who had been researching Woolly Dogs for ten years, thought this might be one.[251] However, it lacks the upright ears, and the hair on the dog looks more silky than woolly. As the dogs were getting rare by the 1850s, this 1896 photo may show a descendant that has a lot of European dog genes, like the Tsawout dogs.

There are, however, a few photos from the Tulalip Reservation area north of Seattle that feature what might be Woolly Dogs.[252] In a 2019 exhibit entitled *Interwoven History: Coast Salish Wool*, held at the Hibulb Cultural Center on the Tulalip Reservation, community members provided some photographs believed to be Woolly Dogs (see Figures 87 and 88).

Figures 87 and 88 were both taken between 1900 and 1920. Also included in the exhibit were a couple more, also of that era, and with similar dogs in them, with the pricked upright ears. It is very possible that in some areas, the dogs survived or descendants still had enough Woolly Dog genes in them. It is also possible that different villages had different looking Woolly Dogs, perhaps slightly different colouring, or length of hair, or size.

ANOTHER PHOTO (Figure 86) has caused much confusion and is a lesson in assumptions, biases, colonialism and racism. It shows the reusing of an image for different purposes, not checking the source or the facts, causing misinformation, and demonstrates how a photograph takes on a life of its own and how hard it is to correct.

The Royal BC Museum has a print of this image labelled "Cape Caution, Smith Inlet Indians 1873," and a note "probably from Gwasilla, Smith Inlet, Kwakiutl, Cape Caution Indians." The photographer is listed as "Maynard."[253]

FIG 84 A November 1935 photo of a mixed-breed pup of a "woolly-haired" dog at the East Saanich Indian reserve. The photo is attributed to anthropologist Diamond Jenness. [241]

FIG 85 The annotation on the back of this photograph—a possible Woolly Dog—reads, "Dog, 14 years old, which had been shorn each year for its wool. E. Saanich reserve." The photo was taken by Dr. Jenness in November 1935, and stamped with "Department of Mines Geological Survey Photographic Division, January 23, 1936."
Ian McTaggart-Cowan Fond Collection, University of Victoria Library

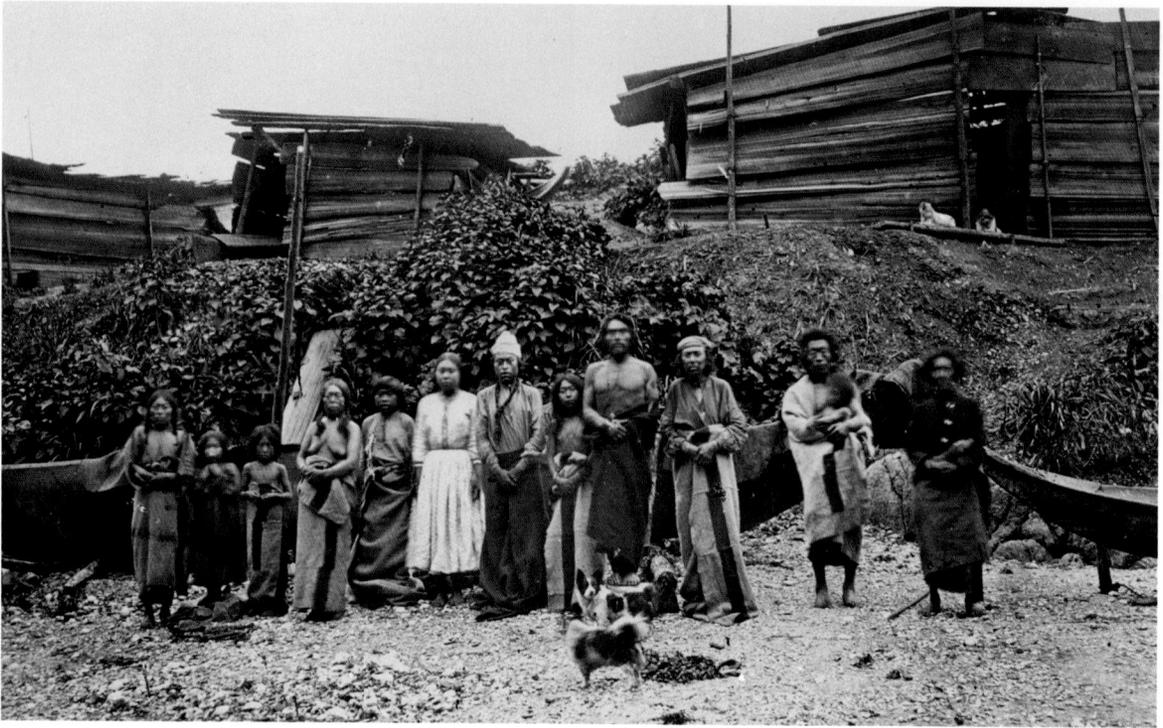

FIG 86

FIG 86 A photograph at the Royal British Columbia Museum, with the caption "Cape Caution, Smith Inlet Indians 1873."
R. Maynard

Both Richard Maynard and his wife Hannah were professional photographers based in Victoria, BC, during the 1870s and into the early 1900s and sold many of their photographs.[254]

The photograph has also appeared in at least three different publications, for three different uses, with three different captions, each giving a different location. Only one of the captions declares this to be a group of Indigenous people wearing dog wool blankets, with their dogs. The other uses of the photograph were for different purposes, nothing to do with the dogs.

One of the earliest uses of the image was in an obscure 1906 novel entitled *Jack the Young Canoe Man: An Eastern Boy's Voyage in a Chinook Canoe*. The caption read only "when they saw the canoe they all stopped and began to stare at it." In this chapter, the fictional hero is canoeing up Jervis Inlet, which is about 300 kilometres or 200 miles south of Smith Inlet as the crow flies.[255]

One year later, in 1907, the photograph makes another appearance, in the book *Among the An-ko-me-nums, or Flathead tribes of Indians of the Pacific Coast* by Rev. Thomas Crosby.[256] As a missionary, Crosby travelled up and down the BC coast, often by canoe.[257] The caption states, "Indian Houses with a Group of Heathens," in a chapter titled "Heathen Street vs. Christian Street" in which Crosby discusses teaching the Indigenous people of Nanaimo

FIG 87

FIG 87 A little girl with a cat, and a possible Woolly Dog, in Tulalip, Washington, circa the 1900s.
Hibulb Cultural Center Collection

(Snuneymuxw) and the Fraser River how to improve their homes. Crosby was convinced that the Indigenous Big House was full of vice: "The old heathen house, from its very character, was the hot-bed of vice. Fancy a great barn-like building..., occupied by as many as a dozen families, only separated from each other by low partitions... [I]s it any wonder that disease and vice flourished under such favourable surroundings?"[258] He went on to suggest "the only way to win the savage from his lazy habits, sin and misery"[259] was to "be able and willing to show how to build a nice little home, from the foundation to the last shingle on the roof."[260]

Crosby probably wanted a photo of a "heathen" house to illustrate the chapter and bought (or used) Maynard's photograph. The image's use in this chapter comparing the Snuneymuxw and lower Fraser River Nations likely made the reader assume the photo was of one of those places. No photographer is listed. Although Crosby's archived documents contain many photos, many with Maynard's stamp (both R. Maynard and Mrs. R. Maynard) on the back, there is no original glass plate negative, nor a copy of this particular image.[261]

The photograph shows up again, this time in the Smithsonian Institution 1924 annual report, with this detailed caption:

An unusual photograph made many years ago showing the crude plank houses of the central Pacific Coast region, near the mouth of Fraser River. The Indians here, belonging to the Salish stock, made blankets from dog wool. Certain dogs were bred for this purpose and were sheared like sheep, as described by the explorer, Vancouver. Such dog wool blankets are actually being worn by the people in the photograph. The author knows of no other photograph showing this kind of dog. Which has become entirely extinct.[262]

FIG 88

FIG 88 Ruth Shelton in a church graveyard with a possible Woolly Dog in Tulalip, Washington, 1922.
Hibulb Cultural Center Collection

The author of this annual report is the same T.T. Waterman in whose earlier, 1920, book, *Types of Canoes on Puget Sound*, the photo of Mrs. Adams and her dog Jumbo appeared (Figure 82). The carefully captioned image is in a chapter entitled "North American Indian Dwellings." Once again Crosby's use of the image in a chapter comparing the Coast Salish of Nanaimo and the Fraser River is taken to mean it is an illustration of house dwellings in those localities. Waterman mentions the "flat" or "shed" roof style being found only in a small area of Puget Sound and at the mouth of the Fraser River, so perhaps he saw this photo in Crosby's book and used it as an example. No photographer is listed. A shed roof is covered in overlapping cedar planks, and has a low pitch or slope, higher in the front and directing rainwater toward the back.

People have since used the roof style in the photograph (Figure 86) as an argument that it indeed originated in Coast Salish Territory and therefore the dogs must be Woolly Dogs. However, the shed roof is also used by other Indigenous groups along the coast. Early sketches in Nootka Sound nuučaańuɫ (Nuu-chah-nulth) territory, for example, depict the shed roof.[263] A shed roof is only one house feature that might identify possible geographic locations, but not a specific location, nor the only feature that should be used.

Each publication step along the way used almost every element in the photo to illustrate different things: people staring, Indigenous houses, shed-roof-style houses, and dogs and dog blankets. The flurries of interest and disagreement involving this picture also extend to the identity of the

190

photographer. George Gustav Heye, founder of the National Museum of the American Indian, corresponded with Billy Newcombe of the Royal BC Museum in 1927, asking Newcombe to explain why the photo is credited to Maynard and not to the US National Museum, saying the National Museum had a negative there.[264] He also asked for more information on Woolly Dogs and dog-hair blankets.[265]

So, which is the correct caption and location? The first publication is a minor work of fiction, so being geographically correct was of little interest to the author, who must have been happy to find a photo of Indigenous people staring toward someone on what might be a river.

Crosby was probably happy to find a photograph of Indigenous people in front of houses in a traditional and, in his estimation, "heathen" setting. He was clearly unconcerned with checking the location.

The last publication, the Smithsonian one, has an air of authenticity. The RBCM not only has a print of the image but also has in its collection a glass plate negative of this photograph, from which prints could be made. This glass plate has been titled "Indians and their dogs at Cape Caution, Queen Charlotte Islands," yet there is a label affixed directly to the glass plate titled "Gwa'sala people, Takush Harbour." The label is much more specific, and arguably is more likely to be geographically correct, than the generalization of Cape Caution, Queen Charlotte Islands (Haida Gwaii).

There seem to be two glass negatives, one at the RBCM and one apparently at the National Museum of the American Indian. However, the RBCM have convincing provenance for their glass plate negative as being the original. It was acquired by the museum from Maynard's son.

Richard Maynard, the photographer, was hired by the British Columbia government in 1873 to accompany the naval gunship HMS *Boxer* up the coast to document Indian affairs. At Takush Harbour, which is in Smith Inlet, around the corner from Cape Caution, some 200-plus miles north of Coast Salish territories, Maynard took individual portraits of some of the people who are standing outside the shed-roof house in the disputed photograph. Those glass negative portrait plates were also acquired from Maynard's son. Having a glass plate negative of a group of people, as well as glass plate negatives of portraits of the same individuals, is convincing evidence that Maynard actually took the original photograph. So, there is a direct line from Maynard travelling north in 1873 to Takush Harbour, Gwa'sala First Nations Territory, in Smith Inlet, to the acquisition of that glass side negative

from his son. Geographically, this indicates that the photograph does not show Coast Salish Woolly Dogs; the location is simply too far north. And judging the dogs by their hair, they do not appear to be any type of Woolly Dog.

As we have seen, the photographic proof of Woolly Dogs is virtually non-existent. Photographs that are said to depict Coast Salish Woolly Dogs turn out to be questionable. Once a photograph was printed, it was printed again and again, perpetuating incorrect information. Although there may be photographs in existence (Figures 87 and 88 are possible, especially when we look at historical descriptions), there doesn't seem to be any that are proof of what Woolly Dogs looked like. We need more information than the images can provide. If we can compare them to written descriptions, it will help to establish evidence.

Descriptions

As we have seen, though there are only a few historical descriptions of the ears of Woolly Dogs, they all agree that the ears are upright. Other historical descriptions exist that provide other hints.

When reading descriptions of Woolly Dogs, one needs to consider the location, the language group the community is a part of and the time frame. Descriptions of the dogs that are geographically close would tend to be of very similar dogs, and those areas are often (but not always) within the same language family, for example, Coast Salish. A different geographic area or a different language family like Wakashan on the outer west coasts of Vancouver Island and the Olympic Peninsula may have different dogs, perhaps similar in some ways (long hair) but not in other visible ways (colour). What we have seen most often in Coast Salish Woolly Dogs is the mention of the colour white, but other descriptions exist.

It is along the outer west coast that other colours are most often mentioned in Woolly Dogs. The earliest known description of a Woolly Dog's colour is in by John Ledyard, who sailed with Captain Cook in 1776 into Nootka Sound, outside of Coast Salish Territory, where they speak nuučaańuł (also known as Nuu-chah-nulth, Nootka), a Wakashan family language. He mentions only that they were white and "of the domestic kind."[266] Yet Charles Hamilton Smith, who went into Nootka Sound sixty-some years later in the 1840s, described the dogs as white and brown and even black.[267] Farther down the West Coast,

Olson's informants (who lived in the 1820s–1870s) said, "In color they varied: black, white, brown and wolf-colored."[268] Artist Paul Kane also wrote in the 1840s of seeing dogs that were white but also dogs that were brownish black at Fort Victoria, where many different Nations would gather.[269] And Teit, who lived toward the eastern edge of Coast Salish territory along the Fraser River, said the dogs were "mostly white but some black."[270]

We should keep in mind the large geographic area and where the sightings and descriptions were based. The First Nations on the west coast of Washington's Olympic Peninsula and British Columbia's Vancouver Island have related languages, and canoes travelled up and down that coast on a regular basis, visiting and trading. Their dogs could have different genetics than the Woolly Dogs in the Salish Sea, Puget Sound and Fraser River areas, which would explain more sightings of coloured dogs on the outer coast. We know Woolly Dogs were not only in Coast Salish territories; other Woolly Dogs existed due to family connections with other communities up and down the coast.

The other geographic area outside of Coast Salish territory that seems to have descriptions slightly different, having white hair but short legs, is Kwakwaka'wakw territory, which covers the northern end of Vancouver Island and parts of the BC central coast. Franz Boas and his Indigenous colleague George Hunt wrote of a chief's dog in that area, a great short-legged dog named Qalakwa (the white you would get when oil and water are poured together and stirred): "The hair of the dog was long like wool, and it hung down to the ground as he was walking about, and the hair was not very curly. The hair was very fine. His eyes did not show on account of the hair that covered them. It looked as though he had no feet, as he was walking about."[271]

A similar description comes from the southern end of Kwakwaka'wakw territory where it meets the northern end of Coast Salish territory. One community member's grandmother described Woolly Dogs this way: "They were always white. They were about the same size [as hunting dogs], but they were broader dimensions across the base. So they're more stocky and bigger legs, but they were short legs and they just ruled the roost sort of thing in the house. They were more of a lap dog that provided what they needed just by combing him."[272]

Generally it seems to be the outer coast that had wool dogs with different colours, whereas in the Coast Salish areas of the Salish Sea, Puget Sound and up the Fraser River, the Woolly Dogs are generally described as white.

Alexander Anderson, who was searching for an easier route from the interior of BC to the coast from 1846 to 1847, wrote:

> From point to point as we descended the [Fraser] River, the palisaded villages which I have mentioned appear. Around gamble whole hosts of white quadrupeds, some shorn like sheep, others sweltering under a crop of flowing fleece...
>
> The dogs in question are of a breed peculiar to the lower parts of Fraser's River, and the southern portion of Vancouvers Island and the Gulf of Georgia. White, with a long woolly hair and bushy tail, they differ materially in aspect from the common Indian cur; possessing, however, the same vulpine cast of continence. Shorn regularly as the crop of hair matures, these creatures are of real value to the owners, yielding them the material whence blankets, coarse it is true, but of excellent fabric, are manufactured.[273]

Many observers described the pelts as thick,[274] very long,[275] very fine[276] and soft.[277] Most but not all wrote that the pelt was white: snowy white or yellowish white.[278] James Teit, like Anderson, also noted the differences between dogs of the plateau (interior of BC) and the coastal wool dogs: "The Lillooet dogs were of the same kind as those of the Thompson and Shuswap and differed from those of the Lower Fraser and Coast tribes, which had very thick, fine and in some cases almost woolly hair."[279]

It makes sense that communities that have closer connections (language, culture, geography and therefore marriages) with other communities would have similar dogs, especially if the dogs were carefully managed for wool. A good example are the Snuneymuxw (Nanaimo) and Quw'utsun (Cowichan) communities, which are only a two-day paddle distance apart, so they would be trading partners, and there would be marriages between the two communities (and those in between); hence their languages are very similar. In the summer, the two communities would paddle across the Salish Sea (Strait of Georgia) and up the Fraser River to their summer fishing sites. The three languages Hul'q'umi'num (Island), Halq'eméylem (or Halkomelem, Upriver), and hən̓q̓əmin̓əm̓ (Downriver) are similar, and family connections are strong between communities. It would be likely that Woolly Dog lines would also be shared between communities. This would be the case with other communities, for example, the W̱SÁNEĆ (Saanich) would easily paddle to the Gulf

Islands, San Juan Islands and Lummi. Paddling to the outer coast, however, is another story. Although it is achievable, it requires good weather and is riskier, with fewer safe havens. Paddling north and south along the coast is more reasonable than paddling west to get to the outer coast then turning north or south. Once the HBC opened Fort Victoria in 1843, things changed, and many Nations from all over the coast came to trade both at Fort Victoria and just inside Puget Sound at Port Townsend, where the trading sailing vessels would stop before going to the outer coast or when coming in. Prior to the HBC, the Woolly Dog breed would have been more easily controlled.

Mutton would fall into the Coast Salish Woolly Dog breed, whereas there may have been other Woolly Dog lines in other areas, like the Nootka Woolly Dog, similar yet different. DNA studies have yet to be done on other dog bones that are assumed to be Woolly Dogs, but now that Mutton's aDNA has been done and DNA markers have been identified, the different dogs from different geographic areas can be looked at to see if they are indeed Woolly Dogs and, if so, how closely related they are to Mutton. Does geographic distance mean a genetic distance too? For now, the common connection of the dogs is the woolly hair used for its fibre.

As for size, Captain Vancouver wrote, "The dogs...resembled those of Pomerania, though in general somewhat larger."[280] Today, Pomeranians are tiny at 15 to 18 centimetres (6 to 7 inches) high, but not 200-plus years ago. To understand what size he meant, it is necessary to know what Pomeranians looked like in Vancouver's time. In 1761, George III, the King of England, married Charlotte of Mecklenburg-Strelitz from what is now Germany, and she brought her pet Pomeranian dogs with her, making them instant dog royalty stars.[281] In 1803, the English Pomeranians were described as "little more than eighteen or twenty inches [about 45 centimetres] in height."[282] So what Vancouver described is not the Pomeranian toy dog but a dog a bit larger, at 45 centimetres (18 inches).

From these descriptions we are starting to get a better picture of what Coast Salish Woolly Dogs looked like: smallish to medium build with thick, long hair; usually white; a pointed face; small, upright ears; and a thick, bushy, curled tail. These descriptions all align with what we know from Indigenous Oral History.

FIG 89

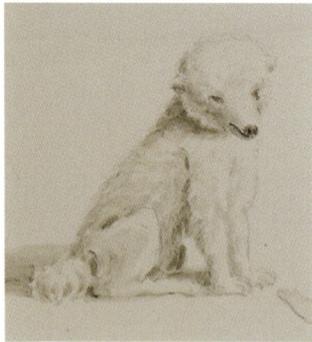

DETAIL

FIG 89 This watercolour and pencil on paper, *Clallam Woman Weaving a Basket*, is another 1847 piece by Paul Kane, with a detail showing a larger image of the Woolly Dog. It is probably a young dog or a recently shorn one.

Stark Museum of Art

Illustrations

Perhaps even better than written descriptions and questionable photographs are early sketches and paintings of Woolly Dogs. The earliest ones we know of are those by Paul Kane, the Canadian artist who travelled across the USA to the west coast and then came to Fort Victoria in April/May 1847.

Kane made a few sketches including dogs in scenes set in a lodge (see Figures 89, 90, 91 and 92). He wrote in his journal, "They have a peculiar breed of small dogs with long- hair of a brownish black and a clear white. These dogs are bred for clothing purposes."[283] At the time, Kane was at Fort Victoria, and he mentioned the village of "Clal-lums" across the harbour from the fort. He may have been referring to the Lekwungen/Songhees Nation, the "Clal-ums" or Klallam/S'Kallam people who lived across the strait along the northern shores of the Olympic Peninsula. Or perhaps the "Clal-lums" were visiting, as Fort Victoria was a gathering place for trade, with the HBC store being located there. If the practice among those groups was to keep the Woolly Dogs in the lodges, then the dogs he sketched were likely Woolly Dogs. In agreement with the descriptions, all the dog sketches show dogs with pricked upright ears and, where the tail is visible, curled, bushy tails.

A few sketches by other artists survive from the 1850s, showing dogs outside of the HBC fort at Fort Hope, and another somewhere along the Fraser River. In these sketches the dogs have upright ears but tails that are straight out—and the dogs do not look woolly or shaggy.

When Susan Crockford did her bone research, she worked with Corporal Cam Pye, a forensic artist for the Royal Canadian Mounted Police, trying to reconstruct what both the village dog and the Woolly Dog looked like. Given the then-current knowledge of the late 1990s, before Crockford knew of the existence of Mutton, Pye and Crockford did an amazing job. As we will see, that image is closest to what Mutton looks like.[284]

The photos of dogs believed to be Woolly Dogs[285] that were submitted by community members for the 2019 exhibit *Interwoven History: Coast Salish Wool* (see Figures 87 and 88), at the Hibulb Cultural Center on the Tulalip Reservation north of Seattle, have a striking similarity to Pye's sketch of a Woolly Dog.

FIG 90

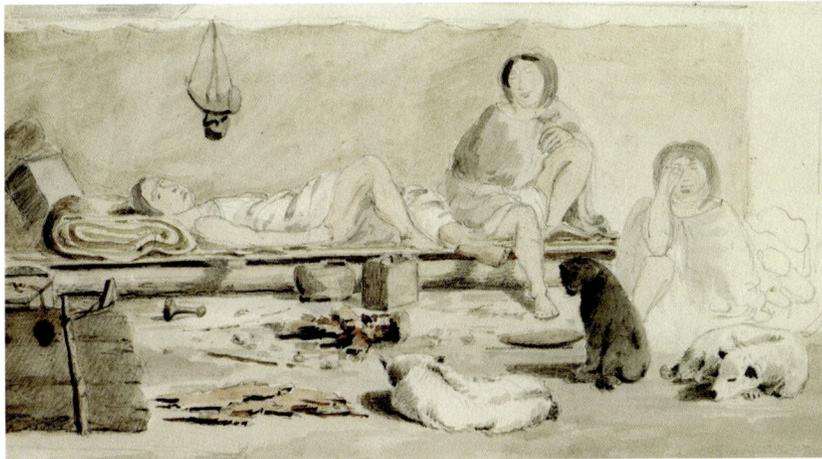

FIG 91

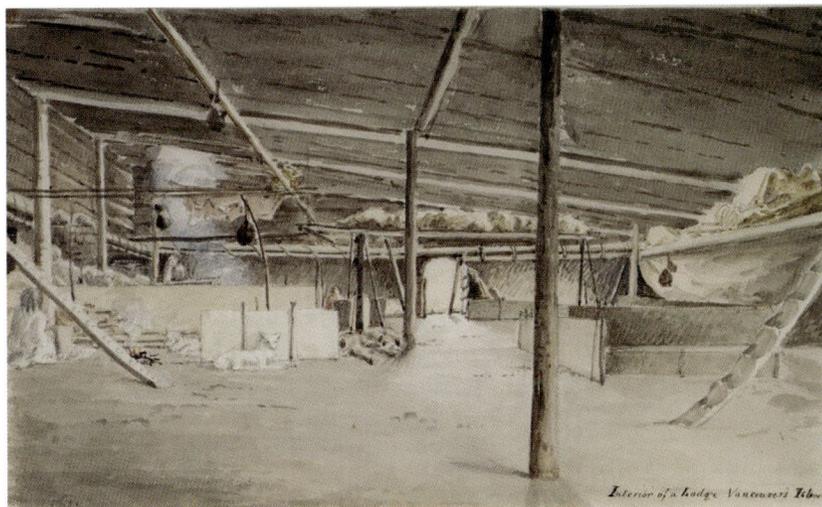

FIG 92

FIG 90 *Studies of Wool Dogs and Interior Furnishings* is a Paul Kane graphite-on-paper drawing from the central Coast Salish, southeastern Vancouver Island area, dating from sometime between April and June 1847.
Royal Ontario Museum

FIG 91 This 1847 Paul Kane watercolour and pencil sketch is called *Interior of a Lodge with Family Group*.
Stark Museum of Art

FIG 92 Paul Kane's *Interior of a Clallam Lodge, Vancouver Island* is also from 1847.
Stark Museum of Art

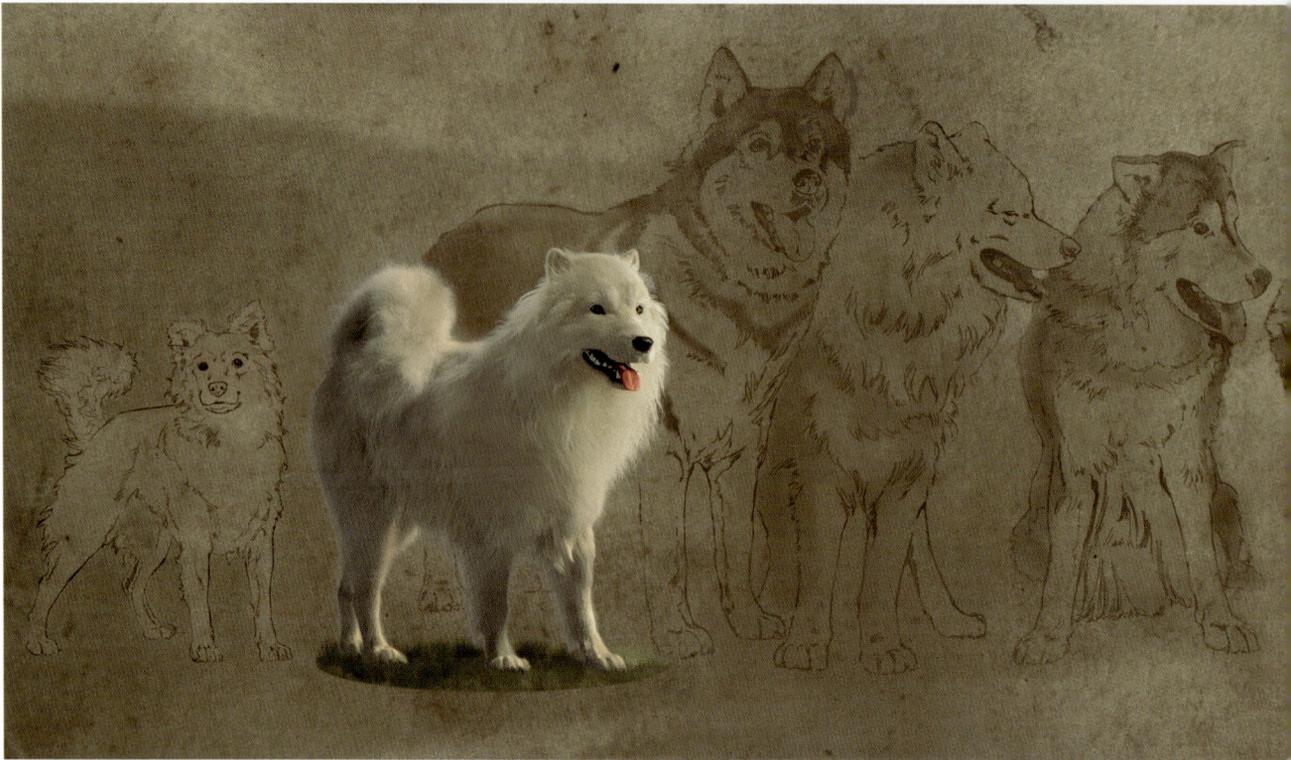

FIG 93 The reconstructed
Woolly Dog, shown at scale, with
Arctic dogs and spitz breeds
in the background to compare
scale and appearance. (This
portrayal does not imply a
genetic relationship.)
Karen Carr

Mutton's Pelt

If Mutton truly represents Woolly Dogs, then surely, we should be able to look at him and see what Woolly Dogs looked like. Given the condition of Mutton's pelt, unfortunately, this is very difficult. His pelt was shipped still damp, folded in three, and had dried with his head flattened, stiff and folded backward. Although Mutton's pelt does give accurate information about his woolly hair, it does not allow us a realistic impression of what he looked like when he was alive.

Audrey Lin and Logan Kitstler, the aDNA scientists at the Smithsonian, decided they would work with an illustrator. Enter Karen Carr, a scientific illustrator known for her skill and accuracy. Carr has done sea monster animations for the US National Museum of Natural History, a life-sized sabre-toothed cat sculpture, paintings for the Montana Historical Society, a map of Operation Desert Storm along with portraits of soldiers for the National Museum of the United States Army, and murals and illustrations depicting dinosaurs and other ancient life forms for museums across the USA. In addition to that, Carr has kept sheep, has dogs and is a spinner and weaver. There

FIG 93

was no budget, aside from some honorariums and some funds to cover the DNA analysis, yet Carr was willing to donate her time. She had all the skills needed to create an image of Mutton, along with a passion for dogs.

Carr needed more information. Mutton's pelt wasn't enough. A skull would be very helpful, but Mutton's skull was nowhere to be found. Iain McKechnie, the archaeologist specializing in coastal marine and animal bones, had a 3D digital scan of what is assumed to be a 1,000-year-old Coast Salish Woolly Dog skull from the Little Qualicum River archaeological site on the east coast of Vancouver Island, in Qualicum First Nation territory. Given this information, Carr absorbed it into her computer program, then added some scanned teeth. Carr worked remotely with Melissa Hawkins, the National Museum of Natural History Curator of Mammals, and with Audrey Lin at the Smithsonian, to obtain accurate measurements of Mutton—his spine, ears, tail and legs—noting all the proportions and using that information along with all the historical descriptions and sketches to create a model. At first, the newly recreated image of Mutton looked like he has just run through a mud puddle, but with a bit more tweaking, and with images of Mutton's hair, he magically appeared before us, in his prime. The image produced by Karen Carr was pretty close to what Corporal Pye had created almost thirty years earlier, and remarkably similar to the dogs in the photographs from the Tulalip family photographs.

In the image (Figure 93), Carr has placed him next to a few modern dog breeds so we can compare his size with other dogs. And so, if Mutton were alive, he would look like this, or very similar: a very handsome and woolly dog.

FUR BEINGS AND WOVEN VISIONS: CONNECTING WITH MUSQUEAM HISTORY

DEBRA QWASEN SPARROW, WEAVER, MUSQUEAM

THERE'S NOBODY to hear from anymore because everybody is gone. I had that one opportunity to my grandfather, which was so fortunate.

I said, "Grandpa," I said, "If you weren't here, I wouldn't have ever known that my great-grandmother was a weaver! Do you know what you just did?

"You just connected me because your grandmother was the last person you saw weaving, and then it was gone for eighty years and now, who do you see, doing it again?"

He said, "You and my granddaughters."

I said, "Yes. So all that time went by and you just connected us again. You reconnected us. I would have never known. I would have said, I wonder if we ever were weavers? So I'm so grateful and honoured to have you here still and tell me all of this."

My names are θəliχʷəlʷət and qwasen, and Debra Sparrow. I'm from Musqueam, and I want to share some of what I've learned about Salish weaving and the little fur beings that are called Woolly Dogs.

But first, I think there are romantic notions in our societies . . . and we've colonialized our way of thinking to think that just because you're a certain age you're an Elder. I have Elders that are way older than me in my community, and it's not my place to call myself an Elder. I think we have to think about this. I'm not taking that role when I have all these other Elders above me. Some of those Elders were in residential school and didn't get the chance to carry any more customary knowledge. And they feel bad about it because they don't have what my grandmother taught to me because they missed it when they were forced into school. You have

to remember, residential schools created huge gaps in our histories and memories, and the families and the children suffered. Of course, there are exceptions where people kept the knowledge going. One of those gems is Stó:lō weaver and Elder Xwelíqwiya Rena Point Bolton.

My grandfather, the late Ed Sparrow Sr., was another gem. He lived to one hundred and I think he passed twenty-five years ago now.[286] He left me with such beautiful visions of the last weavers and of Musqueam. He even shared with me how he remembered seeing Musqueam women weaving when he was about four or five years old, or as he said, "just coming to my senses." Somewhere around that age. He went to residential school at six, but he told me how he watched the women work on weaving. That was the last time he saw it being done. So, that was probably around 1904. Weavers stopped in many communities around that time, not just here. The children being in residential school, they couldn't learn from their families. Colonialism had already done a good job of separating the people from their history by that time.

My grandfather saw his grandmother and her relatives using the wool, so maybe the Woolly Dogs were around and he didn't know that they were Woolly Dogs. You see, he was born in 1898, so maybe they were already on their way out, or they had some hair left because he told me how those layers of roving were put together. But he did tell me where he knew they were kept, at what you know as New Westminster. That was a different village called qiqéyt.[287] And of course, the Musqueam reserve wasn't called "Musqueam" back in the 1700s to 1800s. Every place, every village had its own name in our language. This place where I live today was not called Musqueam prior to the Europeans coming, so our villages were all along here. It is xʷməθkʷəy̓əm.

And I bet you there would be evidence of Woolly Dogs under the ground somewhere, but who knows where? They found two dogs, between five and eight years ago in Nanoose Bay, and they brought them to Victoria. But those didn't include the hair, they were just … the bones. My grandfather told me that every village had them, that they were like gold, because of course, their hair was mixed with the mountain goat and then rove and spun.

FIG 94

FIG 94 View of Poplar Island (yeləɫkʷə and/or skʷtexʷqən) on the Fraser River from River Road, circa 1913.
New Westminster Museum and Archives

So . . . where New Westminster is now, at the foot of 6th Avenue, you know there's a little highway along the water and that mill is there where they used to make tissue? Well, the island behind it is now called Poplar Island (yeləɫkʷə and/or skʷtexʷqən) [see Figure 94].

And that's where my grandfather told me that the dogs were kept. I know that my grandfather told me the exact thing is that they were kept separate always. They had their own pens. They weren't ever taken off the island, unless maybe for use or . . . maybe that was where they lived and bred them too? I think maybe that was a focal point for the dogs around here? And then they'd be taken to each village because there were tons of villages. I think every village had their own dogs, because even the first settlers like Captain Vancouver mentioned about the canoes having little dogs with them. They would have to have had a lot of dogs and a lot of mountain goats to make a lot of blankets, let me tell you.

I don't know if they had a special name for the dogs. I really don't. You know what, I didn't think to ask, "Did you see them?" I know now that the dog was called *sqʷəmeý.* Also, I don't think we ever had "dogs" here, in the European idea of a dog. So, where would we get that name from other than the woolly one? And I mean before contact. My question is, is that "dog" a word that was created for dog,

sqʷəmey̓? Or was that the name of what I think of as a little woolly fur being? The English word and idea for "dog" are a problem for me. That little fur being might have been very different for my ancestors. Because that little fur being didn't have to be a dog, did it? It was unique to us and was something like a dog. My grandfather said it was white and like a small fox, not like a small dog. I know we call it a "dog" now because that's the English-language word that everyone knows, but how did we think about this fur being? Did we think of it like a pet dog, or like some other being that we cared for? I want people not to think of the fur being as a dog that we know today, because maybe it was very different for us before. It was a dog that lived amongst the people. It was their warmth and wealth. It represented so much, and we know that representation. So now for me, it's all about how did they make it? How did they make the yarn with it?

My grandfather said they kept the sqʷəmey̓ in pens, but I think he was generalizing for each village. He did say they kept them in pens so they wouldn't intermix. And no, he didn't say anything about sqʷəmey̓ having a special diet. He did see them process the hair and rove it and get it ready. And weave. He watched the whole thing.

My grandfather saw them using the wool, and he told me how those layers were prepared for roving. He said it was mountain goat, dog hair and clay that they were working with. He told me how the women layered the hair and fibres, and how they were preparing it and roving it, and how they would sprinkle water on it so it would grab the fibres to rove it. So, you can't just think of using mountain goat, because it would deteriorate, it would be gone by now. It was mixed with the clay to help hold the fibres together, and guess what else it would do? It keeps the bugs away. So, mountain goat, dog hair, and the clay all mixed together.

That clay is called diatomaceous earth now, but I wonder what it was called in our language.

Around Musqueam I'm not too sure where there is clay, but we know a place in Stanley Park. I'm going to dry the clay up. My grandfather said they dried it on the fire and then they beat it to a pulp so it was a white powder and then it was laid on the table with adding the mountain goat and dog hair together, and then I think they'd beat that together, and then take the fibre, which would in some cases be

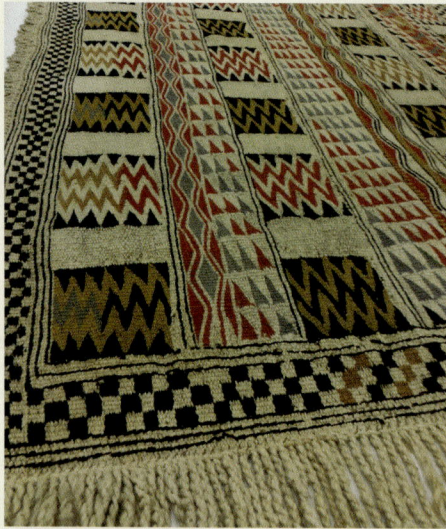

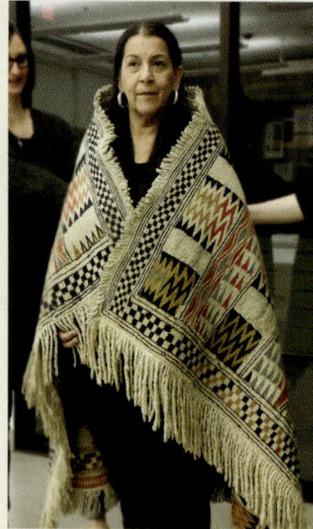

FIG 95 FIG 95 FIG 96

FIG 95 The pre-1828 blanket from the Etholén Collection at the National Museum of Finland.
Liz Hammond-Kaarremaa

FIG 96 Debra qwasen Sparrow wearing the Finland blanket. *Alison Ariss*

cedar and in some cases be stinging nettle. We can't just spin the dog by itself, I think it has to have a core, which would be cedar or would be stinging nettle.

You know there is an old film by Harlan Smith of a woman from Squamish pre-paring mountain goat wool, and I found it interesting [Figure 49]. I think about how he told me they did that to work in the clay. Without the clay and the water, I think it was almost impossible to just grab that wool and make it spin.

And I wonder if they would have to dye that hair before they did this roving process? Maybe they did. And so, would they have dyed it on the skin? Probably. My grandfather told me that the mountain goat was buried in the black clay so it turned black and then they removed the hair from the skin. It would dye the hair, loosen it and then it just falls off after they take it out of the black clay. He said . . . that they dried the white clay on the fire and then they beat it into a powder and then it was laid on the table and added to the mountain goat and dog hair. And then I think they'd beat that together, and then add plant fibre, which would be cedar in some cases, or stinging nettle. Settlers treat stinging nettle like a weed,

FIG 97

FIG 97 Debra qwasen Sparrow's weaving in progress during the Museum of Anthropology's *Fabric of Our Land* exhibition. *Alison Ariss*

but it's a valuable fibre, a food source and a medicine. It's rare to find places where it grows tall anymore.

He said he just watched them process it and rove it and get it ready. He said when they were done, after he watched them, he said, "They baked that clay that I remember them baking the clay and I remember them, beating it to powder on the table and then mixing it all together. After they were finished, they took me to the longhouse later and everybody came and then I got my name."

So, when the UBC MOA brought that Finland blanket home in 2017 (see Figure 95), I studied it a lot. I can't fathom it in my head—how she made it. The only way I can do it is to actually do it. I wove a new blanket during the *Fabric of Our Land* show at MOA that was inspired by the old design, but it is made with sheep's wool (see Figure 97).

I can't even imagine making one as fine as the Finland blanket. There're 500 warps on that blanket. They're so fine they use two warps to every warp, so you count 250, so they were doubled. But I'm going to do it for my documentary film project. I'm excited to do it because everybody says to us, "You guys spin heavy and thick," and we do, but that's because we're using sheep wool.

Studying the Finland blanket and adapting the design for my version inspired me to say I'm just going to buckle down and do a mountain goat and dog-hair blanket and do it the way my grandfather told me to do it. That's why I am going to experiment with cleaning, carding, spinning and dyeing mountain goat and dog hair, because I can picture in my head that there's a process to do it, from what my grandfather explained. He told me step by step by step how to do it, how he watched them. Yeah . . . there will be a lot of fun and trial and error. I'm going to make a blanket with these materials over the next two years.

So, they were preparing everything. He watched them prepare everything for his own naming. He watched the whole weaving being made, that's why I was so shocked when I asked him. I said, "Why didn't you tell me this?" And he says, "Well, because you didn't ask me." And then he says, "Now why would I teach you all that if you don't need it? I didn't think you guys were going to use this in your life. That's why we don't pass anything along that you're not going to use."

So, I'm like, "Oh my god, Grandpa. So, you saw it being done?" And he said, "Well, it wasn't in my house, it was in the back shed. And all the old ladies were together: my grandmother Spahqia, Selisya [who was] Thelekwutun's wife" (see Figure 65), and he named another woman in our language, and he said they worked together. They were working on big pieces, he said. "Not like yours. You guys have small pieces," he said. "And big balls of wool they'd already worked on." He said, "I was only a little boy, and they would always kick me out when I got into too much mischief." His grandparents raised him, not his mother, so he was around them all the time, learning from them. And nobody spoke English at that time, he was learning in his language. He said they were all talking in hən̓q̓əmin̓əm̓ all the time then.

I knew him all my life and he never told me about weaving until I was actually weaving. He just said, "I don't tell you things you're never going to use." So, like I said, colonialism did a good job of devaluing our culture, making us think that—or telling us that—our way of life wasn't right. Residential schools taught him that

our knowledge wasn't valuable. I'm so glad he did share with me finally, what he had seen as a little boy.

I just feel like it's sort of a live fibre, for sure, but when I am weaving it there is a certain sense of some kind of thread to the unknown to where our ancestors are, and that might be what makes any of us feel connected to it. At least that's how I feel. And you know what Louis Riel said? "My people will sleep for 100 years and it's the artists who will wake everybody up again."

And now I'm passing this to my daughter Aileen, because she's learning that. She's done her fourth weaving now. And to my grandson Isaiah. We sit and talk... and they both like it... I think it heals. And I think it's my medicine, and I have absolutely no desire to have any nonsense around my work. I'm too spiritually connected to it. Maybe I'm a romantic and I think of the values of the ancestors, like the dogs and what people have access to, and I like to share that with everybody. All of us in the world are spinners and weavers and we have just put it aside, as if it's not worth anything or it's some artsy thing on the side, but I really feel like it's the core of life.

11 AN ENDING AND A BEGINNING

MY CANOE FAMILY and I were seated on cedar bleachers in a Big House. The fire was burning on the dirt floor and the hosting community were performing a dance to welcome us.

I had been invited to paddle with this canoe family a few years before, and this was our third or fourth Tribal Journey. We had paddled all day, and upon arriving at the village beach, we followed protocol: awaiting our turn to approach the Elders and the welcoming party on the beach, asking permission to come ashore. "We are the *Munu* canoe family from Snuneymuxw. We have paddled far today and have far to go. We are tired and hungry and we ask permission to come ashore and spend the night in your territory." They welcomed us to their Big House for a feast and to share stories and songs.

When the dance ended, I enthusiastically clapped. An Indigenous man seated behind me who had generously been explaining what was happening, leaned forward again and quietly, and in a kind manner, spoke: "In our community we do not clap after a dance. Our dances and songs are ceremony, not entertainment."

I looked around and noticed that after each dance, it was mostly visitors to that particular community who clapped. In other communities, as I later observed, clapping was normal, but not in this community. Each Indigenous community is unique and has its own stories, songs, dances, languages and culture. I realized then that I unconsciously brought with me my own settler culture, biases, assumptions, ways of being and ways of seeing. I walked in

my world with my own atmosphere, my own culture, surrounding me, tinting how I viewed things. If that man hadn't told me, I would never have realized that here, no one was clapping but a few visitors.

What else am I missing? What else am I not seeing or seeing in my Euro-sphere? It dawned on me, that I needed to thin my bias-sphere and to watch, listen and learn more.

Eurocentric people tend to discount Oral Stories as stories, myths, things made up, often to entertain, but they are history in an oral form. The written word can't be privileged over the spoken word, especially if the Oral History was handed down as a teaching. So, although the written word has helped me trace Mutton's particular history and some of the history of post-contact tellings of Woolly Dogs, what is missing? What has been lost? Or perhaps not lost, but in some memories in communities waiting for Mutton to reawaken those memories.

Knowing more of the culture, the context, the values and the teachings will open doors to understanding.

I think knowing more about Mutton is a way to open doors of understanding. But there were nagging thoughts still in my head. How did Mutton die? Was Mutton intentionally killed? Could Gibbs have brought himself to do that for the sake of science? There were still some loose ends.

WHEN THE NORTHWEST Boundary Survey team began the survey back in 1857/58 to place markers along the Canada–US border, they camped out that winter at Semiahmoo, now known as White Rock, BC. They were in, or near, the Peace Arch Park, the imposing site now marking the border south of Van-couver and north of Bellingham on the Pacific coast. In fact, the American NWBS team actually camped on the British side, it being more convenient. They were also smack dab in the middle of Coast Salish territory. This site is now dominated by the highly visible Peach Arch monument, inscribed with the words "Children of a common mother" on the US side and the words "Brethren dwelling together in unity" on the Canadian side. The irony is per-haps not lost on the Coast Salish peoples, whose own longstanding union and commonality, living in this region, faced such massive disruption with the establishment of this border.

As time went on and the Pacific Northwest attracted more settlers and more development, what started out as an imaginary line marked by a series of interspersed physical boundary markers became a border line imposing

many restrictions on Coast Salish people. This border forced some villages to choose which side to live on, or the decision was made for them. It became an invisible wall separating families. It prevented people from accessing their seasonal resource grounds and stopped them working or moving freely within what had become, so suddenly and so strangely, territory claimed and controlled by strangers.

The winter from 1859 to 1860—perhaps the last of Mutton's life—proved to be a hard one for the NWBS team, as young Joseph Harris's letters home recorded. The survey team had arrived at the new US Army Fort Colville, also known as Colville Depot, in mid-November, roughly 450 kilometres (280 miles) from Semiahmoo, more than halfway to their final survey marker at the Rocky Mountains.[288] They had been working in cold weather, with nights going down to –2°F (–19°C), and on these cold nights Joseph Harris (now twenty-two years old) had to take star observations, leaving his tent and warm bed if the night skies cleared, returning to bed only if the skies clouded over. He complained in a letter to his brother that handling the brass equipment in the cold was no joke and described how he had mild frostbite on two of his toes.[289] He wasn't the only one to suffer; several men at Fort Colville were in hospital with frost-bitten feet.

George Gibbs often moved on ahead of the surveyors, figuring out the best trails to take in order to reach the location where the next border marker was to be placed, and working with crews to cut new trails. We don't know how he managed the cold, but at least Gibbs might have had Mutton to keep him warm at night.

Harris was looking forward to spending the winter in rough-hewn log-walled houses complete with plank flooring, fireplaces and chimneys, with the "luxury of having a foot of solid wood between one and the winter blasts"[290] as opposed to the cold, drafty, thin-planked walls of the cabins at Semiahmoo Camp. However, when they arrived at Fort Colville, the construction of the winter camp was at a halt. The cold weather had frozen the pond at the local mill, when temperatures plunged to –15°F (–26°C), preventing lumber being sawn. For the first month they remained housed in their tents until the buildings were finished.

Harris was looking forward not only to his luxurious quarters, but also to eating his much-loved corn mush for breakfast, Johnny cakes for lunch and corn pudding for dinner. He was so disappointed on arriving to find that Fort Colville was all out of corn.[291] It was Harris's letter about the lack of

corn that had helped Chris Stantis home in more on when Mutton died, by analyzing Mutton's hair to determine his diet. We know from the isotopes of Mutton's hair that he lacked corn at his end of life, pointing to time spent at Fort Colville, or being close by after having run out of corn on his journey there.

Food turned out to be plentiful at Fort Colville in some ways, though lacking in others. Harris mentioned Colville Depot had plenty of cattle providing fresh beef, but "milk, eggs, butter, vegetable etc. will not be easily if at all obtainable. We have done without them before and can do it again."[292] Although the survey team and the soldiers stationed at Fort Colville did have some vegetables during their winter there, some of the local Colville Valley men hired in the late winter and the early spring of 1860 came down with scurvy, having survived mainly on salted meat. The scurvy attacked ten of the thirty men engaged in road work. The survey team and the Army men shared whatever tinned vegetables they had with the road workers, but it wasn't enough until, in the springtime, they found a place where wild onions grew, and then the June wild strawberry season produced enough fruit to help them recover.[293]

Gibbs (and we presume Mutton) were at Fort Colville by November 11, 1859, but a few days later, Gibbs headed out to make a reconnaissance of the trail in the direction of the Kootenay River, trying to assess a practical route for the next year. The survey team was eager to finish the last 241 kilometres (150 miles) to the Rocky Mountains before the following winter and wanted a quick start to their next field season. Three years of surveying work was more than enough: everyone was eager to head back to the east coast.[294]

While Caleb Kennerly was back in the warmer climate of Camp Semiahmoo for the winter, the trail blazers were in a deep cold back east near Fort Colville. Archibald Campbell, Commissioner of the NWBS, wrote on November 22, 1859, that a field party under Gibbs was still out, even though the temperature had dipped to –10°F (–22°C) degrees and 3 to 4 inches of snow on the ground would soon force them to retreat back to Fort Colville.

By late November or early December, Gibbs, and perhaps Mutton, returned from the reconnaissance and were back at Fort Colville out of the bitter cold, though Mutton would not be around much longer.

The question that haunted me from the first time I saw Mutton in that drawer at the National Museum of Natural History was this: Did George Gibbs or Caleb Kennerly intentionally kill Mutton to make him a specimen?

FIG 98

FIG 98 A note dated December 24, 1859, from George Gibbs's journal, noting Mutton had not been measured.
Smithsonian Institution Archives

Knowing more about Gibbs and Kennerly made me doubt the intentional killing of Mutton. They do not seem heartless. Given they must have known the importance of Mutton as a specimen, why would they hasten his death?

Mutton's Death

In our careful searches through George Gibbs's journals, hoping to find information about Mutton, we found no mention of him at all, until one short line jumped out at us: "1859 Dec, 24th. 'Mutton' Not measured as he had been sick."[295]

That one short sentence tells us a lot. First, Mutton had been sick. If Gibbs intended to make a specimen of Mutton, he would have measured Mutton shortly before dispatching him, or immediately after, to get the most accurate measurement. Spencer Baird, the curator back at the Smithsonian, had given them written instructions on how to preserve specimens, and he was very clear that specimens such as birds and mammals needed to be measured in a timely manner, before they were dried and before they had any chance of shrinking. The fact that Mutton had been sick likely means his death was unexpected. Why didn't Gibbs measure Mutton just after he died? In failing to measure his pelt, Gibbs may have let his feelings for Mutton interfere with following scientific conventions for making him a specimen.

We don't know if Mutton died on December 24 or if he died before that. It is doubtful that he died much before that date, else why would Gibbs wait until December 24 to record it? Gibbs was faithful in recording things, marking where the specimens came from, helping us to track his travels. However, there is a gap in his collection notebook where nothing was recorded, December 7–23. It could be that Gibbs returned to Fort Colville shortly after December 7 and no more collecting took place and hence no more notes were recorded in his notebook.

There is another possible explanation as to why Mutton was not measured. Perhaps Gibbs left Mutton behind at Fort Colville while he did a reconnaissance during that very cold spell and came back to find that Mutton had died

from a sickness while he was away. Gibbs did have someone in the survey crew who helped him now and then to prepare specimens. Perhaps that person, knowing Mutton's final destination was as a specimen at the National Museum of Natural History, prepared Mutton's pelt and by the time Gibbs returned, the pelt was already mostly dry.

Perhaps Gibbs only recorded the note on December 24, when he was packing specimens to ship back east? There is a strikethrough line in his note, typical of many pages and items in Gibbs's notebook. Maybe as he packed a box, he would strike through those items in his notebook to signify that they had been dealt with.

In any event, Mutton died young, around eighteen months old.

Summarizing what we know builds a case of a late November or December death for Mutton: his hair length; the hair analysis of what he ate (lots of corn after shearing and no corn at the end); aligning the hair analysis with where Gibbs was and when (Chilliwack area, then six months later at Fort Colville). But what about the packing list that stated Mutton was shipped in September?

We do not know what illness struck Mutton—probably not "salmon sickness" as he would most likely have been immune, but maybe Mutton died from a European dog disease such as distemper? Regardless, it seemed to come on suddenly, as no long-term illness showed up in Chris Stantis's analysis of Mutton's hair. A lengthy illness would cause stress and probably show up in his hair—a thinness or a break line. His hair looked healthy, so the illness that caused Mutton's death was probably sudden. And, based on the hair analysis, he did not eat corn—Johnny cakes, Indian pudding or mush of any kind—in the few weeks before he died, though he certainly ate a lot of corn about five to six months before. Matching his diet of corn with where Gibbs was leads to the conclusion that Mutton likely died at least in late November or December 1859, when corn supplies were depleted at Fort Colville. It seemed a sad way to end 1859.

Things were coming to an end. In 1860, Gibbs had supervised the cutting of 275 miles of trails that year alone and had finished his geological reconnaissance to the Rockies. By October 31, he was back at Fort Colville, his fieldwork on the survey completed.

Harris too, having finished his surveying and now in Walla Walla, where he expected to be discharged, wrote about the mule trains moving goods north to Fort Colville:

The principle [sic] article with which these trains are loaded is what do you think? Flour? Pork? Clothing? Boots and shoes? All of these are there no doubt but the meanest kind of liquor is what all rely on mainly to make money out of. I passed one train of 30 or 40 pack horses that had nothing else… I think there will be enough bad whiskey in Colville valley this winter to kill everybody within 100 miles if they would use it all up as fast as the hoarders of it would like.[296]

Commissioner Campbell, geologist Gibbs, and artist James M. Alden (many of whose paintings are featured in this book) left Fort Colville on November 25, 1860, to head back to Washington, DC, to begin writing their reports. At that time, the easiest way back was by ship from Puget Sound to San Franscisco, then down the coast to the Panama (the Panama Canal was not yet built), travelling overland to the eastern coast, and finally boarding a northbound ship.[297] Gibbs and Campbell reached Washington January 10, 1861, the journey having taken forty-six days.[298]

We don't know when Mutton was shipped to the Smithsonian. Shipping boxes of specimens was always a gamble; they were picked up at unpredictable intervals. In October 1860, Kennerly was at Similkameen Depot and had complained to Baird, "I wrote to you long ago about the specimens collected last year by Mr. Gibbs, and sent you a list of them. Well, they unfortunately did not get off from Similkameen Depot as was expected and are still there."[299] He planned on taking them with him when he left in February 1861. When Gibbs was heading back east in December of 1860, he stopped in Port Townsend, where they loaded fifty packages, which had been sitting there for a few months. When Harris left in the fall of 1861, they took with them twenty-four boxes of natural history specimens.[300] They seemed awash in boxes, and keeping track of them clearly proved difficult.

If Mutton died in November or December of 1859—which lines up with what we know of Mutton's diet near the end of his life—either Gibbs took him to Washington, presumably with other specimens, as part of his own baggage, or Mutton remained in one of the boxes left behind in Similkameen Depot. The paperwork is not clear.

It was time to take a good, hard look at that packing list and the accession ledger with the September date and to see if there were any hints. A helpful archivist at the Smithsonian Archives sent me a copy of the packing list, and the accession ledger was available online.

I carefully read the pages from the packing list to see how the list was titled. Kennerly used the term "collecting" or "collection" or "collected." For example, just above field item #288, the page is titled "Continuation of the list of specimens collected by the North West Boundary Survey." Then, after field #319 (Grizzly bear, July 1859) and field item #320 (Goat, July 1859), Kennerly wrote, "The specimens corresponding to the last two numbers were sent off in Aug. last." In other words, two items had been sent off almost a year previously, so it is not exactly a "packing" list or inventory that accompanies items collected and sent off.

Along with the field numbers in the left margin are arrows, one pointing up, as if to say "from here up," and then the word "box," and at the same line an arrow pointing down, as if to say "from here down," and the word "Keg." Items with "box" in the margin are large items, for example, the skin of brown bear, and items in the keg are small items, for example, a bag of snakes. So this note is useful to whoever received it to know what items were packed in a box or keg, but not always, as the goat and bears skins above demonstrated.

After field #358 is a note: "In the large box are also some geological specimens belonging to Mr. Gibbs, which Professor Baird will help dispose of according to request of Mr. heretofore mentioned. —Also a lot of botanical specimens." And then a new paragraph: "If you have any means of ascertaining how many packages I have sent to the Institution up to this time please let me know, as I have no list."

So it appears to be a mixture of a collection list and a packing list, and it was a list sent by mail, not in a box or keg. And it was sent to someone, not Baird, in charge of receiving.

I, and others, had tended to see "packing list" as an inventory of what went into a shipping box, but that was not the case. So if Mutton appeared on a so-called packing list, it does not mean he was packed, as we see from the grizzly bear and the goat. A better term for this list, perhaps, would be a collection list.

Looking carefully at the list, and in particular field #406, "Canis Mr G's dog Mutton," we see that where most items in Kennerly's collection list of specimens have dates, Mutton's field #406 has no date! There is a dash in the date column. Also, even though the field numbers were sequential, some dates above #406 are in 1859 and some in 1860; likewise below field #406. In short, the field number gives no hint as to when Mutton was shipped, which might have helped answer when Mutton died.

FIG 99

FIG 100

The packing list is old and faded, and glancing at it quickly one would just assume the last date written, two lines above, "September, 1859," was also the date for Mutton. Other lines have "ditto" marks (") under the date column, a shorthand symbol meaning it has the same date as the line above. Mutton's entry had no date and no ditto mark. It could very well be that Kennerly marked down Mutton next to the field number he had assigned him and left the date blank to be filled in when he shipped Mutton and he never got around to doing that since it was likely that Gibbs shipped him, and maybe that is why Gibbs crossed out Mutton from his notebook. According to this collection list, the question of when Mutton died (or was shipped) is very much up in the air.

Looking carefully at what is known as the skin ledger, where items were catalogued (see Figure 100), there is a column "When Collected." Once again, no date, no dash and no ditto marks, just a blank entry for "When Collected"

in the row with Mutton's information, similar to the packing list (Figure 99). Also of note, over to the right, there is a column titled "When Entered," and though that too is blank, on the top of that column is the year 1861, a few blanks, then a date of May 8, then more blanks, as if everything below May 8 was added to that ledger on May 8. Sure enough, looking a few pages ahead in that ledger, the top of the column is dated the year 1861, in the same field as the date March 25 for the first item, and below that are blanks until a date of April 8. All this goes to suggest that Mutton was not entered into the records until May 8, 1861.

We do not know exactly when, but thankfully, Mutton did make his way to Washington.

The Demise of the Woolly Dogs

> The first and the most devastating cause of the dogs' demise was the scourge of the pandemics that swept our community. Once the people who took care of the dogs had passed away, it was difficult to take care of the dogs.
> MICHAEL PAVEL, ELDER, SKOKOMISH/TWANA

There are reports dating back to the mid-1800s stating that the arrival of the Hudson's Bay Company and the flood of their HBC-manufactured blankets devalued the dog-hair blankets[301] and hence led to the demise of the Woolly Dogs.[302] With commercial blankets so readily available, why would you need to keep Woolly Dogs? Such theories continue to hold considerable sway, and although they hold some validity, there are other, deeper, aspects to consider. Not everyone had the privilege of wearing dog wool blankets in their daily life—cedar or deerskin clothing were much more common. The HBC blankets allowed more people to clothe themselves in mass-produced blankets instead of their standard clothing of pounded cedar or elk and deer skin. But having more of the population wearing HBC blankets would not have been the only cause of the reduced number of Woolly Dogs.

It's important to keep in mind the different value systems when trade goods are involved. Authors and historians Sylvia Olsen and John Lutz explain this in more detail, but generally where one dog (or mountain goat) blanket would take a year to make, trading a sea otter skin and receiving one or more HBC blankets in return would be a windfall. Lutz points out, "It allowed them to transform something abundant in the territory for something rare."[303]

Where the settler side saw HBC blankets as "trade goods," the Indigenous side traditionally saw blankets as "Potlatch goods." In her book *Working with Wool*, Sylvia Olsen, who married into the Tsartlip First Nation (Saanich Peninsula, southern Vancouver Island), explains the different worldviews:

> When a blanket changed hands, a transformation took place. What the European saw as a purely economic transaction—he turned over a $5 blanket, for which he received goods or services—would have been something very different for the Coast Salish who received the blanket. It may have become a symbol of prestige, the possibility of status, an appeasement to the unseen by the European, and who knows what else—a kind of metaphor for the relationship between the Coast Salish and the newcomers, where intention and meaning were often misunderstood.[304]

A dog wool blanket, whose fibres, spinning and weaving were imbued with cultural importance, could not have been replaced by imported, mass-produced blankets. The HBC blankets provided warmth but not spiritual protection. The demise of the Woolly Dog is often explained by a non-Indigenous worldview of economics and not through a cultural lens.

Other explanations for the demise of the Woolly Dog simply suggest that the Woolly Dogs bred with the village dogs and the genetics faded into a general dog population. However, Mutton had only one European great-grandparent, likely born around 1850, three generations before Mutton was born. The fact that there was not more European ancestry in Mutton (there certainly was in the village dog collected at the same time) speaks volumes, indicating the care to keep Woolly Dogs pure, and that care lasted well after contact. This engrained cultural practice that we know was at least 4,000 years old would not die out so quickly and so easily.

Another reason given for the disappearance of the Woolly Dog breed is the importation of sheep into the area in the late 1840s. This implies dogs quickly became unimportant, supplanted by sheep as a source of wool. Yes, sheep wool was incorporated into blankets, even before sheep were imported to the Salish Sea area, but this was purchased manufactured yarn, not yarn spun locally, until the 1880s, when Cowichan women started spinning sheep wool and knitting sweaters.[305] In my studies of Coast Salish blankets, only commercially spun sheep wool was used in blankets until around the turn of the century, when handspun sheep-wool yarns were incorporated, a timeframe well past the demise of the majority of Woolly Dogs.[306]

Although these contributing factors—the arrival of HBC blankets, increases in accidental crossbreeding, the importation of sheep—likely did play a role in the demise of the Woolly Dogs, the extinction of the Woolly Dogs is much more complicated.

Mutton was very likely one of the last Coast Salish Woolly Dogs. By the 1850s their numbers were dramaticall,y decreasing. A visitor to Snuneymuxw (Nanaimo) territory in 1853 wrote, "The number of white woolly-haired dogs is quite astonishing, in one hut not more than 15 feet square I counted thirteen of them, and nearly as many human beings."[307] John Keast Lord, the naturalist on the British survey team was in Nanaimo on a couple of occasions in 1858, only five years later, and observed that "the dog from which the hair was procured is extinct or very nearly."[308] Another five years later, Capt. Charles Wilson, head of the British team of surveyors, wrote that the Woolly Dogs were "rapidly dying off."[309] Something happened in the 1850s, perhaps, as mentioned, a European dog disease. But from the 1850s on, many factors brought about the demise of the Woolly Dogs, chief among them diseases. We know that European diseases devastated the Indigenous population. Without their caretakers, the carefully maintained breed would diminish, eventually disappear.

The dog was said to have disappeared in the 1860s, though reports of a few individual sightings persisted up to the 1940s. Often ignored or neglected in trying to understand why this dog disappeared is the sequence of events that so greatly impacted life in the Pacific Northwest. In 1855, the non-Indigenous population of Vancouver Island, the Gulf Islands and the Lower Mainland was estimated at less than 1,000. Then the gold rush of 1858 brought over 30,000 miners to the area. In one six-week period, 10,000 people arrived in Victoria and the Fraser River, like a human tsunami. So many arrived in such a short period that the land was thrown open to settlement. The impact on traditional Indigenous life was incalculable. The catastrophic smallpox epidemic of 1862 quickly followed the flood of incomers.[310] Smallpox and other European diseases are estimated to have killed up to 90 to 95 per cent of the Indigenous population of North America.[311] As one Cowichan woman wrote, "Nothing was ever the same again." Entire villages were wiped out. If there were any survivors, there were not enough to bury the dead; "They simply pulled the houses down over the bodies and left them."[312]

Smallpox was not a one-occasion epidemic; many waves of smallpox came through, and it wasn't the only epidemic. Other diseases, such as the flu,

venereal diseases and tuberculosis, took a great toll on the population. There are Elders who remember the impact of TB. Many still carry the TB bacterium in its latent non-infectious form. My Tribal Journeys tentmate over the past dozen years, Fran Tait, has the non-infectious form. Fran's father died of TB when she was three, and Fran contracted it. She spent 18 months in a TB hospital, and by the time she was five years old, her mother had been killed and Fran, now an orphan, was taken from her community to residential school in Port Alberni, hundreds of miles away. Illness and disease re not ancient history; they still live in the bodies and minds of people today. W̱SÁNEĆ Elder Dave Elliott, who passed away forty years ago, wrote about TB in his lifetime, which may still be in living memories today:

> When I was a young man and TB was still running like wildfire, our people were dying so often it seemed like every week we were taking somebody up to the cemetery. In the morning when you'd get up the first thing you would hear somebody crying or wailing. Amid this…you would hear saws and hammers going. We used to make our own caskets.
>
> …This is what we lived through. It lasted up into the fifties.
>
> If you can understand this and feel a little better about us maybe we won't look just like lazy people. We won't look like people that don't know or don't care what we are doing or where we are going. We lived through hell and we survived it. [313]

In the years following the overwhelming migration of gold miners, or as the Halq'eméylem-speaking people called them, the *Xwelítem* (the hungry people), followed by smallpox and many other diseases, and ever-expanding white settlement, the surviving Coast Salish people found their world forever changed. Colonial policies and practices, harsh laws and racist attitudes increasingly held sway.

As we saw in chapter 5, Caroline Solazzo tested eleven Coast Salish textiles at the Smithsonian in 2011.[314] Only seven contained dog wool, and all of those seven had been collected before 1862. So, by the 1860s, it is probable that Woolly Dogs were in decline, though Woolly Dogs most likely survived into the early 1900s in a few communities; no reports exist after the 1940s.

Caleb Kennerly's Death

Caleb Kennerly stayed a few months longer than Gibbs and anticipated arriving in Washington, DC, in March of 1861. Kennerly must have been conflicted emotionally and suffering from anxiety. He was looking forward to getting home, and at the same time dreading the ship's voyage, as he was prone to sea sickness. He would be leaving in the midst of winter, a bad time for storms in the Pacific. Underlying all this, he was leaving his wife and son at Semiahmoo. That could not have been easy, and with a possible civil war brewing, he did not know when he would be back.

Kennerly suffered from alcohol use disorder. Two key factors worked against him: genetics, which accounts for 60 per cent of susceptibility factors, and his environment—too many of his peers drank and drank often. Kennerly, along with the official artist on the NWBS, James Madison Alden, and a few others, boarded a Panama-bound steamer, but just four days later, he died.

In Washington, DC, Spencer Baird received a telegram from George Suckley, another naturalist working with Gibbs and Kennerly, who was waiting in New York for some papers from Kennerly. He was short and to the point:

> Dear Professor,
> Kennerly died at sea between San Francisco and Acapulco. Cause rum.
> Suckley[315]

Baird mentioned getting the news from Suckley in a letter he wrote to Mr. Samuel Hubbard of San Francisco on the morning of February 27, and expressed his sadness:

> Although no relation to him whatever, his death is a sad blow to Mrs. Baird and myself. He was a student in college while I was a professor, fourteen or fifteen years ago, and he has been like a son or younger brother ever since. Our house has been his home and during the whole four years (nearly) of his absence, scarcely a steamer left without a letter from us.[316]

Caleb Kennerly, who had contributed so much knowledge about the natural world, was dead at the age of thirty-two.

George Gibbs

Gibbs arrived safely back in Washington only a scant month before the death of Kennerly. They had worked together closely for four years, both committed to contributing specimens and helping to create the beginnings of the National Museum at the Smithsonian Institution. In his letters and notebooks, Gibbs never once commented on Kennerly's drinking. Even knowing how Kennerly died, he explained his death as "cerebral exhaustion" and did not mention the cause.

Normally, when a collector returned to the Smithsonian, he spent time there working on the collection recently made in the field, making sure specimens were catalogued correctly, and writing up all the reports. With Kennerly's death, Gibbs had to deal with the collection acquired during their time together in the Pacific Northwest, with Kennerly's natural history reports, as well as his own geological and ethnological reports.

He hired many natural history experts to help finish reports on birds, fossils, insects and shellfish, including his friend George Suckley, to work on the studies of fish. Gibbs was still on the NWBS Commission payroll while these reports were being worked on. With his own geology report finished in May of 1862, he proposed working on maps, languages and dictionaries, and a general ethnology, including mythology, culture, population and relations with settlers, but Campbell turned him down. Gibbs's work with the NWBS ended.

Unlike many who worked on the NWBS, Gibbs never married an Indigenous woman, though there was one brief mention of him being attracted to a woman in Semiahmoo. August Kautz, the Army quartermaster, wrote in his diary on February 4, 1859, "Gibbs is gloomy and despondent, his friend in the Indian Camp constantly attracts him in that direction whilst his prudence and wish is to keep away."[317]

Gibbs's mother died late in 1870, when Gibbs was fifty-five. Within months, Gibbs married Mary Kane Gibbs, his first cousin. His biographer, Stephen Beckham, put it this way: "Probably the two cousins had long considered marriage, but it was not until Laura Gibbs was in the grave that her eldest son first mentioned the possibility in a letter to one of his close friends."[318] Once married, Gibbs wrote to a friend, "I now look back on many years wasted in bachelorhood with great regret."[319]

Less than a year later, Gibbs became a near invalid. He suffered from chronic health difficulties such as malaria and gout. His bride nursed him back to health, but not for long. He died just a couple of years later, on April 9, 1873.

At the Smithsonian, Gibbs had focused first on his report commitments to the NWBS, publishing his field notes, then worked on languages and maps he had made or added to. His work on languages was astounding. His dictionary *A dictionary of the Chinook jargon, or, Indian trade language, of the north Pacific Coast* had at least twelve printings between 1875 and 1906. His work on the Nisqually language (southern Lushootseed or Twulshootseed) is regarded as "a treasure trove of information unknown to the modern-day Nisqually."[320] Likewise, linguists of the Nooksack language, impressed with his detailed recording of Nooksack place names and geographical features (rivers, bays, villages, etc.) and a phonetic key for pronouncing words, noted Gibbs was a "superior linguist of his day," acknowledging that his work has helped with the transcription of other works.[321] In all, he left the Smithsonian over one hundred vocabularies in his own handwriting, sixty of which he collected before he left the Pacific Northwest.

Gibbs was a participant in the subjugation of the Indigenous population through his involvement in many of the treaties in Washington and Oregon territory, a complex situation that must have created conflict within him. To his credit, he fiercely argued with Isaac D. Stevens, who wanted to move many villages into one large reservation. Gibbs fought to keep the villages where they were to preserve languages, culture, traditional territories and fishing rights. His suggestion prevailed, but it was the beginning of subjugation.

Gibbs was a complex person and lived in what might have seemed like a simpler time, but in hindsight, decisions that seemed clear and straightforward back then are now seen as muddy and complicated. Did he go far enough, or understand the huge implications that, almost two hundred years later, we are revealing?

Some academics might argue that Gibbs missed an opportunity to make more substantial contributions to ethnology, being distracted by so many diverse cultural interests, his passion for language, and dashing off to visit with any Indian delegations arriving in Washington, but his work has proven invaluable. Many of Gibbs's journals, letters and field notes still exist, including one where he recorded three different stories of the dog children.[322] Much more research could be done into the papers of George Gibbs, trawling through his handwriting, sketches, observations and notes, which recorded a wide range of interests. We could learn a lot more about his affinity with the Indigenous people. Maybe more on Mutton would emerge.

All in all, given the work Gibbs did in his time in the Pacific Northwest,

given his linguistic skills and ethnographic interests, I like to think he decided to let Mutton die due to natural causes (even if that meant a compassionate end to Mutton, if he was sick) before making him a specimen. But once Mutton died, Gibbs wanted to ensure his pelt lived on.

Mutton's Legacy

Since I first saw Mutton's pelt, the long, yellowish-white, woolly hair of which has captivated us, lying in the drawer at the Smithsonian, I have learned a great deal. I've learned how real he was, about his life, the NWBS and the men involved in it, and about the importance of Woolly Dogs to the Indigenous Peoples of the Pacific Northwest. I've also learned a great deal about the impact of colonial policies, biases and attitudes on Indigenous cultures.

Mutton's pelt has acted like a teacher. His teachings have revealed so much, to so many people—not only about dog wool and Woolly Dog aDNA and diet, not only about blankets and weaving and spinning, but about the enduring strength of Oral History. Stories of these little white dogs have lived on in Coast Salish memories even though the dogs themselves have not survived. Mutton died more than 160 years ago, but with the help of many people who have cared about him, he ranks as a Knowledge Keeper, a teller of stories, a teacher of history. Mutton has taught us the importance of listening to Oral Histories of the Woolly Dogs of the Pacific Northwest. What other stories should we be learning from?

When I think of Mutton's pelt, I am reminded of the Traditional Story of the dog children. A young woman gives birth to puppies. While she is off gathering clams at night, she discovers they take off their pelts and turn into humans while she is away. Hearing her come, they quickly don their pelts and again are puppies. One night, she sneaks back, runs in, grabs their pelts, and flings the pelts into the fire so they cannot return to being puppies and must remain human. Feeling guilty, they resolve to be of help.

I like to think that Gibbs, in keeping with the dog children story, separated Mutton from his pelt. Because Mutton's pelt did not end up in a fire, it is still here, and so too is his spirit, wandering amongst us—teaching us how to be human, how to listen to many forms of knowledge.

ACKNOWLEDGEMENTS

I GRATEFULLY ACKNOWLEDGE, with respect and appreciation, the Coast Salish peoples, within whose home territories I am privileged to live and work, particularly the Snuneymuxw First Nations. Their historical relationships with the land continue to this day.

I am so very indebted to the Elders, cultural leaders, and Coast Salish people who helped open my eyes and supported me in many ways. Elder Gary Manson, Donna, and the *Munu* and *A'kwul'muxw* Snuneymuxw canoe families who put up with me over the years and gave me so much. Elders Geraldine Manson, Snuneymuxw; Luschiim Arvid Charlie, Quamichan (Cowichan); Chief tsilixw Bill James, Lummi, who all shared some knowledge with me—I raise my hands to all of you in gratitude.

The book would never have come about without the encouragement of the research advisory committee whose members varied over the years but included the following people: Andrea Fritz, Lyackson; Danielle Morisette, Suquamish and Shxwhá:y; Debra qwasen Sparrow, xʷməθkʷəy̓əm (Musqueam); Michael Pavel, Skokomish/Twana; Susan saɬamit́a Pavel, Senaqwila Wyss, Sḵwx̱wú7mesh Úxwumixw (Squamish Nation); TEEWEEWAS Tillie Jones, Tulalip–Yakama Tribe; Tracy Sesemiya Williams, Sḵwx̱wú7mesh Úxwumixw (Squamish Nation); Violet Snu'Meethia Elliot, Quw'utsun (Cowichan) and Snuneymuxw; Sulqun Philomena Williams, Quw'utsun (Cowichan); Nancy q̓wat́ələmu Bob, Lummi Nation; and Tami Kay Hohn, Puyallup tribe. My humble thanks go to the interviewees and contributors who shared their knowledge and are quoted throughout the book, along with those listed above: Xweliqwiya Rena Point Bolton, Elder and Knowledge Keeper, Sto:lo; Eliot White-Hill Kwulasultun, Snuneymuxw; Clarence "Clay" Koch of the Cowlitz Tribe for permission to include the *yúy'yux̱txn* James Cheholtz story; JSINTEN John Elliott, W̱SÁNEĆ, for permission to include his father's quotes; Ty Elliott, Quw'utsun (Cowichan) and Snuneymuxw; Jared Qwustenuxun Williams, Quw'utsun (Cowichan); Kerrie Charnley, xʷə́lməxʷ, q̓íc̓əy̓/Katzie; William Wasden for sharing his mask story with me; the family of Jeffery Verrege, who gave permission to use his artwork; and Alison Ariss.

I am so grateful to the many curators, collection managers, archivists and staff who were so accommodating. A great example is Felicia Pickering with the National Museum of Natural History, now retired but still there volunteering. A tremendous amount of work went into the gathering of images, a task made easier by my research assistant Zandria Sarrazin and by archival documents.

Museums and staff include Steve Henrickson, Ellen Carrlee, Alaska State Museum; Sandra Johnston, Alaska State Library; Jago Cooper, Cynthia McGowan, and Amber Lincoln, British Museum; Monica Park, Brooklyn Museum; Katie Bunn-Marcuse, Rebecca W. Andrews, Ashley Verplank McClelland, Justin McCarthy, Rose Mathison, and Bridget Johnson at the Burke Museum; Katia Macias-Valadez and Shannon Mooney, Canadian Museum of History; Tristan Evans, Chilliwack Museum and Archives; Rania Taina, the National Museum of Finland; Cynthia Mackey, Peabody Museum of Archaeology and Ethnology at Harvard University; Emilie Miller, Hibulb Cultural Centre; Joanna Cole, Mark Dickerson, and Jeremy Udon, Pitt Rivers Museum; Susan Rowley and Katie Ferrante, Museum of Anthropology, University of British Columbia; Nathan Sowry, Pat Nietfield, and Heather Shannon, National Museum of the American Indian; Mark Hall and Paul Adair, Perth Museum, Scotland; Jade D'Addario and Nicola Woods, Royal Ontario Musuem; Elizabeth Peterson, Steven Davies, India Young, Royal BC Museum; Esther Rimer, Tad Bennicoff, Richard Gilreath, Daisy Njoku, Gina Rappaport, and the many others at the Smithsonian Institution (NMNH, NMAI and Archives); John Foshee, Stark Museum of Art; Heather Dean, University of Victoria; Lisa Marine, Wisconsin Historical Society. Thank you also to artists Jean Compton and Zdenka Hofman and all the staff at Vancouver Island University who supported me in many ways and who all freely shared their knowledge.

I feel it is important to acknowledge the researchers who came before me and whose work in Coast Salish textiles helped lay the foundation for this book: Bill Holm, Paula Gustafson, Chief Janice George and Buddy Joseph, Leslie Tepper, Russel Barsh, and Caroline Solazzo. Other researchers who shared their knowledge include Susan Heald, National Museum of the American Indian; Candace Wellman, who was instrumental in finding Mutton and was a colleague with whom I could confer; Terrence Loychuk and Elaine Humphry, whose microscopic work has been used to identify many blankets containing dog wool; Deb Freedman for sharing her Wickersham notes; Vicki

Tobias, Barnett Richling, Harry Alden, and Desmond Morris (who while in his ninety-fourth year, in 2023, produced four books); Sease Kasey; and Susi Szeremy.

This book would not have come about without my fellow researchers who were inspired by Mutton and reached out to me: Audrey Lin, Logan Kistler and the other researchers at the NMNH; Chris Stantis and Missy Hawkins; Karen Carr, who volunteered to recreate Mutton; and Ian McKechnie and the other co-authors of the Science article. They all made the project so much fun to be a part of.

There were numerous supporters like my mother, Dodie Hammond, brothers and sisters, and friends like Trudy Chatwin who gave me space to work on this; Nicole Norris, Kelly Sullivan and others who gave me good advice; and Nancy Turner for her encouragement. And there are probably numerous more I should mention, but doing so would make the acknowledgements far longer.

However, a few special ones I will be forever grateful for and in debt to: Margaret Horsfield, who encouraged me in my writing over the years, edited my submissions, taught me many writerly things and did what she could to prevent me from embarrassing myself; Rhonda Bailey, who provided her encouragement and expertise; my historian brother Lorne Hammond, who I could call on for facts and footnotes; Monica Hammond, Kerrie Charnley, Alison Ariss and Michael Pavel, who all reviewed various versions of the book before the editing.

Finally, my thanks go to the team at Harbour Publishing: Anna Comfort O'Keeffe; Ariel Brewster, who coordinated everyone; Emma Skagen, my wonderful editor who improved not only my writing but also my math; Zoe Mackenzie, who was able to get the best out of the images; editors Alicia Hibbert and Stephanie Fysh (the perfect proofer); François Trahan, who created such a comprehensive index; and designers John Montgomery and Naomi MacDougall.

My final thanks to the readers, who are supporting Coast Salish weaving-related activities with proceeds from this book.

ENDNOTES

Full citations are found in the References on page 236.

Entries marked with an* indicate hyperlinks are available online at *www.lizhk.ca/Mutton*

INTRODUCTION

1 Latdict, 2, accessed August 28, 2024.*
2 "Two-Eyed Seeing," The Institute for Integrative Science & Health, accessed August 12, 2024.*
3 Lin et al., "The History of Coast Salish 'Woolly Dogs,'"* Within weeks of being published, the article was determine by the tracking company Altmetric to be among the top 5 per cent of all articles ever tracked for quality and quantity of online attention that it has received. Within six months, it had been downloaded over 16,000 times.
4 "Wolf, coyote and dog. As told by yúy'yuχtxn James Cheholts of síq'ʷɬ (Toutle river band of Cowlitz) in 1927," from Adamson, *Folk-Tales of the Coast Salish*, 191. yúy'yuχtxn James Cheholtz was the son of Chief Henry Cheholtz and grandson of Chief Kiscox, representative Chief for the Cowlitz at the 1855 Chehalis River Treaty Negotiations. The Cheholtz family is from the síq'ʷɬ (Toutle river band of Cowlitz) near the middle part of the Cowlitz River in present-day Castle Rock, Washington.

CHAPTER 1: FINDING MUTTON

5 Many early settlers and Hudson's Bay Company workers married local women, for both commercial strategic and personal reasons. Other than in a few diaries, letters home or church records, but not the official HBC records, the women are largely ignored in the records, as Candace Wellman discovered and is trying to address. Some, but not all, of the men considered them "country wives," and after their contract with HBC or other organizations was over, left these wives and went home to their other wife. And some remained happily married for the rest of their lives.
6 Today, you can read many of the documents referred to in this book yourself, as they are digitized online, and a few have even had the original handwriting transcribed. A good example is a journal by George Gibbs, Northwest Boundary Survey, 1857-1862.*
7 Kennerly, letter, August 19, 1859.
8 Crockford, *Osteometry of Makah and Coast Salish Dogs* , 3.*
9 The heart of the Cowichan sweater industry is the Cowichan Valley, hence the term "Cowichan" sweater, in the southern portion of Vancouver Island. However, many Coast Salish women (and men) on the mainland and throughout Puget Sound knit sweaters, sometimes called" Indian sweaters" or "Salish sweaters." In 1990 the Cowichan Tribes registered "Cowichan" as a trademark to ensure only true Cowichan sweaters were marketed. Sylvia Olsen's book *Working with Wool* (2010) is a wonderful read of the history of the Cowichan sweater.
10 Barraclough, "Dogs That Were Indigenous to the Northwest Coast"*
11 Dog wool is known as *Chiengora*—*chien* is French for "dog," and *gora* is short for "angora" as in angora rabbit fur or mohair from angora goats. There are reports that dog hair was used in textiles in prehistoric Scandinavia, by the Chono of Chile, and by the Zuni, but only the Coast Salish bred the dogs specifically for its use in textiles. Segura et al., "Biological and Cultural History of Domesticated Dogs." *
12 Gustafson, *Salish Weaving*, 79.
13 Gustafson, Salish Weaving, 83.

CHAPTER 2: MUTTON'S JOURNEY TO THE SMITHSONIAN

14 Kennerly, letter, August 19, 1859.
15 By 1845, the growing number of Americans colonizing land near Hudson's Bay Company forts (owned by the British) made it necessary to establish a border. The 49th parallel meant the British had to relocate some of their forts northwards out of US territory and into British territory. For example, Fort Vancouver, along the Columbia River was relocated to Vancouver Island and renamed Fort Victoria, and Fort Colville moved north to become Fort Sheppard.
16 Kennerly took a photography course at Olympia in February 1859. Judging by the typical NWBS tent behind him, this is probably taken after that. Kennerly, letter to Spencer Baird, February 3, 1859.
17 Letter from Baird to Joseph Leidy, a professor of natural history and a close friend, October 16, 1861.William Healey Dall, *Spencer Fullerton Baird; a Biography*, 338*
18 Of the men who stayed longer than two years at Fort Langley between 1827 and 1859, twice as many were French-speaking as English-speaking. Barman, *On the Cusp of Contact*, 216–18.
19 Chinook Wawa or Jargon is also known as the Hudson Bay Language. It was widely used on the coast. George Gibbs published the *Dictionary of Chinook Jargon*. There were at least twelve printings of this work between 1875 and 1906. Even the school established in Fort Victoria taught the Indigenous children in Chinook Wawa. It wasn't until the mid-1900s that it disappeared, yet many words are still in use (e.g., *skookum* meaning "strong, brave, powerful, impressive"). Gibbs, *A Dictionary of the Chinook Jargon*ature*
20 Harris and Anderson, *Letters from the 49th Parallel* .
21 Kennerly, letter March 5, 1858, 1833–1887.
22 Barsh, Jones, and Suttles, "History, Ethnography, and Archaeology of the Coast Salish Woolly-Dog," 1–11.
23 Dall and Gibbs, "Tribes of the Extreme Northwest 219.*
24 Stó:lō (meaning "people of the river") is a political amalgamation of eleven communities near the Fraser and Chilliwack Rivers.
25 A large area of land—what is now part of British Columbia, Washington, Oregon, Idaho and parts of Montana and Wyoming—was once called Oregon Territory, between 1846 and 1859. In 1859, the southwestern portion was admitted to the Union as the state of Oregon. The northern section became Washington Territory from 1853 to 1889. That was then admitted to the Union, becoming what we now call Washington State.
26 Carstensen, "Pacific Northwest Letters of George Gibbs." *
27 Letter from Laura Gibbs to Oliver Wolcott, February 23, 1823, Gibbs Family Papers.*
28 The letters are in the Joseph Smith Harris Papers, Yale Collection of Western Americana, Beinecke Rare Book and Manuscript Library. Most of them have been translated in Harris and Anderson, *Letters from the 49th Parallel*, 63, 210.
29 Ian Jackson, introduction, Harris and Anderson, *Letters from the 49th Paralle*, xxiii.
30 Harris and Anderson, *Letters from the 49th Parallel*, 36.
31 Harris and Anderson, Letters from the 49th Parallel, 201–03.
32 Gibbs, Indian Tribes 1853–1854, Gibbs Notebooks of Scientific Observations. *
33 Gibbs, Journal & Notes North West Boundary Survey, 1855–1858, Gibbs Notebooks of Scientific Observation of the Pacific Northwest, 41r*
34 Dall and Gibbs, "Tribes of Western Washington."

CHAPTER 3: THE WOOLLY DOG

35 Captain Vancouver was tasked with surveying. His 1791–95 expedition is known as the longest survey voyage in the world. He was a meticulous mapmaker and spent the better part of that expedition charting the Pacific NW Coast and assigning British place names as he went. Vancouver is named after him, as is Vancouver Island, formerly known as Vancouver's Island.

36 Vancouver, *A Voyage of Discovery to the North Pacific Ocean, and Round the World*, vol. 1, 266.*

37 Menzies, *Menzies' Journal of Vancouver's Voyage*, 58–59.

38 Vancouver, *A Voyage of Discovery*,Vol 1.

39 Simon Fraser became a partner in the North West Company of Montreal (which later merged with the Hudson's Bay Company), which wanted to expand westward. The company was looking for the source of the Columbia River. In 1808, Fraser's group were the first Europeans to explore what turned out to be not the Columbia but an unknown (to newcomers) river, which was named the Fraser River.

40 In 1808 the "Canada" Fraser was referring to was the two colonies of Upper and Lower Canada, now parts of the provinces of Quebec and Ontario. At the time Fraser's use of the place "Canada" was referring to Upper Canada (Ontario). What eventually became British Columbia did not become part of Canada until 1871, sixty-three years later. See Wikipedia The Canadas.*

41 Fraser and Lamb, *The Letters and Journals of Simon Fraser*, 119–36.

42 Scouler, "Dr. John Scouler's Journal of a Voyage to N. W. America," 196.

43 Vancouver, *A Voyage of Discovery*, vol. 1, 266.

44 Suttles, *The Economic Life of the Coast Salish*, 75–86.

45 Anderson, "Notes on the Indian Tribes of British North America," 78.

46 Lord, *The Naturalist in Vancouver Island*, 216.*

47 In a 1877 publication, Eells wrote that they no longer make blankets with dog wool, so the dogs were probably extinct, or becoming so, in that area by then. Eells, Lansdale, and US Geological Survey, *The Twana Indians of the Skokomish Reservation*, 72.*

48 Eells and Castile, *The Indians of Puget Sound*, 122.

49 White and Cienski, "White Nobility Blankets Are Gifts," 7–10.

50 Xweliqwiya Rena Point Bolton, personal communication, February 15, 2022.

51 Michael Pavel, "Coast Salish Woolly Dog: Memories, Stories, and Hopes," interview by Liz Hammond-Kaarremaa, March 4, 2022.

52 Tepper, George, and Joseph, *Salish Blankets: Robes of Protection* xiii.

53 Debra qwasen Sparrow, "Coast Salish Woolly Dog: Memories, Stories, and Hopes," interview by Liz Hammond-Kaarremaa, April 15, 2022.

54 James Tait is a fascinating person, an ethnographer and tireless Indigenous rights activist. To find out more about him, read Wendy C. Wickwire, *At the Bridge: James Teit*.

55 Now called the Royal British Columbia Museum or RBCM.

56 Teit, letter of January 3, 1908.

57 Barraclough, "Dogs That Were Indigenous to the Northwest Coast," 11.

58 Xweliqwiya Rena Point Bolton, "Coast Salish Woolly Dog: Memories, Stories, and Hopes," interview by Liz Hammond-Kaarremaa, February 7, 2022.

59 Pavel, interview.

60 Suttles and Maclachlan, *The Fort Langley Journals*, 75.

61 Barnett, "The Coast Salish of Canada," 123.*

62 Suttles, *The Economic Life of the Coast Salish*, 1.

63 "Voices of Snuneymuxw First Nation," 2007, accessed 2016.*

64 Sparrow, interview.

65 "Interwoven History: Coast Salish Wool," exhibition, Hibulb Cultural Center, Tulalip, WA, 2019.

66 Danielle Morsette, "Coast Salish Woolly Dog: Memories, Stories, and Hopes," interview by Liz Hammond-Kaarremaa, March 4, 2022.

67 Pavel, interview.

68 Janine Ledford, executive director of the Makah Cultural and Research Center, personal communication, May 21, 2024.

69 Paul Kane noted in 1847 that woolly dogs were brownish black and a clear white. In 1840, dogs clipped for their fur in Nootka Sound were said to be white, brown and black. Pavel, interview; Paul Kane, *Wanderings of an Artist*; Hamilton Smith, *The Natural History of Dogs*, 134.*

70 Vancouver, *A Voyage of Discovery*, vol. 1, 266.

CHAPTER 4: THE WOOL

7 Ledyard, *A Journal of Captain Cook's Last Voyage*, 71.

72 Kane, *Wanderings of an Artist*, 210.

73 Wells et al., *The Chilliwacks and Their Neighbors*, 106.

74 Gustafson, *Salish Weaving*, 83.

75 Gustafson, *Salish Weaving*, 83.

76 Elizabeth Miller, 2001. Unfortunately, Miller passed away in 2010, a month after I tried to connect with her, but her email had already been discontinued and there is no record I am aware of for her sources.

77 Point Bolton, interview.

78 "How Many Hairs Are on a Dog?"*

79 Vancouver, *A Voyage of Discovery*, vol. 1, 106.

80 "Roo," *Oxford English Dictionary*, ed. Michael Proffitt (Oxford: Oxford University Press).*

81 Tamsin De La Harpe, "How Long Does Shaved Dog Hair Take To Grow Back?" PawSafe.*

82 Vancouver, *A Voyage of Discovery*, vol. 1, 266.

83 Galiano and Espinosa y Tello, *A Spanish Voyage to Vancouver and the North-West Coast of America*, 49.*

84 Fraser and Lamb, *The Letters and Journals*, 119.

85 Suttles and Maclachlan, *The Fort Langley Journals*, 75.

86 Smithsonian Institution Archives Record Unit 305 United States National Museum USNM Accession Records: 1859 Acc. 00083pt1of2 SIA000305 R008 Y1859A0000083pt1of2.

87 Suttles, *Katzie Ethnographic Notes*.

88 A footnote to this passage reads, "Old Pierre said that the goat's wool blanket was usually flung over both shoulders and pinned at the neck, but that when travelling in a canoe the owner wore it over one shoulder, generally the left, and under the other. The Katzie Indians mixed neither feathers nor cedar-bark with their goat's wool, as was done in some communities where wool was less plentiful." Jenness, *The Faith of a Coast Salish Indian*, 7.

89 At the UBC Museum of Anthropology at the University of British Columbia in Musqueam Territory in 2018.*

CHAPTER 5: WHERE ARE ALL THE BLANKETS?

90 Tepper et al., *Salish Blankets*, xiii.

91 See also a blog post on the National Archives site by Tessa Campbell, former curator of the Hibulb Cultural Centre, "The Birth of an Eternal Document: The Point Elliott Treaty," *Pieces of History*, September 28, 2020, (archives.gov).*

92 Our home on native land.*

93 Meeker, *Pioneer Reminiscences of Puget Sound*, 251.*

94 Beckham, "George Gibbs–, 155.

95 In an earlier research project on Coast Salish yarns, the results suggest you can approximate the date within a decade or two by the diameter of the spun yarn.

96 Around 1978, a film was made of Melissa Peterson (a Makah woman) making a copy of the blanket. You can see the plaid-like design in the video available online. *Tribe and the Professor Weaving Blankets and Baskets*, Approximately 1978 (Clip), Ruth and Louis Kirk Moving Image Collection, PH Coll 1000, VC87 (University of Washington Libraries, Special Collections Division, 1978), MV0940.*

97 Fraser and Lamb, *The Letters and Journals*, 121.

98 Gustafson, in her 1980 book *Salish Weaving*, suggested four categories: plain and organized and within the organized category listed three by time periods: (1) Classic, 1778–1850, (2) Colonial, 1850–1900, and (3) Hybrid, 1850 on.

99 Gustafson, *Salish Weaving*, 48.

100 Tepper, George, and Joseph, *Salish Blankets*, 112–13.

101 These categories are based on the weaving style. Other categories have been suggested and are useful for different purposes. The book *Salish Blanket* suggests categories based on size and the purpose of the blanket. Tepper, *Salish Blankets*, 75. Gustafson, in her book *Salish Weaving* suggests categories based on time periods. Gustafson, *Salish Weaving*, 37.

102 Gustafson, *Salish Weaving*, 79.

103 Gustafson, Salish Weaving, 83–85.

104 From the catalog entry for E177710.

105 Krieger, "American Indian Costumes," 640.

106 This blanket is from an infant's burial. As such, to respect the infant and family, I did not include an image of the blanket. The date is not known, but it was thought to be early post-contact. It is cared for at Simon Fraser University Museum of Archaeology and Ethnology (SFU MAE #257).

107 Schulting, "The Hair of the Dog."

108 Gustafson, *Salish Weaving*, 85.

109 Sarah Moore, "The Digital Evolution of Microscopy," AZOLifeSciences, updated November 21, 2022, accessed November 23, 2023.*

110 Alden's full results were not published until after he retired in 2020. Alden, "Coast Salish Weaving."*

111 "Dr. Elaine Humphrey," UVic Women in Science.*

112 Much of Wickersham's estate was purchased by Belle Simpson, who owned the Nugget store in Juneau, Alaska, where she sold arts, crafts and curios. She closed the store in 1970. It is possible that Sheridan purchased the blanket there.

113 Museums are now much more aware of their history of cataloguing and how the data collected were privileged. For example, in a preformatted catalogue such as the one Mutton was catalogued in (see Figure 100), the columns required specific data: what it was, who collected it, when, where, etc. But early catalogues did not require the village name, the culture or the language of where it was acquired. Those early catalogues were adopted by other departments and museums, which has now created issues with tracing many of these belongings back to their communities, and we have lost some of the stories. An interesting article looks at NMNH cataloguing and its impact: Greene, "Material Connections: 'The Smithsonian Effect,'" 147–62.*

114 Jordan Wilson, a Musqueam curator, writer and PhD student in anthropology at New York University, has written about the concept of "belonging." This blog post provides a good start in thinking about "belonging" and terminology: Wilson, "'Belongings' in ʼc̓əsnaʔəm.'"*

115 Sparrow, interview.

116 HBC-style blankets are plain commercially woven blankets, very similar to the Burke blanket. The early ones were a plain colour with a darker line at both ends. They often have what is called "point lines" that indicate the size of the blanket. These lines run in from one side for a few inches. For more, see Shrumm, "Hudson's Bay Point Blanket."*

117 Interviewed by Dorothy Kennedy and Randy Bouchard. Documented Squamish plants and animals (names/language) including mystical beings, and many different names for them. Bouchard and Kennedy, "Utilization of Fish, Beach Foods, and Marine Mammals."

118 Jacobs, "Skwxwú7mesh Nách'en."*

119 Bouchard and Kennedy, "Utilization of Fish, Beach Foods, and Marine Mammals," 12–13.

CHAPTER 6: MUTTON'S ANCIENT ORIGINS

120 NAGPRA was amended and came into effect in January 2024. It now requires the incorporation of American Indigenous Traditional Knowledge in the storage, treatment and handling of remains and cultural items, and obtaining prior and informed consent from Indigenous communities before displaying and studying cultural objects.

121 A team led by the Robert Fleischer genetics lab at the US National Zoo tried to do a genetic comparison in the early 2000s, but results were never formally published. DNA technology has changed significantly since then, giving more data and clearer results. Another attempt in 2019 by a PhD student working under Professor Sasha (Alexander) Mikheyev at the Australian National University was successful in being able to extract viable DNA from Mutton's pelt, but the student had to pull out for personal reasons.

122 Bidal, "The Story of the Indigenous Wool Dog Told through Oral Histories and DNA."

123 Perri et al., "Dog Domestication and the Dual Dispersal." * Research also shows a possibility of dual domestication independently in east and west Eurasia. Two recent papers that discuss this dual domestication hypothesis are Bergström et al., "Ice Age Wolf Genomes," and Frantz et al., "Genomic and Archaeological Evidence," 1228–31.*

124 Sailing junks from Japan have been known to drift ashore following the Japanese current that flows along the Pacific Northwest coast. I suspect Howay also bases it on reading John Keast Lord's book. Howay, "The Dog's Hair Blankets of the Coast Salish."
There may be a difference in the sounds ancient breeds make, as there are other reports of different vocalizations, not barking, in other ancient breeds in the Pacific areas, but there has been no research on this yet, though researchers are studying the New Guinea singing dog and the Papua Highland wild dogs, which seem to have some of the oldest living dog genomes to look at for genes that might relate to vocalizations.

125 Lord, *The Naturalist in Vancouver Island and British Columbia*, 236–37.

126 237.

127 Vancouver, *A Voyage of Discovery*, vol. 1, 253.

128 Scouler, "Dr. John Scouler's Journal of a Voyage to N. W. America," 201.

129 Fraser and Lamb, *The Letters and Journals* 119.

130 Galiano and Espinosa y Tello, *A Spanish Voyage*, 48.

131 Menzies and Eastwood, "Archibald Menzies' Journal of the Vancouver Expedition," 58.*

132 Lord, *The Naturalist in Vancouver Island and British Columbia*, 217.

133 The research was presented as a student poster at a conference. A. Murray et al., "Investigating the Presence of Dog Hair in Coast Salish Blankets," poster, Recovering the Past: The Conservation of Archaeological and Ethnographic Textiles, North American Textile Conservation Conference, Mexico City, Mexico, 2005.

134 The results of the research were published in December 2023: Lin et al., "The History of Coast Salish 'Woolly Dogs.'"

135 Crockford, *Osteometry of Makah and Coast Salish Dogs.*

CHAPTER 7: OTHER DOGS

136 Senaqwila Wyss (Squamish Nation), "Coast Salish Woolly Dog: Memories, Stories, and Hopes," interview by Liz Hammond-Kaarremaa, April 7, 2022.

137 The Chono of Chile were known to use dog hair for spinning, but those dogs were bred to hunt otters and not for their wool. Many spinners even today look at any dog with a thick, warm, long-hair coat as potential yarn. Spinners will make do with what is available, but chances are the dogs were bred for other purposes.

138 Amarascu, "Tahltan Bear Dog.*

139 Amarascu, "Tahltan Bear Dog."

140 Smith, "The Mysterious Case of the Tahltan Bear Dog," 320.

141 Crisp, "Tahltan Bear Dog," 39.*

142 Halliday, *Potlatch and Totem*, 233.

143 Halliday is famous for being the one who enforced the Potlatch Ban, with thirty-four people arrested, many of them given hard jail time in Vancouver. After many years of fighting for the return of the sacred confiscated masks and regalia, many items were returned and form the collection at the U'mista Cultural Centre in Alert Bay, BC.

144 Dall and Gibbs, "Tribes of Western Washington," 221.

145 He would be referring to a dog burial pre-1950. Barnett, *The Coast Salish of British Columbia*, 97.

146 Barnett, "The Coast Salish of Canada," 123.

147 Kennedy and Bouchard, *Sliammon Life, Sliammon Lands*, 37.

148 Gerdts, "Hul'q'umi'num' to English Dictionary," in *Hul'q'umi'num' to English Dictionary* (2013).*

149 Sparks, *The Life of John Ledyard*, 71.

150 Scouler, "Dr. John Scouler's Journal," 196.

151 Boas and Hunt, "Dog Hair," in Boas, "Ethnology of the Kwakiutl," 1317–18.

152 Barraclough, "Dogs That Were Indigenous to the Northwest Coast," 13.

153 "B.C. Native Dogs Are Located on Coast Island," *The Vancouver Sunday Province* (Vancouver, BC), October 17, 1926.

154 Crockford, *Osteometry of Makah and Coast Salish Dogs.*

155 Smith, *The Natural History of Dogs*, vol. 2, 135.

156 "The Nootka Sound Dog," National Purebred Dog Day, March 1, 2021,.*

157 The Clallam or Klallam peoples live on the northern edge of Olympic Peninsula in Washington State, though a closely related group live on Vancouver Island.

158 Smith, *The Natural History of Dogs*, vol. 2, 134–35.

159 Jenness, *The Faith of a Coast Salish Indian*, 39–40.

160 Elmendorf, *Structure of Twana Culture*, Vol. 2, 97.

161 Elder JSINTEN John Elliott, WSÁNEĆ, personal communication, shared at Tsartlip on the traditional unceded territory of the WSÁNEĆ People, August 15, 2024.

CHAPTER 8: THE DIET OF WOOLLY DOGS

162 Gordon W. Hewes, "Indian Fisheries Productivity in Pre-Contact Times in the Pacific Salmon Area," *Northwest Anthropological Research Notes* 7, no. 2 (1973): 140, as cited in Schulting, "The Hair of the Dog."

163 Henry and Thompson. New Light on the Early History of the Greater Northwest, Vol. 2. .

164 Oregon Territory encompassed Washington State and Oregon and Idaho and parts of Montana and Wyoming from 1848 until 1853, when it was split into two territories, one north of the Columbia River and one south. Suckley and Gibbs, *The Natural History of Washington Territory and Oregon*, 112.*

165 Goater, Goater, and Esch, *Parasitism.*

166 Darimont, Reimchen, and Paquet, "Foraging Behaviour by Gray Wolves," 349–53.

167 Salmon sickness can also infect wolves, racoon, bear or coyote. Goater et al., *Parasitism*, 144.

168 C.J.S., "Salmon Poisoned Dogs," *Forest and Stream* (New York) 14, no. 1 (February 5, 1880), 8.*

169 C.J.S., "Salmon Poisoned Dogs."

170 Elmendorf, *Structure of Twana Culture*, vol. 2, 94.

171 Drucker, *The Northern and Central Nootkan Tribes*, 176.

172 Hillis et al., "Ancient Dog Diets," 15630.

173 Elmendorf, *Structure of Twana Culture*, vol. 2, 97.

174 Stantis and Kendall, "Isotopes in Paleopathology," ch. 7.

175 The Spaniards brought what is known as the Nootka or Ozette potato, originally from South America, which was grown widely on the Pacific Northwest coast. See "Ozette Potato," *Wikipedia*.*

176 Ames et al., "Stable Isotope and Ancient DNA."*

177 Diaz, "Resource Relationships along the Fraser River."*

178 Schulting, "The Hair of the Dog."

179 Kennerly, letter, August 19, 1859.

180 There were two Fort Colvilles. The first was a Hudson's Bay Company fort, but when the border was set and this location was to in Washington Territory, not British, the HBC retreated north. A newer US Army Fort Colville was built 18 kilometres to the southeast to house the Survey team in 1859, and for a couple of years was known as Colville Depot.

181 Specific dates were from survey team correspondence (Harris and Anderson, *Letters from the 49th Parallel*, 144; Streeter, *Joseph S. Harris and the U.S. Northwest Boundary Survey*), general dates are from Gibbs's field notes (Gibbs, Journal, Northwest Boundary Survey and geographical coordinates of the camps and stations are from the United States Northwest Boundary Survey (Baker, *Survey of the Northwestern Boundary* *).

182 Harris and Anderson, *Letters from the 49th Parallel*, 63, 144.

183 Streeter, *Joseph S. Harris and the U.S. Northwest Boundary Survey*, 239.

184 Harris and Anderson, *Letters from the 49th Parallel*, 63, 205 note 10.

185 Specific dates were from survey team correspondence, general dates are from Gibbs' field notes (Gibbs, Journal, 1859), and geographical coordinates of the camps and stations are from the United States Northwest Boundary Survey (Baker, *Survey of the Northwestern Boundary*).

CHAPTER 9: PROCESSING WOOL

186 Gustafson, *Salish Weaving*, 83.

187 Kennerly, letter, August 19, 1859.

188 Paul S. Fetzer, Paul S. Fetzer Papers, Nooksack Ethnography, 1950, Accession No. 4038-003, Special Collections, University of Washington Libraries, Special Collections.

189 Olson, *The Quinault Indians*, 82.

190 Emmons, "The Chilkat Blanket," 334.

191 Paul Stephenson Fetzer (1923–1952) died before completing his graduate work. Fetzer, Paul S. Fetzer Papers, Nooksack Ethnography.

192 Mrs. Catholic Tommy, Billy Sepass's sister, told Mrs. Cooper this. Wells et al., *The Chilliwacks and Their Neighbors*, 106.

193 Olson's chief informants were Bob Pope, Billy Mason, Johnson Wakinas, Alice Jackson, and Sammy Hoh. All were above sixty years old; Pope was over ninety in 1926. Other informants include Julia Cole, Harry Shale, and Mrs. Otto Strom. It isn't always clear which informant had said specific things. Olson, *The Quinault Indians*, 82.

194 Elmendorf, *Structure of Twana Culture*, vol. 2, 95–97.

195 Kane, *Wanderings of an Artist*, 210.

196 Swan, *The Indians of Cape Flattery*, 44.

197 Boas, *Second Report on the Indians of British Columbia*, 566–67.*

198 Ts'umsitun described this to Beryl Cryer in the 1930s. Cryer and Arnett, *Two Houses Half-Buried in Sand.**

199 Pipes were commonly made out of a white clay in the 1700s and 1800s, and the clay was known as *pipe clay*. In this use, he actually meant diatomaceous earth. Boas, *Second Report on the Indians*, 567.

200 Hammond-Kaarremaa, "A Curious Clay."*

201 Olsen, *Working with Wool*, 55–56.

202 Korunic, "Diatomaceous Earths."*

203 Kane, *Wanderings of an Artist*, 210.

204 Swan, *The Indians of Cape Flattery*, 44.

205 Point Bolton and Daly, *Xwelíqwiya, the Life Story of a Stó:Lō Matriarch*, 192.

206 Point Bolton and Daly, *Xwelíqwiya, the Life Story of a Stó:Lō Matriarch*130.

207 The Quinault man could have been Billy Mason, Johnson Wakinas, or Sammy Hoh.

208 Olson, *The Quinault Indians* , 82.

209 At the Canadian Museum of History, the catalogue record no. VII-G-369 for a weaving sword states, "The raw skin is filled with a burnt diatomaceous white earth and well beaten in the hair and wool to absorb the grease." It notes that this object, acquired from the collection of the Anglo-American architect and politician Lord Alfred Bossom, is believed to have been collected by Emmons. The catalogue entry was prepared from an original manuscript, probably made by Emmons, that cannot now be located (Nathalie Guénette, CMH, e-mail message to author, May 2013)

210 Vanderburg, "Chilkat and Salish Weaving."

211 This was the intent of a project started by Jessica Metcalf, then a researcher at UBC and now at Lakehead University, along with graduate students Tessa Grogan and Rhy McMillan. A preliminary step was to use XPRF to fist ascertain if the chemical compositions were different. If so, that could be a fast way of assessing diatomaceous locations. Samples were collected a few deposits and are now stored at UBC awaiting further investigation.

212 Dr. Ellen White, 1922–2018, was a Snuneymuxw Elder, author and academic who was awarded an Order of British Columbia and an Order of Canada for her contributions to society.

213 Tepper, *Salish Blankets*, 151.

214 Teit, letter of January 3, 1908 to Charles Newcombe.

215 Hammond-Kaarremaa, "Threads, Twist and Fibre."

216 Barnett, *The Coast Salish of British Columbia*, 118.

217 Nlaka'pamux were formally known as the Thompson people of the Interior Salish. This was written down in 1971 but could have been recorded much earlier. Annie York was born in 1904 and died in 1991.

218 It would be very interesting to see if any pre-1950 round coiled baskets in museum collections contain guard hairs stuck on the inside. Anderson, *The Chronicle of Warpet Wefter*.

219 Suttles, "Productivity and Its Constraints, 86.

220 Singles are used in contemporary weavings, but I have not seen any blankets or robes made of single yarns yet.

221 Barnett, *The Coast Salish of British Columbia*, 118.

222 The Quinault are at the southwestern portion of the Olympic Peninsula and are Southwestern Coast Salish, sharing some aspects of their culture with northern and southern Indigenous Peoples, so their weaving-related methods and tools might be more varied than those of the central Salish Sea Coast Salish peoples.

223 Olson, *The Quinault Indians*, 81.

224 Most anthropologists, ethnographers and archaeologists in the 1900s were men. As men, they were more interested in subjects related to male roles and not female roles. Hence, women's work is not as familiar to male researchers and either not reported accurately or not prevalent in field studies.

225 Olson's chief informants were Bob Pope, Billy Mason, Johnson Wakinas, Alice Jackson and Sammy Hoh. All were above sixty years old; Pope was over ninety in 1926. Other informants include Julia Cole, Harry Shale and Mrs Otto Strom. It is not always clear which informants provided which information. Olson, *The Quinault Indians*, 81–82.

226 Kane, *Wanderings of an Artist*.

227 Fraser and Lamb, *The Letters and Journals*, 123.

228 There is a note in the photo catalogue associated with Figure 65 of Mrs. Selisya Charlie that states Newcombe, Kissell and James Teit visited Musqueam where the photo was taken. This is the same Teit who talked about the Tahltan bear dogs and made notes on weaving with dog wool.*

229 Kissell, "A New Type of Spinning," 264–70.*

230 Barnett, *The Coast Salish of British Columbia*, 118.

231 Meikle, *Cowichan Indian Knitting*, 11.

232 Kane, *Wanderings of an Artist*, 210.

233 Dall and Gibbs, "Tribes of Western Washington," 219.

234 From catalogue record #1-507, Burke Museum.

CHAPTER 10: WHAT DID WOOLLY DOGS LOOK LIKE?

235 Now the Smithsonian National Museum of Natural History.

236 Krieger, "Archeological Investigations in the Columbia River ," 194.

237 Krieger, *Archeological Investigations in the Columbia River* , 175.*

238 Allen, *Dogs of the American Aborigines* , vol. 4 , 469.

239 Lord, *The Naturalist in Vancouver Island and British Columbia*, 237.

240 Wilson, "Report on the Indian Tribes Inhabiting the Country in the Vicinity of the 49th Parallel of North Latitude," 288,* and Lord, *The Naturalist in Vancouver Island and British Columbia*, 216.

241 The photos (Figures 84 and 85) were found in a file with a note on the back that they were taken by D. Jenness; however, a letter dated December 28, 1935, from Jenness to William Newcombe at the Provincial Museum (now Royal BC Museum) suggests that these photos were taken by Newcombe. Newcombe also wrote in his diary on November 30, 1935, "Take -? Wooly dog Tsawouk."

242 Richling, *The WSÁNEĆ People and Their Neighbours*.

243 The date of 1936 seems to have been a mistake. Newcombe's diary records the date as November 30, 1935, and Jenness was in BC only from October 1935 to the spring of 1936.

244 Diamond Jenness also writes to Billy Newcombe that the photos were taken by Newcombe. This also aligns with Newcombe's diary entry of November 30, 1935, where he wrote "Take? – wool dog Tsawout" which is in East Saanich. Diamond Jenness, letter to Billy Newcombe, December 28, 1935, File MS-1077.371 RBC Archives.

245 Allen, *Dogs of the American Aborigines*, 38.*

246 Barton, "XXIII. On Indian Dogs."*

247 Olson lists all his informants as Bob Pope, Billy Mason, Johnson Wakinas, Alice Jackson and Sammy Hoh. All were above sixty years old; Pope was over ninety in 1926. Other informants include Julia Cole, Harry Shale and Mrs. Otto Strom. I am unsure which three mentioned the dog ears. Olson, *The Quinault Indians*, 81.

248 Mary Adam is the wife of the canoe builder Jack Adam. Waterman and Coffin, *Types of Canoes on Puget Sound*.*

249 The museum is now known as the Canadian Museum of History.

250 This magazine is not the predecessor of the more famous current one, *Nature*. Leechman, "Fleece-Bearing Dogs," 177.*

251 Unfortunately, when I tried to find Elizabeth Miller in 2011, she had recently passed away.

252 The Tulalip Reservation established under the Treaty of Point Elliott in 1855 and boundaries were established in 1873. It was created to provide a permanent home for the Snohomish, Snoqualmie, Skagit, Suiattle, Samish and Stillaguamish Tribes and allied bands in the region.

253 Royal British Columbia Museum, ICAR PN # 10074.

254 It is thought that Richard Maynard was taught photography by his wife. Mattison and Savard, "The North-West Pacific Coast." *

255 Between pages 190 and 191 in Grinnell, *Jack, the Young Canoeman*.*

256 Crosby, *Among the an-Ko-Me-Nums* 49–50.*

257 In 1937, the Powell River Company sold its boat the *Greta M* to the United Church, which, keeping with its coastal mission boats, renamed it the *Thomas Crosby IV* in honour of Rev. Thomas Crosby, whose ministry by boat along the coast started in a canoe in 1874. The son of a Haida chief, Cle-alls was the first Haida to be ordained a minister. Cle-alls was known as Rev. Peter Kelly; he became the first skipper of the *Thomas Crosby IV* and held the job for sixteen years. In 1966 the *Thomas Crosby IV* was renamed the *Argonaut II*. I worked as a deckhand on the boat for a few summers in the 1980s, mostly between Powell River and Bute Inlet and on and off for a few more years when Captain Julian Matson needed an extra hand.

258 Crosby, *Up and Down the North Pacific Coast*.*

259 Crosby, Up and Down the North Pacific Coast.

260 See also Jean Barman's chapter "Taming Indigenous Sexuality—," 135–39.

261 The photos can be found here: Reverend Thomas Crosby fonds - Audrey and Harry Hawthorn Library and Archives.*

262 Waterman, "North American Indian Dwellings," 454, Plate 8. However, there is a note that the chapter was reprinted from another publication dated January 1924. In that publication, the same photograph is listed as from the collection of the US National Museum; Waterman, "North American Indian Dwellings," 18.*

263 Wallace, *Architecture of the Salish Sea*.*

264 Flexible film negatives were available from the 1890s. I have yet to track down what type of a negative the NMAI has in its archives.

265 Heyes, letter October 24, 1927.

266 Ledyard, *A Journal of Captain Cook's Last Voyage*, 71.

267 Smith, *Dogs*, 134.*

268 Olson, *The Quinault Indians*, 81.

269 Kane, *Wanderings of an Artist*, 210.

270 Teit, letter of January 3, 1908 to Charles Newcombe.

271 Boas, "Ethnology of the Kwakiutl," 134.

272 Anza-Burgess, Lepofsky, and Yang, "A Part of the People" 434–50.*

273 Anderson, *Notes on the Indian Tribes*, 78.*

274 Vancouver, *A Voyage of Discovery*, vol. 1, 266.

275 Galiano and Espinosa y Tello, *A Spanish Voyage*, 49; Anderson, *Notes on the Indian Tribes*, 78; Kane, *Wanderings of an Artist*, 210; Lord, *The Naturalist in Vancouver Island and British Columbia*, 216.

276 Menzies, *Menzies' Journal of Vancouver's Voyage*, 58–59.

277 Suckley and Gibbs, *The Natural History of Washington*, 300; Teit, letter of January 3, 1908 to Charles Newcombe.

278 Vancouver, *A Voyage of Discovery*, vol. 1, 266; Galiano and Espinosa y Tello, *A Spanish Voyage*, 49; Menzies, *Menzies' Journal of Vancouver's Voyage*, 58; Scouler, "Dr. John Scouler's Journal," 196; Kane, *Wanderings of an Artist*, 210; Suckley and Gibbs, *The Natural History of Washington*, 112; Anderson, *Notes on the Indian Tribes*, 78; Swan, *The Indians of Cape Flattery*, 44.

279 Teit, "The Lillooet Indians," 223.

280 Vancouver, *A Voyage of Discovery*, vol. 1, 266.

281 Pomerania was along the Baltic Coast, part of what is now the northern coast of Germany and Poland. Pomeranian dogs are part of the German Spitz family.

282 Taplin, *The Sportsman's Cabinet*, 128.*

283 Kane, *Wanderings of an Artist*, 210.

284 Although I do not have permission to reprint the image, it can be seen on the web: Crockford, *Osteometry of Makah and Coast Salish Dogs*," SFU Archaeology Press.*

285 The Tulalip Reservation, established under the Treaty of Point Elliott in 1855 and boundaries established in 1873. It was created to provide a permanent home for the Snohomish, Snoqualmie, Skagit, Suiattle, Samish and Stillaguamish Tribes and allied bands in the region.

286 Edward Sparrow Sr. passed in 1998.

287 East of Musqueam IR 1. See Musqueam Place Names map.*

CHAPTER 11: AN ENDING AND A BEGINNING

288 The original Fort Colville was the British Hudson's Bay Company fort. When the border was agreed upon, the HBC Fort Colville was south of the border and the British had to relinquish it. The new Fort Colville, referred to as Colville or Harney Depot by the survey team, was 16 to 17 miles (26 kilometres) southeast of the HBC Fort Colville.

289 Harris and Anderson, *Letters from the 49th Parallel*, 63, 170.

290 Harris and Anderson, Letters from the 49th Parallel, 172.

291 The old British HBC Fort Colville was now in US territory, and rather than take it over, the US government decided to build a new US Army Fort Colville a few miles south of the original fort.

292 Harris and Anderson, *Letters from the 49th Parallel*, 63, 173.

293 Harris and Anderson, Letters from the 49th Parallel, , 205, 10.

294 Buchanan, *Message of the President of the United States*, 2.

295 Gibbs, Journal, Northwest Boundary Survey, 26.

296 Harris and Anderson, *Letters from the 49th Parallel*, 63.

297 From San Franscisco, you could take the Pony Express if you were travelling light.

298 Baker, *Survey of the Northwestern Boundary of the United States*, 17.

299 Kennerly, Spencer Fullerton Baird Papers, 1860, Box 26, Folder 20, 49.

300 Baker, *Survey of the Northwestern Boundary of the United States*, 17.

301 Seeman suggests that the trade value of dog wool blankets had diminished with the availability of HBC blankets with eight to ten dog wool blankets being traded for one sea otter skin. Seeman, *Narrative of the Voyage*, 109.*

302 Lord, *The Naturalist in Vancouver Island and British Columbia*, 216.

303 Lutz, *Makúk: A New History*, 72.

304 Olsen, *Working with Wool*, 73.

305 Sylvia Olsen's book provides an extensive, and enjoyable, read into the history of the Cowichan/Salish sweaters.

306 Hammond-Kaarremaa, "Threads, Twist and Fibre."

307 Hills, William Henry Hills Journal, 1, 161.*

308 Lord, *The Naturalist in Vancouver Island and British Columbia*, 216.

309 Wilson, "Report on the Indian Tribes."

310 The smallpox epidemic of 1862 was not the first epidemic. There were a series of epidemics starting from even before First Contact, coming up Indigenous trade routes all the way from the Spanish in Mexico. See Boyd, "Smallpox in the Pacific Northwest," and Harris, "Voices of Disaster."

311 Koch et al., "Earth System Impacts.*

312 Boyd, "Smallpox in the Pacific Northwest," 17.

313 PENÁĆ Dave Elliott, W̱SÁNEĆ Elder, in Elliott and Poth, *Saltwater People: A Resource Book*, 68. Thank you to JSINTEN John Elliott for permission to use his father's quote.

314 Solazzo et al., "Proteomics and Coast Salish Blankets," 1418–32.

315 Suckley, letter and telegram to Baird, Feb 26, 1861, Box 34, Folder 7, SF Baird Papers, Private Incoming Correspondence, Smithsonian Archives.

316 Dall, *Spencer Fullerton Baird*, 338.

317 Lieutenant Kautz was a friend of Gibbs from Steilacoom, where Gibbs had purchased some land near the fort. Later, he served as Quartermaster for the Army escort assigned to assist the NWBS. Beckham, "George Gibbs, 1815–1873," 214.

318 Beckham, "George Gibbs, 1815–1873,", 251

319 Beckham, "George Gibbs, 1815–1873,", 252

320 In a modern edition of this book, the linguist and author wrote, "It should be noted that most dictionary efforts made in the mid nineteenth century dealing with North American native languages are usually little more than glossaries of one- or two-word equivalents between a native term and English. Gibbs' work, however, is much more than a mere glossary. In the English to Nisqually (Lushootseed) section he has grouped forms into semantic domains, provided example sentences in Lushootseed, and given, where he could, word analyses by root and affix, etymological information and, especially, ethnological commentary." Gibbs and Zahir, *A Lushootseed Analysis of a 1877 Dictionary by George Gibbs*.

321 Richardson and Galloway, *Nooksack Place Names*, 29.

322 George Gibbs, Ms 1051, Rough Notes and Salishan Legends and Tales, 1850s, 1051, National Anthropological Archives, Smithsonian Institution; Richardson and Galloway, *Nooksack Place Names*.

REFERENCES

Entries marked with an* indicate hyperlinks available online at *www.lizhk.ca/Mutton*

Adamson, Thelma, ed. Folk-Tales of the Coast Salish. Bison Books, University of Nebraska Press, 2009.*

Alden, Harry A. "Coast Salish Weaving: Hair of the Dog and Cedar Bark." *Wiley Analytical Science Magazine*, September 22, 2021.*

Allen, Glover Morrill. *Dogs of the American Aborigines. With Twelve Plates*. Vol. 4, Printed for the Museum [of Comparative Zoology], 1920.*

Amarascu, Dana. "Tahltan Bear Dog." *The Canadian Encyclopedia*, Updated December 17, 2021.*

Ames, Kenneth M., Michael P. Richards, Camilla F. Speller, Dongya Y. Yang, R. Lee Lyman, et al. "Stable Isotope and Ancient DNA Analysis of Dog Remains from Cathlapotle (45cl1), a Contact-Era Site on the Lower Columbia River." *Journal of Archaeological Science* 57 (2015): 268–82.*

Anderson, Alexander Caulfield. *Notes on the Indian Tribes of British North America and the Northwest Coast / Communicated to Geo. Gibbs by Anderson.* March 1863.*

———. "Notes on the Indian Tribes of British North America, and the Northwest Coast." In *The Historical Magazine and Notes and Queries Concerning the Antiquities, History and Biography of America*, Vol. 1, 438. Morrisania, NY: Henry B. Dawson, 1857.

Anderson, S.J. *The Chronicle of Warpet Wefter: A Melodrama.* Museum of Anthropology, University of British Columbia, 1971.

Anza-Burgess, Kasia, Dana Lepofsky, and Dongya Yang. "'A Part of the People': Human-Dog Relationships among the Northern Coast Salish of sw British Columbia." *Journal of Ethnobiology* 40, no. 4 (2020): 434–50.*

Baker, Marcus. *Survey of the Northwestern Boundary of the United States, 1857–1861.* 1900.*

Barman, Jean. *On the Cusp of Contact: Gender, Space and Race in the Colonization of British Columbia.* Edited by Margery Fee. BC: Harbour Publishing, 2020.

Barnett, H.G. *The Coast Salish of British Columbia.* University of Oregon Monographs, Studies in Anthropology no. 4. University of Oregon, 1955.

———. "The Coast Salish of Canada." *American Anthropologist* 40, no. 1 (1938): 118–41.*

Barraclough, Ed. "Dogs That Were Indigenous to the Northwest Coast." *BC Historical News* 2, no. 3 (May 1969).*

Barsh, Russel L., Joan Megan Jones, and Wayne Suttles. "History, Ethnography, and Archaeology of the Coast Salish Woolly-Dog." In *Dogs and People in Social, Working, Economic or Symbolic Interaction*, edited by Lynn M. Snyder and Elizabeth A. Moore, 1–11. Oxbow Books, 2006.

Barton, Benjamin Smith. "XXIII. On Indian Dogs." *Philosophical Magazine Series 1* 15, nos. 57 & 58 (1803): 6–7, 136–43.*

"B.C. Native Dogs Are Located on Coast Island." *The Vancouver Sunday Province* (Vancouver, BC), October 17, 1926.

Beckham, Stephen Dow. "George Gibbs, 1815–1873: Historian and Ethnologist." PhD dissertation, University of California, Los Angeles, 1969. ©1970.*

Bergström, Anders, et al. "Ice Age Wolf Genomes Home in on Dog Origins." *Nature Research Briefings*, June 29, 2022).*

Bidal, Devon. "The Story of the Indigenous Wool Dog Told through Oral Histories and DNA." *Hakai Magazine*, December 14, 2023.*

Boas, Franz. *Second Report on the Indians of British Columbia.* Report of the British Association for the Advancement of Science. London: 1890.*

Boas, Franz, and George Hunt. "Dog Hair." In Franz Boas, "Ethnology of the Kwakiutl, Based on Data Collected by George Hunt," *35th Annual Report of the Bureau of American Ethnology to the Secretary of the Smithsonian Institution, 1913–1914*, 1317–18. US Government Printing Office, 1921.

Bouchard, Randy, and Dorothy I.D. Kennedy. "Utilization of Fish, Beach Foods, and Marine Mammals by the Squamish Indian People of British Columbia." British Columbia Language Project, 1976.

Boyd, Robert. "Smallpox in the Pacific Northwest: The First Epidemics." *BC Studies*, no. 101 (Spring 1994): 5–40.

Buchanan, James. *Message of the President of the United States: Communicating, in Compliance with a Resolution of the Senate, Information with Regard To…The Work of Marking the Boundary…Pursuant To…The Treaty between the United States and Great Britain, June 15, 1846.* Executive Doc. (United States. Congress. Senate); 36th Congress, 1st Session, No. 16; No. 16. Government Printing Office, 1860.*

Carstensen, Vernon. "Pacific Northwest Letters of George Gibbs." *Oregon Historical Quarterly* 54, no. 3 (1953): 190–239.*

C.J.S., "Salmon Poisoned Dogs," *Forest and Stream* (New York) 14, no. 1 (February 5, 1880), 8.

Crisp, W.G. "Tahltan Bear Dog." *The Beaver*, Summer 1956, 38–41.*

Crockford, Susan J. *Osteometry of Makah and Coast Salish Dogs.* Archaeology Press, Simon Fraser University, 1997.*

Crosby, Thomas. *Among the an-Ko-Me-Nums, or Flathead Tribes of Indians of the Pacific Coast.* 1907.*

———. *Up and Down the North Pacific Coast by Canoe and Mission Ship.* Missionary Society of the Methodist Church, the Young People's Forward Movement Department, 1914.*

Cryer, Beryl Mildred, and Chris Arnett. *Two Houses Half-Buried in Sand: Oral Traditions of the Hul'q'umi'num' Coast Salish of Kuper Island and Vancouver Island.* Talonbooks, 2007.*

Dall, William Healey. *Spencer Fullerton Baird; a Biography, Including Selections from His Correspondence with Audubon, Agassiz, Dana, and Others.* J.B. Lippincott Company, 1915.*

Dall, William Healey, and George Gibbs. "Tribes of the Extreme Northwest by W.H. Dall. Tribes of Western Washington and Northwestern Oregon by Geo. Gibbs." In *Tribes of Western Washington and Northwestern Oregon,* edited by George Gibbs. US Government Publishing Office, 1877.*

Darimont, C.T., T.E. Reimchen, and P.C. Paquet. "Foraging Behaviour by Gray Wolves on Salmon Streams in Coastal British Columbia." *Canadian Journal of Zoology* 81, no. 2 (2003): 349–53.

Diaz, Alejandra Lydia. "Resource Relationships along the Fraser River : A Stable Isotope Analysis of Archaeological Foodways and Paleoecological Interactions." PhD dissertation, University of British Columbia, 2019.*

Drucker, Philip. *The Northern and Central Nootkan Tribes.* US Government Printing Office, 1951.

Dylan Hillis, Iain McKechnie, Eric Guiry, Denis E. St. Claire, and Chris T. Darimont. "Ancient Dog Diets on the Pacific Northwest Coast: Zooarchaeological and Stable Isotope Modelling Evidence from Tseshaht Territory and Beyond." *Nature Scientific Reports* 10, no. 1 (2020): 15630.*

Eells, Myron, and George Pierre Castile. *The Indians of Puget Sound: The Notebooks of Myron Eells.* University of Washington Press, 1985.

Eells, Myron, R.H. Lansdale, and United States Geological Survey. *The Twana Indians of the Skokomish Reservation in Washington Territory.* n.p., 1877.*

Elliott, Dave and Janet Poth. *Saltwater People: A Resource Book for the Saanich Native Studies Program.* School District 63, 1990.

Elmendorf, William W. *Structure of Twana Culture*, Vol. 2. Edited by June M. Collins. Garland Publishing, 1974.

Emmons, George T. "The Chilkat Blanket." *Memoirs of the American Museum of Natural History*, Vol. III, Part IV. American Museum of Natural History, 1907.

Fetzer, Paul S. Paul S. Fetzer Papers, Nooksack Ethnography. 1950. Accession No. 4038-003, Special Collections, University of Washington Libraries.

Frantz, Laurent A.F., Victoria E. Mullin, Maud Pionnier-Capitan, Ophélie Lebrasseur, Morgane Ollivier, et al. "Genomic and Archaeological Evidence Suggests a Dual Origin of Domestic Dogs." *Science* 352, no. 6290 (2016): 1228–31.*

Fraser, Simon, and W. Kaye Lamb. *The Letters and Journals of Simon Fraser, 1806–1808.* Voyageur Classics. Dundurn Press, 2007.

Galiano, Dionisio Alcalá, and Josef Espinosa y Tello. *A Spanish Voyage to Vancouver and the North-West Coast of America: Being the Narrative of the Voyage Made in the Year 1792 by the Schooners.* Translated by Cecil Jane. Argonaut Press #10. Da Capo Press, 1971. Originally published 1930.*

Hul'q'umi'num' to English Dictionary. 2013.

Gibbs Family Papers 1762–1918. Wisconsin Historical Society, Division of Library, Archives, and Museum Collections.*

Gibbs, George. *A Dictionary of the Chinook Jargon, or, Indian Trade Language, of the North Pacific Coast.* 1871.*

———. Indian Tribes 1853–1854. George Gibbs Notebooks of Scientific Observations of the Pacific Northwest. Yale University, Beinecke Rare Book and Manuscript Library, Western Americana Collection.1854.*

———. Journal & Notes North West Boundary Survey. George Gibbs Notebooks of Scientific Observation of the Pacific Northwest. Yale University Library, Beinecke Rare Book and Manuscript Library. 1855–1858.*

———. Journal, Northwest Boundary Survey, 1857–1862. Smithsonian Institution Archives. 1859.

———. Ms 1051, Rough Notes and Salishan Legends and Tales. National Anthropological Archives, Smithsonian Institution. 1850s.

Gibbs, George, and Zalmai ʔesweli Zahir. *A Lushootseed Analysis of a 1877 Dictionary by George Gibbs.* Zahir Consulting Services, 2009.

Goater, Timothy M., Cameron P. Goater, and Gerald W. Esch. *Parasitism: The Diversity and Ecology of Animal Parasites.* 2nd ed. Cambridge University Press, 2014.

Greene, Candace S. "Material Connections: 'The Smithsonian Effect' in Anthropological Cataloguing." *Museum Anthropology* 39, no. 2 (2016): 147–62.*

Grinnell, George Bird. *Jack, the Young Canoeman: An Eastern Boy's Voyage in a Chinook Canoe.* 1906.*

Gustafson, Paula. *Salish Weaving.* University of Washington and Douglas & McIntyre, 1980.

Halliday, W.M. *Potlatch and Totem: And the Recollections of an Indian Agent.* Dent, 1935.

Hammond-Kaarremaa, Liz. "A Curious Clay: The Use of a Powdered White Substance in Coast Salish Spinning and Woven Blankets." *BC Studies*, no. 189 (2016): 129–49.*

———. "Threads, Twist and Fibre: Looking at Coast Salish Textiles." Paper presented at The Social Fabric: Deep Local to Pan Global, Vancouver, BC, September 19–23, 2018.

Harris, Cole. "Voices of Disaster: Smallpox around the Strait of Geogia in 1782." [In English]. *Ethnohistory* 41, no. 4 (Fall 1994 1994): 591.

Harris, Joseph S., and Samuel Anderson. *Letters from the 49th Parallel, 1857–1873: Selected Correspondence of Joseph Harris and Samuel Anderson.* Edited by Ian C. Jackson. Technical appendix by Louis M. Sebert. Champlain Society, 2000.

Henry, Alexander, and David Thompson. *New Light on the Early History of the Greater Northwest : The Manuscript Journals of Alexander Henry, Fur Trader of the Northwest Company.* Vol. 2, 1897.

Heyes, George Gustav. Letter from Heyes Secretary Hodge to Newcombe re. Maynard Photo, 1927. Newcombe Family Fonds, William A. Newcombe, Correspondence Series A. Royal BC Archives.

Hills, William Henry. William Henry Hills Journal Kept on Board H.M.S. *Portland*, August 8–October 5, 1852 and H.M.S. *Virago*. Mitchell Library, NSW State Library, Australia. *

Jacobs, Deborah Anne. "Skwxwú7mesh Nách'en: Xwech'shí7 Tl'a Nexwnineẁ Iy Sneẁíyelh Squamish Praxis the Interspace of Upbringing and the Teachings." 2016.*

Jenness, Diamond, *The Faith of a Coast Salish Indian*. Edited by Wilson Duff. Anthropology in British Columbia Memoirs No. 3. Co-published with Wayne P. Suttles, *Katzie Ethnographic Notes*. British Columbia Provincial Museum, Department of Education, 1955.

——. Letter to Billy Newcombe. December 28, 1935. File MS-1077.371 RBC Archives.

Kane, Paul. *Wanderings of an Artist among the Indians of North America: From Canada to Vancouver's Island and Oregon through the Hudson's Bay Company's Territory and Back Again*. Longman, Brown, Green, and Roberts, 1859.

Kennedy, Dorothy I.D., and Randy Bouchard. *Sliammon Life, Sliammon Lands*. Vancouver, BC: Talonbooks, 1983.

Kennerly, Dr. Caleb Burwell Rowan. Letter, March 5, 1858. Spencer F. Baird Collection, 1833–1887. Smithsonian Institution Archives, Washington, DC.

——. Letter, August 19, 1859. Spencer F. Baird Collection. Smithsonian Institution Archives, Washington, DC.

——. Record Unit 7002. Box 26, Folder 19. Smithsonian Institution Archives, Washington, DC.

——. Spencer Fullerton Baird Papers. Box 26, Folder 20. Smithsonian Institution Archives, Washington, DC, 1860.

Kissell, Mary Lois. "A New Type of Spinning in North America." *American Anthropologist* 18, no. 2 (1916): 264–70.*

Koch, Alexander, Chris Brierley, Mark M. Maslin, and Simon L. Lewis. "Earth System Impacts of the European Arrival and Great Dying in the Americas after 1492." *Quaternary Science Reviews* 207 (March 1, 2019): 13–36.*

Korunic, Zlatko. "Diatomaceous Earths, a Group of Natural Insecticides." *Journal of Stored Products Research* 34, nos. 2–3 (1998): 87–97.*

Krieger, Herbert W. "American Indian Costumes in the United States National Museum." In *Annual Report of the Board of Regents of the Smithsonian Institution*, 623–661. Board of Regents, United States National Museum, Smithsonian Institution, 1928.

——. "Archeological Investigations in the Columbia River Valley: Field Season of 1926." In *Explorations and Field-Work of the Smithsonian Instution in 1926*, 187–299. Smithsonian Miscellaneous Collections, vol. 78, no. 7. Smithsonian Institution, 1927.

——. *Archeological Investigations in the Columbia River Valley—Field Season of 1926*. Institution, 1927.*

Ledyard, John. *A Journal of Captain Cook's Last Voyage to the Pacific Ocean, and in Quest of a North-West Passage, between Asia & America: Performed in the Years 1776, 1777, 1778, and 1779*. Printed and sold by Nathaniel Patten, 1783.

Leechman, Douglas. "Fleece-Bearing Dogs." *Nature Magazine* 14, September 1929, 177–79.*

Lin, Audrey T., Liz Hammond-Kaarremaa, Hsiao-Lei Liu, Chris Stantis, Iain McKechnie, Michael Pavel, Susan sa'hLa mitSa Pavel, et al. "The History of Coast Salish 'Woolly Dogs' Revealed by Ancient Genomics and Indigenous Knowledge." *Science* 382, no. 6676 (2023): 1303–08.*

Lord, John Keast. *The Naturalist in Vancouver Island and British Columbia*. R. Bentley, 1866.*

Lutz, John S. *Makúk: A New History of Aboriginal–White Relations*. Vancouver: UBC Press, 2008.

Latdict Latin Dictionary & Grammar Resources.

Mattison, David, and Daniel Savard. "The North-West Pacific Coast." *History of Photography* 16, no. 3 (1992): 268–88.*

Meeker, Ezra. *Pioneer Reminiscences of Puget Sound: The Tragedy of Leschi; an Account of the Coming of the First Americans and the Establishment of Their Institutions; Their Encounters with the Native Race; the First Treaties, with the Indians and the War That Followed*. Lowman & Hanford Stationary and Print. Co., March 1905.*

Meikle, Margaret. *Cowichan Indian Knitting*. UBC Museum of Anthropology, 1987.

Menzies, Archibald. *Menzies' Journal of Vancouver's Voyage, April to October, 1792*. Edited by C.F. Newcombe. Botanical and ethnological notes by C.F. Newcombe. Biographical note by J. Forsyth. University of British Columbia Library, 1923.*

Menzies, Archibald, and Alice Eastwood. "Archibald Menzies' Journal of the Vancouver Expedition." *California Historical Society Quarterly* 2, no. 4 (1924): 265–340.*

Moore, Sarah. "The Digital Evolution of Microscopy."*

Murray, A., H. Alden, T. Gluick, S. Heald, I. Chang, and M. Jones. "Investigating the Presence of Dog Hair in Coast Salish Blankets." Poster, Recovering the Past: The Conservation of Archaeological and Ethnographic Textiles, North American Textile Conservation Conference, Mexico City, Mexico, 2005.

Olsen, Sylvia. *Working with Wool: A Coast Salish Legacy and the Cowichan Sweater*. Sono Nis Press, 2010.

Olson, Ronald L. *The Quinault Indians: Adze, Canoe, and House Types of the Northwest Coast*. University of Washington Press, 1967.

Perri, Angela R., Tatiana R. Feuerborn, Laurent A.F. Frantz, Greger Larson, Ripan S. Malhi, et al. "Dog Domestication and the Dual Dispersal of People and Dogs into the Americas." *Proceedings of the National Academy of Sciences* 118, no. 6 (2021): e2010083118.*

Point Bolton, Xwelíqwiya Rena, and Richard Daly. *XwelíQwiya, the Life Story of a Stó:Lō Matriarch.* Athabasca University Press, 2013.

Richardson, Allan, and Brent Douglas Galloway. *Nooksack Place Names: Geography, Culture, and Language.* UBC Press, 2011.

Richling, Barnett, ed. *The WSÁNEĆ People and Their Neighbours: Diamond Jenness of the Coast Salish of Vancouver Island, 1935.* Rock's Mills Press, 2016.

Schulting, Rick. "The Hair of the Dog: The Identification of a Coast Salish Dog-Hair Blanket from Yale, British Columbia." *Canadian Journal of Archaeology* 18 (1994): 57–76.

Scouler, John. "Dr. John Scouler's Journal of a Voyage to N. W. America. [1824-'25-'26.] Leaving the Galapagos Islands for the North Pacific Coast." *The Quarterly of the Oregon Historical Society* 6, no. 2 (1905): 159–205.

Seeman, Berthold. *Narrative of the Voyage of H. M. S. Herald during the Years 1845-51, under the Command of Captain Henry Kellett... Being a Circumnavigation of the Globe, and Three Cruizes to the Arctic Regions in Search of Sir John Franklin.* Vol. 1. Reeve and Co., 1853.*

Segura Valentina, Madeleine Geiger M, Tesla A. Monson, David Flores, and Marcelo R. Sánchez-Villagra. "Biological and Cultural History of Domesticated Dogs in the Americas." *Anthropozoologica* 57, no. 1 (2022).*

Shrumm, Regan. "Hudson's Bay Point Blanket," *The Canadian Encyclopedia*, December 18, 2018.*

Smith, Alisa. "The Mysterious Case of the Tahltan Bear Dog." In *Way Out There: The Best of* Explore, edited by James Little. Greystone Books, 2006.

Smith, Charles Hamilton. *Dogs*, Vol. II. The Naturalist's Library, Vol. XIX: Mammalia. Edited by William Jardine. Illustrated by James Stewart and W.H. Lizars. W.H. Lizars; 1843.*

———. *The Natural History of Dogs: Canidae or Genus Canis of Authors; Including Also the Genera Hyaena and Proteles.* Vol. 2. Edited by William Jardine. Edinburgh: W.H. Lizars, 1840.*

Solazzo, Caroline, Susan Heald, Mary W. Ballard, David A. Ashford, Paula T. DePriest, et al. "Proteomics and Coast Salish Blankets: A Tale of Shaggy Dogs?" *Antiquity* 85, no. 330 (2011): 1418–32.

Sparks, Jared. *The Life of John Ledyard, the American Traveller: Comprising Selections from His Journals and Correspondence.* Hilliard and Brown, 1828.

Stantis, Chris, and Ellen J. Kendall. "Isotopes in Paleopathology." In *The Routledge Handbook of Paleopathology*, edited by Anne L. Grauer, ch. 7. London: Routledge, 2022.

Streeter, Anne P. *Joseph S. Harris and the U.S. Northwest Boundary Survey, 1857–1861.* Trafford Publishing, 2012.

Suckley, George. Letter and Telegram from Suckley to Baird, February 26, 1861, Box 34, Folder 7, SF Baird Papers, Private Incoming Correspondence. Smithsonian Archives.

Suckley, George, and George Gibbs. *The Natural History of Washington Territory and Oregon.* Reports of Explorations and Surveys to Ascertain the Most Practicable and Economical Route for a Railroad from the Mississippi River to the Pacific Ocean. A.O.P. Nicholson, Printer, 1860.*

Suttles, Wayne. "Productivity and Its Constraints: A Coast Salish Case." In *Indian Art Traditions of the Northwest Coast*, edited by Roy L. Carlson, 67–87. Archaeology Press, Simon Fraser University, 1982.

Suttles, Wayne P. *The Economic Life of the Coast Salish of Haro and Rosario Straits.* Vol. 1, Garland Pub, 1974.

Suttles, Wayne P. *Katzie Ethnographic Notes.* Edited by Wilson Duff. Anthropology in British Columbia Memoirs No. 2. Co-published with Diamond Jenness, *The Faith of a Coast Salish Indian.* British Columbia Provincial Museum, Dept. of Education, 1955.

Suttles, Wayne P., and Morag Maclachlan. *The Fort Langley Journals, 1827–30.* UBC Press, 1998.

Swan, James G. *The Indians of Cape Flattery: At the Entrance to the Strait of Fuca, Washington Territory.* Smithsonian Institution, 1870.*

Taplin, William. *The Sportsman's Cabinet, or a Correct Delineation of the Canine Race*, Vol. 2. J. Cundee, 1803.*

Teit, James Alexander. Letter of January 3, 1908 to Charles Newcombe. Newcombe Family Files. RBCM Archives.

———. "The Lillooet Indians." *Memoirs of the American Museum of Natural History* 4, part 5 (1906).

Tepper, Leslie H., Janice George, and Willard Joseph. *Salish Blankets: Robes of Protection and Transformation, Symbols of Wealth.* University of Nebraska Press, 2017.

Tribe and the Professor Weaving Blankets and Baskets, Approximately 1978 (Clip). Ruth and Louis Kirk Moving Image Collection, PH Coll 1000, VC87. University of Washington Libraries, Special Collections Division, 1978. MV0940.

"Two-Eyed Seeing." The Institute for Integrative Science & Health, accessed August 12, 2024.*

Vancouver, George. *A Voyage of Discovery to the North Pacific Ocean, and Round the World.* Vol. 1: G.G. and J. Robinson... and J. Edwards, 1798.*

Vanderburg, Joanne. "Chilkat and Salish Weaving." MA thesis, University of Washington, 1953.

"Voices of Snuneymuxw First Nation." 2007.*

Wallace, Christina L. *Architecture of the Salish Sea Tribes of the Pacific Northwest | Shed Roof Plank Houses.* James Marston Fitch Charitable Trust, 2017.*

Waterman, T.T. "North American Indian Dwellings." In *Annual Report of the Board of Regents of the Smithsonian Institution.* Washington, DC: Smithsonian Institution 1924. 461–86,5

———. "North American Indian Dwellings." *Geographical Review* 14, no. 1 (1924): 1–25.*

Waterman, T.T., and Geraldine Coffin. *Types of Canoes on Puget Sound.* Museum of the American Indian, Heye Foundation, 1920.*

Wells, Oliver, Ralph Maud, Brent Douglas Galloway, and Marie Weeden. *The Chilliwacks and Their Neighbors.* Talon Books, 1987.

White, Bill, and Andrew Cienski. "White Nobility Blankets Are Gifts of the Creator… We Must Follow Our Customs." *Snuneymuxw News* (Nanaimo, BC), October 21, 2011, 7–10.

Wickwire, Wendy C. *At the Bridge: James Teit and an Anthropology of Belonging.* UBC Press, 2019.

Wikipedia contributors, "The Canadas," *Wikipedia, The Free Encyclopedia*, accessed November 20, 2024).*

Wilson, Charles. "Report on the Indian Tribes Inhabiting the Country in the Vicinity of the 49th Parallel of North Latitude." *Transactions of the Ethnological Society of London* 4 (1866): 275–332.*

Wilson, Jordan. "'Belongings' in 'c̓əsnaʔəm: The City before the City,'" *iPincн: Intellectual Property Issues in Cultural Heritage*, January 27, 2016.*

CONTRIBUTORS

LIZ HAMMOND-KAARREMAA, ICELANDIC/IRISH/SCOTTISH SETTLER

Liz Hammond-Kaarremaa has an MA in educational technology and holds a Master Spinner Certificate from Olds College. She is a researcher of Coast Salish spinning and collaborates with museums and Indigenous communities, sharing her knowledge through research writing, workshops and lectures. Her research and publications focus on Coast Salish textiles, including articles in academic journals (*Science, BC Studioes*) and magazines (*Spin-Off, Ply, Selvedge*). She lives on Protection Island, near Nanaimo, BC.

Manu Ronse

CHEPXIMIYA SIYAM CHIEF DR. JANICE GEORGE AND SKWETSIMELTXW WILLARD (BUDDY) JOSEPH, SḴWX̱WÚ7MESH ÚXWUMIXW (SQUAMISH NATION)

Chief Janice George graduated from Capilano University, North Vancouver, BC, and the Institute of American Indian Arts, Santa Fe, NM. She feels her education at these schools helped her excel as a teacher, adding to her most important traditional teachings. She is a Hereditary Chief, trained museum curator and educator. George also co-organized the first Canada Northwest Coast Weavers Gathering, with other Squamish Nation Weavers. George and Joseph are from prominent Squamish families and have numerous ceremonial and cultural responsibilities in their community. Joseph is the former director of the Squamish Housing and Capital Projects and currently consults on capital projects for Indigenous communities.

Marion Jacobs

DEBRA QWASEN SPARROW, X̱ʷMƏΘKʷƏÝƏM (MUSQUEAM)

Debra Sparrow has been deeply involved with the revival of Musqueam weaving for over thirty years, and has many years of study, trial and learning directly from the work of her ancestors. Her work has been collected and exhibited nationally and internationally including the University of British Columbia, the Canadian Museum of History (previously Civilization), the Royal BC Museum, the Vancouver International Airport (YVR Collections), the Burke Museum of Natural History and Culture (Seattle), and the Smithsonian. She was the recipient of the BC Creative Achievement Award for First Nations Art in 2008. Most recently, she participated in *The Fabric of Our Land: Salish Weaving* at the Museum of Anthropology at UBC as both an exhibitor and as a regular, active weaving demonstrator using a traditional loom from the museum collection.

Ollie Dickerson

241

Maxine Bulloch Photography

SENAQWILA WYSS, S̱ḵW̱X̱WÚ7MESH ÚXWUMIXW (SQUAMISH NATION)

Senaqwila Wyss is from the Sḵwx̱wú7mesh Úxwumixw (Squamish Nation), with Tsimshian, Stó:lō, Hawaiian and Swiss ancestry. She is an ethnobotanist, warrior entrepreneur, co-owner of Raven and Hummingbird Tea Co. and a weaver. She is also an Indigenous cultural programmer at Museum of North Vancouver (MONOVA), where in May 2023 she coordinated the public presentation of *Stémxwulh: Woolly Dog Weavings*, featuring two rare Salish Woolly Dog ceremonial robes. In 2021, Senaqwila's six-part #WoollyWednesday series highlighted Salish perspectives and demystified colonial narratives, bringing forth the beautiful relationship the Salish Nations had with their Salish Woolly Dogs. It was also broadcast on CBC.

Michelle Cohen

saɫamitća SUSAN PAVEL, PHD, BORN FILIPINO, RAISED IN KOREAN/CAUCASIAN FAMILY, MARRIED INTO SKOKOMISH

saɫamitća Dr. Susan Pavel, Filipina by birth, first learned Coast Salish wool weaving during the summer of 1996. Her master teacher was subiyay Bruce Miller of the Skokomish Nation, uncle to her husband, Michael Pavel. Each summer she would take three full months to produce one ceremonial blanket and then gift it to Elders of the tribe. By the fourth year, it was suggested she sell her creations as an exchange of gifts and she started along that path. By the seventh year, she was invited to teach weaving classes with Tribal Nations and has taught hundreds of students. Susan has curated, participated in, and solo exhibited in twelve museum exhibits and over twenty-five gallery exhibits. She has been awarded seventeen artist-in-residence or grant opportunities. She has over thirty bibliographic acknowledgements. She has consistently taught, presented and/or demonstrated for twenty-five years. Her weavings can be seen in ten public venues and numerous private collections across the nation. She currently serves as the executive director of the Coast Salish Wool Weaving Center, as well as an adjunct faculty member at The Evergreen State College in Olympia, WA. Today, Susan continues to weave and teach, as she is obedient to SQ3Tsya'yay Weaver's Spirit Power.

DR. MICHAEL PAVEL, SKOKOMISH/TWANA

Dr. Michael Pavel is a Salish Tradition Bearer, highly regarded scholar, and accomplished traditional artist. Michael has worked throughout his life to bridge the divide between Indigenous ways of knowing and knowledge systems of contemporary Western society. He is a Tradition Bearer of Southern Puget Salish traditional language, culture, history as well as a leader in the traditional guardian winter spirit society in the House of slanay on the Skokomish Reservation. Michael has had the opportunity to apprentice with many respected Elders throughout his life and continues to seek any and all opportunities to promote the significance of traditional ancestral teachings of Salish cultures, which are still highly applicable to our Salish communities and overall society.

Mark Colson

SNUMITHIA' VIOLET ELLIOTT, SNUNEYMUXW AND QUW'UTSUN (COWICHAN)

Violet is from Snuneymuxw, Stzuminus, Penalekut and Cowichan now residing in Quamichan, which is in Cowichan. She lives with her Sta'lus, Joe Elliott, her Memuna', Jeremy Elliott, married to Maria, and they have two beautiful daughters, Adelie and Evelie. Her youngest son is Tyrone Elliott, and his fiancé is Jasmine Dionne.

Violet has been weaving for twenty-five years. She has taught hat-weaving and purse-weaving workshops, and visits schools to introduce children and youth to the values of cedar-bark gathering. She also enjoys gathering other natural weaving materials and being in the outdoors. Violet has primarily worked in the counselling/facilitating field, teaching history and impacts of colonization and Indian Residential Schools.

Liz Hammond-Kaarremaa

TUWUXWUL'T-HW TYRONE ELLIOTT, QUW'UTSUN (COWICHAN) AND SNUNEYMUXW

My name is Tyrone Elliott; my Ancestral name is Tuwuxuwult-hw, a name I've had passed to me by my father. I am the son of Violet Elliott, who is Snuneymux' and a highly regarded weaver, and Joe Elliott, who is Quw'utsun and taught me all about harvesting and passed unto me a wealth of knowledge about local plants. I come from other Nations, Lands and Waters, too, but those are the ones I hold closest. I am a Cedar Weaver, a visual artist, a mentor to youth and early career artists, a facilitator of decolonial history and Indigenous consultation, among many other occupations, relations and responsibilities. My interest in the Woolly Dog comes from my weaving background and a yearning to feel closer to my Ancestors. I am in awe of the knowledge, technology and science that was necessary to selectively breed a dog for its wool.

Tyrone Elliott

Jared Qwustenuxun Williams

JARED QWUSTENUXUN WILLIAMS, QUW'UTSUN (COWICHAN)

Jared "Qwustenuxun" Williams is a passionate traditional foods chef who works with Elders and knowledge holders to keep traditional food practices alive. Qwustenuxun spent much of his youth with his late grandmother, immersed in Salish culture. After nearly a decade and a half of cooking for his communities' Elders, Qwustenuxun now works as an Indigenous foods educator, writer and consultant.

Qwustenuxun won a Canadian Online Publishing Award for best multicultural story. He was nominated for the 2022 BC Multiculturalism and Anti-Racism Award and helped FNHA (First Nations Health Authority) complete their first smoked salmon project, proving that Salish smoked salmon is a safe and effective technique for food preservation. Qwustenuxun has also been a featured guest on APTN's hit series *Moosemeat and Marmalade*, cooked Indigenous foods on *Flavours of the Westcoast* television show, and has been featured on CBC Radio many times for his efforts in First Nations food sovereignty. Qwustenuxun also maintains a very popular and active social media presence, from sharing language videos on TikTok and funny Indigenous memes on Instagram, to a blog on Facebook about the lasting impacts of colonization.

SiSeeNaxAlt Gail White Eagle

KERRIE CHARNLEY, xʷə́lməxʷ, PHD, q̓íc̓əy̓/KATZIE

Kerrie Charnley is an apprentice Coast Salish wool weaver under the guidance and teaching of Musqueam master weaver Debra Sparrow and Squamish master weavers Janice George and Buddy Joseph. Her grandmother, Amanda Pierre, was a Coast Salish knitter and wool spinner. The source of her wool was her English husband Clinton Charnley's brother, her brother-in-law Frank Charnley, who was a biologist and BC's first fisheries officer (his personal papers are in the UBC archive), as well as the owner of a sheep hobby farm on Barnston Island. Kerrie is a proud member of the q̓íc̓əy̓ (Katzie) First Nation, who are a part of the xʷməθkʷəy̓əm (Musqueam), sc̓əwaθen (Tsawwassen), səlililw̓ətaʔɬ (Tsleil-Waututh) and q'ʷa:n̓ƛ'ən̓ (Kwantlen) Nations, who are all interrelated as the downriver hən̓q̓əmin̓əm̓-speaking Coast Salish family of peoples. Kerrie has a PhD in Language and Literacy Education with a focus on Coast Salish family pedagogies, and multimodal and land-based literacies, from the University of British Columbia. Over the past twenty years, she has taught courses in Indigenous education, literature, Indigenous health and English and cultural studies at UBC Vancouver, SFU and the Institute for

Indigenous Governance (NVIT) and, most recently, in her role as assistant professor of teaching in the Faculty of Creative and Critical Studies, at UBC Okanagan. Kerrie is a grand-niece of Simon Pierre and the great-grand-daughter of Peter Pierre. Simon Pierre was the secretary and translator for the Indigenous Chiefs in British Columbia during the early part of the twentieth century, and in 1906 he travelled with the Chiefs to England to petition King Edward.

ANDREA FRITZ, LYACKSON FIRST NATION

Andrea Fritz is a Coast Salish artist and author from the Lyackson First Nation of the Hul'qumi'num-speaking Peoples, on the West Coast of Canada. She learned West Coast Native art in the Victoria school district from Victor Newman (Kwagiulth).

Jordan Glowicki

Andrea strives to express her people's history (and all our futures) using her art. She focuses on animals and scenes of the West Coast of Canada, and our intricate relationships with them. Andrea works in the mediums of acrylic on canvas/wood, serigraph, vector art and multimedia. She has had numerous shows of her work including at Eagle Feather Gallery in Victoria, the Place Gallery and The Outpost at Ketchikan.

Andrea teaches Coast Salish art to students in the Victoria school district and throughout the province. Andrea has participated in community-based art pieces including Oaklands walking signs, a mural at Sir James Douglas Elementary, and an elder gift from her nation for an Elders' retreat to Lummi. Andrea plans to continue sharing her knowledge of the art as well as create new art to inspire change. She hopes to show the beauty of the people, places, animals and stories in our corner of the world.

JEFFREY VEREGGE, S'KALLAM TRIBE (1974–2024)

Jeffrey Veregge was an award-winning Native American artist and writer from the Port Gamble S'Klallam Tribe. His work, which blended traditional Coast Salish aesthetics and pop culture references into what he called "Salish Geek" style, was featured in exhibitions at the George Gustav Heye Center, the IAIA Museum of Contemporary Native Arts, and the Center on Contemporary Art. Jeffrey was also known for his work in the comic book industry, including variant covers for Marvel Comics.

Christina Veregge

YÚY'YUx̣TXN JAMES CHEHOLTZ

In 1927, *yúy'yuxṭ xn* contributed a Traditional Story and was the son of Chief Henry Cheholtz, and Grandson of Chief Kiscox, representative Chief for the Cowlitz at the 1855 Chehalis River Treaty Negotiations. The Cheholtz family is from the síq'ʷɬ (Toutle river band of Cowlitz), near the middle part of the Cowlitz River in present-day Castle Rock, WA.

ALISON ARISS, IRISH/SCOTTISH SETTLER

Alison Ariss is a PhD candidate in art history at the University of British Columbia, and a UBC Public Scholars Fellow. She holds an MA in art history (UBC) and a BA (Honours) in anthropology (Waterloo). She centres Indigenous knowledges in the analyses of public art installations of twenty- and twenty-first-century Salish weavings. Her research interests include Indigenous women-identified art forms, textiles, museum studies, feminism and public art. She has published in the *Journal of Textile Design Research and Practice* and in *RACAR*. Alison is grateful to have attended Salish weaving workshops led by Chepximiya Siyam Hereditary Chief Janice George and Skwetsimeltxw Willard (Buddy) Joseph, Debra Sparrow, Frieda George and Dr. Susan Pavel. Alison volunteered with the UBC Museum of Anthropology for the Fabric of Our Land exhibition in 2017–18, held a special curatorial internship at the Morris and Helen Belkin Gallery in 2019–20 and is collaborating with the Coqualeetza Cultural Education Centre to document Salish Weavers Guild weavings.

Paul H. Joseph

ELIOT WHITE-HILL KWULASULTUN, SNUNEYMUXW

Eliot graduated from Vancouver Island University with a Bachelor of the Arts, and a MFA from Emily Carr. Eliot is a published author and artist with written works of fiction in the magical realism genre and his art in traditional Coast Salish style. He sees his work as an artistic extension of his storytelling. He was awarded two YVR Emerging Artist Scholarships in 2021 and 2022. He is one of five Northwest Coast artists participating in a 2024 exhibition at the American Museum of Natural History (AMNH) in New York City.

Liz Hammond-Kaarremaa

DANIELLE MORSETTE, SUQUAMISH AND SHXWHÁ:Y (STÓ:LŌ NATION)

Danielle Morsette is from the Suquamish tribe and Band Shxwhá:y Village. Her work includes regalia items to be worn by Indigenous people as well as wall hangings made to be displayed. She has been featured in multiple art exhibitions in Washington, Oregon and British Columbia.

XWELÍQWIYA RENA POINT BOLTON, (STÓ:LŌ NATION)

Rena is a Stó:lō matriarch, artist, basket weaver and wool weaver. She is also a Knowledge Keeper and assisted in keeping the old crafts alive during a time of cultural repression to avoid persecution by the Canadian government. Schooled by her mother and grandmother, she helped keep these practices alive. Her childhood training ultimately set the stage for her roles as a teacher and activist. Recognizing the urgent need to forge a sense of cultural continuity among the younger members of her community, Rena visited many communities and worked with federal, provincial and Indigenous politicians to help break the intercultural silence by reviving knowledge of, and interest in, Indigenous art.

Liz Hammond-Kaarremaa

IMAGE CREDITS

FIG 1 *Esquimalt Harbor*, US National Archives (ID#102278812).

FIGS 3 & 4 Courtesy Smithsonian Institution Archives (Record Unit 7002, Box 26, Folder 19).

FIG 5 *HBC Fort Langley*, US National Archives (ID# 305495).

FIG 7 Courtesy Smithsonian Institution Archives (SIA #78-10093).

FIG 8 Courtesy Smithsonian Institution Archives (SIA_000095_B27B_016).

FIGS 10 & 11 Wisconsin Historical Society Archives, Gibbs Family Papers, PH 3696 MAD 4/90/F4 Folder 1.

FIG 12 *View from hill on San Juan Island*, US National Archives (ID #305493).

FIG 16 *Camp Sumas*, US National Archives (ID #102278836).

FIG 17 Courtesy Department of Anthropology, Smithsonian Institution (USNM 4762).

FIG 18 Courtesy City of Vancouver Archives. AM54-S4-: In P120.2.

FIG 19 Courtesy City of Vancouver Archives, VCA P41.1.

FIG 20 Suttles, Wayne P., Wilson Duff, and Diamond Jenness. *Katzie Ethnographic Notes.* British Columbia Provincial Museum, Dept. of Education (Victoria, BC: 1955).

FIG 22 Courtesy Burke Museum, University of Washington, Seattle (2_5e1965).

FIG 23 Gift of the American Antiquarian Society. Courtesy of the Peabody Museum of Archaeology and Ethnology, Harvard University (90-17-10/48410).

FIG 24 Gift of the American Antiquarian Society, 1890. Courtesy of the Peabody Museum of Archaeology and Ethnology, Harvard University (90-17-10/48411).

FIG 25 Gift of the American Antiquarian Society. Courtesy of the Peabody Museum of Archaeology and Ethnology, Harvard University (95-20-10/48393).

FIG 27 © Pitt Rivers Museum, University of Oxford (PRM1884.88.9).

FIG 29 Courtesy National Museum of the American Indian, Smithsonian Institution (9/9820).

FIG 31 Courtesy the National Museum of Finland, Etholén Collection, catalog number (signum) VK1.

FIG 33 Courtesy Department of Anthropology, Smithsonian Institution (E177710).

FIG 34 Courtesy National Museum of the American Indian, Smithsonian Institution (13/8571).

FIGS 38 & 39 House of Wickersham Collection, Alaska State Museum (LC424-1).

FIG 40 *View of Snuneymuxw Village*, looking north. Courtesy of the BC Archives, PDP02144.

FIG 41 Courtesy of the Royal BC Museum and Archives (PN01500).

FIG 42 *Crossing the Strait of Juan de Fuca*. It Watercolor and pencil on paper, 5½ × 9⁷⁄₁₆ inches (14 × 24 cm), Stark Museum of Art, Orange, Texas, Bequest of H.J. Lutcher Stark (1965, 31.78.70).

FIG 43 Courtesy Canadian Museum of History (#33106, CD95-905-009).

FIG 49 Still image from a 1928 film by Harlan I. Smith. Courtesy of Skwetsiya's family and the Canadian Museum of History (IMG2015-0346-0001-DM)

FIG 50 National Museum of the American Indian, Smithsonian Institution (19/9059).

FIG 51 ©Pitt Rivers Museum, University of Oxford (PRM1954.8.152).

FIG 53 National Museum of the American Indian, Smithsonian Institution (16/2072).

FIGS 56 & 57 Courtesy National Museum of the American Indian, Smithsonian Institution (13/847).

FIG 58 Courtesy Burke Museum of Natural History and Culture, University of Washington, Seattle (7997).

FIG 61 Courtesy UBC Museum of Anthropology, Vancouver, Canada (Object #A17028).

FIG 62 Spindle Whorl (Sulsultin), 19th century. Hardwood, pigment traces, 8¾ × 8¾ × ⅜ in. (22.2 × 22.2 × 1 cm). Brooklyn Museum, Museum Expedition 1905, Museum Collection Fund (05.588.7382).

FIG 63 National Museum of the American Indian, Smithsonian Institution (15/8959).

FIG 64 Department of Anthropology, Smithsonian Institution (NMNH E221179E).

FIG 65 Courtesy Royal BC Museum and Archives (PN00083).

FIG 66 *A Songhees Girl Spinning*, Songhees (Victoria Harbour, Central Coast Salish) by Paul Kane, April-June, 1847. Watercolour and graphite on paper. 18.1 × 13.3 cm. Courtesy Royal Ontario Museum (#ROM946.15.226.1).

FIG 67 © The Field Museum (No. A112845_4c, Cat. No. 85378.H).

FIG 68 Courtesy Royal BC Museum, Victoria, Canada (Object#2907).

FIG 69 *A Woman Weaving a Blanket*, Songhees/Saanich (Central Coast Salish), Oil on canvas, 1849-1856; Paul Kane (1810 Mallow, Ireland– 1871 Toronto, Canada); Courtesy of Courtesy of ROM (Royal Ontario Museum), Toronto, Canada.(ROM 912.1.93) ©ROM.

FIG 70 Oil on canvas, painted sometime between 1849–1856, measuring 76.5 × 63.9 cm; by artist Paul Kane (1810 –1871); Courtesy of Courtesy of ROM (Royal Ontario Museum), Toronto, Canada. (ROM 912.1.89) ©ROM.

FIG 71 *A Clallum Girl*, Clallam (Central Coast Salish). Painted between 1849-1856, measuring 63.4 × 51.2 cm; by artist Paul Kane (1810–1871); Courtesy of Courtesy of ROM (Royal Ontario Museum), Toronto, Canada. (ROM912.1.86) ©ROM

FIG 72 Artist: Paul Kane (1810–1871), *Woman Spinning Yarn*, 1847. Watercolor and pencil on paper, 5 × 7 inches (12.7 × 17.8 cm), Stark Museum of Art, Orange, Texas, Bequest of H.J. Lutcher Stark, 1965 (31.78.96).

FIG 73 Artist: Paul Kane (1810–1871), *Interior of a Lodge with Indian Woman Weaving a Blanket*, 1847. Watercolor and pencil on paper, 5½ × 9⅜ inches (14 × 23.8 cm), Stark Museum of Art, Orange, Texas, Bequest of H.J. Lutcher Stark, 1965 (31.78.73).

FIGSS 74 & 75 Department of Anthropology, Smithsonian Institution (E-1894-0).

FIG 76 Department of Anthropology, Smithsonian Institution (NMNH E221408-0).

FIG 78 Courtesy of the Perth Art Gallery and Museum, (Acc. No. 1978.1761).

FIG 79 Courtesy Burke Museum, University of Washington, Seattle (obj #1-507).

FIG 81 Wanapum woman, children, and puppy at Priest Rapids, WA, 1926. Krieger papers, box 26, Courtesy Department of Anthropology, Smithsonian Institution.

FIG 82 Courtesy Seattle Public Library (SPL-NWP-00042).

FIG 83 Courtesy Chilliwack Museum and Archives (1963.015.025).

FIGS 84 & 85 COWAN_PH_066; Cowan_PN_579 & PN_065; Cowan B & W Photographs - Species and Locations - Box 3.

FIG 86 Courtesy Royal British Columbia Museum and Archives, Victoria, BC (ICAR: PN10074).

FIG 89 *Clallam Woman Weaving a Basket*, Paul Kane (1810–1871), 1847, Watercolour and pencil on paper, 5½ × 9⅜ inches (14 × 23.8 cm), Stark Museum of Art, Orange, Texas, Bequest of H.J. Lutcher Stark, 1965 (31.78.45).

FIG 90 *Studies of Wool Dogs and Interior Furnishing*, Central Coast Salish, Graphite on paper, Southeastern Vancouver Island, April–June 1847, 12.8 × 18.0 cm; Paul Kane (1810 Mallow, Ireland–1871 Toronto, Canada); Courtesy of ROM (Royal Ontario Museum), Toronto, Canada. (ROM946.15.225.1) ©ROM.

FIG 91 *Interior of a Lodge with Family Group*, 1847. Paul Kane (1810–1871). Watercolor and pencil on paper, 5 ½ " × 9 3/8" (14cm x23.8cm), Stark Museum of Art, Orange, Texas, Bequest of H.J. Lutcher Stark, 1965 (31.78.87).

FIG 92 *Interior of a Clallam Lodge*, Vancouver Island, 1847. Paul Kane (1810–1871). Watercolor and pencil on paper, 5⅜ × 8¹⁵⁄₁₆ inches (13.7 × 22.7 cm), Stark Museum of Art, Orange, Texas, Bequest of H.J. Lutcher Stark, 1965 (31.78.80).

FIG 94 View of Poplar Island yeɬkʷə on the Fraser River from River Road. [ca.1913]. Courtesy New Westminster Museum and Archives (IHP2656).

FIG 98 (Journal, Northwest Boundary Survey, 1857-1862, pg 26), Courtesy Smithsonian Institution Archives SIA RU007209 Box 1 Folder 2.

FIG 99 Courtesy Smithsonian Institution Archives. SIA000305 R008 Y1859 A0000083 pt1of2, Record Unit 305.

FIG 100 Courtesy Smithsonian Institution NMNH, Ledger Volume 2 (Skins): USNM 004751-004775.

INDEX